SPANISH SCULPTURE

Published with the generous assistance
of the Cañada Blanch Foundation

Through the encouragement of research,
the Cañada Blanch Foundation promotes
the education of Spanish and British citizens
in each other's history and culture.

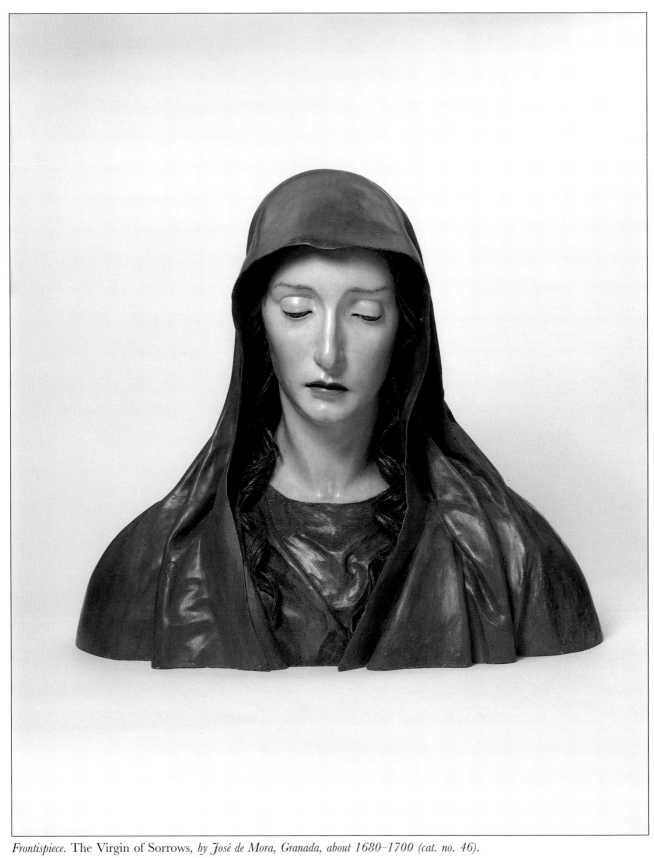

Frontispiece. The Virgin of Sorrows, *by José de Mora, Granada, about 1680–1700 (cat. no. 46).*

SPANISH SCULPTURE

Catalogue of the Post-Medieval Spanish Sculpture in
Wood, Terracotta, Alabaster, Marble, Stone, Lead and Jet
in the Victoria and Albert Museum

MARJORIE TRUSTED

VICTORIA AND ALBERT MUSEUM
Published with the assistance of a grant from the Cañada Blanch Foundation

First published by the
Victoria and Albert Museum,
London, 1996

The Victoria and Albert Museum
London SW7 2RL

ISBN: 1 85177 177 8

A catalogue record for this book is available from the British Library

Produced by Sutton Publishing Limited, Stroud, Gloucestershire.
Printed by Butler and Tanner, Frome, Somerset.

CONTENTS

For Thomas Jordi and Isabella May

ACKNOWLEDGEMENTS

In the writing of this catalogue I have received tremendous help and encouragement from many people. While some are acknowledged in individual catalogue entries, the colleagues mentioned below have given me advice and support in a multitude of ways. The catalogue was completed largely thanks to a period of six months' study leave, when I was attached to the Research Department of the Victoria and Albert Museum; this was invaluable, and I should particularly like to thank Charles Saumarez Smith, Malcolm Baker and Paul Greenhalgh for their support, as well as those colleagues in the Sculpture Department who stood in for me during that time. The Cañada Blanch Foundation generously sponsored the publication. Within the Victoria and Albert Museum I am especially indebted to Anthony Radcliffe (formerly Keeper of Sculpture), Paul Williamson, who commented extensively on the text, and gave me many helpful suggestions, as well as Peta Evelyn, Lucy Cullen, Wendy Fisher, Norbert Jopek, Fiona Leslie, Alex Kader, Chloë Archer, Diane Bilbey, Sarah Herring, Clare Browne, Paul Harrison, Robin Hildyard, Reino Liefkes, Anthony North, Pippa Shirley, John Guy, Caroline Goodfellow and Claire Sussoms. Mary Butler helped greatly with preparing the text for publication. Colleagues in the Conservation Department provided invaluable advice on the materials and techniques used for Spanish sculpture, particularly Richard Cook, Josephine Darrah, Alexandra Kosinova, Charlotte Hubbard, Victoria Oakley, Diana Heath, John Larson (formerly Head of Sculpture Conservation), and Anne Brodrick (formerly Senior Conservator in Sculpture Conservation). Most of the photographs of sculpture in the Museum were taken by Stanley Eost and Mike Kitkatt. In addition to colleagues within this Museum, I should like to thank Nicholas Penny, Gabriele Finaldi, Timothy Wilson, Robin Crighton, Johannes Röll, David Davies, Enriqueta Harris Frankfort, Carmen Fracchia, Hilary McCartney and Duncan Bull for their comments and advice. In Spain I benefited from the generous assistance of a number of people, including Luis Luna Moreno, Manuel Arias, Mª Rosario Fernández González, Profesor J. J. Martín González, Margarita Estella, Angela Franco, María Jesús Herrero, Julia Ara Gil, Jesús Mª Parrado del Olmo, Fernando Benito, Cristóbal Belda, Domingo Sánchez-Mesa Martín, Jesús Palomero, Teresa Macià, and Padre Josep de C. Laplana; I am especially grateful to Jesús Urrea, whose interest in the project and acute opinions on the objects were of immense help to me. Finally my thanks to my husband Charles Bird for his support during my research, as well as his comments on the text.

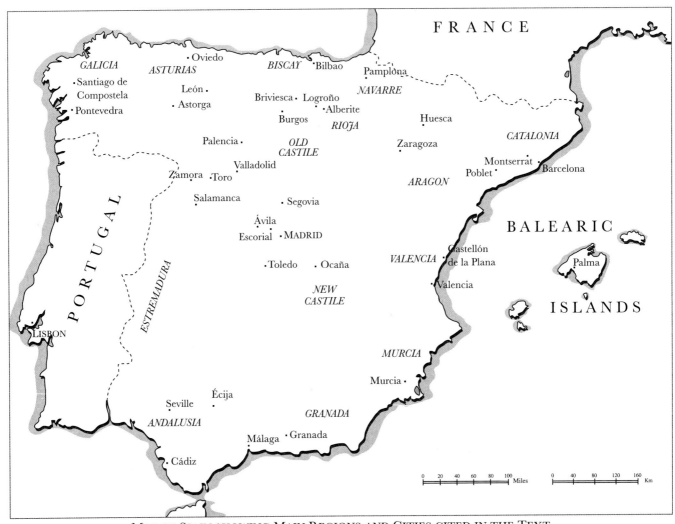

FRANCE

GALICIA ASTURIAS · Oviedo BISCAY · Bilbao · Pamplona

· Santiago de
Compostela León · NAVARRE
Briviesca · Logroño
· Pontevedra · Astorga · Alberite
Burgos · Huesca
RIOJA CATALONIA
PORTUGAL Palencia · OLD Zaragoza ·
CASTILE Montserrat Barcelona ·
Valladolid Poblet ·
Zamora · Toro ARAGON BALEARIC
Salamanca · · Segovia
ÁRAGON
Ávila · VALENCIA Castellón ISLANDS
Escorial · MADRID de la Plana Palma
ESTREMADURA · Toledo · Ocaña · Valencia
NEW
CASTILE
LISBON MURCIA
Murcia ·
Écija
Seville · GRANADA
ANDALUSIA Málaga · Granada
· Cádiz

0 20 40 60 80 100 Miles 0 40 80 120 160 Km

MAP OF SPAIN SHOWING MAIN REGIONS AND CITIES CITED IN THE TEXT

INTRODUCTION

I: 'Failures as Works of Art'?[1] British Attitudes to Spanish Sculpture and the Formation of the Collection

BRITISH ATTITUDES TO SPANISH SCULPTURE

Historically Spanish sculpture has been little admired in Britain, and far less appreciated than Spanish painting.[2] There are political and religious reasons for this, as well as aesthetic ones, although of course these overlap with one another. Both a cause and an effect of the relative lack of interest in Spanish sculpture is that most of the material has remained in Spain, and comparatively few English travellers have gone to see it.

When Charles I (1600–1649) visited Spain as Prince of Wales in 1623, he was presented with Giambologna's monumental work, *Samson and the Philistine* (now in the Victoria and Albert Museum), which had itself been a diplomatic gift of 1601 from the Grand Duke Ferdinand de'Medici of Tuscany to the Duke of Lerma in Valladolid.[3] An Italian garden marble group was no doubt considered to be an aesthetically acceptable object for one who was both a sophisticated connoisseur and heir to the throne of England.[4] Charles was certainly not offered, nor would he have presumably wanted, any Spanish sculpture. As is clear from the contemporary accounts by the painter and theorist Vicente Carducho (*c.* 1576–1638), during his 1623 visit the British Prince enjoyed viewing Spanish and Italian paintings, as well as ancient marbles, but implicitly not the vernacular sculpture.[5] His son Charles II (1630–1685) did apparently order a statue (and perhaps a painting) from Alonso Cano (1601–1667) through his English agent in Madrid Henry Bonner in 1660, but whether the commission was carried out, and if so what became of the work, is unknown.[6]

During the eighteenth and nineteenth centuries, while many British travellers journeyed to Italy and Northern Europe, often as part of the Grand Tour,

Spain was far less frequently visited.[7] Even in the present century only a minority of art-lovers have spent much time in Spain, partly because of the political troubles the country has suffered until relatively recently. But perhaps as strong a reason for the lack of enthusiasm for Spanish sculpture in Britain was the uneasiness forcibly expressed by many nineteenth-century observers about what was perceived as the overdone naturalism of Spanish sculpture, in particular the use of colour. In 1839 the English writer George Dennis wrote of the painted wood sculpture in Málaga Cathedral:

'While contemplating these statues, I was led to enquire why plain marble figures seem superior as works of art to this painted sculpture; which is undoubtedly the case. Is it the force of habit leading us to associate the coloured figures with the wax-work busts that in England adorn the barbers' windows? It may be so in part, but I think not entirely. There seems to be a legitimate reason why plain sculpture, *cæteris paribus*, should be preferred to coloured. The latter is too natural – the colour imparts an air of life which destroys its ideality . . . The very incompleteness of sculpture constitutes its peculiar excellence.'[8]

A few years later the renowned traveller and writer on Spain Richard Ford (1796–1858) confirmed this view, emphasising how Spanish sculpture departed from the Greek, or perhaps more precisely the neoclassical tradition of white marble sculpture:[9]

'[Spanish works of sculpture] have a startling identity: the stone statues of monks actually seem petrifactions of a once living being . . . from being clothed and painted they are failures as works of art, strictly speaking, for they attempt too much. The essence of statuary is *form*, and to clothe a statue, said Byron, is like translating Dante: a *marble* statue never deceives; it is the colouring it that does, and is a trick beneath the severity of sculpture. The imitation of life may surprise, but . . . it can only please the ignorant and children . . . to whom the painted doll gives more pleasure than the Apollo Belvidere [sic.].'[10]

1

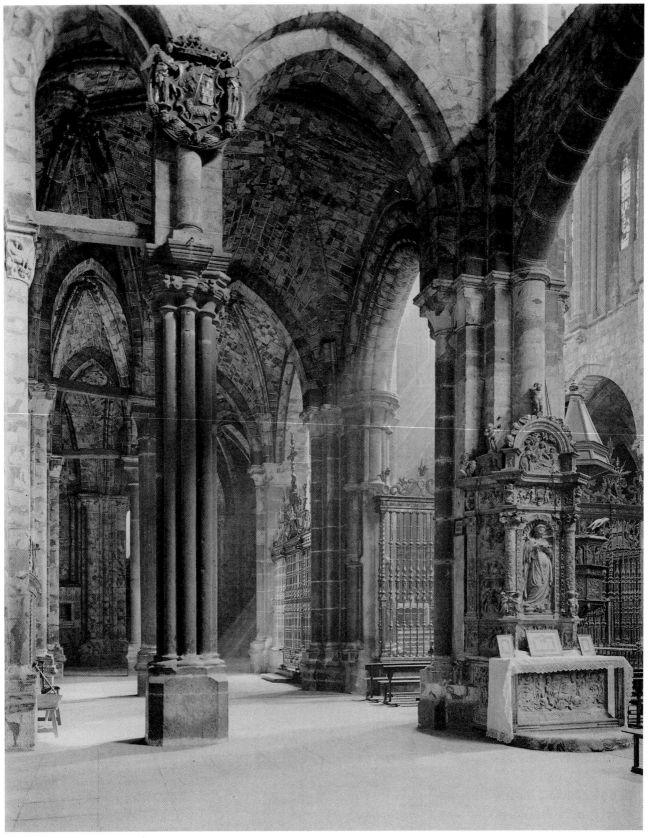

Figure 1. The North aisle of Ávila Cathedral (begun in 1157), showing the alabaster altar of St Catherine by Vasco de la Zarza, Juan Rodríguez and Lucas Giraldo, completed in 1529. Photograph by J. R. H. Weaver (active 1914 onwards). Victoria and Albert Museum inv. no. E.2016–1995.

The almost moral disapproval expressed here about the aesthetic qualities of the sculpture ('a marble statue never deceives') was mingled with the distaste Ford clearly felt for the subjects portrayed in Spanish sculpture, and the way they were interpreted. He went on:

'The imitation is so exact in form and colour, that it suggests the painful idea of a dead body, which a statue does not. But no feeling for fine art or good taste entered into the minds of those who set up those tinsel images. They made sculpture the slave of their end and system; they used it to feed the eye of the illiterate many; to put before those who could not read, a visible tangible object, which realised a legend or a dogma; and there is no mistake in the subject which was intended to be represented; nothing was risked by trusting to the abstract and spiritual.'[11]

Ford here expresses his two intertwined objections to Spanish sculpture: its uncomfortable realism, and what he believed was its sole purpose as a vehicle for 'system' and 'dogma'. Like other Protestant visitors he was fiercely critical of the despotism of the Church in Spain. His choice of the image of 'the painful idea of a dead body' may well be a conscious indirect reference to figures of Christ on a bier seen in innumerable Spanish churches.[12]

An anonymous article in the *Art-Journal* written in 1865, shortly after the Museum had acquired several pieces of Spanish sculpture, condemned them as inappropriate (partly because at that date the Museum was thought to be primarily 'for the use of students in Art-manufacture'). The writer demanded to know,

'Of what use to [students] can those hideous Spanish terra-cottas be, that represent the Saviour and various saints in the most repulsive style? The Saviour is upon the cross,[13] covered with blood and bruises; His knees are bared of flesh, which is blackened round the bones. Is such a figure here to be studied for reproduction? Is it not rather an eye-sore and an offence to a rightly-conditioned mind? Less disgusting, but more absurd and useless, is another figure[14] of the Saviour bearing His cross in a magnificent flowered dress of green and gold, a work of modern date. . .'[15]

Such responses, dating from the mid-nineteenth century, are less current today, when colour in sculpture is not seen as necessarily detrimental, and when religious sculpture is felt to have complex cultural functions and purposes. Apart from the effigies (cat. nos. 2, 3, and 4), the heraldic relief

(cat. no. 5), and one of the jets (cat. no. 86), virtually all the Spanish sculpture in the collection of the Victoria and Albert Museum is religious. A number of pieces are small-scale, mainly because such objects were more easily transported; many are indeed fragments from altarpieces. Having lost their original functions and contexts to be displayed in a secular environment, some of their intended meaning, purpose, and visual power has inevitably been lost; the fundamentally sacred nature of the images, as Ford knew, affects our perceptions of them as works of art (*cf* fig. 1, the north aisle of Ávila Cathedral, where a side-altar is seen in its intended context). Whilst being one of the most important single groups of Spanish sculpture outside Spain,[16] only a small minority of these objects has been published since 1881.[17] These two facts indicate that both collectors and art historians, at least in Britain, have generally devoted more time to other fields.[18]

The exceptional systematic formation of the present public collection in the mid-nineteenth century was without precedent.

THE FORMATION OF THE COLLECTION
I: JOHN CHARLES ROBINSON

Just over a decade after the foundation of the South Kensington Museum (part of which was to become the Victoria and Albert Museum), in a report of June 1863, the Science and Art Department of the Committee of Council on Education reported on the Art Collections of the Museum:

'Their Lordships are of opinion that on the whole the valuable collections which have been made, contain the classes of objects which it was considered desirable to acquire when the collections were commenced. They consider that perhaps the most useful and important section of art, namely that of Medieval Italy is well represented; and remark that other sections are incomplete, and some, such as Spanish, are hardly represented at all.'[19]

At that date the Museum owned only one minor piece of Spanish sculpture (cat. no. 59), and it must have been as a result of the above report that the collection was initiated. The man primarily responsible for this was John Charles Robinson (1824–1913) [fig. 2].[20]

Robinson had been in the service of the Museum

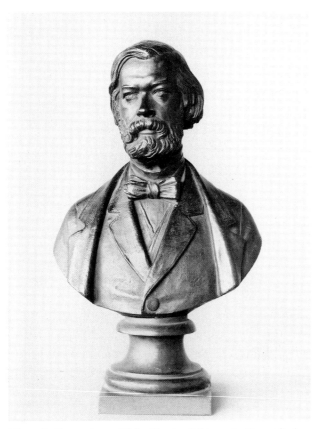

Figure 2. Bronze bust of John Charles Robinson by Baron Carlo Marochetti (1805–1867); c. 1864–5. Victoria and Albert Museum (inv. no. A.202–1929).

exceptional pieces, and how he fared as a curator within the Museum under its Director and Secretary, Henry Cole (1808–1882).

As well as being the first and probably the greatest curator of the then South Kensington Museum, Robinson also stood in a tradition of more or less intrepid English travellers to Spain, the most famous of whom was Richard Ford, whose *Handbook to Spain* (quoted above) had been published to great acclaim in 1845. Robinson himself was to write in 1881:

'Ford was the first to call attention to classes of art monuments, in which the Peninsula undoubtedly stands unrivalled . . . It was impossible to read his enthusiastic, yet well warranted, descriptions of these marvels, without experiencing the keenest desire to become better acquainted with innumerable art monuments, obviously differing very greatly from those of an analogous kind in other countries.'[21]

By the time Robinson was travelling in Spain in the 1860s railways were being built. Nevertheless even by train Toledo was 'only three hours from Madrid' (the two cities are about thirty-five miles apart), while some places, such as Cuenca, could only be reached by diligence; being ninety miles from the capital, this took fifteen hours on a 'fairly easy road'.[22]

Rather like the much larger and more prestigious holdings of Italian sculpture in the Museum,[23] the strength of the collection derives primarily from the core of objects acquired by Robinson. Looking back on his career in an article he wrote in 1897, he spoke of the difficulties of acquiring works of art in Paris and Germany in the 1860s, but went on to say that Italy and Spain

'especially the latter country, with its sister realm of Portugal, were differently situated . . . the peninsular countries were still a virgin soil. In those regions . . . the collection of works of art in their original sources and habitations, was still feasible and calculated to yield a rich harvest. The most important gatherings of the South Kensington Museum . . . were mainly the result of the writer's successive yearly expeditions of several months' duration, in which innumerable art auctions, dealers' gatherings, old family collections, convent and church treasuries, yielded up an infinity of treasures. . .'[24]

This open admission of appropriating works of art from convents, churches, old families and so on does not mean that Robinson was insensitive to the undesirability of removing works of art from their original contexts. In a letter to the *Times* of

since 1853, at first as Curator of the Art Collections, but in 1863 he was appointed Art Referee, recommending for purchase a wide range of works of art, including metalwork, woodwork, textiles and ceramics, and is especially remembered today for his acquisitions of sculpture. He purchased on behalf of the Museum twenty-four of the objects here catalogued on journeys to Spain in 1863 and 1865 respectively; in 1879, after he had left the Museum, two further pieces of Spanish sculpture (also acquired in Spain) were bought from him.

Robinson's collecting of Spanish sculpture is known from three main sources: the objects themselves, the surviving notes, minutes and correspondence written by Robinson, or addressed to him (held both at the Victoria and Albert Museum and at the Ashmolean Museum in Oxford), and to a lesser extent his published essays and catalogues. From these can be gauged how he journeyed from city to city in Spain, often securing

December 26th 1877 he wrote about a door carved by Alonso Berruguete for a church at Guadalajara, despairing that it had not been acquired for the Archaeological Museum in Madrid, and noting that it was bought by a 'Continental amateur' who subsequently sawed it in two. Robinson commented, 'Now it is clear such a work as this should never have been allowed to leave Spain.'

Robinson's journeys to Spain in his capacity as Art Referee had two purposes. As he noted in the report made for Henry Cole on his return, dated March 1st 1864, he had been asked first to 'find out and effect the purchase of objects of art, more especially of Spanish national origin, suitable for the Kensington Museum; and secondly to inspect the permanent monuments of art with a view to the procuring such illustrations or reproductions of them as it might seem desirable to add to that collection.'[25] He continued:

'I should propose that a certain number of photographs be taken [at Toledo] less with a view to ultimate exhibition in the Museum, than for the systematic forming of a Spanish collection to be kept for reference and study in the Library . . . [and] that a few large and in every respect thoroughly detailed and effective coloured drawings of objects of great importance only, should be put in hand at the same time, these for public exhibition in the Museum, and that if any casts were undertaken, that they should be of such dimensions, general importance and sightliness as to prove attractive objects for exhibition to the general public, and not mere reproductions of minor details, liable to be lost sight of among the great mass of similar casts already obtained.'[26]

Robinson went on to propose that the choirstalls by Berruguete in Toledo Cathedral be cast, and a drawing be made of a Renaissance *custodia* (monstrance) also in the Cathedral. In fact, these were neither drawn nor cast, but other objects were reproduced and brought to South Kensington in the next few years, most notably the Pórtico de la Gloria of the Cathedral at Santiago de Compostela, the plaster cast of which is now in the Museum.[27]

Apart from sculpture, the other major objects Robinson bought in Spain were items of metalwork,[28] and after his 1863 visit it was a goldsmith's piece [fig. 3] which Robinson singled out as the most important of all his Spanish acquisitions:

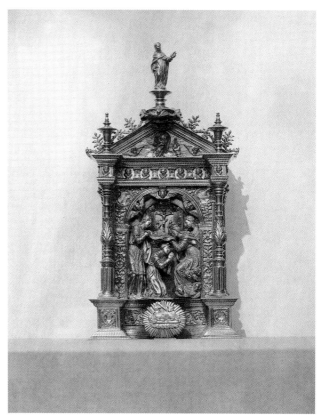

Figure 3. Silver gilt pax attributed to Juan de Orna; Burgos; c. 1525. Victoria and Albert Museum (inv. no. 314–1864).

'The most important specimen acquired is undoubtedly the silver gilt pax believed to be the work of the celebrated silversmith Antonio d'Arfe. This object . . . is . . . of the highest order in point of style and execution, and will give a not inadequate idea of the general characteristics and quality of the splendid works in the precious metals executed with such profusion during the first half of the sixteenth century in Spain.'[29]

Although the formation of the collection of Spanish sculpture rather than metalwork is being discussed here, it is worth pausing briefly to look at the way Robinson justified the acquisition: first of all, it is a 'specimen', so one of a class of objects; secondly, it is technically good, 'of the highest order in point of style and execution'; and thirdly it will represent the 'splendid works' 'executed with such profusion' at that date. In other words, the quality of the piece was indubitably high, but Robinson wrote about it in terms which presumably appealed to Henry Cole, as an object which could primarily educate the audience, because it represented a class of objects.

Each of Robinson's three visits to the Iberian peninsula on behalf of the Museum took about three months; he travelled extensively despite evident practical difficulties, whether poor travelling conditions, lack of art dealers, cold inns, or illness. On his first visit to Spain (the most important in terms of acquisitions of sculpture), he visited a total of twenty-nine cities, mainly in Castile, Andalusia, and Catalonia, including Madrid, Burgos, Valladolid, Salamanca, Seville, Málaga, Granada, Murcia, Valencia and Barcelona. He bought a wide range of sculpture on this trip, mostly in Madrid, where he noted both dealers and works of art could be more readily found, the latter in Robinson's phrase, of an 'available, or if I may so term it, floating kind'.[30]

Although as mentioned above, Robinson was to describe Spain as 'virgin soil', and therefore likely to yield up previously unknown works of art more readily than countries with established art markets, this too created problems, as he noted in his report on his return from this first visit:

'Whatever may be the relative artistic wealth of Spain at the present time in specimens available for purchase, it is certainly more difficult there than elsewhere to find out and acquire such objects, whereas for instance in Italy, Germany and France, everything is known and noted . . . and the machinery of acquisition if I may so term it organized in the most complete and practical manner, in Spain comparatively little of the kind has been done. There are as a rule no dealers, no local guides, no middle men. . .'

He went on,

'Certain national characteristics moreover should be taken into account. . . The innate pride and reserve of the Spanish people indispose them to invite the attention of strangers to their possessions; and it is as difficult to obtain information in respect to objects of art in private hands in Spain as it is easy in Italy. . .'[31]

To understand the art market such as it was in Spain in the 1860s, it is necessary to look briefly at the immediate historical context. The Spanish War of Independence, and the French occupation (1808–1814) in the early years of the century had meant that many works of art were removed from their original settings, while others were damaged or lost altogether. Twenty or so years later a large number of paintings and sculptures were appropriated by the state, when the *desamortización* or secularisation took place in the 1830s. This governmental act, carried out by royal decree in 1835, and orchestrated by the Minister of Finance, don Juan Alvarez Méndez, known as Mendizábal (1790–1853), led to the closure of the smaller monasteries and convents, in an attempt to avert an economic crisis; the works of art previously housed in them were claimed by the Spanish government.[32] This led directly to the formation of a number of museums of fine arts, such as those at Valladolid and Seville, although unfortunately not all the objects found their way to museums, and some were either neglected or misappropriated by the commissioners appointed to the task.[33] Many of Robinson's purchases were certainly originally housed in churches or convents which had been closed down or despoiled of their works of art a few decades previously, such as the figure by Berruguete (cat. no. 11).

Robinson was keen to acquire examples of painted wood sculpture, which he termed 'the thoroughly national category'.[34] He believed he had brought back 'two, if not three, original works from the hand of the greatest Spanish master in that speciality, Alonso Cano'.[35] If Spanish sculpture was largely ignored in England during the nineteenth century, Cano's work may have provided the one exception. Although known primarily as a painter, he was to receive the accolade of being represented as a sculptor on the Albert Memorial, the only Spanish sculptor to be so honoured.[36] By 1895 (and probably long before that date) Robinson himself owned a statuette of the Virgin and Child in polychromed wood, which he believed to be the work of Cano; the present location of this piece is unknown.[37]

None of the acquisitions which Robinson thought to be by Cano is now attributed to this artist. As is the case with several other items in the collection, the attachment of a great name may have given them an initial prestige, but on closer analysis a more accurate description (or what is thought to be so) may reveal a significant piece, but not necessarily the autograph work of a named artist. One of the objects formerly attributed to Cano is a small crucifix (cat. no. 30); it must be contemporary with his activity, and almost certainly comes from

Andalusia, probably Granada or Seville, but is incompatible stylistically with his known works. The other piece Robinson thought to be by him was the figure of the infant St John the Baptist or the Christ Child, now ascribed to José Risueño (cat. no. 44), again different in style from, and in this case slightly later than Cano's work, but from the same geographical area.

Robinson's second trip to the Iberian peninsula, in 1865, concentrated on North West Spain and Portugal; an outbreak of cholera in Madrid curtailed his itinerary. This time he bought only three pieces of Spanish sculpture (as well as some important Hispano-Moresque ivories), perhaps the most important of which was the small figure in polychromed wood of St Francis after Pedro de Mena, although Robinson mistakenly believed it to be after Alonso Cano (cat. no. 24).

Robinson's third trip to Spain on behalf of the Museum took place from September to December 1866; this was the year in which the Pórtico de la Gloria at Santiago was being cast. Political unrest in Spain meant that some works of art were more readily available. Robinson wrote rather feverishly to Cole on October 4th 1866:

'I am very anxious to get authority to buy . . . *now is the time –* this country is in semi-revolution, money has disappeared . . . and whatever there is to be sold is in the market for a fraction of what would have been formerly asked.'[38]

He did buy a number of pieces of jewellery and metalwork, as well as some ivories, but this was his last official trip to Spain for the Museum. He was ignominiously superannuated the following year, 1867, probably primarily because he found Museum protocol, and working under Henry Cole himself, impossible to bear.[39] Surviving correspondence shows his indignation at his treatment. He requested a letter of support from the former Chairman of the Committee of Council on Education, Lord Granville, who replied to him on January 4th 1868, noting Robinson's important services to the Museum, as well as his honour and integrity, but he added, significantly, 'I must add that I did not consider you to be very amenable to official rules and discipline.'[40]

Relations with the Museum slowly healed, and over ten years later, in 1879, six years after Cole had retired, Robinson himself sold to the Museum for £6,800 a collection of 301 Spanish works of art, which included two pieces of sculpture (cat. nos. 7 and 50). He may have bought the objects privately on one of his earlier visits to Spain when he was on Museum business, but it is more probable that he acquired them on one of his subsequent visits to the peninsula.[41] Robinson wrote on May 15th 1879 to the Director, Sir Philip Cunliffe-Owen,

'As you are aware a considerable proportion of the specimens have been gathered together in Spain, during my last three journeys in that country . . . some few specimens . . . were purchased at *high prices*, but in many more instances they were bought for *mere fractions* of their real value. This of course is now only possible in a country like Spain.'[42]

The external adviser on the purchase, Augustus Franks of the British Museum, wrote on May 16th:

'It will be probably very difficult to obtain such good specimens of Spanish art, and they seem to me full of useful suggestions to art students.'[43]

Here again the language used to justify the purchase emphasises the educational possibilities of the objects.

The two pieces of Spanish sculpture from his collection illustrate Robinson's range. Neither is of polychromed wood, and (although very different from each other) each could be classified as Renaissance. One is the unpainted boxwood statuette of *St Michael* with silver mounts (cat. no. 50). This was described on acquisition (no doubt on Robinson's advice) as from Toledo, and dating from around 1490–1500. Although still dated to the same period, it is here catalogued as probably from Catalonia. The other piece acquired was the alabaster relief of the *Virgin and Child* by Diego de Siloe (cat. no. 7). These two objects, along with other Spanish works of art acquired by or through Robinson were exhibited in the Special Loan Exhibition of Spanish and Portuguese Ornamental Art held at the South Kensington Museum two years later in 1881. Robinson was on the Exhibition Committee, and wrote the introduction to the catalogue.[44] He admitted that for the catalogue he had drawn heavily on the work of Juan Facundo Riaño y Montero (1829–1901). Riaño, an eminent scholar of great accomplishment based in Madrid,

was Professor of History of Art at the Escuela Superior de Diplomática from 1864 to 1888. In 1878 he established the Museo de Reproducciones Artísticas, of which he was assistant director until his death. He acted as an outside consultant to the South Kensington Museum on their acquisitions of Spanish and Hispano-Moresque works of art during the 1870s, and the Museum also apparently bought a piece of Spanish sculpture from him in 1870 (cat. no. 51). Riaño's introduction to his *Catalogue of Art Objects of Spanish Production* for the Museum, originally published in 1872, was reprinted in the 1881 Loan Exhibition catalogue. He was later to write a handbook on *The Industrial Arts in Spain* for the Museum in 1879 (reprinted in 1890). As well as his advisory work for the South Kensington Museum, Riaño published widely in both Spain and Britain, and was also employed (primarily because of his expertise as an arabist) by the British Museum.[45]

THE FORMATION OF THE COLLECTION II: WALTER LEO HILDBURGH

Apart from the purchases made by Robinson, the single most important individual responsible for the collection of Spanish sculpture was Dr Walter Leo Hildburgh (1876–1955), an American citizen of private means who had settled in London in 1912.[46] This generous benefactor donated a great number of works of art to the Museum, especially in the fields of metalwork and sculpture, and was to give eighteen pieces of Spanish sculpture over a period of more than thirty-five years, from 1919 to 1955, as

well as additionally presenting twelve jet carvings in 1953. Like Robinson, he travelled in Europe, and seems to have acquired some pieces of sculpture in Spain, although unfortunately he rarely supplied detailed provenances. Among his most outstanding gifts are the two marble reliefs by Vigarny (cat. nos. 8 and 9), and the figure of St Roch (cat. no. 60). But also typical of the objects Dr Hildburgh gave are what might be described as those on the periphery of the field, such as the two papier-maché reliefs (cat. nos. 15 and 16) one of which, in a contemporary sixteenth-century frame, is the only dated piece of Spanish sculpture in the collection, and in addition is inscribed with the name of the original owner. Another object of great interest presented by Dr Hildburgh is the lead statuette of the *Virgin of the Immaculate Conception* (cat. no. 37), an example of lead production in Seville not otherwise represented in the collection. Such items reveal much about the materials used in sculpture in Spain (they are discussed below in this context), and immeasurably broaden the subject, which is otherwise in danger of being confined to discussions of polychromed wood altarpieces. Dr Hildburgh had become a Fellow of the Society of Antiquaries in 1915, and his donation of an impressive range of jet carvings (some of which he had published himself) reflects his antiquarian interests.

Between them Robinson and Hildburgh were responsible for the formation of over half the collection of Spanish sculpture. The rest is made up of gifts, bequests and purchases (the last of which was in 1965) from divers sources, listed in the provenances of the objects.

II: Materials and Techniques

Colour was felt to be virtually essential for sculpture produced in Spain during this period: Francisco Pacheco (1564–1638) noted in 1622 that 'the figure of marble or wood requires the painter's hand to come to life'.[47] Polychromed gilt images were in the spirit of the Counter-Reformation, in that they were more faithful representations of sacred subjects, and a decree issued from the Episcopal Synod held at

Pamplona in the late sixteenth century ruled that figures and reliefs should be gilded and painted when possible.[48] The variety of textures and glowing pigments used for sculpture was particularly effective for images seen in the relatively dark interiors of churches and chapels, illuminated perhaps only by candlelight. Seen in this environment their realism must have seemed even more potent.

Contemporary accounts, most notably Pacheco's *Arte de la Pintura* of 1638, are a valuable source of information on polychromed wood sculpture, although they tend to concentrate on the painted surface (Pacheco was himself a painter), and less information is available on the types of wood used, methods of carving, or indeed the working of other materials, such as terracotta or alabaster. A number of more recent publications discuss techniques used for Spanish sculpture, again especially those employed for what is clearly the most important and widespread type: painted and gilt wood.[49] Partly because this field has been well-covered, it is unnecessary to repeat the information at length here, and what follows is a brief capitulation of the skills employed in the making of wood sculpture from the late fifteenth to the mid-eighteenth century, followed by some further discussion of other aspects of sculpture-production as illustrated by the present collection.

1: WOOD

Several types of wood were used for sculpture in Spain, and a rough breakdown of them by geographical area suggests that there was no clear pattern of use by region. Pine, walnut, oak, lime, box, poplar and alder all seem to have been employed in Castile, Andalusia and elsewhere, and are represented by pieces in this catalogue. Although they are not necessarily associated with a particular province, function did influence the choice of wood. Some timbers were clearly more suitable for certain types of sculpture; boxwood for example being particularly well-suited for small-scale figures, such as the *St Michael* (cat. no. 50). In some cases one wood was utilised for a figure, and another for the base, for instance Salzillo's *St Joseph* (cat. no. 54), which is of walnut with a pine base. Pieces from Hispano-America tend to be carved in tropical hardwoods like Spanish cedar (cat. nos. 66 and 67).

In order to make a figure a block of wood was usually carved horizontally; holes drilled in the tops of the heads of some of the pieces are likely to have been for fixing the original block of timber for this purpose; such a hole is seen in Risueño's *Christ Child (or St John the Baptist)* (cat. no. 43).[50] Often freestanding figures were made from pieces of wood fitted together, the knots or joints sometimes being concealed by strips of linen applied with a flour paste. Carnicero's *Christ Bearing his Cross* (cat. no. 26) and Salzillo's *St Joseph*

(cat. no. 54) are two of the works for which this technique was applied. The most elaborate example in the present collection is José de Mora's *Virgin of Sorrows* (cat. no. 46), which is an intricate construction of separate pieces of wood artfully combined to create the veil, ringlets, neck, shoulders and face. Figures might also be made from just one block of timber which was hollowed out, or more commonly roughly carved at the back, and often with hands separately dowelled in, as seen in the Seville *Mourning Virgin* (cat. no. 35).

Although the collection does not include a complete wood altarpiece, several of the figures and reliefs, such as the *St Roch* (cat. no. 60), the *Figure holding Symbols of the Passion* (cat. no. 62), and the *St Michael* (cat. no. 58) probably come from retables. These were complex and expensive commissions of which sculpture was only one element, to be installed in the framework made by the *ensamblador* (carpenter). If decorative motifs were to be included they were the work of an *entallador* (the carver). The sculptor might also be known as an *imaginario* (maker of images), *escultor* being a term that was more current from the early sixteenth century onwards.

Wood sculpture which was to be painted had to be prepared for the pigments by the *aparejador* (preparer). He painted on to the surface of the wood layers of glue size and white ground. Four or five layers of coarse white ground (*yeso grueso*) and five or six layers of finely textured plaster of Paris (*yeso mate*) were then put on. The *aparejador*'s skill lay in not losing the definition of the carving by these applications. The layers of white ground on the wood were sometimes treated in a sculptural fashion before pigment or metal leaf was applied; decorative lines might be scraped into the surface, as seen on the robe of Salzillo's *St Joseph* (cat. no. 54) [see plate 1]. Occasionally the pattern on the surface would be raised; areas of the white ground, perhaps thickened with size, and defined with the help of stencils, could form a low relief, an example being the fleurs-de-lys on the dress of the *Virgin* from Seville (cat. no. 38), and the foliate designs on the robe of the Indo-Portuguese male saint (cat. no. 68).

2: GOLD AND SILVER LEAF

If the wood was to be gilded using the water-gilding process, four or five layers of red bole were put on top of the white ground. The gold leaf was placed on top of the dampened bole, and then burnished

with polished stone. Oil-gilding was less commonly practised, and was employed when a matt finish was required, as the gold could not be burnished. The gold leaf would be applied with an oil medium, without an underlying layer of bole. A gilder was known as a *dorador*, although this term was generally employed for one who gilded the framework of the altarpiece, not the figurative elements. The gold leaf was melted down from coins, such as Castilian doubloons, the quality of gold often being specified in the contracts for altarpieces. More gold was available during the sixteenth century thanks to the large amounts imported from Spanish possessions in South America. Silver was occasionally used in the same way, but this is rarely observable now, because the silver has generally oxidised and corroded. The linings of the cloak and tunic of the *St Roch* (cat. no. 60) were originally silvered, but only barely visible fragments survive; when it was first applied the silver would probably have been protected from tarnishing by a glaze.

3: PAINTING

The painting of images was usually carried out by a *pintor de imaginería*, as opposed to a *pintor de pincel* (brush painter, one who painted pictures), although many renowned easel painters also painted figures, such as the Seville portrait-painter Pacheco, as mentioned above, who painted works sculpted by Juan Martínez Montañés (1568–1649). Some sculptors, such as Alonso Berruguete (see cat. no. 11), were also skilled as painters, in which case the painting of the figures and reliefs was carried out by their own shops, but normally the carving and polychromy were commissioned separately. The sculptor might not necessarily supervise the painting, so that the finished work of art could be the product of two distinct artists, sculptor and painter. Disputes might arise if a sculptor unlawfully contracted for the painting of an altarpiece as well as the sculpture. The painters' guild in Seville brought a successful case against Martínez Montañés for doing just this in 1621.[51]

The painting of sculpture was specialised into separate skills: an *encarnador* was a painter of flesh-tones, while an *estofador* was a painter of painted and gilt decoration imitating the textiles or stuff (*estofa*) of the draperies. The flesh colours could be polished (using an oil medium) or matt (using tempera, i.e. egg

yolk), although matt was usually favoured as being more naturalistic. The skin of the *Child With a Skull* (cat. no. 23) and that of the *Saint Sebastian* (cat. no. 25) are polished, and reminiscent of enamel, while the *St Francis* after Pedro de Mena (cat. no. 24), and the *Virgin of Sorrows* by José de Mora (cat. no. 46) are matt. The medium used for painted draperies was usually tempera, although oil was sometimes present.

Estofado polychromy is most often today associated with the rich coruscating surfaces of Spanish sculpture, although it actually originated in the Netherlands in the late fifteenth century.[52] A layer of gold leaf is overpainted with pigments which are then scratched away using a stylus, punches or wax-resist to produce patterns imitating embroidered stuffs and brocades. The *King David* from the workshop of Pedro de la Cuadra (cat. no. 19) and the *St Cecilia* (cat. no. 36) exemplify this technique in the present collection. A closely similar decorative device, whereby colour is scraped away to reveal gold, but not specifically to represent textiles, known as *esgrafiado* (scratched through) can be seen in the sixteenth-century Castilian *Lamentation* relief (cat. no. 18). As mentioned above, glazes could also be applied over metal leaf, giving the appearance of coloured precious stones, as seen in the punched decoration of the robe of Salzillo's *St Joseph* (cat. no. 54).

4: OTHER MATERIALS USED FOR SURFACE DECORATION

Painting and gilding were methods of enlivening the surface of sculpture, but Spanish works are also renowned for the combination of materials to enhance the realism of the subject. Glass eyes and sometimes eyelashes were commonly inserted into wood or terracotta figures, as seen in the *St Joseph* by Salzillo (cat. no. 54), Carnicero's *Christ Bearing his Cross* (cat. no. 26), Risueño's *Christ Child or the Infant St John the Baptist* (cat. no. 43), Mora's *Virgin of Sorrows* (cat. no. 46), and numerous other pieces in the collection. When glass eyes were to be fitted into a wood figure, generally the face was made as a mask, so that the eyes could be fitted from behind. In the same way the tongue and teeth might be inserted into the cavity of the mouth, before the face was joined to the rest of

the head; this is seen for instance in the *St Francis Xavier* (cat. no. 49). The back of the terracotta head of *St John of God* (cat. no. 45) is missing, so that the way the eyes have been fixed in with wax can be seen. The lack of polychromy on this piece may mean that it was left unfinished in the workshop; no other example is known of a terracotta with glass eyes, but without a painted surface. Red glass droplets set into the surface of the lead crucifix (cat. no. 65) imitating drops of blood illustrate another combination of elements peculiar to Hispanic (in this case probably Hispanic-American) sculpture. The crown of thorns worn by the crucifix figure by José de Mora (cat. no. 47) seems to consist of real hawthorns, while the girdle worn round the waist of Carnicero's *Christ* (cat. no. 26) is of woven gold thread over silk, and the rope round the neck is woven brass thread. Although the girdle and rope may postdate the original sculpture, even that would illustrate the continuing tradition of such practices. Specialist craftsmen were employed by sculptors for these additions. The Castilian sculptor Gregorio Fernández (*c.* 1576–1636) specialised in wood-carving, and other elements of his work had to be subcontracted. His processional group (*paso*) of the *Pietà*,[53] formerly owned by the confraternity of the *Angustias* in Valladolid, is known to have been carved in 1616, and painted in 1617, going out in procession for the first time in March of that year.[54] A stone-worker ('*lapidario*') provided glass eyes for the figures, while a painter was paid specifically for the gold for the hair of Christ, St John and the Magdalene.[55]

Fabric was also attached to wood and sometimes terracotta sculpture to give freestanding figures a more naturalistic appearance. Strips of linen across the feet of Salzillo's *St Joseph* (cat. no. 54) imitate the straps of the sandals. Although dressed images (*imágenes de vestir*) are not well represented in the collection, the Hispano-American wood bust of a saint (cat. no. 67) was almost certainly intended as part of a full-length figure whose draperies do not survive.[56] The small terracotta bust of St Philip Neri (cat. no. 41) has fabric glued on in imitation of a soutane. Cloth soaked in size (*tela encolada*) was sometimes combined with wood figures, because it

could fall in folds more fluently than might necessarily be carved; an instance of this is the loincloth of the crucifix figure by José de Mora (cat. no. 47). It also strengthened and disguised joins in the wood in the preparatory stages of a sculpture, as remarked above, and as illustrated by the Andalusian head of a saint (cat. no. 31), which was also probably an *imagen de vestir*.

5: OTHER MATERIALS USED FOR SCULPTURE

Other sculptural materials include alabaster, which was especially favoured in North East Spain where it occurred naturally.[57] Gilding functioned as a way of highlighting or inscribing alabaster; the relief by Diego de Siloe (cat. no. 7) has the remains of a gilt inscription on it. The alabaster relief of the *Lamentation* from the Basque region (cat. no. 61) has a later painted surface, but this may well reflect an earlier coloured finish. Terracotta and lead tended to be employed above all for Andalusian sculpture. These might also be given painted surfaces, although generally not as elaborate as polychromed wood sculpture. Polychromy primarily adorned a plain surface, but it could also depict a scene, such as the painted landscape background of the terracotta *Lamentation* relief by Juan de Juni (cat. no. 14); this may have been executed by an easel painter, rather than a painter of images, although Juni (like Berruguete) appears to have had painting generally carried out in his own workshop.

Before the eighteenth century, sketch-models (*bocetos*) for sculpture rarely survive, and were perhaps not valued early on in the way that Italian ones were.[58] Documentary sources indicate however that wax, clay, plaster and wood models were used in the sixteenth century.[59] During the eighteenth century, probably because of the presence of a number of Italian and French artists in Spain, as well as the influence of the Academy of Fine Arts in Madrid (founded in 1752), models are more common.[60] The scale-marks on the terracotta *St Lucy* (cat. no. 29) suggest that it was a preparatory sketch which was then squared up for the production of a full-size figure.

III: Multiples and Variants: Workshop Practice and Devotional Imagery

Several of the objects in the collection are reduced variants of celebrated works, but in some cases no 'primary version' is known, and a piece is simply one of a number of examples. This has helped identify certain sculptures, but conversely a precise attribution to a named artist (as opposed to a probable date and location) can be far more problematic, simply because the iconography or compositions are not unique. A discussion of the recurrence of types in Spanish sculpture is crucial to an understanding of the way sacred images were perceived, as well as revealing how sculptors worked, how sculpture was sold (not necessarily to commission), and additionally suggesting how an individual sculptor might influence contemporaries and later artists.

Certain substances lend themselves to reproduction from moulds. In Spain the most commonly surviving material of this type is terracotta. Several of the terracottas in the collection illustrate this reproductive aspect. The relief from Juan de Juni's workshop (cat. no. 14) is one of several surviving versions. Until recently it was believed that one must be an original version from the hand of Juni, while any other examples were aftercasts or 'workshop', but it is more probable that Juni intended from the outset to reproduce the composition in multiples, using the casting process, largely for economic reasons. In one sense, all the reliefs were 'workshop'.[61]

The terracotta by Luisa Roldán (cat. no. 27) employs a slightly different type of repetition of forms, and again reflects the way the sculptor's workshop might have operated. Its close analogies with the group of The Mystic Marriage of St Catherine by Roldán in the collection of the Hispanic Society of America imply that she may have used moulds to repeat certain figures in her groups. It seems likely that her workshop, organised around the production of closely similar small-scale groups, almost certainly intended for private chapels, depended on a high proportion of delegated work. Roldán could have designed the compositions of the groups, and made the initial figures; she might then have multiplied these by having moulds made, so that they could be

adapted for various groups, sometimes depicting entirely different subjects. Even if certain elements were not actually cast from moulds, the undeniable repetition of forms in her pieces suggests a streamlined way of organising her workshop. This may have been partly for iconographic or devotional reasons; for example, it might have been thought desirable that representations of the Virgin were similar, if not identical. But perhaps the primary reason was again economic: so that she could run an efficient workshop producing large numbers of such works.

Another piece, the statuette of Beata Mariana (cat. no. 28) exemplifies how an image, this time dating from the late eighteenth century, could be reduced and reproduced (almost certainly not by the original sculptor's workshop) on a smaller scale, and in a cheaper form. The prototype, Julián San Martín's lifesize polychromed wood figure of Beata Mariana, was reproduced in other contemporary wood versions (no other terracottas are known, although they almost certainly existed at one time), as well as engravings, an even cheaper and more portable way of disseminating the image. Here devotional and economic motives are intermingled: the holy portraits of the recently beatified individual, whose appearance was known from her death-mask, were widely available to the faithful in various forms, and at different prices. They were unlikely to have been commissioned, but were sold off-the-peg, perhaps in markets, at pilgrimage centres, or direct from the workshops where they were produced.

The reproduction of images in comparatively cheap materials is exemplified by the lead statuettes produced in Seville, such as the figure of the Immaculate Conception (cat. no. 37) after Juan Martínez Montañés. Similarly the two sixteenth-century Castilian papier-maché reliefs cast from moulds (cat. nos. 15 and 16) show that inexpensive materials could be exploited for sculpture. In the case of the reliefs, no specific model from which they derive can be identified. The contemporary inscription on the

frame of one implies it belonged to a high-ranking individual, and that the painting on the frame at least was done to order, although perhaps after it had been bought. This suggests that even relatively inexpensively-produced items were only cheap in relation to say large-scale pieces in wood.

There are other repeated images which cannot have been made simply because it was less costly to produce multiple copies. One of the most widely disseminated and popular subjects of the seventeenth century was that of the *Virgin of Sorrows*. The version in the present collection (cat. no. 46) is by José de Mora. Mora's slightly older contemporary in Granada, Pedro de Mena, originated and refined the type most commonly produced in the seventeenth and early eighteenth century, although antecedents by sculptors such as the García brothers are known. For this reason, the attribution of the Museum's bust to Pedro de Mena had been generally agreed from 1950 until recently, partly because it is understandably always tempting to ascribe an outstanding work of art to the most eminent name associated stylistically.[62] The many surviving busts of the same subject referred to in the entry for cat. no. 46 are similar and highly-worked objects made by independent sculptors, each of whom was successfully working in or around Granada at about the same time, the second half of the seventeenth century and the early eighteenth century. The subject was a standard icon, but was codified by the artists concerned at the same time and in the same place. The busts are not identical to one another but contemporary variants of the same type, and the majority are carved from wood, not cast from a mould. Although it is possible to distinguish different pieces stylistically, individual artists were producing numbers of similar versions. About eighteen survive associated with Pedro de Mena for example, although these do vary from one another in points of detail. What was important was the devotional image. Perhaps the considerable craftsmanship, clearly a continuing part of the thriving vernacular tradition of polychromed wood sculpture, was also a way of suggesting the dedication of the artist, as well as the amount of money spent by the individual or institutional patron. The representations of such subjects could be rich in spiritual meaning and power. When the full-length *Soledad* figure by José de Mora was installed in the church of St Philip Neri in Granada in 1671, a contemporary chronicler recorded that it was

taken there at midnight, accompanied by a congregation of the devout holding torches, and that on this journey to the church the image performed a miracle, bringing back to health a woman gravely ill, as it passed by her house.[63]

A further type of reproduction in Spanish sculpture can be discerned, also associated most strongly with Pedro de Mena. This is his figure of St Francis of Assisi, portrayed in the form of a resurrected dead body (fig. 4; see also cat. no. 24). Most of the surviving versions of this subject (listed in the catalogue entry) derive from his figure in Toledo Cathedral, or from his relief of the saint in the choirstalls at Málaga Cathedral.[64] Unlike the representations of *Beata Mariana*, these are not simply replicas in cheaper forms. Neither are they quite analogous to the variant types of the *Virgin of Sorrows*, because they can virtually all be traced back directly to the pieces created by Pedro de Mena, although each exhibits differences from the others to a greater or lesser extent. In this way, they were propagated by Pedro de Mena's originals, but are themselves variants. The version in the present collection probably dates from the first half of the eighteenth century, perhaps nearly a hundred years after Pedro de Mena's figure in Toledo, and has been reduced in size to a more portable and domestic object. The same legend is illustrated (the miraculous posthumous appearance of the saint), and in one sense the type created by Pedro de Mena is being deliberately emulated, although not directly copied, since clearly avoidable changes have been made, as in the fall of the drapery. This suggests a different meaning for the phrase the 'stylistic influence' of an artist, and the chosen portrayal of the saint must be seen as bound up with the miraculous nature of the event.

THE SCOPE AND FORMAT OF THE CATALOGUE

As the subtitle implies, certain categories have been excluded, notably bronzes, ivories and waxes. The justification for this is that each of these fields can be more appropriately seen in the context of a catalogue by material, and work on a revised catalogue of European ivories is in progress.[65] The majority of pieces are of wood, usually polychromed, or with remains of polychromy (39 pieces); terracotta (11 pieces) and alabaster (9 pieces) are also

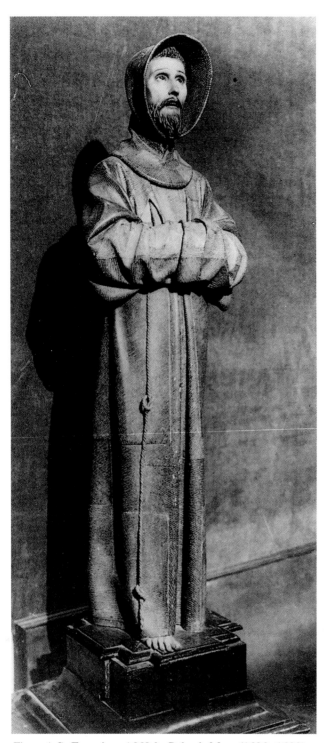

Figure 4. St Francis *c. 1663 by Pedro de Mena (1628–1688). Toledo Cathedral Treasury (see also cat. no. 24).*

have been included (cat. nos. 68 and 69), along with a few pieces from Hispano-America. No Portuguese sculpture, other than the colonial works listed above, is thought to be in the collection. Two objects which may well be Italo- or Franco-Spanish (cat. nos. 63 and 64) are also catalogued. Medieval sculpture is not included; the period covered is from the end of the fifteenth century onwards, and the latest piece in date is from the early nineteenth century.[66]

The catalogue is divided geographically by region, and within those divisions chronologically. Civil wars and dynastic battles are part of the history of the Iberian peninsula, yet despite subsequent upheavals the identity of modern Spain can be fairly dated to the late fifteenth century, following the union of the Crowns of Aragon and Castile, which occurred on the marriage of Ferdinand of Aragon and Isabella of Castile, the *Reyes Católicos*, in 1469. Their reconquest of Granada from the Moors in 1492 established national boundaries. But although 'Spanish' sculpture has a broadly definable character, Spain is composed of several heterogeneous regions, one of which might have been Portugal had different alliances been formed in the fifteenth century.[67] In some of these regions, such as Castile, relative autonomy was conferred by the existence of the *Cortes*, councils which met more or less regularly and which constituted a form of local government.[68]

The distinctive provinces of Spain mean that the origins of objects from certain areas can be defined for stylistic reasons. Conversely defining local styles is on occasion problematic: artists travelled between regions; artists from other countries came to certain areas; foreign works of art (especially from the Netherlands and Italy) were imported; a work of art made in one city could be sent off to a province some distance away.[69] For these reasons, the short introductions to the regions of Spain in the catalogue are intended only to give rough parameters, and to help the reader put the sculpture into a broad geographical and cultural context. Some provinces are not represented here, notably Estremadura, the Asturias and (with the exception of the jets) Galicia. By far the majority of objects come from Castile and Andalusia respectively, more or less accurately reflecting that these areas did produce proportionately more sculpture than other parts of the country.

A number of objects formerly thought to be Spanish are now no longer considered to be so. These are listed in an appendix for reference purposes.

represented, along with a few items of marble, limestone, papier-maché and lead respectively. The 17 jets form a discrete group, and for this reason are in a separate section within the catalogue. For the sake of completeness, two colonial Portuguese items

Notes

1. Ford 1845, p. 169 (see below).
2. For a useful summary of British attitudes to Spanish painting from the eighteenth century onwards see the introduction by Allan Braham to *El Greco to Goya*, pp. 3–44. The exhibitions of Spanish art held in England since 1881 (when the Loan Exhibition of Spanish and Portuguese Art was held at South Kensington) have concentrated on painting, with sculpture, if it was included at all, as an adjunct to this. Exhibitions were held at the New Gallery, London, 1895–6; Corporation of London Art Gallery, 1901; the Grafton Gallery, London, 1913–14; the Royal Academy, London, 1920–21; the Burlington Fine Arts Club, London, 1928; Nottingham University Art Gallery, 1980 and the National Gallery, London, 1981 and 1995.
3. Inv. no. A.7–1954; Pope-Hennessy II, pp. 460–5.
4. Although the subject is ostensibly biblical, it is primarily a study of two male nudes. Philip II favoured an Italian sculptor Pompeo Leoni to provide works in bronze for the Escorial (see Mulcahy). Surviving records of royal and aristocratic collections even within Spain indicate a preference for secular works of art, and for Italian and Netherlandish masters. See Martín González 1984, pp. 180–94, where further references are cited.
5. Carducho, pp. 100, 101, 422, 434–8. See also Sánchez Cantón 1949, p. 557. Van der Doort's inventory of 1639/40 of Charles I's collection lists a number of paintings by Titian and one marble bust of Faustina (presumably ancient) which were acquired in Spain (Millar, pp. 4, 16, 19, 73, 190 and 225). In 1640 moulds of three antique marble heads from Aranjuez were sent to the English monarch at his request; he gave in return some English mastiffs and Irish bloodhounds to the Spanish Court (Harris 1967, pp. 415–16).
6. Gómez-Moreno 1937, p. 233, and Wethey 1955, p. 25 and p. 122, notes 57 and 58. I am grateful to Profesor J. J. Martín González for these references, and to Enriqueta Harris Frankfort for her comments. The document alluding to the commission, from the *Actas Capitulares del Archivo de la Catedral de Granada de 1656 a 1660* is held in the Archivo Histórico Nacional in Madrid. It refers to the King of Great Britain (*el Rey de la Gran Bretaña*); Charles II had been restored to the throne only days before, on 29 May 1660, but he was known as the King by his supporters following his father's execution eleven years previously. The text of the document (which I have not seen personally, but have taken from Gómez-Moreno, cited above) reads as follows (my parentheses):

 'Ilustrísimo Señor:
 Don Alonso Cano, racionero de Granada, diciendo que tiene orden pressisa de V.S.I. de salir luego desta corte [Madrid] para hacer su residencia en dicha ciudad [Granada] y no aviendo aún acabado una ymagen que estava trabaxando para el Rey de la Gran Bretaña mi señor, con otro quadro considerable en lo que es de una persona muy servidor de V.S.I. y assí vengo a suplicar a V.S.I. se sirva de mandar alargar a dicho Don Alonso Cano su término de estar aquí aún 15 o 20 días más para que el Rey mi señor no pierda la satisfación de tener una tan buena pieça de tan famoso maestro, ni yo tampoco la occocación de agradecer a V.S.I. este favor tan particular como será para mí y otros que V.S.I. me hará, mandándome muchas cosas en su servicio, cuya Illustrísima Persona guarde Nuestro Señor muchos años. De casa a I.o de Junio de 1660. Muy servidor de V.S.I.,
 q.s.m.b.
 D. Enrique Bonnor (?)
 Ilustrísimo Sr. D. Diego Biriaño y Gambóa.'
7. Nevertheless a number of travel books by British visitors to the peninsula were written from 1760 onwards; for a survey of them see Robertson 1975.
8. Dennis, II, pp. 263–4. These remarks were based on Dennis's travels of 1836.
9. The debate about coloured marble sculpture, particularly Greek sculpture, was brought to a head some years later when the British sculptor in Rome John Gibson (1790–1866) shocked many by the creation of his *Tinted Venus*, a painted marble figure, exhibited at the 1862 London International Exhibition. Other sculptors during the mid-nineteenth century, such as Marochetti and Cordier experimented with colour, but such pieces were usually regarded as aberrations. Classical marble sculpture was still held to have been white, despite the evidence that it was sometimes painted. See Greenwood, pp. 53–4.
10. Ford 1845, p. 169.
11. *Ibid.*, pp. 169–70.
12. Cf cat. no. 21. Ford did in fact own two small seventeenth-century terracotta reliefs of *Christ and the Infant St John the Baptist* and *St Catherine of Siena* attributed to Juan Martínez Montañés (1568–1649), which he had bought in Seville in 1832. These were illustrated in early photographic images (Talbotypes) produced by Fox Talbot in 1847 for a limited edition of twenty-five copies of a fourth volume (issued the following year in 1848) of William Stirling's (later Sir William Stirling-Maxwell Bt) *Annals of the Artists of Spain*; the terracottas appeared as plates XIII and XIV. Stirling described them as 'perhaps the sole specimens of the national Spanish sculpture in England'. A copy of this rare book is at Pollok House, Glasgow. I am grateful to Sir Brinsley Ford, Anthony Hamber, Hilary McCartney, Rosemary Watt and Roger Taylor for this information.
13. Probably cat. no. 47, although possibly cat. no. 30. The writer was mistaken in thinking either of these was terracotta.
14. Cat. no. 26. This also is wood, not terracotta.
15. *Art-Journal*, p. 282. I am grateful to Diane Bilbey for this reference.
16. American collections, notably that of the Hispanic Society of America are comparable; see Gilman 1930 and Stratton 1993.
17. Following the early published inventories and the 1881 Loan Exhibition of Spanish and Portuguese Art, pieces have been only intermittently studied. Recent publications include Baker 1984, and Trusted 1994.
18. Spanish sculptures in private collections were generally acquired by Catholic families for devotional purposes, such as the crucifix at Arundel owned by the Duke of Norfolk. See Baker 1984, p. 343.
19. Report no. 446 (Henry Cole Secretary). One copy is held in the National Art Library: Art Referee Reports, II, Part III.

20. The information given here about Robinson is adapted from a paper I gave at the Annual Conference of the Association of Art Historians at the Victoria and Albert Museum in April 1995. A number of recent publications have appeared discussing Robinson, including Baker 1984. See also Davies. For a brief summary of Robinson's life, see *DNB* 1927, pp. 471–2.

21. *Loan Exhibition*, p. 8 (Introduction by J. C. Robinson).

22. Robinson's manuscript notes on Spain; Robinson Ashmolean, Box I, file 4.

23. See Pope-Hennessy.

24. Robinson 1897, pp. 962–3.

25. Robinson Reports, Vol. I, March 1st, 1864.

26. *Ibid.*

27. See Baker 1982 and 1988.

28. These number twenty-four, and are all described and illustrated in Oman.

29. Robinson Reports, Vol. I, March 1st, 1864. This is inv. no. 314–1864 now attributed to Juan de Orna. See Oman, cat. no. 50, p. 21, and pl. 60, fig. 102 and pl. 61, fig. 103.

30. Robinson Reports, Vol. I, March 1st, 1864. Some of these are no longer thought to be Spanish. See the list of Rejected Attributions.

31. *Ibid., loc.cit.*

32. See Moreno Mendoza, p. 19.

33. *Ibid.*, pp. 23–5.

34. Robinson Reports, Vol. I, March 1st, 1864.

35. *Ibid., loc.cit.* The objects Robinson referred to are cat. nos. 30, 39 ('School of Cano'), and 44. None of these is now given to Cano. See below.

36. See Bayley, p. 85, fig. 44 and Baker 1984, p. 349, where this is recorded as being noted by Enriqueta Harris Frankfort.

37. Robinson lent it to an exhibition of works of art held at the Corporation of London Art Gallery in 1895 (Corporation of London 1895, p. 16, cat. no. 22).

38. Robinson Reports, Vol. V, part II.

39. He may also have been held culpable for making private purchases for himself and friends while on Museum business, but he strenuously denied this, and accusations were never formally made by the Museum authorities. See Oman, pp. ix–x, and Pope-Hennessy I, pp. x–xi. After his dismissal he did buy and sell works of art; see Evans, pp. 7–8.

40. Robinson Reports, Vol. VI, part III.

41. See note 39. Robinson had made two private visits to Spain between 1868 and 1877, and may have bought the objects on one of these trips. (Letter from Robinson to *The Times*, December 26, 1877). See Evans pp. 7–8 for an account of his visit in 1871.

42. Robinson Nominal File, Victoria and Albert Museum Registry.

43. *Ibid.*

44. *Loan Exhibition.*

45. Ruiz Cabriada, pp. 822–5. I am most grateful to Elena Santiago of the Biblioteca Nacional in Madrid for this information.

46. These biographical details are based on the entry by Paul Williamson on Hildburgh for the forthcoming Macmillan *Dictionary of Art*. See also the obituaries on Hildburgh in *The Burlington Magazine* XCVIII, 1956, p. 56 and *The Times*, 28 November, 1955, p. 13. I am grateful to Paul William-

son for showing me his entry prior to publication, and for giving me these references.

47. Pacheco, *A los Profesores del arte de la pintura* [Seville, 1622], translated in Enggass and Brown, p. 222. This is also quoted in Kasl, p. 33 (Stratton 1993). See note 49 below.

48. '. . . mandamos que las tales imágenes se hagan de vulto o tabla, doradas y estofadas, y cuando no se pueda hazer, se aderezen con toda honestidad'; Constituciones Synodales del Obispado de Pamplona, Lib. III, Tit. XX, Pamplona, 1591, quoted in Echeverría Goñi, p. 42 and p. 47, note 26.

49. For English translations of extracts of contemporary treatises, see Veliz. Among more recent publications on the subject are Martín González 1953, Sánchez-Mesa Martín 1971, *ibid.* 1991, pp. 54–84, Echeverría Goñi, and R. Kasl, 'Painters, Polychromy and the Perfection of Images' in Stratton 1993, pp. 32–53. This last is a particularly accessible and coherent account of the subject for English readers. I am indebted to all these studies for most of the technical information here.

50. For this tradition in South German wood sculpture Cf Baxandall, p. 41, fig. 20, and for Gothic examples see Williamson 1988.

51. This is discussed in Kasl, p. 49 (Stratton 1993). Kasl also discusses the guilds and the impact they had on the practice of sculpture more widely.

52. Gilman 1951, pp. 80–1.

53. The *St John* and the *Magdalene* from this group are now in niches in the chapel of the Virgin of Knives in the church of the Angustias in Valladolid. The other figures from the group are in the National Museum of Sculpture in Valladolid. See Trusted 1995, p. 62 and p. 63, fig. 5.

54. Martín González 1980, p. 216.

55. *Ibid., loc.cit.*

56. Cf the dressed image of *St Ignatius Loyola* by Juan Martínez Montañés in Seville, which was made for the festival celebrating his beatification in 1610, and numerous other instances of dressed images used for festivals and ceremonies; Martín González 1984, pp. 122–6.

57. Hull, p. 164. I am grateful to Henry Buckley of the Natural History Museum for this reference.

58. Martín González 1984, p. 216.

59. For example Berruguete made a wax model for the tomb of Pedro Fernández de Velasco, Constable of Castile *c.* 1554/6, whereas he made a wood one for the sepulchre of Cardinal Tavera at about the same time (del Rio de la Hoz, p. 36). An inventory of Juan de Juni's possessions of 1596–7 lists models in plaster and wood (Fernández del Hoyo, pp. 339–40). A clay model was produced by Juan Bautista Vázquez el Viejo for a relief of Nuestra Señora de los Remedios (both the model and the finished relief now lost) for the portal of the Colegio de Doncellas Nobles in Toledo in 1558 (Estella Marcos 1990, p. 62).

60. The sculptor Nicolás Salzillo (d. 1727), who came originally from Italy, but settled in Murcia in 1695, owned wax and plaster models, according to the inventory made after his death (Salzillo 1983, p. 134). A number of clay models by his son Francisco Salzillo (see cat. no. 54) are extant, some of them in the Museo Salzillo in Murcia (Sánchez Moreno 1983, pp. 80–3).

16

61. One relief is probably an aftercast (that in Zaragoza), but it could even have been produced in Juni's workshop. See the entry for cat. no. 14.
62. The previous less convincing attribution to Martínez Montañés was similarly accepted in part because Montañés was a famed Andalusian sculptor.
63. F. Hurtado de Mendoza, *Fundación y Crónica de la Sagrada Congregación de San Phelipe Neri de la Ciudad de Granada*, Madrid, 1689, cited in Gallego y Burin, p. 158. The figure is now in the church of Santa Ana Granada.

64. A few depend from the figures by Gregorio Fernández. See the entry for cat. no. 24.
65. Many of the Spanish ivories are indeed catalogued in Longhurst.
66. Some of the medieval Spanish pieces have been previously published. See for example Williamson 1983, pp. 102–5.
67. Elliott, pp. 21–3.
68. See for example Elliott, pp. 150–1 and elsewhere. See also the entry for cat. no. 4.
69. Martín González 1984, p. 275.

Castile

Castile (comprising Old and New Castile, and the province of León) is the largest region of Spain. It is geographically central, and of central importance artistically from the late fifteenth to the eighteenth century.

During the late fifteenth century, and throughout the sixteenth century, the most significant centres for sculpture in the region were Burgos, Valladolid, Palencia, Toledo and Ávila. Sculptors originating from Northern Europe travelled to Castile, among them Gil de Siloe (the father of Diego), Felipe Vigarny (cat. nos. 8 and 9) and Juan de Juni (cat. no. 14), who all came to Spain at different times from the Netherlands, Burgundy, and France respectively. Other native sculptors, such as Alonso Berruguete (cat. no. 11) and Diego de Siloe (cat. no. 7), spent time in Italy before working in Castile. When the Court was briefly based in Valladolid in the early years of the seventeenth century, the Milanese court sculptor Pompeo Leoni (1530–1608) executed the stone effigies of the Duke and Duchess of Lerma for the church of S. Pablo in Valladolid. His work exercised a major influence on Gregorio Fernández and other Castilian sculptors of the first half of the seventeenth century. This influx of influences from other parts of Europe paradoxically led to the development of distinctively Castilian styles of sculpture. During the early sixteenth century the classicising forms introduced by Diego de Siloe, particularly in Burgos, were predominant. Berruguete's work in Valladolid and elsewhere in Castile from the 1520s onwards had a tremendous impact on other sculptors, and variants of his sinuous expressive forms were produced in the middle decades of the sixteenth century by countless followers. During the second half of the century an incipient baroque style was apparent, epitomised by the heavy facial features, stylised curly hair, and thick drapery folds seen in work executed in Astorga, Valladolid and other centres by sculptors such as Gaspar Becerra, Juan de Ancheta, Esteban Jordán, and Pedro de la Cuadra (cat. no. 19). This classicising style, known as Romanism because of its indebtedness to the High Renaissance in Rome, particularly the work of Michelangelo, had a particularly strong impact in regions of North East Spain, such as Rioja and Navarre.

The major sculptor of the seventeenth century in Castile was undoubtedly Gregorio Fernández (see cat. no. 21). Based in Valladolid, he produced a large number of processional groups and altarpieces, whose naturalistic figures and relatively plain surfaces contrasted with the rich gilding and polychromy of the work of Juan de Juni and Berruguete of the previous century. During the eighteenth century other centres in Castile became more important, notably Salamanca and Toro, where the work of Luis Salvador Carmona, Alexandro Carnicero (cat. no. 26), and the flamboyant ensembles (sadly not represented in the present collection) of the Churriguera and Tomé families attained prominence. Madrid, where the Court and later the Academy were based, will be discussed separately.

1. THE MOURNING VIRGIN

WALNUT
CASTILE (?); about 1490–1500
Inv. no. A.12–1920
H. 35.5 cm.

Provenance
Given by A. G. B. Russell Esq Rouge Croix through the National Art-Collections Fund in 1920.

Condition
At the back severe woodworm attacks in the past and rotted wood are evident, perhaps because the figure once stood against a damp wall. The surface has been coated with bitumen, and in addition probably consolidated at the back. Minor chips are visible elsewhere, particularly on the face and fingers. Traces of paint are evident on the face. The remains of a dowel hole can be seen underneath.

The Virgin stands with a sorrowful expression and hands clasped. She wears a wimple and loose hooded garment over a robe.

The poor condition of the present piece, as well as the relatively crude carving make it difficult to ascribe to a particular region or to date confidently. The oval face, heavy-lidded eyes and loose drapery are broadly reminiscent of the work of Gil de Siloe (active 1480– *c.* 1504), and the figure may have been made in Burgos in the late fifteenth century.[1] It probably formed part of a crucifixion group.

NOTE
1. For the work of Gil de Siloe, see Wethey 1936, and Gilman 1951, pp. 48–107.

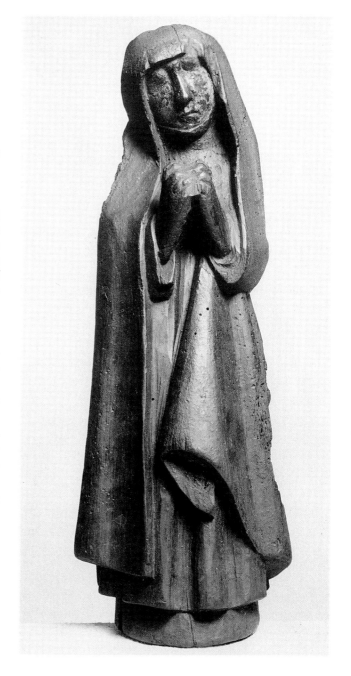

2. EFFIGY OF A LADY

PAINTED AND GILT POPLAR AND CANVAS
CASTILE (TOLEDO?); about 1490–1510
LENT BY SIR EDGAR SPEYER
H. 28 cm. W. 46.5 cm. L. 158 cm.
See plate 2

Provenance
Unknown.

Condition
Much of the paint is missing, and some of the colour on the cloak is probably a later restoration (see below). The nose is half-broken, and the right hand and all the toes are missing, except for the little one on the left foot. The left hand is also damaged; an area of loss runs along the top of the wrist and hand to the thumb. A crack runs down the left side of the head, and another through the cushions beneath; a third crack runs down the right side of the dress. A large hole is visible on the right side of the figure's chest, and a small unpainted rectangular piece of wood has been inserted near this cavity. Another hole occurs near the right shoulder. There are signs of former insect infestation. Fragments of coarse woven linen can be seen under the head, on top of the lower head-cushion, and at the left shoulder. A filled hole on top of the head may have been used as a fixing point when the block of wood was being carved. The hollow figure lies on wood boards fixed together, and the lower head cushion has been roughly sawn through at the base.

The subject is shown with eyes closed lying on her back, her arms bent, held over her chest. The figure is hollow, and rests on boards, as noted above. She wears a cloak over a robe, and a widow's veil and barbe around her head.[1] Two folds of the cloak are gathered up under her arms. The head is supported by two tasselled cushions, and the feet by one. The borders of the cloak are carved with tendril designs. Elsewhere the garments are decorated in the *estofado* technique,[2] although some of the designs on the cloak appear to be later, probably dating from the eighteenth century. The fragments of woven textile noted above were probably added to strengthen the figure; gilding and paint were applied over this.[3] It seems probable that the lower head cushion was sawn through and the supporting boards added when the figure was removed from its original setting. Possibly this occurred as early as the eighteenth century, when it is likely that the polychrome restorations noted above were undertaken.

Spanish wood effigies are comparatively rare, probably because wood is less durable than stone, and wood effigies were therefore less commonly

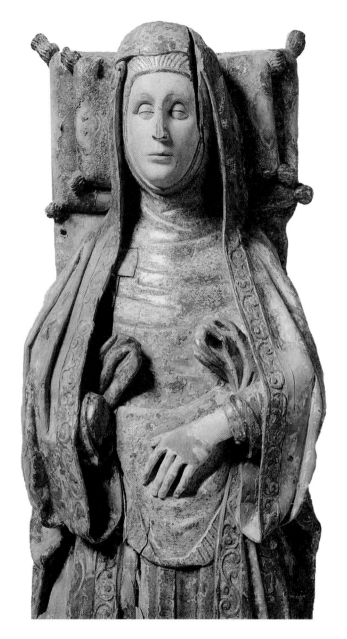

commissioned, although it is possible that they were less unusual than now appears, and that many have simply not survived.[4] As Redondo Cantera has remarked, wood was cheaper than stone, and more rapidly worked; conversely it was associated with transitoriness.[5] Extant tombs are more commonly of marble or alabaster.[6] The late fifteenth-century wood effigy (*c.* 1475–1500) of don Rodrigo Alonso Pimentel, Conde de Benavente, does however survive, and is now in the National Museum of Sculpture, Valladolid,[7] and a sixteenth-century one (*c.* 1585) of Conde Pedro Ansúrez is to be seen in Valladolid Cathedral.[8] Although damaged, the present figure has survived in relatively good

condition, and has a number of fine features: the left hand, with delicately bent fingers; the idealised and sensitively carved face; and the surviving sixteenth-century decoration of the costume, sufficiently intact to suggest the sumptuous and elaborate effect it must have once created. The identity of the subject is unknown, although the costume suggests she was probably a widow; perhaps the original tomb displayed heraldic devices since lost. The pose and costume recall a number of effigies made in Castile in the late fifteenth and early sixteenth century, including the alabaster figure of doña Maria de Perea in the present collection (cat. no. 4). The alabaster figure of doña Constanza of Castile of about 1490–1500, now in the Archaeological Museum in Madrid, although dressed in the plainer habit of her Order, rather than the rich costume of the present figure, is comparable in pose. This effigy is thought to have been made in Toledo.[9] The slightly later stone figure of María de Herrera (d. 1513) in Santa María del Campo in Burgos wears a similar costume.[10] The effigy of Juana de Pimentel, the wife of the Constable of Castile, in Toledo Cathedral, attributed to Sebastián de Almonacid and executed after 1489, provides another close

stylistic parallel.[11] Also comparable is the early sixteenth-century tomb of doña Sancha Vázquez (d. 1465) in Sigüenza Cathedral.[12] These comparative pieces all suggest that the present figure is Castilian (probably school of Toledo), and dates from the late fifteenth, or more probably the early sixteenth century.

NOTES

1. I am grateful to Linda Woolley for her advice on the costume.
2. See the introductory essay on Materials and Techniques for a brief discussion of this technique.
3. Cf cat. no. 42.
4. A small number of wooden effigies of the thirteenth and fourteenth century from Burgos are known. See Gillerman, pp. 174–5.
5. Redondo Cantera, pp. 73–4.
6. Cf cat. nos. 3 and 4.
7. Ara Gil 1977, pp. 299–300 and pl. CLII.
8. Martín González and Urrea Fernández 1985, p. 14.
9. Franco Mata 1993, cat. no. 91, pp. 109–12 and figs. 91A and 91B.
10. Gilman 1951, p. 268, fig. 169 and pp. 269–70.
11. *Ars Hispaniae* VIII, p. 337 and fig. 324. See also the entry for cat. no. 4, note 24.
12. Orueta 1919, pp. 221–3, fig. 53.

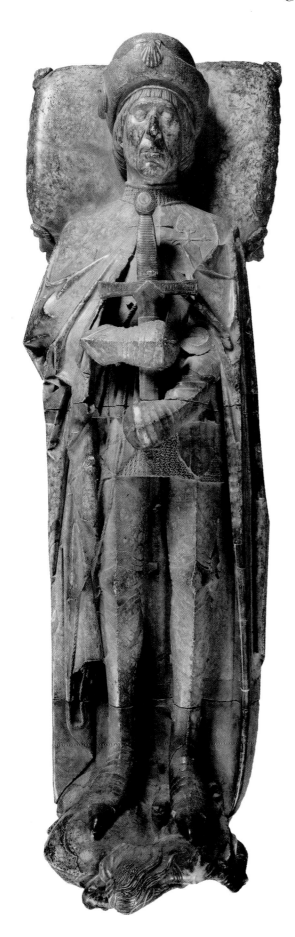

3. EFFIGY OF DON GARCÍA DE OSORIO (d. after 1502)

ALABASTER

CASTILE (TOLEDO?); after 1499

Inv. no. A.48–1910

H. 40 cm. W. 61 cm. L. 198 cm.

Provenance
See the following entry (cat. no. 4).

Condition
The figure is of three pieces of alabaster, the joins being at the hips, and just above the ankles. Although chipped in places, it is generally in good condition. In the early years of this century, when the figure was still in the chapel at Ocaña, one of the feet was recorded by the Conde de Cedillo as missing.[1] Both feet seem now to be original; the right foot has however been broken off and re-fixed, and must presumably have been stored in the chapel and re-fitted before the Museum acquired the piece. Fills are evident on both feet. The blade of the sword is missing; this too was recorded as lost by the Conde de Cedillo.[2] The head of a modern screw sticks out from behind the helmet at the figure's feet; this must have held the replacement blade. The nose has been replaced, and there are filled breaks on the cloak and on the hilt of the sword. Remains of polychromy can be seen on the cushions beneath the head, and on the inner thighs. The colour on the legs is a relatively crudely applied vermilion, and does not seem to be original. That on the cushions is blue and red, and may indicate that the whole effigy was once coloured, but see the entry for cat. no. 4.

The figure lies with closed eyes, grasping his sword. He is clean-shaven, but with stubble on his face clearly shown. His woven straw hat is decorated with a tasselled cord, and the shell of the Order of Santiago. The mantle of the Order, with its badge on his left breast, is worn over his armour.[3] The pommel of the sword is inscribed: 'IESVS : [VICT half legible] ORIAM' [Jesus (give me) victory] and the hilt, 'X DEO X BENEDICTVS' [The blessing of God]. The effigy's head rests on two cushions with laced edges and pointed ornaments at the corners, one is carved with a cover held together by fictive leather thongs. At the feet is a kneeling female figure on a much smaller scale. She appears to be sleeping, resting her right elbow on a helmet. She wears a loose tunic tied at the waist, and long hair bound with twisted cord. Distinctive knots on the belt and hairband of this figure are similar to those on the gloves and feet of the effigy, and resemble those knots on the companion effigy and the attendant figure at her feet (see the entry for cat. no. 4).

For further discussion of this piece and bibliography, see the entry for cat. no. 4.

NOTES

1. Cedillo 1920, p. 36.
2. *Ibid., loc.cit.* The blade was temporarily replaced by a wooden one (seen in Museum photographs of 1911), but this was subsequently removed.
3. Male effigies (unless prelates) were almost always shown wearing armour at this date; cf Lenaghan, p. 131.

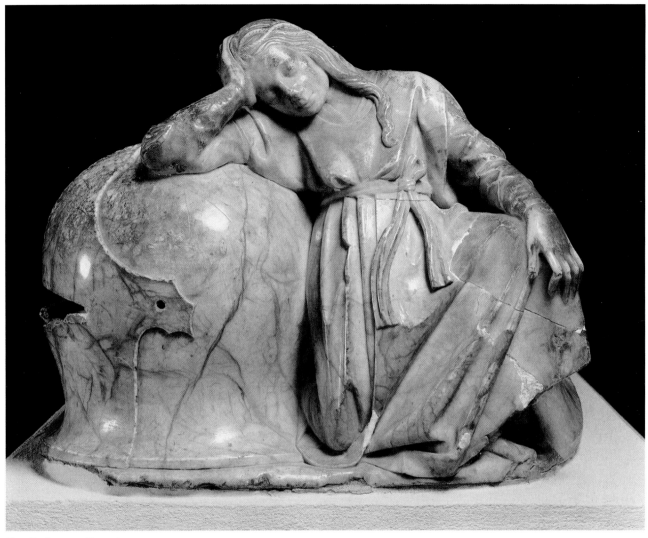

Detail of cat. no. 3.

4. EFFIGY OF DOÑA MARÍA DE PEREA (d. after 1499)

ALABASTER

CASTILE (TOLEDO?); after 1499

Inv. no. A.49–1910

H. 31 cm. W. 60 cm. L. 198 cm.

Provenance

Originally both this work and the effigy of don García Osorio (cat. no. 3) were placed in the chapel built by him in the church of S. Pedro at Ocaña, in the region of Toledo, near Aranjuez.[1] They were moved from their central position in the centre of the chapel to the right corner in the 1870s.[2] The church was declared structurally unsafe in 1906, and was destroyed in 1907.[3] These figures, along with other sculptural elements from the same church, were dispersed at this time.[4] They were bought by the Museum from Lionel Harris, of Bond Street, London, in 1910 for £1,000. (Harris had probably bought the whole ensemble from Borondo, a Madrid dealer).[5]

Condition

The face of the figure at the feet of the effigy has been badly damaged, and the features almost obliterated. Remains of colour and gilding were noted at the time of acquisition by Eric Maclagan of the Department of Architecture and Sculpture; faint traces are visible on the tassels of the cushions under the effigy's head. The date of the removal of the polychromy, if indeed there ever was substantial colour, is unknown; both effigies were described as being of white marble ('todo de mármol blanco') when they were seen at Ocaña by the Conde de Cedillo in the early years of this century.[6] The nose of the figure is a replacement. Most of the rosary has been lost, and there are numerous breaks on the robes.

Like cat. no. 3, this effigy is made from three substantial pieces of alabaster, the joins being approximately at the top of the legs, and at the ankles. The veiled figure lies with her eyes closed, resting her head on two tasselled cushions, holding the remains of

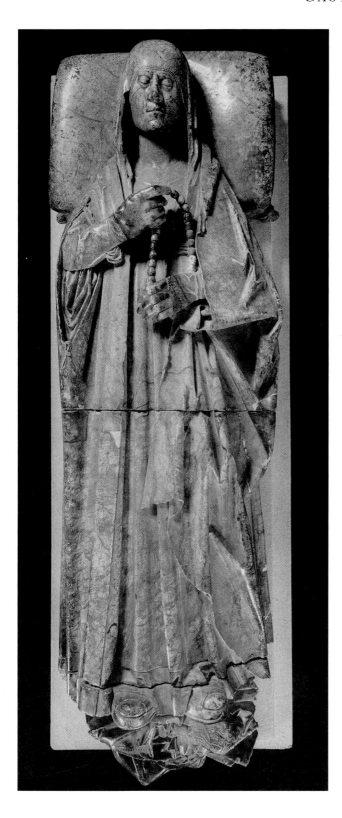

an undergarment with an embroidered border fastened with small buttons, four of which are open at the neck. She wears thick-soled shoes with round toes. At her feet a smaller female figure, with long hair, in a loose dress tied round the waist, and bare feet, reclines on her left elbow, resting on three books. Distinctive knots are to be seen carved on the belt and hairband of the small figure at the effigy's feet, and on the effigy's overgarment. These are identical with knots on the feet and gloves of the male effigy (cat. no. 3).[7]

At the time of acquisition, this effigy and its companion (cat. no. 3) were erroneously described by the vendor as those of Teresa Chacón and her husband don Rodrigo de Cárdenas respectively. This mistake arose from the fact that two pairs of effigies were placed in the same chapel in the church of S. Pedro at Ocaña from the 1870s until the dispersal of elements from the church in about 1906. When they were removed from the chapel, the identity of one pair (the present figures) was confused with the other, while that of the second pair (now in the collection of the Hispanic Society of America) was forgotten soon after it left Ocaña, and only rediscovered in 1959.[8] The article by the Conde de Cedillo published in 1920 was to be used to establish the identity of each pair, which the author had seen *in situ* at Ocaña.[9] Cedillo seems to have been unaware of the later locations of the effigies, but stated categorically that at the feet of Cárdenas was a lion, and at the feet of his wife, Teresa Chacón, was a dog, while at the feet of Osorio was a helmet; this implied that cat. no. 3 must be Osorio, and that therefore his companion must be María de Perea; the features of the pair in the Hispanic Society corresponded to the descriptions of Cardenas and his wife.

The church of S. Pedro was of great historical importance. It was closely associated with the military Order of Santiago, providing the location for meetings of Chapters; many of its members were buried there, including the subject of the present male effigy, don García Osorio. Its origins date back to the late twelfth century, when Ocaña became the property of the Order, although the building from which the effigies come dated mainly from the fifteenth century. There were also strong connections with the Spanish monarchy, who attended the church to celebrate the Castilian *Cortes*, where government decisions of local and national significance were taken; a number of royal funerals were held there.[10]

The two figures formed part of one large and elaborate tomb ('un monumento sepulcral . . . consistente en un sarcófago común y dos yacentes estatuas'),[11] originally placed in the centre of the Chapel of the Blood of Christ and of the *Pasos* (*Capilla*

a string of rosary beads in her hands. She appears to be wearing gloves, although the damage to the hands means this is uncertain. She wears a loose cloak, with an opening for her right arm, over an open necked gown with long sleeves almost covering her hands, and

Detail of cat. no. 4.

de la Sangre de Cristo y de los Pasos), which had been built by Osorio in the late fifteenth, or possibly early sixteenth century.[12]

According to the account given by the Conde de Cedillo, the sides of the tomb-chest on which the figures rested were richly decorated with reliefs of angels, putti, the four cardinal virtues, and angels holding coats of arms of the Osorio and Perea families respectively. Most of the reliefs were adorned with shells, an indication of the family's connections with the Order of Santiago.

One end and the length of one side of the sarcophagus were visible in the chapel when Cedillo saw it before the church's destruction. From his description, along one side were Temperance, St Catherine, and in the centre two angels, the coat of arms of Osorio, two more angels, and various other figures, shells, and further angels. At one end, under

the effigies' heads were Prudence, an angel, and the coat of arms of Perea. The hidden sides must have displayed similar motifs, including the other two cardinal virtues (Justice and Fortitude).[13] Twenty-one reliefs purporting to be from the tomb are recorded, which are now scattered in various European and North American collections.[14] Shortly after the present effigies were acquired by the Victoria and Albert Museum, Eric Maclagan wrote in reply to Sydney C. Cockerell, the Director of the Fitzwilliam Museum, Cambridge (the Fitzwilliam having negotiated the purchase from Lionel Harris of one relief supposedly from the tomb), that Harris had an incomplete set of reliefs, probably from Ocaña, although not necessarily from the same tomb as the London effigies.[15] Three days later he wrote again saying, 'There was a similar set (which Harris swears were copies of his!) sold in Paris a while ago; and there is another, coarser set at

Schutz' on the Quai Voltaire now, which I saw a month ago.'[16] The surviving reliefs vary in quality, and there appear to be duplicates, for example, of the angel with a cross, to be seen both at Worcester, Massachusetts, and in San Diego. Maclagan's second letter even implies that some might be modern copies. Their correct positioning, were they to be reunited, and the iconographical programme is therefore problematic, and has never been fully discussed; it is not appropriate to do so here.

Stylistically and iconographically the present effigies present parallels with late fifteenth- and early sixteenth-century works in Castile, particularly Burgos, Toledo and Ávila.[17] The most famous example of a tomb depicting recumbent effigies of both husband and wife is that of Juan II and Isabel of Portugal at the monastery of Miraflores, Burgos, which was erected by Isabella the Catholic Queen to her parents, and executed by Gil de Siloe (active 1486–1499) in about 1489–1493.[18] Slightly later, and considerably less elaborate, is the joint tomb of Juan Dávila (d. 1487) and his wife Juana Velázquez (d. 1504), dating from the mid-sixteenth century, in the church of Santo Tomás in Ávila.[19] Perhaps the closest parallel is provided by the joint tomb of don Fernando de Arce (d. 1522) and doña Catalina de Sosa in the Chapel of St Catherine in Sigüenza Cathedral, perhaps by a sculptor from Toledo.[20] Here the male effigy holds a sword, while the female fingers a rosary, and the facial features are similar in both pairs.[21] The device of a page leaning on a helmet at the feet of the male effigy is seen in the earlier tomb of Pedro de Valderrabano (d. 1465) in Ávila Cathedral,[22] and in that of Rodrigo de Campuzano (d. 1488) in the church of S. Nicolás at Guadalajara.[23]

On acquisition, cat. nos. 3 and 4 were attributed to the sculptor of the tombs of don Alvaro Luna and his wife Juana Pimentel in Toledo Cathedral, dating from after 1489; this sculptor was at that time named as Pablo Ortiz, due to a misreading of a document; he was subsequently identified as Sebastián de Almonacid.[24] However shortly afterwards Mayer proposed that the present figures and the dispersed reliefs from the sides of the tomb chest were by Gil de Siloe with the possible assistance of his son Diego de Siloe (active 1517–1553), while Wethey suggested that they were merely influenced by Gil de Siloe's work.[25] Gilman originally attributed them (in 1930) to the same sculptor responsible both for the effigies of don Diego Lopez de Toledo and Doña María de Santa Cruz in the Museo de Santa Cruz in Toledo, as well as those in the Hispanic Society (also from Ocaña, although not recognized as such in 1930).[26] Mayer's

attribution to Gil de Siloe and his workshop, and Wethey's refinement of this to a sculptor influenced by Gil de Siloe were based on analogies of features on the present figures and their accompanying reliefs with the tomb at Miraflores, such as the gloves worn by María de Perea, which he believed to be similar to those worn by Isabel of Portugal,[27] the general facial types, and the slender fingers of the figures on the dispersed Ocaña reliefs, compared with those on the base of the Miraflores tomb. In my view, closer stylistic parallels can be found in works known to be by Sebastián de Almonacid (in addition to the tomb in Toledo Cathedral mentioned above), such as the tympanum above the portal of piety dating from 1486–7 in Segovia Cathedral, where the facial types are strongly reminiscent of the face of María de Perea.[28] Also strikingly similar are the effigies at Sigüenza noted above, where the string-like hair of the effigy of don García de Osorio is paralleled by a similar treatment of the hair of don Fernando de Arce. The stubble and idiosyncratic facial features of de Osorio, for example the wrinkled forehead, suggest that the face may be a portrait from the life. Perhaps the tomb was commissioned after the death of María de Perea (whose face is less individualized) in 1499, but before that of her husband in 1502. The sculptor may be from Toledo, but a more precise attribution is not possible.

BIBLIOGRAPHY
(including publications on related works from the Church of S. Pedro at Ocaña)

Quadrado and de la Fuente, p. 381.
Cedillo 1920, pp. 32–8.
Ibid. 1959, pp. 206–10.
Mayer 1923, pp. 255–6, and unnumbered illustrations.
Ibid. 1925, pp. 48–55.
Ibid. 1928, p. 148 (mistakenly states that both pairs of effigies are in the Victoria and Albert Museum).
Comstock, 1927, pp. 30–6.
Wethey 1936, pp. 101–3.
Gilman 1930, pp. 37–8.
Ibid. 1932, pp. 137–9.
Ibid. 1951, pp. 193, 355, 484–5, 495.
Ibid. 1959, pp. 29–37.
Hispanic Society Handbook, pp. 75–6.
Rogers, 1935, pp. 1–5.
Ars Hispaniae VIII, p. 335 and fig. 321.
Anderson, 1969, no. 5, fig. XVIII (b).
Ibid. 1979, fig. 533.
Gillerman 1989, pp. 286–9 (entry by R. Steven Janke).

NOTES
1. For the history of the church, see Cedillo 1920, and ibid. 1959, pp. 206–7.
2. Ibid. 1920, p. 36, and ibid. 1959, p. 210.

3. *Ibid.* 1920, pp. 34–5.

4. *Ibid.* 1920, p. 38, and *ibid.* 1959, p. 208. See note 14 below for references of present locations of other pieces of sculpture from the church.

5. The pair of effigies from the same chapel acquired by the Hispanic Society of America in 1906 were bought from Harris, who stated that he had purchased them from Borondo (Gilman 1959, p. 29). Lionel Harris (1862–1943), and later his son Tomas, (and to a lesser extent another son, Maurice) dealt in works of art, specialising in Spanish paintings, from 1910 onwards. Until 1900 he had been based in Spain, dealing in diamonds before he sold works of art. I am grateful to Enriqueta Harris Frankfort for giving me biographical details of members of her family. See also cat. no. 60.

6. Cedillo 1920, p. 37.

7. Similar knots are to be seen on the slate and alabaster effigies of Alfonso Polanco and his wife of about 1511 in the church of S. Nicolás in Burgos (Gilman 1951, p. 102, fig. 63).

8. Gilman 1959.

9. Cedillo 1920, pp. 35 and 36.

10. *Ibid.* p. 33, and Gilman 1959, pp. 207–8.

11. Cedillo 1920, p. 36.

12. *Ibid.* p. 36 and Gilman 1959, p. 207.

13. Cedillo 1920, pp. 36–7.

14. Their locations are as follows:

a) *Fitzwilliam Museum, Cambridge*
i) Putto with a shell
(*Friends of the Fitzwilliam Museum Annual Report*, 1910).
b) *Hispanic Society of America, New York*
i) Coat of arms of Perea (or, five poplar leaves vert) supported by two angels and a putto
ii) Four reliefs each with a putto supporting a shell
(Gilman 1932, *loc. cit.* in the bibliography for this entry).
c) *Metropolitan Museum of Art, New York*
i) coat of arms of Osorio (or, two wolves passant in pale) supported by two angels and a putto
ii) one angel weeping
iii) one angel praying
iv) one angel carrying a cross
v) two reliefs each of a putto supporting a shell
(Mayer 1923 and 1925, *op.cit.* in the bibliography for this entry, and Comstock, *op.cit.* in the bibliography for this entry).
d) *Worcester Museum, Worcester, Massachusetts*
i) one angel carrying a cross
ii) Fortitude
iii) Temperance; closely similar to the St John the Evangelist in Greenville, South Carolina; see (f).
iv) Prudence
v) St Catherine
(*Bulletin of the Worcester Art Museum*, and Gillerman, *op.cit.* in the bibliography for this entry).
e) *Fine Arts Gallery, San Diego, California*

i) one angel carrying a cross; closely similar to the one in Worcester, Mass.; see (d).
(Comstock, *op.cit.* in the bibliography for this entry).
f) *Bob Jones University Art Gallery, Greenville, South Carolina*
i) St John the Evangelist (formerly P.W. French and Co. New York; called St Thomas Aquinas in Comstock, *op.cit.*, p. 34). I am grateful to Mrs Joan C. Davis for confirming the location of this relief.
g) *Los Angeles County Museum of Art (formerly, c. 1927, New York art market (P. W. French and Co.), then William Randolph Hearst Collection.)*
i) one angel weeping (inv. no. 49.23.17)
ii) one angel praying (inv. no. 49.23.18)
(Schaefer and Fusco, p. 189)
I am grateful to Paul Williamson for drawing my attention to the present location of the Los Angeles reliefs.

In addition, the reredos from the chapel with the coats of arms of Osorio and Perea respectively is in the St Louis City Art Museum (*Bulletin of the City Art Museum, op.cit.* in the bibliography for this entry).

15. Letter of 6th January, 1911 from Eric Maclagan to S. C. Cockerell (Fitzwilliam Museum, Cambridge). I am grateful to Robin Crighton for sending me copies of the correspondence relating to the reliefs.

16. Letter of 9th January, 1911 from Eric Maclagan to S. C. Cockerell. (Fitzwilliam Museum, Cambridge).

17. For a general survey of funerary monuments in the provinces of Ciudad Real, Cuenca, and Guadalajara, see Orueta 1919. For more recent surveys, see Cloulas 1991, and *ibid.* 1992 and 1993. See also Franco Mata 1993, pp. 109–12.

18. Gilman 1951, p. 52, fig. 31, and Cloulas 1991, pp. 61–2.

19. See *Ávila* 1983, p. 189 and figs. 429–30; Cloulas 1991, pp. 65–6, fig. 6; Redondo Cantera, pl. 4a and p. 273.

20. *Ars Hispaniae* XIII, p. 109, fig. 93, and p. 105; Redondo Cantera, pl. 31a.

21. Cf also the slightly later tomb of Gutierre de Monroy (d. 1521) and Constanza de Anaya in the Catedral Vieja, Salamanca; Redondo Cantera, pl. 46a.

22. *Ávila* 1983, p. 100 and fig. 78; Gilman 1951, p. 166, fig. 104.

23. *Ibid.*, p. 180, fig. 112.

24. For the early attribution, see Mayer 1923, p. 256. For the identity of the sculptor, see Gilman 1951, p. 484, note 157, and *Ars Hispaniae*, VIII, p. 336–7. See also Lenaghan, pp. 42–3.

25. Mayer 1925, p. 55. See also Wethey 1936, *loc. cit.* in this bibliography, where he stated that Mayer no longer supported the attribution to Gil de Siloe and his workshop.

26. Gilman 1930, p. 38. In her 1959 article she attributed the New York effigies to a sculptor working in Toledo in about 1520, and did not discuss the stylistic parallels with the London figures.

27. As stated above, the present condition of the piece means that the gloves are difficult to read clearly.

28. *Ars Hispaniae* VIII, fig. 323.

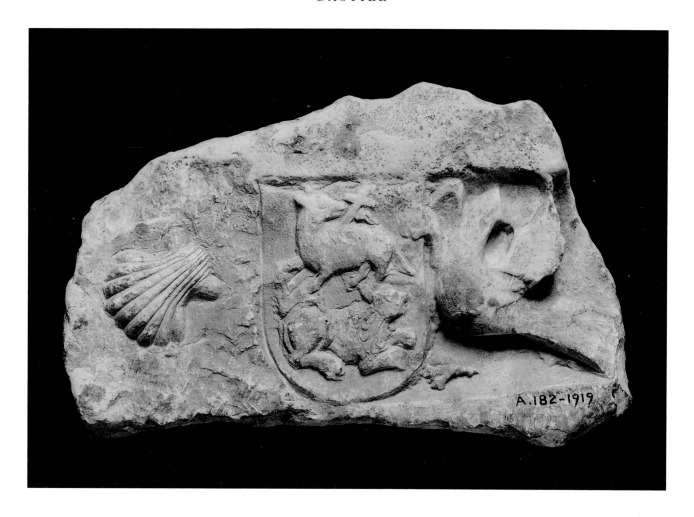

5. COAT OF ARMS

LIMESTONE
CASTILE (TOLEDO); about 1500
Inv. no. A.182–1919
H. 20 cm. W. 31 cm. D. 9 cm.

Provenance
Given by Dr W. L. Hildburgh F.S.A. in 1919. Acquired in Toledo.[1]

Condition
The piece is badly weathered. The head and tip of the left wing of the bird are missing; the heads of the lamb and lion are damaged, as are the paws of the lion. The back is roughened as if the relief were originally keyed in to a larger ensemble.

The heraldry of the piece can be blazoned as follows: in pale an *Agnus Dei* [alternatively a Paschal lamb] and lion couchant. Supporters: dexter: an escallop; sinister: a dove (?) volant (?). The escallop may be a badge, rather than a supporter, while the bird may be an eagle rather than a dove.[2]

This irregularly-shaped heraldic relief was perhaps an architectural decoration in a secular building or church, or possibly it adorned the side of a tomb. The imagery suggests an ecclesiastical context. The sunken field implies it might have been part of a moulding, either for a tomb or as part of an architrave. In style the piece recalls late fifteenth- and early sixteenth-century pieces in Castile, and its provenance supports the idea that it was produced in Toledo. It is in the same tradition as the far larger and more magnificent coats of arms (*c.* 1485–90) in the north transept of S. Juan de los Reyes in Toledo by Juan Guas (active 1459–d. 1496).[3] What is probably a slightly later heraldic relief is to be seen on the side of the tomb of Juan López de León (d. 1529) in Toledo Cathedral.[4]

BIBLIOGRAPHY
Review 1919, p. 3.

NOTES
1. Museum records.
2. I am grateful to John Meriton for his advice on this.
3. Gilman 1951, p. 138 and figs. 81–2.
4. *Ibid.*, p. 351 and fig. 215.

6. FEMALE SAINT

PAINTED AND GILT OAK

CASTILE (UNDER NETHERLANDISH INFLUENCE); about 1510–20

Inv. no. 379–1890

H. 36 cm.

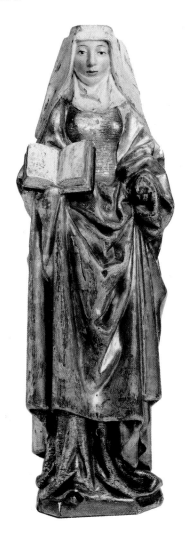

Provenance
Bought for £13 13s in 1890 (W. Maskell Collection Sale, Christie's London, 25 July, 1890, lot 91).

Condition
The face, veil and robe have all been extensively re-painted. Some paint is missing on the robe, and the tip of the right shoe is missing. Later green paint has been applied to the integral base, and spots of paint can be seen on the underside of the base. The back of the figure has been sawn flat, and a filled hole can be seen in the middle of the back. The top of the head is shaped as if to take a crown; damage is evident around this area, and there is also a small hole in the top. A hole has been drilled in the middle of the chest. The left hand is missing. Inscribed on the back in ink are characters which may be interpreted as 'M / S L / –', perhaps an abbreviation for Maskell, the former owner. The surface was consolidated in 1968.

The saint stands with her right foot slightly forward, holding an open book in her right hand covered with her cloak. She wears a wimple, and a gold cloak over a robe decorated with red and gold *estofado* designs.[1] Like cat. no. 36, in scale and pose this figure recalls South Netherlandish figures of the early sixteenth century, particularly figures of St Anne from Malines, such as the group of St Anne with the Virgin and Christ Child in the Metropolitan Museum of Art, New York.[2] The figure may be St Anne, and her now damaged left hand could have held diminutive figures of the Virgin and Christ Child; the hole in the middle of the chest would then have been a fixing point for them. But although this theory is attractive, most comparable known groups from Malines depicting St Anne and the Virgin and Child generally show St Anne holding the Virgin in her right hand, and a book in her left, in contrast to the present figure.[3] In addition the indentation on her head suggests she may have originally worn a crown, not normally an attribute of St Anne. For this reason the figure was tentatively identified as St Elizabeth of Hungary, who does normally wear a crown, by Borchgrave d'Altena.[4] The type of polychromy, although partially restored, suggests that this figure was made in Castile, but under Netherlandish influence. The style of carving is comparable with the work of Felipe Vigarny (active 1498–1542); an analogous figure of St Casilda attributed to the workshop of Vigarny is in the Archaeological Museum in Burgos;[5] also comparable is his statuette of St Catherine of Siena of about 1506 on the high altar of Palencia Cathedral.[6] The present piece is probably slightly later in date, and could be by another immigrant Netherlandish sculptor, of which there were a number in the early sixteenth century, including some who worked in the circle of Berruguete, such as Juan de Cambray (c. 1508–after 1557) and Pedro de Flandes (c. 1498–1566/7).[7]

BIBLIOGRAPHY
Maskell, pl. XXXII, fig. 2.
Borchgrave d'Altena, p. 61 and p. 60, fig. 55.

NOTES
1. See introductory essay on Materials and Techniques for a brief description of this technique.
2. Inv. no. 352; Godenne 1963, pp. 128–9 and pl. CXXXII. For other examples see *ibid.*, 1969, pls. II, 158 and II, 164. The present piece was published as recalling the Malines workshops in a study of statuettes from Malines in 1959; see Borchgrave d'Altena in the bibliography for this entry. I am grateful to Paul Williamson for this reference.
3. See Godenne, *op.cit.* above, pl. CXXXV and *ibid.* 1973, pls. II/231–4. Borchgrave d'Altena however (*op.cit.*, pp. 42–3, fig. 38) illustrates an exceptional group in the Verheyllewegen Collection, Brussels, of St Anne holding the Virgin in her left hand, and the book in her right.
4. Borchgrave d'Altena, *loc.cit.* in the bibliography for this entry. For St Elizabeth of Hungary see Hall, pp. 112–13, and LC1, 6, pp. 134–9.
5. Unpublished. Formerly in the church of S. María de Vileña Burgos.
6. Portela Sandoval, pp. 46–58 and pl. 29.
7. See Parrado del Olmo *Palencia* 1981, pp. 67–8 and p. 193, and *Vlaanderen*, especially the introductory essay by J. J. Martín González, pp. 95–110.

DIEGO DE SILOE (also known as DIEGO SILOEE, SILOÉ)

(b. c. 1490 Burgos; active after 1517–d. c. 1553)

Like Alonso Berruguete (*c.* 1489–1561), Diego de Siloe was named as one of the seven 'eagles' of the Spanish Renaissance by the Portuguese artist and theorist Francisco de Hollanda (*c.* 1517/18–1584), a designation revived by Manuel Gómez-Moreno in his study of four of these artists in 1941. Diego de Siloe, sculptor and architect, was the son of the sculptor Gil de Siloe (active 1480–*c.* 1504), who came from the Netherlands, but worked in Burgos, notably at the Monastery at Miraflores during the 1480s. Diego was probably born in about 1490, and early in his career spent some time in Italy, where he is documented in Naples around 1516 working with Bartolomé Ordóñez (active *c.* 1516–1520). On his return to Spain in 1519 he is recorded in Burgos, where his work includes some of the sculpture on the altarpiece of St Anne (begun by his father) in the Constable's Chapel in the cathedral. From 1523 he collaborated with Felipe Vigarny (active 1498–1542) on the high altarpiece in the same chapel. He was also responsible for the design of the gilt iron *Escalera Dorada* (Golden Staircase) of 1519–22 in Burgos Cathedral. From 1528 onwards he was in Granada, where his most important architectural work was the Cathedral, partly based on but transcending the designs of Enrique Egas of 1524. He also designed the church of S. Jerónimo in Granada. Outstanding among the sculpture executed after he had settled in Granada is his marble tomb of Cardinal Fonseca in the convent of St Ursula in Salamanca. This was commissioned in 1529, and exemplifies his ability to combine Italian Renaissance motifs with the Spanish traditions of rich surface decoration and a mannerist figure style.

BIBLIOGRAPHY

Ceán Bermúdez IV, pp. 374–7; Gómez-Moreno 1941, pp. 41–98; *ibid.* 1963; Checa 1983 (numerous references); *Reyes y Mecenas*, pp. 297–8 and pp. 569–70.

7. VIRGIN AND CHILD

ALABASTER WITH TRACES OF PAINT AND GILDING, IN METAL RIM

BY DIEGO DE SILOE

BURGOS; about 1519–1528

Inv. no. 153–1879

H. 26.6 cm. (excluding metal rim) W. 19.6 cm. (excluding metal rim)

Provenance
Bought from John Charles Robinson in 1879.[1]

Condition
A small break has occurred at the bottom of the relief, where a chip approximately 2 cm by 1 cm has been lost. A hairline crack runs along horizontally about 6 cm down from the top; this is barely visible at the front, but is more clearly seen on the reverse. The back of the piece is heavily scored, as if as a preparatory measure for fixing it to a backing, although there are no signs of adhesive.

The oval relief depicts the half-length figure of the Virgin and Child. The Virgin, wearing a billowing veil, holds an open book in her left hand. The standing Christ Child is supported round his waist by the Virgin's right hand, while his bent right leg rests on the head of a cherubim. His left hand is placed under his mother's chin, as he appears to turn her face towards

his. A band across the bodice of the Virgin's robe shows remains of faint lettering, standing proud of the surface, probably originally gilt, only visible under raking light. Even with the aid of a video microscope it was impossible to decipher the inscription. The letter E (or L) followed by R was visible at the left side (as the viewer looks at it), and perhaps the remains of the letter M and O at the right.[2] The prominent position suggests the complete inscription was more likely to have been devotional, rather than an artist's signature. The use of gold to highlight parts of the alabaster recall the same decorative technique seen on the marble *Virgin and Child* attributed to Bartolomé Ordóñez (active *c.* 1516–1520) in the Cathedral at Zamora.[3] When purchased by the Museum, the piece was described as being in a 'metal frame with ring'. The ring is now missing, but the present metal surround (the edge of which is just visible in the present illustration) is probably the same; it is likely to date from the nineteenth century. It may have been attached to strengthen the alabaster after the slight damage described above occurred, or for display purposes.

Three other versions of this relief (all of approximately the same size) are known: in Burgos Cathedral, in the Cathedral Museum in Valladolid, and in the Metropolitan Museum, New York, respectively.[4] The relief in Burgos is thought to have been commissioned by don Iñigo Fernández de

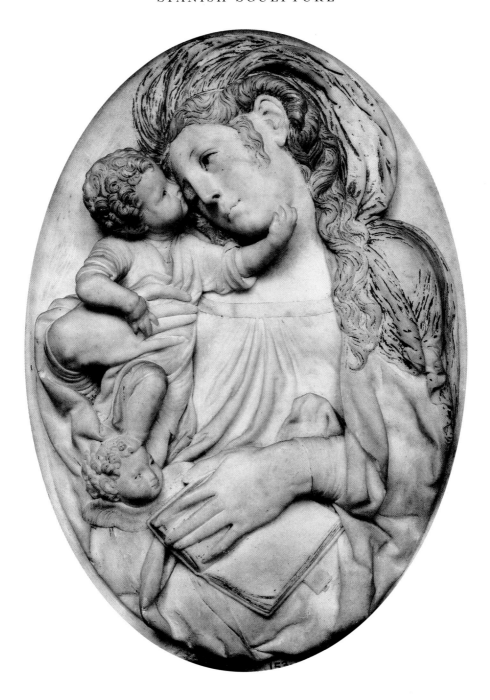

Velasco, the Constable of Castile (d. 1528), and is likely to have been given to the Treasury of the Constable's Chapel by his son, don Pedro Fernández de Velasco, who succeeded him as Constable in 1528; it is first documented in 1542.[5] None of these is signed (although the early documented reference to the Burgos relief gives a date *ante quem*), and the attributions must depend primarily on style. Further variants survive: an alabaster in a painted wood frame showing the *Virgin and Child with the Infant St John the Baptist* in the Archaeological Museum in Valladolid,[6] a painted terracotta version also in a painted wood frame in the National Museum of Sculpture in Valladolid,[7] a polychromed wood version on the Hamburg art market in 1989,[8] and an alabaster relief in the parish church of Santa Leocadia (Toledo).[9]

The present example was ascribed to Diego de Siloe on acquisition, and this attribution was maintained by Wethey, although disputed by Gómez-Moreno, who ascribed it to a follower of Diego de Siloe, perhaps Gregorio Pardo (1517–1552), the son and pupil of Diego de Siloe's collaborator in Burgos, Felipe Vigarny (b. *c.* 1470; active 1498–d. 1542).[10] Both Vigarny and Gregorio Pardo have also been suggested as the

authors of some of the other versions; comparison of their work with cat. no. 7 however suggests that neither is responsible for the present piece.[11] The most recent published work on the reliefs supports the view that cat. no. 7 is by Siloe, while those in Burgos, Valladolid, and New York are by a follower of the artist in Burgos, or by a member of Vigarny's workshop, although probably not Gregorio Pardo.[12]

All four reliefs are clearly related to Diego de Siloe's and Felipe Vigarny's work, but their precise authorship, their relationship to one another, and their respective datings are difficult questions to resolve. Their style and composition are closely comparable with a number of larger-scale works, notably the relief of the Virgin and Child in the lunette forming part of the tomb of Canon Diego de Santander (d.1523) in Burgos cathedral. This tomb is not documented, but is generally given to Diego de Siloe for convincing stylistic reasons.[13] He is known to have been in Burgos from about 1519 until 1528, when he left for Granada. Like the reliefs under discussion here, this lunette shows the Virgin and Child leaning their heads towards each other, and similar billowing draperies. This composition can also be seen in a roundel in the chancel of S. Lesmes in Burgos,[14] and in one on the tomb of Juan García de Burgos and his wife in the Chapel of the Nativity in the church of S. Gil, also in Burgos.[15] The roundel of the Virgin and Child by de Siloe above the portal of the sacristy of Granada Cathedral is also closely comparable.[16] Above the portal of the church of Santa Ana in Granada is another comparable roundel, dating from 1542–1547; this is known to be by one of Diego de Siloe's followers, Diego de Aranda.[17] In the choirstalls of S. Jerónimo, Granada, Diego de Siloe's wood relief of the full-length Virgin and Child shows a similar relationship between the two figures.[18] Using these comparisons, it seems clear that all four reliefs are related to work executed probably in Burgos by Diego de Siloe. The features of the Virgin in cat. no. 7 recall those of the Valladolid version, and are more classical than the other two; they are closer still to the image on the lunette on the tomb of Diego de Santander. Like that image, and unlike those on the pieces in Burgos and New York, the London Virgin has a book.[19] The Virgins on the three other alabaster reliefs are half-smiling and more delicately featured, in contrast to the more solemn image seen in the London version and the relief on the Burgos tomb. The naturalistic detail of the fold of the Virgin's dress caught under her left wrist also distinguishes the London version from the other three. These elements imply that the present alabaster is closer to the work of Diego de Siloe done in Burgos than the other known versions, and it seems reasonable

to attribute it to him. It may date from the time of the artist's activity in that city (about 1519–1528).

The Italianate features of the composition have often been remarked upon.[20] The probable Florentine sources of the composition may be due to Diego de Siloe's stay in Italy in the years preceding his work in Burgos.[21] The influence of Donatello, Desiderio da Settignano, and others did however reach Spain through works of art exported from Italy in the early sixteenth century.[22]

BIBLIOGRAPHY

List 1879, p. 15.
Loan Exhibition, p. 113, no. 704.
Wethey, 1940, pp. 190–6.
Ibid., 1943, p. 336.
Gómez-Moreno, 1941, p. 51 and p. 164, note 29.
Reyes y Mecenas, p. 340, (where further literature on the other versions is quoted).

NOTES

1. Like 138–1879, this was one of 301 Spanish objects (including silver and textiles) bought from Robinson for a total price of £6,800 in 1879. They represented 'acquisitions he has made from time to time on his travels in Spain' (minute from Sir Philip Cunliffe Owen to Edward J. Poynter, 19 May, 1879. John Charles Robinson Nominal File, Vol. I., Victoria and Albert Museum Registry).
2. I am grateful to Richard Cook for his help in deciphering these letters.
3. *Reyes y Mecenas*, p. 329, cat. no. 60, and *Castilla y León*, pp. 18–19, cat. no. 3. Cf also cat. no. 56 in the present collection.
4. For those in Burgos and New York (inv. no. 31.33.7) see Wethey, 1940, figs. 5 and 6. The Burgos relief measures 30 cm by 22.5 cm (information kindly supplied by Sr Alberto Bartolomé Arraiza). The New York relief is 29.2 cm by 22.2 cm (see Wethey 1940, p. 193, note 15; measurements given there are imperial). For the one in Valladolid, see Urrea Fernández, 1978, p. 58, fig. 62 (measurements not given). A fifth rectangular relief (30.5 by 27.5 cm), which is only distantly related stylistically was sold at Sotheby's, London, 20th April 1989, lot 50. This was almost certainly by Gregorio Vigarny (Pardo) for whom, see below; cf Wethey, 1940, p. 194, fig. 7.
5. *Tesoros*, pp. 136–7, cat. no. 41 (entry by A. B. Arraiza). I am grateful to Sr Arraiza for kindly showing me his entry in draft form. See also *Reyes y Mecenas*, p. 340, cat. 72.
6. Unpublished. I am grateful to Eloisa Wattenberg García for giving me access to this piece.
7. Inv. no. 808. Also unpublished. I am grateful to Luis Luna Moreno and Manual Arias for giving me access to this piece.
8. This was an oval relief measuring 38 by 30.5 cm; Hausdewell & Nolte auctioneers, Hamburg. The present location of this piece is unknown.
9. Nicolau 1983. This relief is probably by Gregorio Pardo. I am grateful to Eloisa Wattenberg García for this reference.
10. *Loan Exhibition*, p. 113, cat. no. 704. There attributed to 'Diego de Siloe of Granada' and dated 1530–1550. See Wethey,

1940, p. 192, and Gómez-Moreno, 1941, p. 51 and p. 164, note 29.

11. The roundels above the sepulchral monuments of Diego de Avellaneda, the father of the Bishop of Túy, and his son and namesake the Bishop of Túy, now in Alcalá de Henares and the National Museum of Sculpture, Valladolid respectively are similar to the reliefs under discussion, although closer to those in Burgos, Valladolid and New York than the present one. These were formerly in the monastery of S. Jerónimo, Espeja, and have been attributed to the workshop of Felipe Vigarny, including his son Gregorio Pardo. See Sánchez Cantón, 1933, pp. 117–25. Azcárate attributed the two reliefs in Burgos and New York respectively to Gregorio Pardo (*Ars Hispaniae*, XIII, p. 227), and Urrea Fernández confirmed the Burgos attribution (Urrea Fernández, 1982, p. 71), although he called the Valladolid version simply sixteenth century (*Ibid.*, 1978, p. 58). The relief in Toledo is likely to be by Gregorio Pardo (see note 9).

12. *Reyes y Mecenas*, pp. 340–1. Arraiza attributes the Burgos and New York reliefs to Diego de Siloe as well. Urrea Fernández describes the Valladolid relief as sixteenth-century; Urrea Fernández 1978, p. 58, fig. 62.

13. The tomb is illustrated in Gómez-Moreno, 1941, p. 50, fig. 21, *ibid.* 1963, pl. XL–XLI, and in Wethey, 1940, fig. 1. The ornamental motifs of the tomb show a striking similarity to those on the 'Golden Staircase' in Burgos Cathedral documented as Siloe's; Gómez-Moreno, 1941, p. 45 and fig. 17.

14. Weise 1929, p. 159, fig. 52.

15. *Ibid.*, pl. 256.

16. Gómez-Moreno, 1941, p. 72 and fig. 46.

17. Gallego y Burin, 1982, pp. 334 and 337.

18. Wethey, 1940, fig. 3.

19. A book is also held by each of the Virgins in lunettes on the tombs of Diego de Avellaneda and his son, the Bishop of Túy (see note 11 above), and on the tomb of Juan García de Burgos (see note 15 above).

20. Wethey 1940, p. 191, and *Reyes y Mecenas*, p. 340.

21. See Gómez-Moreno, 1941, pp. 42–3.

22. Cf the marble relief of the Virgin and Child after Desiderio in the Cathedral Museum at Badajoz (*Reyes y Mecenas*, p. 324), and the gilt bronze plaquette in the style of Donatello in the Cathedral Museum at Gerona (*ibid.*, pp. 292–3 and *Ars Hispaniae*, XIII, p. 19, fig. 1), as well as the glazed terracotta relief after Benedetto da Maiano in the Museo Nacional de Cerámica González Martí in Valencia (*ibid.*, p. 293). See also *Ars Hispaniae*, XIII, pp. 18–19, figs. 2 and 3.

FELIPE VIGARNY (BIGARNY)

(b. Langres (Burgundy) c. 1470; active 1498–d. Toledo 1542)

Probably born around 1470, and originally from Burgundy, Vigarny is known to have been in Burgos by 1498. He was there commissioned to carve a relief in marble of *The Way to Calvary* for the *trasaltar* (back of the altar) in the Cathedral, and a few months afterwards he was to execute other reliefs on the *trasaltar*. Later (*c.* 1515) he was to collaborate with other sculptors on the choirstalls of Burgos Cathedral. He also carried out commissions in Toledo, Palencia and Salamanca. In 1519 he was in Zaragoza, where he signed a contract to work with Alonso Berruguete (*c.* 1489–1561), who had recently returned from Italy. Some of his most important work was undertaken from 1521 onwards, when he produced the high altarpiece and kneeling figures of Ferdinand and Isabella for the Royal Chapel in Granada. In the 1520s he worked with Diego de Siloe (*c.* 1490–*c.* 1553) on the altarpiece for the Constable's Chapel in Burgos Cathedral. Vigarny also produced a number of fine tombs, such as that of Gonzalo Díez de Lerma (see below), and those of the Bishop of Túy and his father, now in Alcalá de Henares and the National Museum of Sculpture, Valladolid respectively. He collaborated with Berruguete once more on the choirstalls of Toledo Cathedral in 1539.

BIBLIOGRAPHY

Ceán Bermúdez V, pp. 228–31; Checa 1983; *Reyes y Mecenas*, pp. 341–2 and pp. 532–3.

8. ST JOSEPH (?)

ALABASTER
BY FELIPE VIGARNY (BIGARNY)
BURGOS; about 1524–30
Inv. no. A.40–1935
H. 36 cm. W. 12.8 cm. D. 3.7 cm.

Provenance
Given by Dr W. L. Hildburgh F.S.A. in 1935.

Condition
The nose is damaged, and there are minor chips elsewhere, particularly on the hair, beard and fingers; part of the left sleeve is also broken. There are signs of iron staining. The piece is a fragment, and the damage on the left side of the neck and face, and the saw-marks at the sides indicate that it was removed from its original context; it must have been part of a larger whole (along with cat. no. 9). The back of the piece is smooth, and one side of a bevelled frame has been carved into it.

The half-length image of the bearded saint shows him inclining his head towards his right with his hands clasped together in an adoring pose, the fingertips touching.

On acquisition the subject was described as St Peter, but this was later revised as St Joseph, as no attributes are visible, while the likely positioning of the present piece on one side of the Virgin and Child (now lost) suggests St Joseph is more probable. The remains of a circular or oval border carved into the alabaster at the lower right corner (damage occurs at a corresponding point, the lower left corner, of cat. no. 9) suggest that both fragments were originally part of an oval relief or circular medallion, similar to, though larger than the *Virgin and Child* (cat. no.

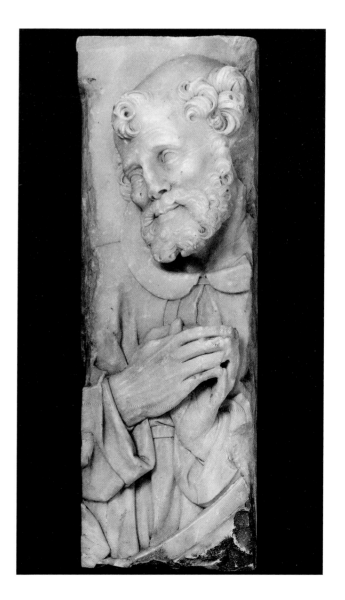

7). The style of this relief and cat. no. 9 (*St Jerome*) strongly recalls the work of Felipe Vigarny, in particular his alabaster medallions of saints on the tomb of Gonzalo Díez de Lerma, commissioned in 1524, in Burgos Cathedral.[1] The high quality of carving suggests it is by Vigarny, and dates from the time of his activity in Burgos.

NOTES

1. Weise 1929, pl. 166, and *Ars Hispaniae* XIII, fig. 28.

9. ST JEROME

ALABASTER
BY FELIPE VIGARNY (BIGARNY)
BURGOS; about 1524–30
Inv. no. A.41–1935
H. 36.9 cm. W. 12.9 cm. D. 8.3 cm.

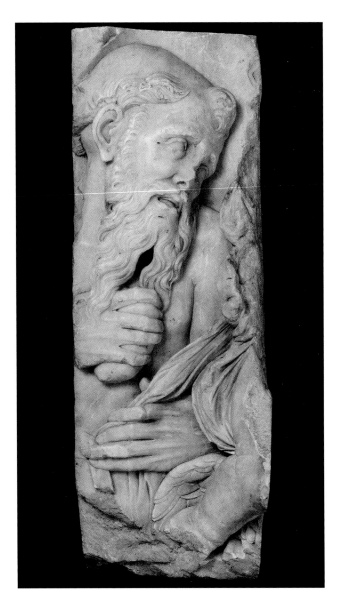

Provenance
Given by Dr W. L. Hildburgh F.S.A. in 1935.

Condition
The nose is broken, and there are minor chips and iron stains elsewhere. There are saw-marks on both sides of the block, indicating it has been removed from a larger piece (cf cat. no. 8). On the back the piece is smooth, and one side of a bevelled frame has been carved onto it. A dowel hole on the left side of the block (as we look at it) is partly filled with glue; the right side of the block is more seriously damaged.

The half-length image shows a naked bearded man holding a rock in his right hand, the attribute of St Jerome. He holds his head tilted towards his left, his mouth half-open; he was almost certainly originally on one side of a now-lost *Virgin and Child*, with the other male saint (cat. no. 8) on the other side. The placing of the left hand holding drapery is difficult to understand. At first glance it seems impossible anatomically that it should belong to the saint, as there is no room for the forearm, yet it is closely comparable to the left hand of St Jerome holding drapery in the relief by Vigarny on the tomb of Gonzalo Díez de Lerma, commissioned in 1524, in Burgos Cathedral (see fig. 5).[1] The Christ Child's right leg and the wing of a cherub below from what must have been the central image of the *Virgin and Child* are visible beside the hand.

As discussed above, along with cat. no. 8, this piece would have formed part of a larger oval or circular relief, the centrepiece now lost.[2] The style of the present relief is particularly close to the analogous image of St Jerome by Felipe Vigarny on the tomb of Gonzalo Díez de Lerma referred to above, particularly the hands and locks of hair. Its high quality indicates that it is probably by Vigarny himself, and is likely to date from the period of his activity in Burgos, where he was working from about 1524 onwards.[3]

NOTES

1. Weise 1929, pl. 166; for the tomb, see *Ars Hispaniae XIII*, fig. 28 and p. 45.
2. See the entry for cat. no. 8.
3. See note 1 above, and *Reyes y Mecenas*, pp. 532–3.

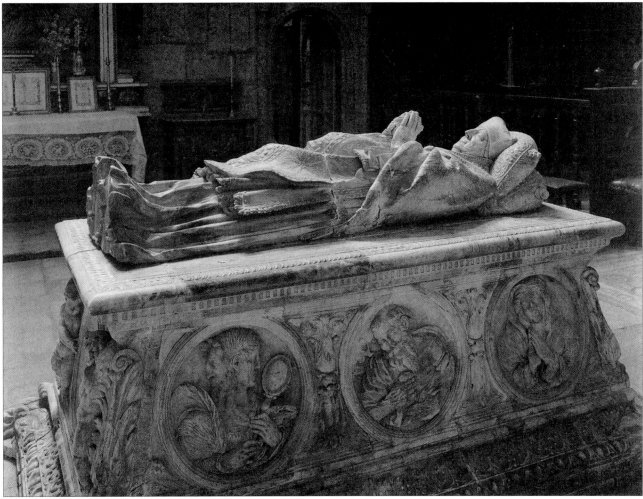

Figure 5. The Tomb of Gonzalo Díez de Lerma, marble. By Felipe Vigarny. Burgos Cathedral. Photograph by J. R. H. Weaver (active 1914 onwards). Victoria and Albert Museum inv. no. E. 2182–1995. See cat. no. 9.

10. PIETA

ALABASTER

CASTILE; about 1530

Inv. no. A.185–1919

H. 39.7 cm. W. 29.5 cm (in addition a broken border on part of one side of about 1 cm). D. approximately 3.5 cm (at the base approximately 5 cm).

Provenance
Given by Dr W. L. Hildburgh F.S.A. in 1919. Acquired by the donor in Madrid (date unknown).[1]

Condition
The relief has been broken into three pieces; the two repaired breaks are visible. One of these runs above the Virgin's head and through the ladder leaning against the cross; the Virgin's head is missing except for the chin and some of her veil, and the ladder is damaged. The other main break runs horizontally through Christ's legs. The lower left corner of the relief is missing, and only fragments remain of the integral border, which perhaps once slotted into a surround. The Virgin's left arm is lost, as is Christ's right arm and his right leg; part of his left leg is broken off. Small drops of varnish are on Christ's hair, and a dark spot of paint is visible on the cross. Museum records indicate that when acquired the relief included later plaster restorations to the figures, and to the left side of the panel; these must have been subsequently removed. Also removed was a gilded and painted wood frame.[2]

The Virgin sits at the foot of the cross with Christ's body laid across her knees. She cradles his head in a cloth held in her right hand. A ladder leans against the cross on the left, and the crown of thorns is placed over the cross; above is the cartouche faintly inscribed INRI, and two nails on the cross-beam are visible. The stigmata are visible on Christ's left hand and foot. Behind is the walled city of

37

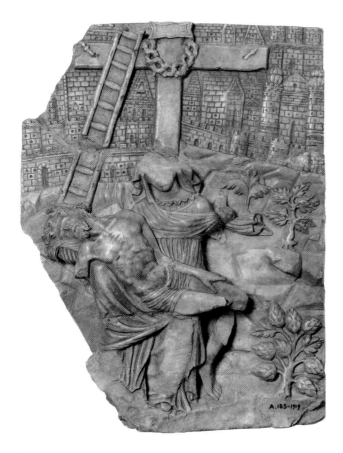

Jerusalem. On the rocky ground are three small trees or shrubs, perhaps an acanthus, an oak and an artichoke.

This piece has certain distinctive characteristics: the city rising up behind, blocking out any sky (the remaining border at the top indicates that the buildings extended to the very edge of the relief), the strange plants growing on the rocky ground, almost certainly with symbolic intent, and the finely carved head of Christ, with his hair flowing upwards over the Virgin's supporting hand. Four other versions of this relief are known: one in the Archaeological Museum Valladolid,[3] one in the church of S. Antolín in Tordesillas,[4] one owned by the Ayuntamiento, Segovia,[5] and one in the Convent of Santa Teresa in Valladolid.[6] The existence of these suggests that a workshop, probably specialising in alabaster, was producing a number of similar pieces relatively cheaply.[7] It is known that certainly during the fifteenth century Spanish alabasters were being exported to Germany.[8] A precise attribution is not possible, but like the others the present relief probably dates from around 1530, although it is reminiscent of a slightly earlier style; it is likely to have been made in Castile.

BIBLIOGRAPHY

Review 1919, p. 3.

NOTES

1. Museum records.
2. Museum records. No photographs survive showing these additions.
3. Inv. no. 2.514. Martín González *Catálogo* 1983, pp. 70–1 and fig. 147. I am grateful to Luis Luna Moreno for drawing my attention to this, and to Eloisa Wattenberg García for enabling me to have access to it.
4. Ara Gil and Parrado del Olmo 1994, p. 167 and pl. CXXXII, fig. 281. I am grateful to Jesús Parrado del Olmo for drawing my attention to this.
5. Santamaria, p. 72, no. 60. I am most grateful to Eloisa Wattenberg García for this reference.
6. Martín González and Plaza Santiago 1987, pl. CCXCII, fig. 909.
7. Cf the production of English alabasters in the fifteenth century. Ninety English alabaster heads of St John the Baptist survive (Cheetham, p. 28). Cheetham also notes that English alabasters had a comparatively low value in the sixteenth century (*ibid.*, p. 31).
8. A fifteenth-century account book records the export of 'ymages de pedra de alabastre' from Catalonia listing prices in Rhineland currencies; Schulte II, p. 212. I am grateful to Norbert Jopek for this reference.

ALONSO BERRUGUETE

(b. c. 1489 Paredes de Nava–d. 1561 Toledo)

The son of the painter Pedro Berruguete (d. 1494), who had worked at the court of Urbino, Alonso Berruguete was one of the foremost Spanish artists of the sixteenth century. Like Diego de Siloe, he was named as one of the seven 'eagles' of the Spanish Renaissance by the Portuguese artist and theorist Francisco de Hollanda (*c.* 1517/8–1584), a designation revived by Manuel Gómez-Moreno in his study of four of these artists in 1941. Berruguete spent some years in Italy (mainly Rome and Florence), from about 1506 onwards, and returned to Spain by 1517. His subsequent work shows he had learned from the work of Michelangelo, as well as recently excavated antique sculpture, such as the *Laocoön*. In 1518 he was described as '*pintor del rey*' (painter to the King, Charles I, Emperor Charles V), and documents record his commissions to paint standards, and sails for the armada. From 1518 to 1520 he worked alongside Felipe Vigarny in Zaragoza, and in 1521 was collaborating with Vigarny on the high altar of the Capilla Real in Granada. In 1522 he is recorded as painter and gilder of the high altar of Oviedo Cathedral, and is again named as '*pintor de su Majestad*'. The first known work he produced as a sculptor as well as a painter was the altarpiece for the Monasterio de la Mejorada, Olmedo (1523–6), now in the National Museum of Sculpture, Valladolid. He worked on the S. Benito altarpiece shortly after this (see below), and at that time built himself a sumptuous house in Valladolid. As well as other altarpieces, he was primarily responsible for the reliefs in walnut and alabaster respectively for the choirstalls and Archbishop's throne for the cathedral of Toledo (*c.* 1535–45). His last work was the tomb of Cardinal Tavera in the Hospital de S. Juan Bautista, Toledo, completed in 1561.

BIBLIOGRAPHY

Ceán Bermúdez I, pp. 130–44; Palomino *Lives*, pp. 9–10; Camón Aznar 1980; Gómez-Moreno 1983, pp. 121–60; Checa 1983 (numerous references).

11. AN APOSTLE(?)

PAINTED AND GILT WALNUT

WORKSHOP OF ALONSO BERRUGUETE

VALLADOLID; about 1526–1533

Inv. no. 249–1864

H. 83 cm. W. of base 19 cm.

See plate 3

Provenance

Bought from Pérez Minguez in Valladolid by John Charles Robinson in 1863 for 500 reals (£5 5s 3d). Robinson made a hastily pencilled semi-legible note about its purchase in Valladolid at the time: 'In Museum made sketch of Juan de Juni Magdalene I noted the Berruguete figures – afterwards to doctor dealer in antiquities – got one of the Museum series of the Berruguete/ [?saints], but not one of the good ones . . .'[1]

Condition

The statue, damaged in places, was described by Robinson soon after the time of its purchase in 1863 as 'unfortunately mutilated' (see below).[2] The fingers and thumb of the left hand are broken off, while the thumb and first two fingers of the right hand, along with most of the book or scroll held in that hand, are also missing. The toes of the right foot are broken. The integral wood socle is chipped. Slight chips to the paint on the face, hair, and drapery are visible.

The bearded figure stands with his weight on his right foot, the other foot resting on a small block. He is turning his head to his left, his left arm half-outstretched, while his right hand holds the remains of what might be a scroll, tablet, or book, the rest of which may have been supported by his outstretched left hand. His robes, reminiscent of classical dress, are painted and gilded in the *estofado* technique.[3] The wood is unpainted and roughly carved at the back, and a metal eye (perhaps original) has been screwed in as a fixing device. The right forearm is sliced down at the back, perhaps so that the figure could be fitted into its original niche.

On acquisition this piece was correctly identified as a figure from the altarpiece by Alonso Berruguete formerly in the church of S. Benito in Valladolid. Robinson described it in his report: 'Statuette of a saint or apostle in carved and gilded wood, the drapery diapered or pricked out in colour ('Estofado') the work of Alonso Berruguete. This statuette carved in walnut is one of the very numerous figures, which formerly adorned the now dismantled altarpiece or 'retablo' of San Benito el Real at Valladolid, one of the most celebrated works of the master (see Ceán Bermúdez – entry Berruguete) where the original contract . . . is quoted.[4] A considerable number of the more important of the statues and groups for the retablo are now preserved in the public Museum at Valladolid. The present specimen, unfortunately mutilated, is also one of the most hastily executed and mannered of the

series, having been doubtless one of those originally placed very high up at a great distance from the eye.'⁵

The church of S. Benito had been occupied by French troops in the early years of the nineteenth century, and fell into disuse in 1837 after the *desamortización* (the secularisation of many of the smaller monasteries in Spain). It remained closed until 1892 when it passed to the venerable Orden Tercera del Carmen, and in 1897 it came under the protection of the Padres Carmelitas Descalzos, who reside there still.⁶

A number of altarpieces and works of art were installed in S. Benito during the sixteenth century; the complex history of their placement and dismemberment was discussed in two extensive articles by Agapito y Revilla in 1913.⁷ The present altarpiece was commissioned by the abbot of the monastery of S. Benito in 1526, and was assessed in 1533. After some dispute between Berruguete and the abbot about its quality, it was completed in 1535, the final payment being made to Berruguete in 1539.⁸ It consisted of over thirty painted and gilt wood statues of differing sizes, painted and gilt wood reliefs, and four paintings, set in an elaborate architectural framework. Parts of the altarpiece were dismantled and taken to the Provincial Museum of Fine Arts in Valladolid over a period from about 1844 to 1880.⁹ The decorative framework remained in the church until after 1881. This, along with the elements in the museum, were seen and commented on by the architect G. E. Street, who wrote in 1865: There were also three great Retablos to the principal altars at the ends of the aisles. The Renaissance frames of these are mostly *in situ*, but the sculptures have all been taken . . . to the museum . . . I never saw such contemptible work; yet Mr. Ford calls this work [Ford 1845, II, p. 948] 'the *chef d'oevre* of Berruguete, *circa* 1526–32'. I can only say that the architecture is bad, the sculpture is bad; that all three are bad of their kind, and that their kind is the worst possible. It is in truth the ugliest specimen of the imbecility and conceit which usually characterise inferior Renaissance work that I ever saw . . .¹⁰

Street's hostile views unfortunately apparently prevented him from describing the altarpiece in more detail. Two earlier Spanish commentators, Ponz (in 1787) and Bosarte (in 1804) described the whole altarpiece when it was still *in situ*.¹¹ A sketch of the surviving framework in the church was made by the architect Iturralde, and although much of the framework was gone by then, the drawing showed the essential structure.¹² This, along with Bosarte's detailed description, enabled the architect Constantino Candeira y Pérez to suggest how the altarpiece could be reconstructed, when it was decided to re-display it

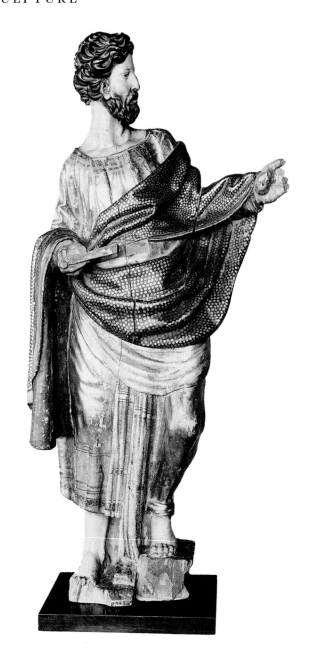

in the National Museum of Sculpture in Valladolid in 1930 (established in that year with the collections which had previously constituted the Provincial Museum of Fine Arts). Due to its enormous size however, the altarpiece is presently displayed in its dismantled state in several rooms of the National Museum of Sculpture. The original appearance of the altar according to Candeira is shown in a painting executed to his instructions by Mariano de Cossío (see fig. 6).¹³ Candeira's explanation of his reconstruction, along with a detailed examination of the altarpiece's history, was delivered as a lecture early in 1960, having been published in book-form in 1959.¹⁴ He believed that one of the statues was missing, and postulated that

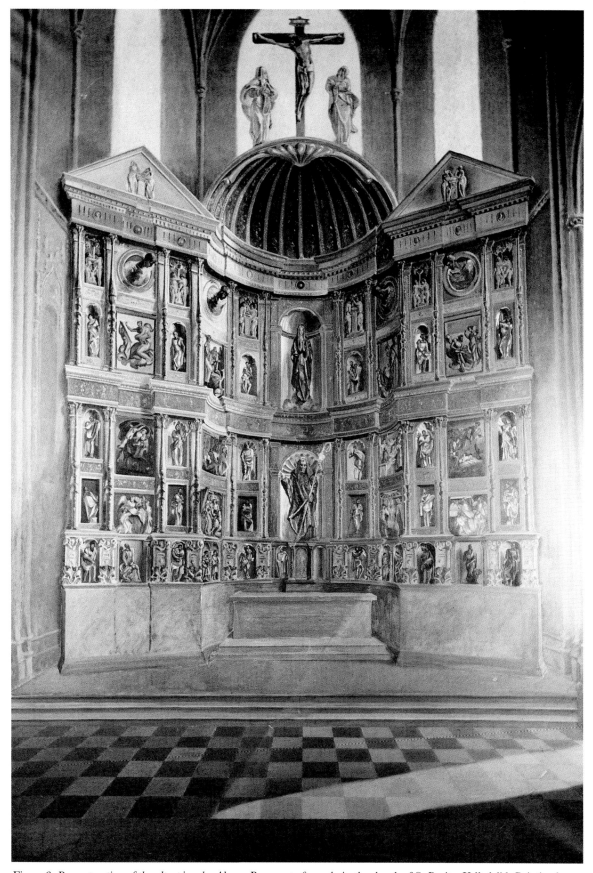

Figure 6. Reconstruction of the altarpiece by Alonso Berruguete formerly in the church of S. Benito, Valladolid. Painting by Mariano de Cossio. Museo Nacional de Escultura, Valladolid.

cat. no. 11 was this missing piece, even without apparently knowing its provenance.[15] According to the painting by de Cossio, the empty niche was in the *banco*, the lowest tier of the altar. The present work compares closely in style and size with other statues believed to come from this tier.[16] In the centre of this register was a Baroque-style tabernacle or *custodia*, which apparently replaced an earlier one designed by Berruguete himself. The replacement tabernacle was made in the late eighteenth century, and Ponz refers to its installation with some disapproval.[17] In de Cossio's watercolour, the empty niche is next to the tabernacle, and it is possible that the present work was damaged (and even removed) at the time the new tabernacle was put in.

This piece was tentatively identified as Moses in 1974, because of its resemblance to a statuette thought to be Moses in the middle register.[18] It seems however unlikely that two representations of the same figure would appear on one altar, and there are no outstanding features on cat. no. 11 (such as horns on the forehead) associated with Moses. Its missing attribute of a scroll, tablet or book held in the left hand would not necessarily clarify the iconography. The contract stated that the figures on the *banco* should include the twelve Apostles, and that if more were needed, the abbot should be consulted.[19] In the finished work, it seems that fourteen figures and groups were installed on the *banco*, although this is not entirely clear.[20] Given the original contract, it is possible that the present piece is an Apostle, although, as few of the other statues from the altarpiece can be named with any certainty (including those thought to have been placed on the *banco*, and therefore most nearly associated with cat. no. 11), the present work can only be tentatively identified. How far cat. no. 11 is an autograph work, and how far the work of assistants is also difficult to establish. According to the contract, Berruguete was personally responsible for finishing and 'polishing' the faces and hands of the figures.[21] The present piece could well be largely workshop.[22]

BIBLIOGRAPHY
Inventory 1852–67, p. 71.
Inventory 1864, p. 20.
Riaño, p. 7.
Loan Exhibition, p. 126, no. 809.
Baker 1984, pp. 344–5 and p. 348, fig. 9.

NOTES
1. Robinson Ashmolean Museum, file 6 (Valladolid folder).
2. Robinson Reports, I, Part III, *Description of objects purchased in France and Spain 1863–4*, 10th March, 1864, p. 242. I am greatly indebted to Anthony Radcliffe's observations in the Museum records on this figure and its original placing on the S. Benito altarpiece.
3. For a brief discussion of this technique, see the introductory essay on Materials and Techniques.
4. The original contract based on a transcription made in 1802 had in fact been published in 1862 (see Cruzada Villaamil). See note 8 below.
5. Robinson Reports, Vol. I, Part III *loc.cit.*. As will be seen below, in fact the statue probably came from the lowest tier.
6. In 1845, Richard Ford said of S. Benito, 'during the recent civil wars [it was] converted into a fort' (Ford, 1845, II, p. 948). For S. Benito see Rodríguez Martínez and Martín González and Plaza Santiago, pp. 237–48.
7. Agapito y Revilla 1913.
8. The contract for the piece, and documents detailing the subsequent disputes were transcribed by Bosarte in 1804 (Bosarte, pp. 359–77). See also Cruzada Villaamil, 1862, p. 147, and Camón Aznar, 1980, p. 61 and pp. 86–7. Camón Aznar does not mention the piece in the Victoria and Albert Museum, nor indeed that there is a figure missing from the altarpiece.
9. In 1843 the English traveller S. E. Widdrington reported 'the great retablo by Berrugusto [*sic*.] had not been removed from [S. Benito]'. Widdrington 1844 II, p. 30. Stirling-Maxwell included in his *Annals of the Artists of Spain* (first published 1849, later expanded edition 1891) a wood engraving of a profile head which he believed to be a portrait of Berruguete from the choirstalls formerly in S. Benito; this he captioned as: 'From the author's own sketch, which he lent to Mr Thomas Macquoid to make a drawing for the head in the Renaissance Court in the Crystal Palace, Sydenham, 1854.' (Stirling-Maxwell I, p. 160).
10. Street, I, p. 86.
11. Ponz, XI, p. 65; Bosarte, pp. 157–61 and pp. 359–77. Bosarte's account is by far the most detailed.
12. Candeira y Pérez, 1959, p. 16.
13. This is illustrated in Candeira Pérez, fig. 1, and in Camón Aznar, p. 62.
14. Candeira y Pérez, *op.cit.* in note 12.
15. *Ibid.*, p. 42.
16. See the illustrations of other figures from the altarpiece in Camón Aznar, especially pp. 65, 69, 70–1.
17. '. . . No es facil que la nueva obra diga con el estilo del antiguo retablo.' Ponz, p. 65.
18. Museum records.
19. Bosarte, p. 363.
20. See Candeira y Pérez, p. 20.
21. 'La intervención personal de Berruguete se exije en el desbaste y en el acabado de rostros y manos de la escultura, y en la terminación de los cuadros o "historias de pincel".' Candeira y Pérez, p. 20.
22. Perhaps the London figure was by one of Berruguete's known followers, Juan de Cambray or Cornielles de Holanda. See Martín González, *Valladolid*, 1983, p. 30.

12. THE VIRGIN ANNUNCIATE

WALNUT

CASTILE (BURGOS/PALENCIA?); about 1520–50

Inv. no. A.11–1955

H. 72.5 cm. W. 26.5 cm.

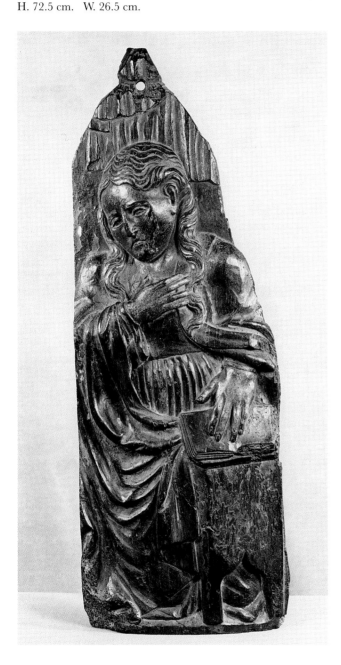

Provenance

Given by the Parochial Church Council of Christ Church, Waterloo Road, Wolverhampton in 1955. Formerly in the south aisle of the church, and apparently previously in the collection of don Alberto Gongsley-Almen of Seville.[1]

Condition

Remains of paint and white ground survive on the surface; varnish was applied after the removal of the polychromy. A horizontal channel runs across the back of the relief. Two mirror-plates have been attached to the top and bottom of the piece. A hole is drilled through the top.

This fragmentary relief from an *Annunciation* scene shows the Virgin kneeling before a *prie-dieu*, her left hand resting on a book, her right hand held to her breast. Part of a canopy (or perhaps the curtains of a bed) can be seen above her head.

The style of this piece recalls the reliefs on the choirstalls in Burgos Cathedral, which were executed by the workshop of Felipe Vigarny (active 1498–1542) in the early sixteenth century.[2] The face of the Virgin here is reminiscent of the Virgin in the *Visitation* from the choirstalls,[3] while the pose of the figure echoes that of the Annunciate Virgin in Vigarny's *Annunciation* scene.[4] Parallels can also be found in mid-sixteenth century work in Palencia, such as the high altarpiece at Boadilla del Camino (Palencia) by Juan de Cambray (*c.* 1508–1558) and others, and probably dating from the 1550s, and the work of Juan Ortiz el Viejo I (active 1518–before 1558), such as the high altarpiece of 1544 at S. Ginés at Villabrágima (Valladolid).[5] Despite the provenance of Seville, Castile is the most likely place of origin. The vestiges of polychromy on the present relief suggest that originally the figure came from an altarpiece; the channel at the back must have been used to attach it to a larger ensemble.

NOTES

1. Museum records (Registered Papers 55/891).
2. Weise 1929, pls. 136–46, and pp. 78–80.
3. *Ibid.*, pl. 136.
4. *Ibid.*, pl. 144.
5. Parrado del Olmo *Palencia* 1981, pp. 80–2 and pl. XI, figs. 27–8, and *ibid.*, pp. 91–3 and pl. XXXIV, fig. 85.

indicate that the wood was originally painted, and the bust may have been part of a full-length figure, perhaps from an altarpiece. The facial expression, headdress and costume could mean that the bust was originally part of a figure of the Virgin Annunciate. The style of carving is reminiscent of sculpture in Burgos and Castile of the 1520s, in particular the work of Felipe Vigarny (active 1498–1542), and Diego de Siloe (active after 1517–c. 1553). The reliefs on the high altar by Vigarny and Siloe of 1523 onwards for the Constable's Chapel in Burgos Cathedral are comparable stylistically. The heads of the figures in *The Annunciation* and *The Visitation* also have high foreheads and faces framed by wavy hair.[1] A *Virgin Annunciate* in the tradition of Vigarny and Siloe in Roa (Burgos) shows similar features.[2] The later reliefs on Vigarny's choirstalls of about 1539 for the Cathedral at Toledo also recall the present piece, in particular the head of a female saint (St Margaret?).[3]

NOTES
1. Weise 1929, pls. 204–5, and pp. 133–8.
2. *Ibid.*, pl. 247 and p. 157.
3. *Ibid.*, pl. 171, and pp. 104–5.

13. BUST OF A WOMAN (FRAGMENT OF A VIRGIN ANNUNCIATE?)

WALNUT
CASTILE; about 1540–50
Inv. no. A.162–1922
H. 25 cm.

Provenance
Given by Dr W. L. Hildburgh F.S.A. in 1922.

Condition
The bust has suffered from previous woodworm attack, and losses have occurred at the back of the head, on the back of the right shoulder, and on the left side of the hair; old woodworm holes are evident, especially on the back. The left nostril is slightly damaged, and the veil over the head is cracked. Remains of polychromy can be seen in the hair and elsewhere.

The long-haired woman is leaning slightly to her right. She wears a veil, and a tunic over a chemise.

The subject and original context of this piece are difficult to establish. The vestiges of polychromy

JUAN DE JUNI

(b. c. 1507 Joigny–d. 1577 Valladolid)

His name indicating that he was probably a native of Joigny, on the borders of Champagne and Burgundy, Juni appears to have spent most of his working life in Castile and León. Circumstantial evidence suggests he was in Italy in his youth, and he may have been brought to Spain by the Portuguese bishop don Pedro Alvarez de Acosta from Rome. Acosta, who was to be a patron of the sculptor, became Bishop of León in 1534, the year in which Juni is first recorded in Spain, when he was working at S. Marcos in León. Here in collaboration with other sculptors he produced the stone medallions on the outside of the building, as well as the wood choirstalls (c. 1534–7). He was in Medina de Rioseco in 1537, and appears to have settled in Valladolid in about 1539. He continued to provide sculpture for other centres, such as Burgo de Osma, Ciudad Rodrigo, Tordesillas, Salamanca, Segovia, Cáceres and León. Much of his most important work is however in Valladolid, including the high altarpiece (1545–60) made originally for the church of La Antigua, and now in the Cathedral. His expressive lifesize *Lamentation* group (completed in 1544) originally made for the convent of S. Francisco in Valladolid is now in the National Museum of Sculpture in the same city. Juni worked in stone, terracotta and wood. Like that of his slightly older contemporary Alonso Berruguete (c. 1489–1561), his workshop also undertook the polychromy of his sculpture when necessary. Juni's sculpture predicates a knowledge of Italian Renaissance sculpture, for example the work of the quattrocento sculptor Jacopo della Quercia (c. 1367–1438), (who was, like Juni himself, influenced by Burgundian prototypes), and the antique, such as the *Laocoön*, excavated in Rome in 1506.

BIBLIOGRAPHY

Palomino *Lives*, pp. 70–3; Ceán Bermúdez II, pp. 359–64; Martín González 1974; *Juan de Juni y su Epoca*; Checa 1983 (numerous references).

14. THE LAMENTATION

PAINTED AND GILT TERRACOTTA IN A PAINTED AND GILT WOOD FRAME

BY THE WORKSHOP OF JUAN DE JUNI

CASTILE (SALAMANCA?); about 1540–50

Inv. no. 91–1864

H. (with frame): 45 cm. H. (without frame): 30.5 cm.

W. (with frame): 55 cm. W. (without frame): 40 cm.

D. (with frame): 6 cm.

See plate 4.

Provenance
Bought by John Charles Robinson from don José Calcerrada in Madrid in 1863 for £4.[1]

Condition
This polychromed terracotta relief is held by pegs in a painted and gilt wood frame; one of the pegs is partly visible at the upper right, beneath the tree, where there is a break.[2] There are other areas of damage in the terracotta on the top edge, and Christ's left foot is missing. Remains of sealing wax on Christ's left leg indicate an old repair; wax can also be seen at the base of the tree at the top right, and wax droplets (apparently accidental spillages) are present on the left and right edges of the wood frame. The frame is chipped in places and a sliver is missing on the lower left. The paint is flaking in places.[3] Fragments of the original polychromy lie beneath the now muted tones of the terracotta surface, and indicate that the relief was originally much brighter than its present appearance suggests. Traces of azurite, a brilliant blue, were found in the Virgin's robe, and gold leaf was certainly present elsewhere on the

robe, on the trees behind, and on the ground beneath the Virgin's hand. A layer of red bole found over the preparatory white ground, and dating from the time when the relief was first polychromed, indicates that gold leaf may have been present over the whole surface, over which paint would have been applied and then scratched through to reveal patterns of gold (the technique known as *esgrafiado*).[4] The terracotta has been overpainted at least twice, once probably in the seventeenth or eighteenth century, and once in the nineteenth century.[5] The frame too has been overpainted; one of the original gold letters of the inscription can be seen on the lower right (the second 'A' of 'ANIMAM'), although the inscription now visible appears to be the same as the earlier one.

The Virgin supports the supine body of Christ at the foot of the cross. She leans back, her head sideways over her left shoulder; Christ's body is twisted, with his left arm stretched back behind him, and his legs slightly bent. In the landscape behind, a man is seen carrying away a ladder on the right, while on the left a figure is bending over the tomb, seen through an opening in the hillside. The crown of thorns and a white cloth are resting on the trunk of a small bush to the left. Painted in the distance are the towers and buildings of Jerusalem. The frame is inscribed in gold: QVOS OMNES QVI TRANSITIS./ PERVIAM. ATENDITE ET VIDE[T]E SI EST. / DOLOR SIMILIS, SICVT. DOLOR MEVS / QUINET TVAMIPSIVS ANIMAM PENE[T]R[A]BIT GLADIVS (Is it nothing to you, all ye that pass by? Behold, and see if there be any sorrow like unto my sorrow. And why will not the sword pierce your soul also?) The first part of the inscription (up to 'sorrow') is

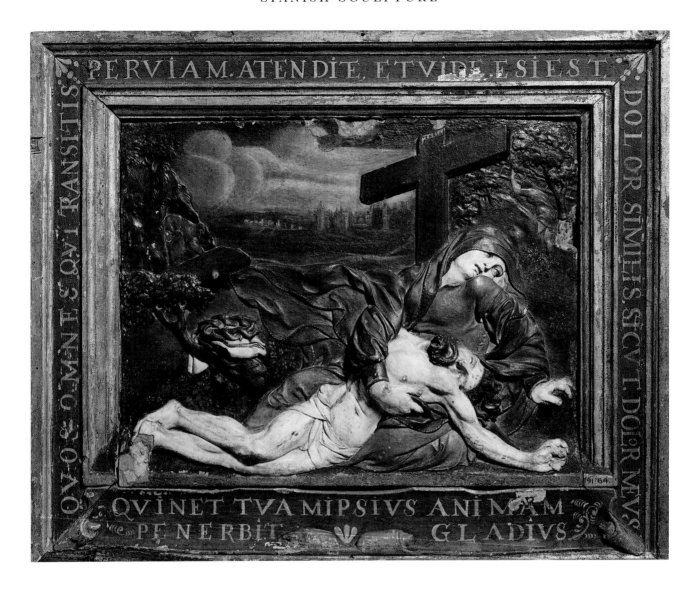

from the Book of Lamentations, 1, 12.[6] It has not been possible to trace the source of the final sentence, which is inscribed along the bottom of the frame. The Latin appears to be corrupt and may be the result of a later repainting of the lettering. Infra-red photography did not reveal an alternative wording beneath the present surface.[7] The bottom of the frame is elaborately shaped, with scroll-like corners at the lower edge, and shallow curves scooped out of the upper edge, giving the effect of a cartouche.

The mannerist style of the composition, with its elongated, contorted figures, and *nerviosidad* is typical of the work of Juan de Juni. Comparable works by this artist include a *Pietá* on the tomb of Gutierre de Castro in the Cathedral at Salamanca, almost certainly dating from around 1540 (see fig. 7),[8] and a figure group of the Virgin with the dead Christ attributed to Juan de Juni in the Museo Marés, Barcelona.[9] Other versions of the present piece are in the Archaeological Museum in León, in the Diocesan Museum in Valladolid, and in

the Camón Aznar Collection formerly in Madrid, and now in Zaragoza. With the exception of the Camón Aznar relief, they are virtually identical in size.[10] A smaller variant with the composition laterally inverted is in the National Museum of Sculpture in Valladolid.[11] The versions in the Diocesan Museum in Valladolid,[12] and in the Archaeological Museum in León respectively have also been attributed to Juan de Juni. The difficulties arising from trying to distinguish autograph from workshop versions of these reliefs can be seen from the fact that Martín González ascribed the one in León to Juan de Juni in 1977,[13] citing Gómez-Moreno. Gómez-Moreno had described the piece as: 'bajorrelieve de barro policromado; su tamaño, 31 por 40 centímetros; roto. Obra de Juní, conocida por otro ejemplar igual que hay en San Martín de Valladolid; representa la Piedad, con paisaje y figurillas por fondo.'[14] Martín González also attributed the Valladolid relief to Juan de Juni in the

versions existed.[19] However, with one probable exception, the known surviving pieces are probably contemporary with one another, whereas the theory that copies were made by other artists implies that they were made at a slightly later date, perhaps after Juan de Juni's death in 1577. There is no perceptible difference in the definition of the forms in the examples in Valladolid, León and London, although the polychromy varies in quality. Recent examination of the backs of the versions in Valladolid and León has however indicated they were made slightly differently from each other. Each was cast from a mould, but the clay used for the Valladolid version was carefully and compactly inserted, while the clay for the one in León was inserted in layers in a far cruder construction. This suggests that they were certainly made by different hands, perhaps at slightly different times.[20] The Valladolid, León and London pieces are all of the same size; the Camón Aznar version is approximately 5 cm smaller in both height and width. This piece will be discussed separately below. Unfortunately I have not been able to examine the back of the reliefs in London or Zaragoza, and the above information about the other two is based on the examination of their reverses by other colleagues. The frame on the London version could only have been removed at great risk to the terracotta. The front of the present version has been closely studied, but I have only inspected briefly those in Valladolid, León, and Zaragoza. All these works appear however to have been made for display. This can be inferred from the fact that in all cases polychromy contemporary with the reliefs survives at least in part, and that wood frames are extant on all but the Valladolid version.[21] (This seems to contradict Palomino's comments, which imply that other artists made copies for their own use, in adulation of Juan de Juni.) For these reasons, it seems possible, and even probable, that despite differences between the known surviving versions, the composition was always intended to be reproduced in multiples, and that the reliefs in Valladolid, León and London should be accorded equal status, no one of them necessarily being closer to (or further from) the work of the sculptor than any of the others. Having modelled an 'original' in clay, which was probably then fired in order to harden it, Juan de Juni could have had made in his workshop a mould of this, from which were cast numerous copies.[22] These were then painted, framed and sold to customers. The painting is likely to have been carried out in Juan de Juni's own workshop, rather than to have been sub-contracted.[23] The technical difference between the Valladolid and León versions described above may mean however that these two were made at different times from one another, although almost certainly during the sixteenth century,

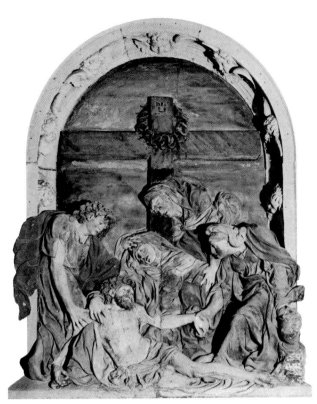

Figure 7. Pietá on the tomb of Gutierre de Castro, polychromed sandstone. By Juan de Juni. Salamanca Cathedral.

text of his monograph, contrasting it with the León and Camón Aznar pieces, which were said to be 'after' the Valladolid relief.[15] However in the catalogue at the end of the monograph, Martín González described the León version as a product of Juni's workshop,[16] but by implication both the Valladolid and the Camón Aznar versions are listed as autograph; they are included in the catalogue of works without the word *'taller'* (workshop).[17] In correspondence, Profesor Martín González has confirmed that he believes the Camón Aznar relief to be workshop.

Profesor Martín González has argued that the 'original' version by Juan de Juni himself is the one in Valladolid, which may in turn be identical with the relief mentioned in the inventory of the belongings of Juana Martínez, of the parish of S. Ildefonso in Valladolid. This inventory was made on 10 January, 1613, shortly after the death of Juana Martínez. She was the widow of Isaac de Juni, Juan de Juni's illegitimate son, himself a sculptor. The inventory lists a relief in terracotta of the *Descent from the Cross*, although it must remain speculative whether this is indeed one of the reliefs under discussion, as Martín González notes.[18] In the early eighteenth century, Palomino stated that the version now in Valladolid (then in the church of St Martin in Valladolid) was cast by 'algunos escultores', which was why various other

and probably within Juni's workshop. The relief mentioned in the 1613 inventory (if it does have any connection with the present pieces) may be a fifth version which has been subsequently lost, or it may be identical with one of the surviving examples in Valladolid, León or London. Although Juana Martínez lived in Valladolid, insufficient evidence exists to suggest it is the piece now in Valladolid.

The relief in Zaragoza is a reduced version of the composition of the other three; it does not seem to have been cut down, despite the fact that it is about 15 per cent smaller than them. This could be accounted for by postulating that it is an aftercast. If a mould had been made from one of the surviving (larger) reliefs, and clay was pressed into this, and then fired, the shrinkage caused by the firing would account for the difference in size.[24] This would also explain why the forms are less clear, because it was made at one remove. It may be contemporary with the other pieces, but it is more likely to date from a later period, after the original mould (used for the other pieces) was lost or destroyed.

The present version should be assigned to the workshop of Juan de Juni, and can be tentatively dated to the 1540s, approximately contemporary with the Salamanca relief mentioned above. It was probably a devotional object, intended to be hung in a chapel or church, or in a private house. The inscription on the frame reinforces its devotional purpose.

BIBLIOGRAPHY
Inventory 1864, p. 7.
Inventory 1852–67, p. 52.
Loan Exhibition, p. 114, no. 717.
Riaño, p. 2.
Trusted, 1993, pp. 323–7 and pl. II.

NOTES
1. Robinson Reports, Vol. 1. (Reg. no. 2931, dated 15th February, 1864).
2. I am grateful to Richard Cook for drawing my attention to this, and for his other comments on the condition of the piece.
3. The piece was cleaned in 1991 by Sarah Boulter. I am grateful to her for her comments on it.
4. Red bole is normally used as a preparatory layer for water-gilding (see introductory essay on Materials and Techniques). Samples of polychromy were analysed by Josephine Darrah; I am grateful to her for her comments.
5. The first re-paint contains at least one colour (bice) which was not generally used after the eighteenth century. The second re-paint, which is in parts thick, and of duller colours, must have been applied before the relief was acquired by the Museum in 1864.
6. A similar inscription (*Videte si est dolor sicut meus*) is under a *Pietá* on an altarpiece dedicated to St Lawrence dating from the last third of the sixteenth century formerly in the parish church of Pesquera de Ebro (Burgos), and now in the Museum of the Altarpiece in Burgos; Lázaro López, p. 71. See also cat. no. 15 in the present collection.
7. I am grateful to Stanley Eost for undertaking the infra-red photography, and to Caroline Elam and Rowan Watson for their comments on the Latin inscription.
8. Martín González has pointed this out. See Martín González, 1974, pp. 133–42 and fig. 101.
9. *Ibid.*, pp. 118–20, fig. 80.
10. Martín González, 1974, pp. 115–17, and Trusted 1993, pp. 324–5, note 22. According to Martín González (*op.cit.*, p. 378), the measurements of the relief in León are: h. 30 cm; w. 39 cm. M. Gómez-Moreno stated that the measurements were h. 31 cm; w. 40cm. (Gómez-Moreno, 1925, p. 313). The discrepancy of 1 cm in height and width must be due to manual error. Martín González gives the same measurements (30 x 39 cm) for the one in Valladolid (Martín González, 1974, p. 379). These measurements are sufficiently close to those of the London relief to suggest the pieces are actually identical in size, and apparent differences are due to manual errors of measuring. However, the measurements of the version in the Camón Aznar collection are: h. 25 cm; w. 35 cm. The measurements given by Martín González are virtually the same: h. 25 cm; w. 34 cm. (*ibid.*, p. 378). The difference must again be due to manual error in measuring a slightly irregular piece. The Camón Aznar relief was also published in *Museo Camón Aznar* 1979, unnumbered plate.
11. This is a painted terracotta relief in a wood frame (h. 22 cm; w. 33.5 cm); inv. no. 828; unpublished. I am grateful to Luis Luna Moreno and Manuel Arias for giving me access to this piece.
12. Henceforward in this entry this will be the relief called the Valladolid version, rather than the variant in the National Museum of Sculpture in the same city.
13. *Juan de Juni y su Época*, p. 51, cat. no. 2, and p. 96, pl. 2.
14. Gómez-Moreno, 1925, p. 313.
15. Martín González, 1974, pp. 115–17.
16. *Ibid.*, p. 378.
17. *Ibid.*, pp. 378 and 379.
18. The wording of the inventory is 'una echura de una ymagen de barro de medio rreliebe del descendimiento de la cruz'. This is quoted in Martí y Monso, p. 369, (cited in Martín González, 1974, p. 115). An earlier inventory dating from December 1596 to May 1597 lists '122 piezas de barro todas modelos de su mano ansi ystorias come figuras pequeñas de las por acabar'. See Fernández del Hoyo, 1991, p. 339.
19. Palomino stated: 'En la iglesia de San Martín de dicha ciudad [Valladolid] hay una historieta de barro cocido del Descendimiento de la Cruz, que le han vaciado algunos escultores por ser cosa tan peregrina.' Palomino, *El Parnaso*, p. 76, cited in Martín González, 1974, p. 115.
20. I am grateful to John Larson for this information.
21. The wood frames are not decorated in the same way: the León version is inscribed 'O mater Dei, memento mei . . .', while the Zaragoza piece is painted to imitate marble (perhaps a later re-painting). See Martín González, 1974, pp. 116–17.
22. The piece from which the mould was made is likely to have been fired in order to harden it. J. W. Mills notes, 'Although it is possible to make a piece-mould from clay it is not as precise as that taken from a hard surface.' Mills, p. 55.
23. See Martín González, 1974, p. 58.
24. I am grateful to John Larson for his comments on this.

15. THE LAMENTATION

PAINTED *PAPELÓN* (PAPIER-MACHÉ) IN PAINTED AND GILT
PINEWOOD FRAME

CASTILE; FRAME DATED 1567

Inv. no. A.100–1929

H. (with frame): 35.3 cm. H. (without frame): 26.5 cm.

W. (with frame): 28.3 cm. W. (without frame): 20 cm.

D. (with frame): 3.9 cm.

See plate 5

Provenance
Given by Dr W. L. Hildburgh F.S.A. in 1929. Bought by the
donor in San Sebastián in 1916.[1]

Condition
The figures in relief have been heavily overpainted and varnished.
There are cracks in the surface, notably below Christ's body;
woodworm holes are to be seen on the reverse. A number '4516'
(significance unknown) is inked onto the back. Four holes have been
drilled into the top of the frame for display purposes. Wax droplets
are evident on the lower part of the object, both on the relief, and
on the frame. These are almost certainly deposits from candles. The
paper used for the *papelón* seems to have been made from flax.[2]

Christ's body lies in the foreground, his left hand held by the Virgin,
with St John the Evangelist supporting the head to the right of her,
and Mary Magdalene on the left, holding her pot of ointment.
Painted onto the background are two bearded men (Nicodemus
and Joseph of Arimathaea), one holding pincers. The painted
background shows a landscape and night sky. The INRI scroll is
fixed to the top of the cross behind. The frame is inscribed with
what must be contemporary inscriptions. On the front a gilt
inscription reads: 'O VOS HOMINES / QVI TRANSITIS PER
/ VIAM ATENDITE / ET VIDETE SI ES DOLOR' (O you
men who go this way, stop and see if this is sorrow). This is taken
from the Book of Lamentations, 1, 12.[3] The letters are decorated
with tendrils, and the background is enhanced with gold designs
scratched through. The back and sides of the frame are painted
black, and on the reverse is a painted white cartouche with the
following inscription: 'ES DE / LA SE ÑO / RA TA / MAYO
1567 / [A] NOS' (It belongs to Señora Tamayo in the year 1567).

 This is the only piece of Spanish sculpture inscribed with
a date in the collection, and the inscription also exceptionally
reveals the person to whom it belonged, and perhaps for
whom it was made. Although the date could have been
added later, the style of the relief suggests it was made at
about this time (see below). The Tamayo family seem to
have been originally of Catalan origin, but the name was
widespread throughout Spain.[4] The relief was cast from a
mould, and is almost certainly from the same workshop
which produced cat. no. 16, although the reliefs differ in size,
suggesting they are not a pair. *Papelón* was used in Spain
during the sixteenth century, notably for early *pasos*
(processional groups); most no longer exist,[5] but among those

which have survived is the crucifix figure by Marcos Cabrera
(active 1575–1581) owned by the Brotherhood of the
Expiration, Seville.[6] Seventeenth-century examples made
in this material include a head of Christ in the convent of the
PP. Agustinos Filipinos in Valladolid,[7] and a crucifix in the
Convent of Portaceli, Valladolid.[8] Stylistically the present
relief is in the tradition of Castilian sculpture of the mid-
sixteenth century, and although figuratively naive, it is
distantly related to works such as the relief of the *Lamentation*
of about 1540 by Juan de Juni (*c.* 1507–1577) on the tomb of
Gutierre de Castro in the Old Cathedral of Salamanca.[9]

NOTES
1. On the back of cat. no. 16 (a pendant to the present piece),
a label states that it was bought in San Sebastián in 1916; it is
practically certain this piece was also obtained at the same time.
2. I am grateful to Richard Cook for his comments on this.
3. Cf the inscription on the frame of the terracotta relief by
Juan de Juni (cat. no. 14).
4. See de Atienza, p. 1231. I am most grateful to John
Meriton for his help in tracing references to the family.
5. Agapito y Revilla 1926, pp. 4–7; Trusted 1995. The *paso* of
Christ's Entry into Jerusalem in the church of the True Cross in
Valladolid is of papier-maché (García Chico 1962, pl. VI).
6. T. Gómez, R. Cruz and I. Poza, 'The Conservation and
Restoration of a Processional Image: The Christ of the
Expiration' in *Madrid Congress* 1992, pp. 57–61 and pl. 16.
7. *Pedro de Mena*, p. 26, no. 3.
8. *Arte en las Clausuras*, no. 29.
9. Martín González 1974, p. 137, fig. 101. Cf also cat. no. 14.

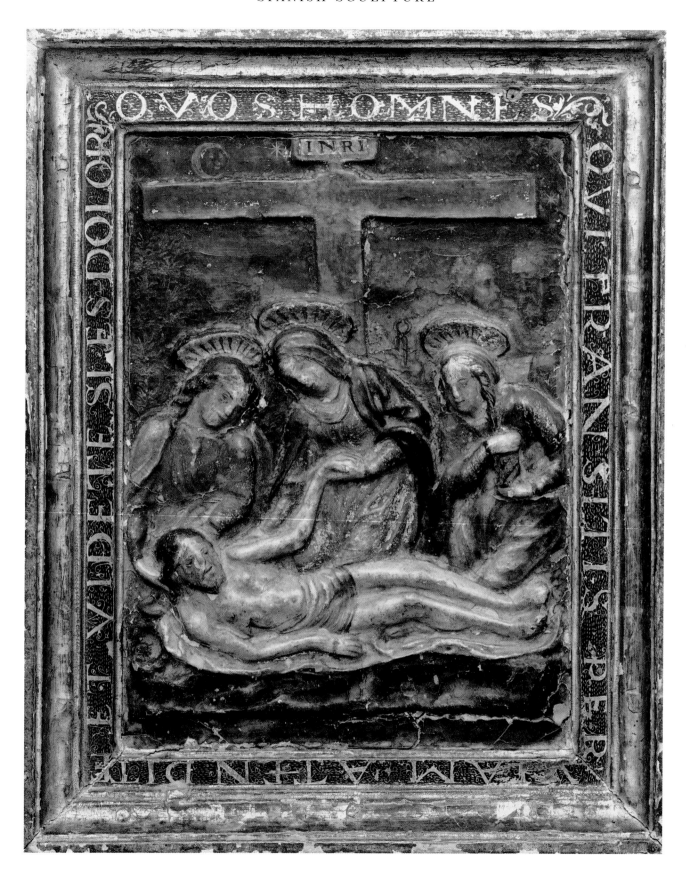

16. THE CRUCIFIXION

PAINTED *PAPELÓN* (PAPIER-MACHÉ) IN LATER PINEWOOD
FRAME

CASTILE; about 1567

Inv. no. A.101–1929

H. (with frame): 36.1 cm. H. (without frame): 30.6 cm.

W. (with frame): 29.2 cm. W. (without frame): 23.8 cm.

D. (with frame): 3.4 cm.

Provenance
Given by Dr W. L. Hildburgh F.S.A. in 1929. Bought by the
donor in San Sebastián in 1916.

Condition
The frame is later (probably nineteenth century). The relief has
been overpainted, and the nail heads holding it to the wood
backing are visible. Surface cracks are evident on Christ's halo,
and at the base of the cross. Woodworm holes are to be seen on
the reverse. A label on the back written by Dr Hildburgh states:
'Framed papier-maché. Crucifixion. San Sebastian '16'.

Christ is suspended on the cross, with the Virgin on the
left, and St John the Evangelist on the right. At the foot
of the cross is a skull and bones.

This relief was cast from a mould, and is from the
same workshop as cat. no. 15, whose frame is dated
1567, which gives a probable date for the present work.
Stylistically, this piece is in the tradition of Castilian
sculpture of the mid-sixteenth century, and although
relatively crude and on a much smaller scale, it is
related to works such as the crucifixion group of about
1544 by Francisco Giralte (1490/1500–1576) on the
high altar of Villabrágima (Valladolid).[1] The twisting
pose of St John can also be compared with the work of
Juan de Juni (c. 1507–1577).[2]

NOTES
1. Parrado del Olmo *Palencia* 1981, p. 91 and pl. XXX,
fig. 78.
2. Cf the figure of St John from the *Crucifixion* by Juni in the
chapel of the Palace of the Marquis of Espeja, Ciudad Rodrigo;
Juan de Juni y su Epoca, p. 104, pl. 10.

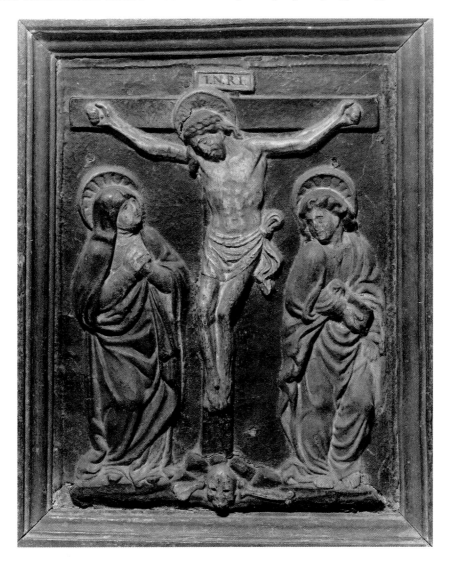

17. THE ENTOMBMENT

OAK

STYLE OF MANUEL ALVAREZ (C.1517–1587/9)

CASTILE; about 1550–80

Inv. no. 414–1887

H. 30.8 cm. W. 38.8 cm. D. 3.4 cm.

Provenance
Bought from Mr C. Coleman (33 via Margutta, Rome) in 1887 for £14.

Condition
Almost all of the polychromy and gilding has been lost on this piece, although some survives on the moulding of the integral frame, and the darkened white ground is visible in some of the crevices of the carving. Christ's right thumb is missing, and there are two small holes, one in the upper right, near a tree, and the other behind the Virgin's head on her left. There are minor chips and losses on the frame. Three pairs of holes have been drilled through on the back, probably for mirror-plates. Two pairs of interconnecting holes have been drilled through in the centre at the top and back, also doubtless for fixing

purposes, and their larger size and more used appearance suggests they are possibly slightly earlier than the other ones. The back of the frame is painted black.

Christ is supported at his head by a beardless youth (St John the Evangelist), and at his feet by a figure in swirling drapery and a turban (probably Joseph of Arimathaea). In the centre the Virgin clasps her hands in sorrow. The background shows a stylised landscape consisting of a few trees and buildings. The moulding of the sarcophagus is visible at the bottom of the composition. The anatomical proportions of the figures are disjointed, particularly the standing figure of St John, and the angle of Christ's head as it rests on his chest. The haloes of Christ and the Virgin are carved as elliptical discs in high relief. These apparent distortions imply that the relief was intended to be seen from below.

Although the relief was described as 'Flemish, late 16th century' when first acquired, the facial features and drapery suggest that it is Castilian, and that it

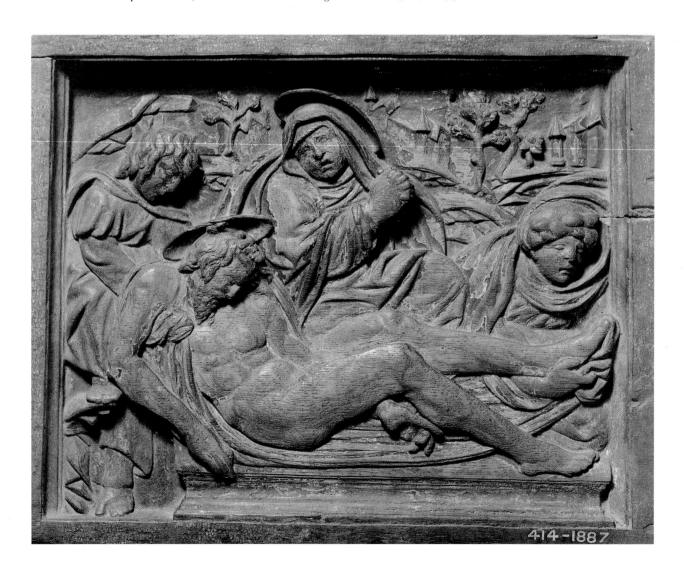

52

dates from slightly earlier in the sixteenth century. It is distantly reminiscent of the work of Juan de Juni (c. 1507–1577), such as his more sophisticated version of the same subject in Segovia Cathedral, dated 1571.[1] It is closer still to the relief of the *Lamentation* on the altarpiece from Berceruelo (Valladolid), now in the Diocesan Museum, Valladolid.[2] This has been recently established as the work of Manuel Alvarez (c. 1517–1587/9), and dates from 1576.[3] Alvarez was active in Palencia and Valladolid, and collaborated with Alonso Berruguete (c. 1489–1561), as well as being closely associated with Francisco Giralte (c. 1490/1500–1576), whose sister he married.[4] Although Alvarez's sculpture is comparable, the loss of polychromy in the present piece, accentuating the crudity of the carving, means that it is difficult to attribute precisely. The integral frame, as well as the scale and proportions of the relief suggest it is a devotional panel, probably for a domestic context, rather than having formed part of an altarpiece. It may be comparable in function with the terracotta relief by Juan de Juni in the present collection (cat. no. 14).

NOTES
1. Martín González 1974, p. 280, pl. 252.
2. Parrado del Olmo, *Palencia*, pl. LXXXV, fig. 225.
3. *Ibid.*, pp. 233–4.
4. *Ibid.*, pp. 195–207.

18. THE LAMENTATION

PAINTED AND GILT PINEWOOD

CASTILE (TOLEDO); about 1560–70

Inv. no. 106–1864

H. 30.9 cm. W. 74.8 cm. D. 1 cm.

See plate 6

Provenance
Bought by John Charles Robinson from Vincente de Pablo, Toledo for £3 3s 2d. (Transferred from the Woodwork Department in 1963).

Condition
Holes on the edge of the frame indicate that this object was at one time fixed to something, probably the framework of an altarpiece (see below). A horizontal crack on the left runs through the figure of Nicodemus, and elsewhere the paint has flaked in parts, for example on Christ's left leg, and on the Magdalene's left arm and hand. One arm of the pincers held by Nicodemus is broken off, and the hand of the Mary standing behind the Virgin is damaged, but otherwise the piece is in good condition. On the back a pine infill has been set in to cover what was probably a natural fault in the timber; this is likely to have been done at the time the piece was carved. A round knot of wood is also visible at the back. An irregular painted red line round the edge of the frame may be the remains of painting from an outer frame which is no longer present.[1] The holes round the edge would also have been concealed behind this frame. Two nails and the

remains of wire survive on the upper back of the frame; these seem to be connected with two holes filled with wire at the top. This must have been a later fixing. At the top and bottom right corners of the frame are stuck small fragments of coloured material; these could be the remains of cloth used to hold the frame as it was being given a wax or varnish layer.[2]

The relief has an integral bevelled frame. In the centre the dead Christ is supported by the Virgin and St John. One of the Holy Women is in the background. To the right are St Mary Magdalene, kneeling, and another Mary. Standing separately at either end of the composition are (left) Nicodemus, holding pincers, and (right) Joseph of Arimathaea, holding the crown of thorns and the shroud. The figures are set on a rocky ground, which protrudes into the frame at the sides, as do the heads at the top. This piece displays its original polychromy, although the colours have faded and changed tonally, probably due to surface dirt, as well as varnish and wax being applied as a protective layer. The technique of *esgrafiado*, the application of gold under colour, which is then scratched through, has been employed over much of the surface.[3] The gold is revealed in different patterns on the drapery and rocky background, while elsewhere, notably in the flesh areas, it lies beneath, giving depth and luminosity to the colour.

When published in 1911, this relief was described as 'portion of a predella. Painted. Spanish. Seventeenth century.'[4] The size and shape suggest that the original function must indeed have been as part of a predella, but the style of carving implies an earlier date than the seventeenth century. Numerous parallels exist in Castile dating from the mid-sixteenth century, particularly in Valladolid, Ávila and Toledo.[5] The figures ultimately recall the work of Alonso Berruguete (c. 1489–1561) (cf cat. no. 11).

A relief of the *Descent from the Cross* now in the Diocesan Museum in Valladolid is related to the present piece.[6] This is attributed to a follower of Berruguete, Isidro de Villoldo (active 1538–d. before 1556). Villoldo was strongly influenced not only by Berruguete but by the most important sculptor active in Ávila in the early sixteenth century, Vasco de la Zarza (active 1508–1524).[7] The profiles of the faces and thick drapery folds are similar in Villoldo's relief and cat. no. 18, although the one in Valladolid is much larger than the present work,[8] and lacks a frame. In addition, the composition is denser, and the figures less Italianate, and the polychromy is markedly different in treatment, the relief in Valladolid exhibiting more surface design than the present piece.

The strong Italianate elements of cat. no. 18, seen most notably in the figure of Christ,[9] and the twisting pose of the kneeling Magdalene imply that this relief comes from the circle of sculptors a generation or more younger than Berruguete, known as Romanists, so-

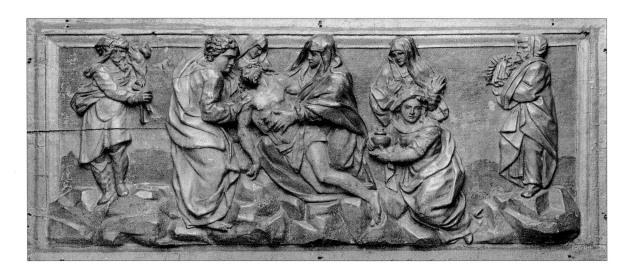

called because they perpetrated a style even more indebted to the High Renaissance in Rome, particularly the work of Michelangelo. This circle included most notably the painter and sculptor Gaspar Becerra (1520–1568), who had worked on frescoes in Rome with Vasari, Daniele da Volterra and others; on his return to Spain he was active as a sculptor in Madrid, Toledo and elsewhere in Castile.[10] His altarpiece at Astorga of 1558–62 is a major example of the classicising style brought to Spain in the second half of the sixteenth century.[11] Certain figures on the reliefs of this altarpiece are analogous to those on the present predella.[12]

The provenance of cat. no. 18 suggests that it is likely to have been executed in Toledo, where a number of important sculptural commissions by Villoldo, Becerra, and others were undertaken following Berruguete's and Felipe Vigarny's activity in Toledo Cathedral in the 1530s.[13] The most important sculptors there during the 1550s and 1560s were Juan Bautista Vázquez el Viejo (c. 1525–1588), and his collaborator Nicolás de Vergara el Viejo (active before 1542–d.1574).[14] The angular drapery seen in cat. no. 18 is analogous to work attributed to Vergara, such as his relief of the *Virgin and Child with St Anne* in the Chapel of St Anne, Toledo Cathedral,[15] or the *St John* in the chapel of St Gil, also in Toledo Cathedral.[16]

Although it is not possible to attribute the present relief to a named sculptor, it is likely to have been executed in Toledo around 1560–70 by a sculptor in the circle of Vergara, following in the wake of Becerra and Vázquez.

BIBLIOGRAPHY

Inventory 1864, p. 9.
Inventory 1852–67, p. 53.
Riaño, p. 6.
Loan Exhibition, p. 123, no.785.
Maskell, plate XXXIII, fig. 2.

NOTES

1. I am grateful to Richard Cook for suggesting this.
2. I am grateful to Hannah Eastwood for pointing this out.
3. See Introductory essay on Materials and Techniques.
4. Maskell, *loc.cit.* in the bibliography for this entry. A subsequent note in the Museum records suggests an attribution to Pedro de la Cuadra (active 1589–1629) (cf cat. no. 19), but this is not sustainable stylistically.
5. A comparative example in Ávila is a relief of the *Lamentation* in the Museum of Ávila Cathedral attributed to Pedro de Salamanca (active 1532–d. 1569/71); Parrado del Olmo *Ávila* 1981, pl. XCIII, fig. 178. A relief of the *Adoration of the Shepherds* showing similar stylistic features was auctioned at Sotheby's Zurich in 1994 (June 1, 1994, lot 283); the piece was unattributed, and no provenance given.
6. It was previously ascribed to Francisco de la Maza (active 1567–d. 1585). See Martín González, 1971, p. 320; Parrado del Olmo *Ávila* 1981, pl. LXVIII, fig. 123; *Escultura en Valladolid*, (unnumbered pages); and *Escultura en Castilla*, pp. 64–7.
7. For Isidro de Villoldo, see Gómez-Moreno 1942, and Parrado del Olmo *Ávila* 1981, pp. 195–233.
8. It measures 68 cm by 96 cm.
9. Cf for example the figure of Christ in the *Lamentation* of 1559 by Jacopo Tintoretto in the Accademia, Venice; Pugliatti, fig. 61.
10. See *ibid.*, fig. 98 and figs. 118–20 for examples of Becerra's frescoes.
11. I am grateful to David Davies and Carmen Fracchia for discussing this piece at length with me, and in particular for suggesting the stylistic connections of this piece with the work of Becerra and Vergara. For Becerra's altarpiece see Velado Graña. See also the entry for cat. no. 57.
12. The Virgin in the *Pentecost* relief has a similar twisting pose to the Magdalene in cat. no. 18 (Velado Graña, p. 34); a man leaning on a staff in *Christ among the Doctors* recalls the figure of Nicodemus in cat. no. 18 (*ibid.*, p. 30); the face of the Magdalene here is related to that of the midwife holding the infant Virgin in *The Birth of the Virgin* (*ibid.*, p. 16).
13. Villoldo had also worked in Toledo with Vázquez, and Villoldo's widow requested Juan Bautista Vázquez el Viejo (see below) to finish some incomplete commissions after his death in 1558; Estella Marcos 1990, p. 31.
14. See Estella Marcos 1990 for a discussion of the work of both artists.
15. *Ibid.*, pl. LXXXV, fig. 115.
16. *Ibid.*, pl. LXXV, fig. 100.

PEDRO DE LA CUADRA

(active Valladolid 1589–d. Valladolid 1629)

Pedro de la Cuadra was active in Valladolid at the same time as Gregorio Fernández (*c.* 1576–1636), and his later output shows his indebtedness to the more renowned sculptor. But his style also reflects the mannerism of the late sixteenth century, in particular the work of Adrián Alvarez (active 1591–1599), with whom he collaborated in Valladolid. He had also worked with Francisco de Rincón (*c.* 1567–1608), who probably taught Fernández, on an altarpiece for the hospital of Simón Ruiz in Medina del Campo in 1597. Pedro de la Cuadra specialised in wood reliefs and figures for altarpieces, and funeral effigies; he also executed two processional figures (*pasos*) for Grajal de Campos (León) in about 1623. The facial types of his figures tend to be heavy-featured, and the thick curly hair recalls the work of one of his predecessors in Valladolid, Esteban Jordán (*c.* 1529–1598). Much of his work is in Valladolid, and a number of reliefs are in the National Museum of Sculpture.

BIBLIOGRAPHY

Ars Hispaniae XIII, p. 292; Martín González 1959, pp. 251–6; García Chico 1960; Martín González 1980, pp. 79–80; *ibid.* 1983, p. 69.

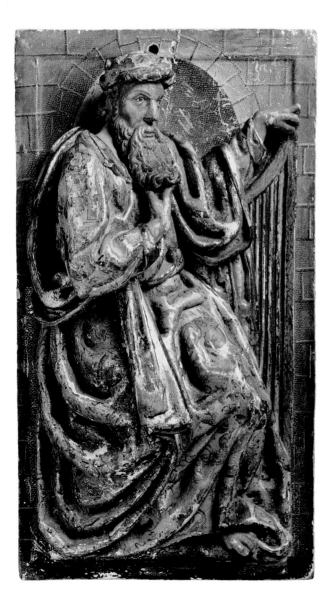

19. KING DAVID

PAINTED AND GILT WALNUT
BY PEDRO DE LA CUADRA
VALLADOLID; about 1590–1610
Inv. no. A.70–1923
H. 34.9 cm. W. 19.4 cm. D. 10 cm.
See plate 7

Provenance
Given by Dr W. L. Hildburgh F.S.A. in 1923. Purchased by the donor in Burgos in 1921.

Condition
The piece has two vertical cracks coming down from the top, one in the centre, and one on the right. Some of the paint has flaked in places, and the underlying white ground is visible. Some re-touching of the polychromy has occurred on the face and hands, and on the beard and hair. A hole has been drilled at the top near the head of the figure, and a smaller hole next to it has been partly drilled; these may have been made at a comparatively recent date, when the piece was removed from its original context. Faint numbers are painted on the painted stone archway: 3a, 4c. These may refer to the positioning of the panel on an altarpiece. On the back of the panel is a label reading: 'Polychromed wood relief. King David. Burgos '21.'

King David is depicted bearded, wearing a crown over a headdress. He is seated, resting his left hand on his harp, while his right hand fingers his long grey beard. His left bare foot is visible beneath his green robe, resting on a cushion. His robe is richly decorated with polychromed foliate designs. A stone archway is painted behind, flecked with gold. The gold flecks do not extend to the edge of the relief, and a border of approximately 1 cm is less elaborately painted,

indicating that the piece may have been framed, perhaps in its original context as part of an altarpiece.

The swirling drapery and heavy forms of the body visible beneath the robe suggest that it dates from the late sixteenth or early seventeenth century, and comes from Castile; the place of purchase suggests that it could be from Burgos. The facial type, along with the stylised flowers of the robe and the flecks of gold on the archway strongly recall the work of Pedro de la Cuadra, for example his reliefs of the *Redemption of the Captives by St Peter Nolasco* and *St Peter Nolasco* of about 1599, formerly on the high altarpiece of the monastery of the Merced Calzada in Valladolid, and now in the National Museum of Sculpture in Valladolid.[1] The present relief was probably originally part of an altarpiece, perhaps forming one side of a tabernacle.[2]

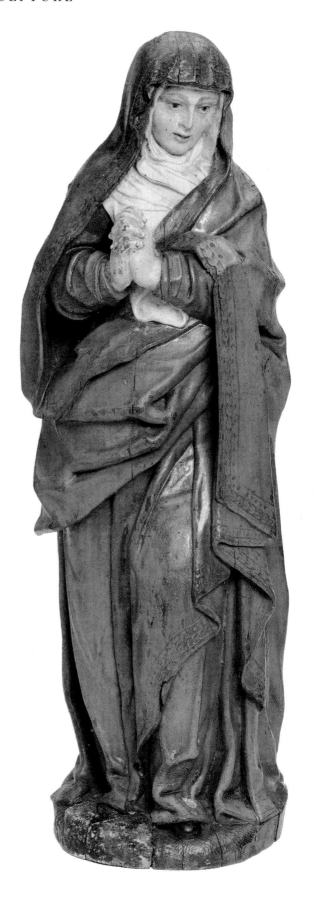

NOTES
1. García Chico 1960, pp. 24–5 and pls. 15 and 17. I am most grateful to Luis Luna Moreno for suggesting the relief had affinities with the work of Pedro de la Cuadra.
2. Cf the tabernacle of the late sixteenth-century altarpiece dedicated to St Clement Pope and Martyr, formerly in Huidobro (Burgos), and now in the Museum of the Altarpiece, Burgos; see Lázaro López, pp. 64–6. In the present piece the depiction of an Old Testament figure may preclude this, as normally Evangelists or angels are represented on tabernacles (I am grateful to David Davies for raising this question).

20. THE MOURNING VIRGIN

PAINTED WALNUT

CASTILE; about 1600–1630

Inv. no. A.40–1951

H. 38.7 cm.

Provenance
Given by Dr W. L. Hildburgh F. S.A. in 1951; purchased by the donor in Madrid in 1921.[1]

Condition
The paint is relatively recent, and probably dates from the nineteenth century; some of this paint is chipped, and remains of varnish are visible. The wood is in good condition, with no visible damage.

The Virgin stands with her hands clasped, looking down towards her left. She rests on her right foot, and steps forward with her left. She wears a blue cloak with a punched border over a red robe, and a white wimple. She stands on a circular base, painted to simulate grassy ground.

The figure must come from a crucifixion group, and

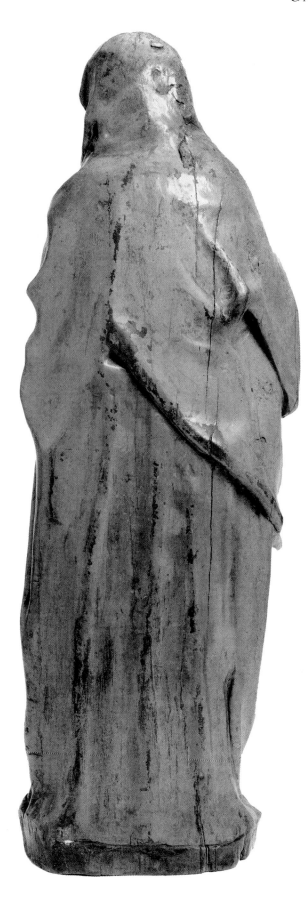

in style recalls Castilian sculpture of the late sixteenth or early seventeenth century. The later paint means that it is more difficult to ascertain the date of the carving. The facial features and drapery folds are reminiscent of the work of the Castilian sculptor Juan Bautista Vázquez el Viejo (1525–1588), for example the *Mourning Virgin* of 1554–5 from the altarpiece formerly in Almonacid de Zorita (Guadalajara) and now in the Colegiata at Torrelaguna (Madrid).[2] The clasped hands and columnar pose parallel another mid-sixteenth-century figure also of the *Mourning Virgin* recently on the Spanish art market.[3] However the sweetness of the face implies it must be considerably later than this date, while the shape of the body and the lack of movement in the drapery suggest that it cannot have been executed later than the first third of the seventeenth century.

NOTES

1. A label on the bottom of the piece is inscribed in Dr Hildburgh's handwriting: 'Painted Wood Figure of Virgin Mary. Madrid '21'.
2. Estella Marcos 1990, pl. II, fig. 2.
3. Owned by Luis Elvira Anticuario, Castellón in 1990. This figure is also slightly earlier than cat. no. 20; it was catalogued as Valladolid, second third of the sixteenth century. See *Luis Elvira*, pp. 108–9, cat. no. 6.

GREGORIO FERNÁNDEZ (HERNÁNDEZ)

(b. Sarria (Lugo) c. 1576; d. Valladolid 1636)

Gregorio Fernández was the leading Castilian sculptor of the first half of the seventeenth century. First recorded in Valladolid in 1605, he was to spend the whole of his working life there. Initially he collaborated with, and probably trained under the Valladolid sculptor Francisco de Rincón (*c.* 1567–1608); he was also influenced by the work of his sixteenth-century predecessor in the city Juan de Juni (*c.* 1507–1577), and by the effigies of the Duke and Duchess of Lerma by Pompeo Leoni (b. *c.* 1530–d. 1608), who was in Valladolid in 1601. Fernández specialised in carving wood figures and reliefs for altarpieces, as well as processional groups (*pasos*). He neither painted them, nor did he design the architectural framework of the altarpieces; these tasks were carried out by other workshops. Although some of his figures incorporate illusionistic additions such as eyelashes, fingernails made from horn, and cork imitating congealed blood, the drapery is often relatively plain and unpatterned, and the paint surface always matt. He established a number of influential iconographic types which came to be much imitated during the seventeenth century, such as his *Dead Christ on a Bier* (see below), his *Christ at the Column* (see below), and the *Virgin of the Immaculate Conception* (see cat. no. 80). Most of his works were made for churches in Castile, and particularly Valladolid, where they are to be seen today.

BIBLIOGRAPHY

Palomino *Lives*, pp. 70–3; Ceán Bermúdez II, pp. 263–71; Martín González 1980; *Fernández*.

21. THE DEAD CHRIST ON A BIER

PAINTED AND GILT LIMEWOOD ON LATER CONIFER SOCLE
AFTER GREGORIO FERNÁNDEZ
CASTILE; about 1630–50
Inv. no. 167–1864
H. 5.8 cm (without socle). W. 7 cm (without socle). L. 22.5 cm (without socle).

Provenance
Bought for £1 7s. in 1863 by John Charles Robinson from don José Calcerrada in Madrid.

Condition
The polychromy seems to be original in some areas, although the thick dark paint on the hair and beard is probably later, perhaps covering a lighter brown tone. The eyebrows have also been re-painted. Some flaking of the paint is apparent, and the nipples have slightly lifted off, perhaps because they seem to be formed of pins painted over. The gold decoration of the coverings of the bier is rubbed in places, revealing the underlying red bole. The sides of the bier have been re-painted with uneven wavy red lines, perhaps shortly before the time of acquisition. The whole is set into a modern socle, perhaps to conceal damage to the base. As it is firmly fixed (probably glued) it is not possible to investigate this further.

The dead figure of Christ, with closed eyes, lies on a bier, resting his head on two pillows. His left hand holds some of the cloth on which he is lying over his groin. His right hand lies at his side. His hips are twisted so that his legs turn to his right, his slightly bent left leg over his right. His head leans on his right shoulder. The stigmata on his right hand and right foot respectively are holes partly drilled, as is the navel and the wound in his side.

The life-size sculpted image of the dead Christ on the bier was known throughout Spain in the seventeenth and eighteenth century, and seems to have originated during the sixteenth century.[1] Like the processional groups, such images would be venerated during Holy Week (although not always taken out through the streets).[2] The almost doll-like facial features of this piece recall eighteenth-century images in Valencia,[3] but the figure is more reminiscent of the larger life-size pieces by the Castilian sculptor Gregorio Fernández, who popularised the type.[4] Although Fernández' figures are of higher quality both in their carving and their polychromy than the present diminutive version, they share a similarity of pose. The relevant works by Fernández in the National Museum of Sculpture in Valladolid (see fig. 8) and in the Convent of the Capuchinos of El Pardo in Madrid provide particularly close parallels.[5] His figures were sometimes reproduced in reduced forms, such as the series of six scenes from the Passion in glazed cases (*escaparates*) in the Convent of St Teresa in Valladolid; the sixth of these shows a recumbent Christ similar to cat. no. 21.[6] The provenance of the present carving suggests that it is likely to come from Castile, as do its similarities in style with the works by Fernández, which also indicates that it dates from approximately the second third of the seventeenth century. It probably served as a private devotional piece.

58

Figure 8. Dead Christ on the Bier. *Polychromed wood. By Gregorio Fernández. Museo Nacional de Escultura (Valladolid). Ministerio de Cultura.*

BIBLIOGRAPHY

Inventory 1864, p. 14.
Inventory 1852–67, p. 70.
Riaño, p. 7.
Loan Exhibition, p. 125, no. 802.

NOTES

1. Martín González, 1983, p. 62. Cf the reliquary figure attributed to Gaspar Becerra (*c.* 1520–70) in the Monastery of the Descalzas Reales, Madrid (*Ars Hispaniae*, XIII, fig. 151 and p. 174, and Checa 1983, p. 235, fig. 193).
2. See Igual Ubeda, pp. 11–2, where the liturgical functions of Valencian examples are discussed.
3. See the unattributed image in the church of Santo Domingo, perhaps associated with Juan Bautista Balaguer or his follower Francisco Vergara. *Ibid.*, pl. 15. See also the image by Ignazio Vergara (1715–1776) of *c.* 1750 in Valencia Cathedral (Igual Ubeda and Morote Chapa, pls. XXIX–XXX and p. 23).
4. Martín González, 1983, p. 62. For a slightly later example of this type, cf the figure by Juan Sánchez Barba (1615–1670) in the church of the Carmen, Madrid (*Ars Hispaniae* XVI, pp. 318–19 and p. 321, figs. 287 and 288).
5. See Martín González, 1980, figs. 155–72. See also Urrea Fernández, 1972.
6. *Pequeñas Imágenes*, pp. 16–17, cat. no. 6. See also *ibid.*, pp. 63–7 for analogous pieces elsewhere in Valladolid.

22. STANDING CHRIST (CHRIST AT THE COLUMN)

BOXWOOD

CASTILE; about 1680–1710

Inv. no. A.95–1911

H. (including base): 40 cm.

Provenance

Bought from Mirza Khan of 1 Coptic Street Bloomsbury London in 1911 for £20.[1]

Condition

When this piece was acquired, Eric Maclagan of the Department of Architecture and Sculpture, noted that the figure was 'at present covered with a thin coat of paint'.[2] Remains of cream paint are to be seen in certain areas, notably on the inner folds of the loin cloth, under the right arm, and on the face and hair; the drops of paint on the face resemble tears. The whole figure is covered with more than one layer of darkened varnish, which is damaged in places, and seems to have been applied over the remains of the paint. This varnish may even be the 'thin coat of paint' noted by Maclagan. Filler has been applied to the left wrist, and the drapery of the loin cloth extending from the right hip has been broken off and re-fixed. A crack runs down the centre of the torso. The wrists have been broken and repaired, as have the left forearm and thumb. The circular base is broken at one edge, where presumably the column would have stood; a rubbed mark on the surface of the base indicates where part of it would have been fixed. Two filled holes in the base may have been used to hold the original block of wood steady when the sculptor was working on the carving; [3] alternatively they may simply indicate where it was attached to a socle. The Museum photograph of 1947 (illustrated here) shows the figure set upon a stone pillar, from which it has since been removed.

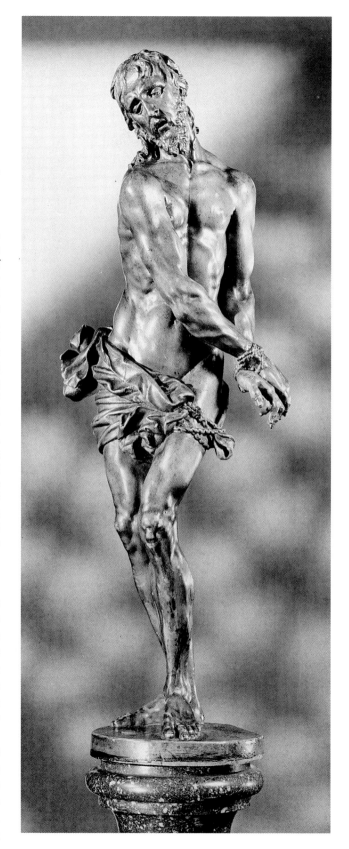

Christ stands with his hands bound and held out to his left, his torso twisted round, looking downwards to his right. The teeth and tongue are carved within the mouth, and the pupils of the eyes are shown. He steps forward slightly on his left foot, resting on his right foot. His wrists are bound with twisted rope, and he wears a loosely tied loincloth. As noted above, the composition would have almost certainly originally included a column.

The subject of *Christ at the Column* (as opposed to *The Flagellation*, when Christ is shown with flagellants) was represented relatively frequently in Spain during the seventeenth century following the Counter-Reformation.[4] The low column seems to have been introduced into the iconography of the subject following the discovery of the supposed original column in Rome.[5] The pose of the present figure is ultimately derived from the work of Gregorio Fernández (*c.* 1576–1636), who executed a number of

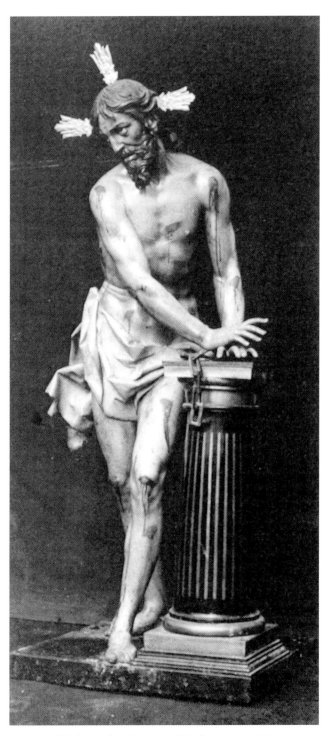

Figure 9. Christ at the Column. *Polychromed wood. By Gregorio Fernández. Church of the True Cross, Valladolid.*

versions, and whose sculpture was widely imitated during the seventeenth century.[6] It recalls in particular the life-size figure of *Christ at the Column* by Fernández in the church of the True Cross in Valladolid (see fig. 9).[7] A smaller version of the same subject (h. 53 cm) by Fernández exists in the convent of St Teresa in Valladolid.[8] However the agitated drapery, elongated Italianate body and facial features of cat. no. 22 preclude the attribution to Fernández himself, and suggest a date towards the end of the seventeenth century or early eighteenth century. Broadly comparable is the work of Bernardo Pérez de Robles of Salamanca (*c.* 1610–1683), such as his *Crucified Christ*, known as the *Cristo de la Agonía* of 1671 in the church of the Capuchins, Salamanca.[9] Also stylistically similar is the sculpture of Nicolás de Bussy (active 1676–1706), such as the face of his *Christ of Blood* (*Cristo de la Sangre*) in the church of the Carmen, Murcia.[10] The sculptor of the present figure was probably Castilian, working at the end of the seventeenth century or perhaps during the early eighteenth century.

NOTES

1. Eric Maclagan recorded in a minute of 14 November 1911 that the vendor 'has now, under protest, reduced the price from £35 to £20'. Museum records Registered Papers 11/4491M.

2. Museum records *Ibid.*.

3. I am grateful to Richard Cook for this suggestion.

4. One of St Teresa's visions was of Christ tied to the column (Martín González 1980, p. 167).

5. Mâle, pp. 265–6 and Martín González 1980, *loc.cit.*; see also *Pequeñas Imágenes*, pp. 19–23. Cf an anonymous Spanish drawing of the first half of the seventeenth century of the *Agrippine Sibyl* now in the Uffizi. She is shown holding a picture of Christ bound to a low column with two flagellants (Angulo and Pérez Sánchez II, p. 63, no. 350 and pl. LXXXVIII).

6. See Martín González, 1980, pp. 167–73 and plates 117–23. The six figures by Fernández discussed by Martín González of varying sizes and dates, are all larger than the present piece, and are thought to range in date from about 1610–12 to about 1636. For examples deriving from the work of Fernández, see the two figures of *Christ at the Column* in the church of the Angustias, Valladolid (Martín González *Castellana* 1959, p. 239, figs. 166 and 167), and the figure at La Vid, Burgos (Martín González *Castellana*, 1971, p. 191, fig. 240). For further examples scc *Pequeñas Imágenes*, pp. 26–35.

7. Martín González 1980, pl. 119. This figure was also used as a processional *paso* figure. See Trusted 1995, p. 63, fig. 6 and p. 64.

8. Martín González 1980, pp. 168–9, pl. 118.

9. Rodríguez Ceballos 1971, pl. I. I am grateful to Luis Luna Moreno for suggesting Pérez de Robles as a possible comparison.

10. Sánchez-Rojas Fenoll, p. 58, fig. 12 and p. 61.

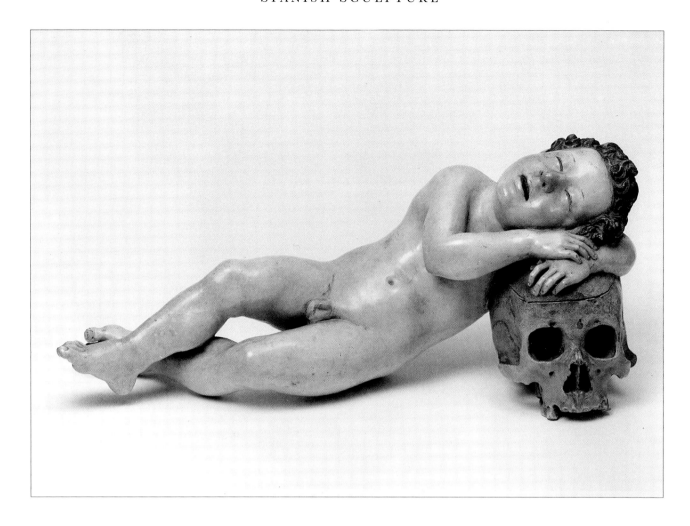

23. CHILD WITH A SKULL (THE CHRIST CHILD)

POLYCHROMED AND GILT LIMEWOOD OR POPLAR

CASTILE (VALLADOLID?); about 1650–1700

Inv. no. A.103–1929

H. 16 cm. W. 11.5 cm. L. 34 cm.

Provenance
Given by Dr W. L. Hildburgh F.S.A. in 1929. Acquired by the donor in San Sebastián in 1920.

Condition
The polychromy seems to be largely original, although there are signs of slight re-touching on the left buttock and the feet, and perhaps on the hair. White ground is visible on the left elbow, and three depressions in the paint on the left leg must indicate where the figure rested while the paint was still wet. Similarly, an imprint visible on the right knee is perhaps the result of the figure having been placed on some canvas before the paint had dried. A hole drilled into the left buttock implies the figure was once fixed to something (see below). A slight crack on the skull has been filled in.

The figure lies naked, resting his head on both hands, the right crossed over the left, and with his left leg bent back under his right. The head is disproportionately large for the body, which is comparatively slender. The hair is tightly curled, and the mouth half-open, with the teeth visible. Although the child is shown asleep, the facial expression is half-smiling. The skull on which he rests is much larger than his own head.

The two most significant elements of the present composition are the portrayal of the child sleeping, and the inclusion of a skull, both of these suggesting the presage of death. The child with a skull derives ultimately from the composition by the Venetian medallist Giovanni Boldù on the reverse of a medal dated 1458.[1] It was repeated in slightly different forms in Italian, Netherlandish and German prints, paintings and sculpture during the sixteenth and seventeenth century, notably in an engraving by Hendrik Goltzius of 1594.[2] As pointed out in the works cited, the sleeping child with a skull is similar to images of the Christ child sleeping on the cross, also often shown with a skull. In some representations an hour-glass is

62

additionally present, the image clearly being a *memento mori*.

The Child sleeping without a skull is often seen in Spanish and Portuguese ivories of the seventeenth century, and in colonial sculpture from the Iberian peninsula of the same date.[3] The image of a sleeping child has antique precedents, in the form of sleeping cupids, which probably also underlie the present composition. Two antique Roman marble sleeping cupids in the Uffizi may be related to what is likely to be a sixteenth-century Italian version of the subject sometimes associated with Michelangelo; these or other antique or later versions could well have been known in Spain by the seventeenth century, if not before.[4]

The cult of the Christ child was widespread in Spain and elsewhere in Europe during the seventeenth century, and both sculptural and painted images abound.[5] The Christ child sleeping on a skull suggests a foreshadowing of the Passion, and representations of this were objects of pious meditation, as the seventeenth-century commentator Fray Juan Interián de Ayala remarked.[6] The 1700 inventory of the Alcázar in Madrid lists two sculptures of the Christ child in a glass case, one with a skull: 'un niño dormido sobre una muerte';[7] four statuettes of the Christ child (although not necessarily sleeping) were in the collection of the Duke of Lerma (1553–1625).[8] Five figures of the sleeping Christ child are in the Convento de las Descalzas Reales in Madrid, three of these with a skull and lying on the cross, and two with just a skull (although the crosses may have been lost).[9] A figure attributed to Pablo de Rojas (active Granada 1580–1607) is in a private collection in Granada.[10] A comparable seventeenth-century standing figure of a Christ child leaning his elbow on a skull is in the parish church of St Ursula, Tenerife.[11]

The hole in the present figure suggests it was set onto a base. Although this might have been a simple socle, it could also be evidence of its having once been fixed to a cross placed on a socle. Although as indicated above, the subject was popular throughout Spain during the seventeenth century, the form of the body is reminiscent of seventeenth-century Castilian

sculpture. A figure of similar proportions thought to date from *c.* 1600 is in the Ermita del Ecce Homo, Arrabal de Portillo (Valladolid).[12] Others are known in Valladolid.[13] The present piece was probably made in Castile (perhaps Valladolid) during the second half of the seventeenth century.

NOTES
1. Hill, I, p. 111, no. 421 and II, pl. 80. See Seznec.
2. See Janson and Wittkower, although unfortunately neither article discusses Spanish examples. See also LCI, 2, pp. 405–6, and Sebastián, pp. 327–9; I am grateful to David Davies for this last reference, and for his general comments on this entry.
3. Estella Marcos 1984, II, pp. 229–39, cat. nos. 504–32. Cf also *Expansao Portuguesa*, pp. 91–4, figs. 219–32 and Luso-Oriental, pp. 78–9, nos. 104–7. An analogous ivory figure is in the Victoria and Albert Museum, inv. no. A.16–1922 (Longhurst II, p. 113). Another (with a decorative bed) is in the Indian Collection of the Museum (inv. no. IM16–1915) (unpublished). For colonial art in Goa generally, see the essay by K. S. Desai in Doshi, pp. 77–88. I am grateful to John Guy for this reference, and for alerting me to the ivory figure in the Indian collection.
4. A sheet of three seventeenth-century drawings of this composition also exists in an album in the Royal Library at Windsor. The marble associated with Michelangelo is at Corsham Court, Wiltshire; the antique examples are in the Uffizi, Florence. See Bober and Rubinstein, p. 89, no. 51 and figs. 51 and 51a. See also Hirst and Dunkerton, pp. 24–8.
5. Praz, p. 144 and p. 155.
6. Sánchez-Mesa Martín 1988, p. 51.
7. Martín González 1984, p. 191.
8. *Ibid.*, p. 182.
9. Inv. nos. 00611522, 00612124, 0061013, 00616186, and cat. no. ED/70; Ruiz Alcón, pp. 28–36. I am most grateful to Mª Jesús Herrero for giving me this information, and for suggesting further bibliographical references in this area.
10. Sánchez-Mesa Martín 1988, pl. XXI.
11. This figure appears to be of polychromed wood, although I have only seen it in reproduction. It is likely to be Spanish, and a related drawing exists attributed to Francisco Ribalta (Hernández Perera, pp. 59–60 and pl. II).
12. de Vega Giménez, p. 130.
13. For example, a painted wood figure dating from the second half of the seventeenth century is in the convent of St Catherine, Valladolid (Martín González and Plaza Santiago, p. 59 and pl. LXIV, fig. 183).

PEDRO DE MENA Y MEDRANO
(b. Granada 1628–d. Malaga 1688)

Pedro de Mena was the son of the sculptor Alonso de Mena (1587–1646), and initially trained under his father in Granada. In 1652 he began working alongside Alonso Cano (1601–1667), who had come to Granada in that year. In 1658 he left Granada for Málaga, where he commenced work on the choirstalls for the Cathedral, including a relief of St Francis (see below). This commission brought him great prestige, and in 1663 he was named as sculptor to Toledo Cathedral, although he seems to have continued living in Málaga. For Toledo he made his renowned figure of St Francis (see below). He undertook numerous commissions during the 1670s, including busts of the *Virgin of Sorrows* (see the entry for cat. no. 46), and *Christ Man of Sorrows*, as well as his figure of *Mary Magdalene* of 1664 for the Jesuit Convent of St Philip Neri (now on loan from the Prado to the National Museum of Sculpture, Valladolid). Despite his reputation as a sculptor, he failed to gain the office of Court Sculptor (*escultor de Cámara*), for which he petitioned in 1679. Pedro de Mena was a devout man whose five children all entered holy orders, and whose art is in accord with his deep religious beliefs. His technically brilliant and naturalistic figures strongly reflect the style of Alonso Cano, and like him he specialised in individual devotional figures or busts rather than altarpieces.

BIBLIOGRAPHY

Palomino *Lives*, pp. 314–17; Ceán Bermúdez, III, pp. 108–13; Orueta 1914; Martín González 1983, pp. 207–21; *Pedro de Mena* 1989; Sánchez-Mesa Martín 1990.

24. ST FRANCIS OF ASSISI

PAINTED PINEWOOD AND CORD, WITH GLASS EYES

After PEDRO DE MENA

CASTILE; about 1720–40(?)

Inv. no. 331–1866

H. 50.5 cm. W. 13.3 cm. D. 13.4 cm.

See plate 8, and fig. 4 on p. 14

Provenance
Bought by John Charles Robinson from Cavalletti in Madrid for £3 13s 6d in 1865.

Condition
Scratch marks are visible on the left side of the saint's habit; minor chips have occurred, some of which have been painted over; slight damage is visible to the top of the head. The base is cracked at the front; the corner on the saint's left side at the front has come apart and been re-stuck. There are also minor chips elsewhere on the base; underneath a dowel-hole is lined with what seem to be pieces of a nineteenth-century Spanish newspaper, and signs of glue on the underside of the base indicate where it was once fixed to a socle (this socle, which was almost certainly nineteenth-century, is visible in a museum photograph shown here, taken in 1939). The polychromy of the habit simulates the stitching of the robe: vertical lines at the sides and on the hood imitating the joins of the material.[1] A length of knotted cord is fixed through a hole at the front, behind the saint's hands; at the back, a double cord is threaded around his waist, and drilled into two holes under his left and right shoulders, giving the illusion that the cincture is tied around his body, half-hidden by his capacious sleeves. The glass eyes seem to be set in from behind the face, which was itself almost certainly carved separately, and set into the hood like a mask, like the face of the *Virgin of Sorrows* (cat. no. 46).[2]

The bearded St Francis is shown standing, looking upwards, his right sandalled foot forward, thereby revealing the stigmata, with hands clasped together in the sleeves of his habit, the hood over his head. The fine striations painted on the habit simulate the texture of the cloth. The figure is integrally carved with the simulated rocky base.

The image of St Francis of Assisi (1182–1226) was frequently represented in Spain following the Council of Trent of 1563.[3] His cult was particularly associated with Toledo, where El Greco (1541–1614) executed a large number of paintings of the saint from about 1586 onwards, their iconography influenced almost certainly by the proximity of the celebrated Franciscan convent, S. Juan de los Reyes.[4] In the present piece, the moment depicted is from the legend of the miraculous posthumous appearance of the saint, when his tomb was allegedly opened in the presence of Pope Nicholas V in 1449 (or possibly Nicholas IV in 1288). According to this legend, his body was unchanged, his eyes open, and his hands clasped together in the sleeves of his habit.[5] To indicate death's presence, the face is sallow, and the eyes ringed in shadow. The legend was first represented visually probably in the early seventeenth century.[6] It had been popularised in Spain by a number of publications, such as Pedro de Ribadeneira's *Flos Sanctorum o Libro de las Vidas de los Santos*, which was first published in Madrid in 1599.[7] The first sculpted interpretations of the subject seem to have been produced by Gregorio Fernández (*c.* 1576–1636); one, which Martín González dates to not later than 1620, is in the Monasterio de las Descalzas Reales in Valladolid; the other, in the church of Santo Domingo in Arévalo (Ávila) probably dates from *c.* 1625–30.[8] Both these figures almost certainly pre-date the three paintings of the same subject by Francisco de Zurbarán (1598–1664), which are undated, but which have been assigned to about 1640–45.[9]

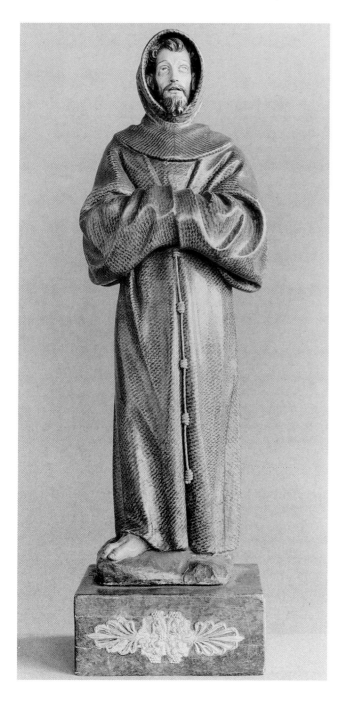

Like the *Virgin of Sorrows* (cat. no. 46), the present figure is known in several similar versions. Two autograph images of *St Francis* by Pedro de Mena – the high relief in the choirstalls of Málaga Cathedral, and the statue (fig. 4 on p. 14) in the Treasury of Toledo Cathedral respectively – seem to be the starting points for this figure and for the other variants, although most of these differ substantially one from another.[10] The choirstalls in Málaga date from 1658–62, while the *St Francis* in Toledo seems to have been executed shortly afterwards, in about 1663.[11] In the catalogue of the exhibition on Pedro de Mena and Castile held in 1989–90 a third prototype was suggested, where

the habit is shorter, and both feet are visible; this type however, as the compiler admits, derives ultimately from the Toledo figure.[12] The figure in Toledo suggests that Pedro de Mena must have almost certainly known at least one of the figures of St Francis illustrating the same legend (mentioned above) ascribed to Gregorio Fernández, which is closely analogous, although the later sculptor altered certain details, and refined the facial features.[13]

The type of standing saint as a devotional image, rather than an element in an altarpiece, is also seen in the work of Alonso Cano (1601–1667), with whom Pedro de Mena collaborated in Granada, and to whom indeed Pedro de Mena's Toledo *St Francis* (along with other variants) has sometimes been ascribed.[14] When the present figure was acquired, Robinson described it as a 'statuette of a Franciscan monk, carved in wood and painted. A contemporary repetition of a very famous statuette by Alonso Cano, preserved in the sacristy of the Cathedral of Toledo. Spanish 17th century sculpture'.[15] It was published soon afterwards in a general guide book (not produced by the Museum) as by Cano.[16]

The present work is clearly based on the Toledo figure, rather than on the relief in Málaga. Other pieces which correspond iconographically to this type are those in the church of St Martin in Segovia,[17] the Municipal Museum, Antequera,[18] the Ny Carlsberg Glyptothek, Copenhagen,[19] one formerly in the Österreichisches Museum, Vienna,[20] one in the Meadows Museum, Southern Methodist University, Dallas,[21] one in the Instituto de Valencia de Don Juan, Madrid (unpublished), one recently acquired by the Louvre, Paris,[22] one in the church of St Louis on the Ile de St Louis in Paris,[23] and a variant in the Fray Pedro Bedón Museum, Convent of Santo Domingo, Quito.[24] Although all these pieces superficially form a group, and have been dated to the seventeenth century, they are not simply replicas, for each exhibits differences from the others to a greater or lesser extent in the facial expressions, and in the fall of folds of the drapery.

The widespread popularity of the image, along with the paucity of other evidence, means that with a few exceptions, the dates and attributions of the variants can be problematic, and depend ultimately on questions of style. Two inscribed versions are dated, and the signature on one is also legible. The signed and dated figure is in the National Museum of Sculpture in Valladolid; it is signed by the Málaga sculptor Fernando Ortiz (b. 1717), and dated 1738.[25] The other dated version is in the Convent of Santa Clara, Medina de Rioseco; the inscription on its socle is in parts illegible, but the date 1732 is clearly visible.[26] These two are markedly different in style from the present piece, and are clearly only indirectly related to it stylistically. The subject continued to be popular into the nineteenth century, and at least two versions dating from then are known.[27]

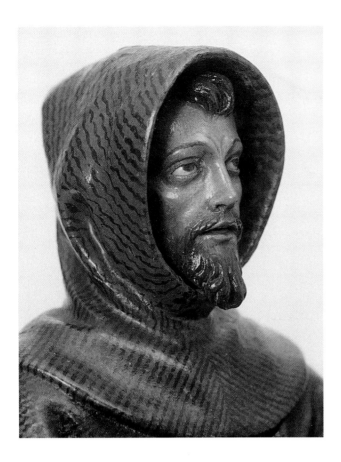

The London version is relatively close stylistically and iconographically to the autograph piece in Toledo, although it is only just over half the size. Conversely the above comparative works are much closer in scale to the Toledo figure, their heights varying from between approximately 84 to 100 cm. The present figure is technically highly accomplished, such details as the fitting of the glass eyes, the cowl around the head, and the cincture being in accord with seventeenth-century practices. These techniques however continued to be current into the next century, and other stylistic aspects, such as the diagonal folds of the drapery and the fuller sleeves, suggest a slightly later date. These features can be compared with the figures known to date from the early eighteenth century in Valladolid and Medina de Rioseco mentioned above, and imply that the present figure dates from the early eighteenth, rather than the mid-seventeenth century.[28]

BIBLIOGRAPHY

Inventory 1852–67, p. 28.
Riaño, p. 7.
Loan Exhibition, p. 126, no. 813.
Conway, p. 77.
Maskell, p. 213.
Golden Age, p. 45, cat. no. 72.
El Greco to Goya, cat. no. 76.
Louvre: Nouvelles Acquisitions, p. 52.
Penny 1993, p. 142, fig. 130 and p. 281.

NOTES

1. Luis Luna Moreno has remarked that this use of polychromy seen in Pedro de Mena's work (as well as in the figures he and Alonso Cano collaborated on in Granada) exerted an important influence on Castilian sculpture. See *Pedro de Mena*, 1989, p. 14.

2. To investigate whether there was a hollow space behind the face, it was found that thin strips of paper could be inserted to the following depths into the mouth (2.3 cm), the top of the head (6.5 cm), the side of the head (5.5 cm), and at the neck (2.3 cm). I am grateful to Nicholas Penny for this sensible if unorthodox method of investigation.

3. Mâle, pp. 481–83.

4. Réau, III, 1, p. 529.

5. Ribadeneira stated that Nicholas IV witnessed the miracle (Ribadeneira p. 709); other sources say Nicholas V (Réau, *op.cit.*, p. 530, and LCI, 6, p. 311).

6. Seen in an engraving of about 1610 by Jean Le Clerc (LCI, *loc.cit.*). The scene was also depicted in Thomas de Leu's *Vida de San Francisco*, published in about 1600 (Martín González, 1980, p. 249, and *Pedro de Mena*, 1989, p. 22). I have not been able to see a copy of either publication.

7. A second part appeared in 1601. I have only been able to see a copy of the 1643 edition, but I am grateful to Mª Rosario Fernández for the details of the earlier dates of publication.

8. Height: 104 cm. Martín González 1980, p. 249, and *Pedro de Mena*, 1989, pp. 22–3, cat. no. 1. An eighteenth-century variant after Gregorio Fernández is illustrated in *Pedro de Mena*, 1989, pp. 84–5, cat. no. 32.

9. Martín González 1980, pp. 249–50. The paintings are in the Museum of Fine Arts, Lyons, the Museum of Fine Arts, Boston, and the Museum of Fine Arts of Catalonia, Barcelona respectively. See Gregori, 1973, nos. 369–70 (bis), and Brown, 1973, p. 134, pl. 38.

10. The autograph versions are described and illustrated in Orueta, 1914, p. 128, fig. 21 and pp. 163ff. and fig. 54, and in *Ars Hispaniae*, XVI, pp. 245–6, figs. 221 and 223.

11. Orueta, 1914, pp. 71–3 and 77, and p. 169.

12. *Pedro de Mena*, 1989, p. 100.

13. *Ibid.*, pp. 9–10 and 22.

14. Sánchez Cantón believed a figure of St Francis formerly in the Odiot collection was by Cano, and that it pre-dated the examples by Pedro de Mena (Sánchez Cantón 1926, p. 42, and plate opposite p. 44). This is the version now in the Louvre, and is no longer thought to be by Cano.

15. Robinson Reports. Vol. V; part III. Minute of February 5th, 1867.

16. Cf Cano's figures of St Joseph and St Anthony of Padua respectively in the Museum of Fine Arts, Granada (*Cano Centenario*, II, pl. XIV and XV). For the ascription of *St Francis* to Cano, see *Loan Exhibition*, *loc.cit.* in the bibliography for this entry, von Falke, 1893, p. 16, XXXVII; Gómez-Moreno, 1926, figs. 64 and 65; *Pedro de Mena*, 1989, p. 10, and *Louvre: Nouvelles Acquisitions*, p. 50. For the ascription of the present piece to Cano, see Conway, *loc.cit.* in the bibliography for this entry.

17. H. 84 cm. *Pedro de Mena*, 1989, pp. 50–1, cat. no. 15.

18. H. 100 cm. Gómez-Moreno, 1974, pp. 68–70. This piece is not illustrated, but the author believed it to be an autograph work by Pedro de Mena. See also *Pedro de Mena*, 1989, p. 10.

19. H. 87 cm. Purchased in 1885 from the dealer Goupil in Paris (Orueta, 1914, p. 170, fig. 57).

20. Von Falke, 1893, pl. XXXVII, 2. This figure was formerly in the Österreichisches Museum für angewandte Kunst in

Vienna (inv. no. H366), but was deaccessioned in 1944. I am grateful to Ingrid Kummer for this information.

21. H. 74.1 cm. Stratton 1993, p. 76 and pp. 124–5, cat. no. 23.

22. H. 87 cm. *Louvre: Nouvelles Acquisitions*, pp. 50–3. Recent analysis by x-radiographs has shown that the glass eyes of this figure were fitted from behind, and that the face was inserted like a mask into the cowl, as is probably the case with cat. no. 24.

23. Unpublished. I am grateful to Nicholas Penny for telling me about this piece. This figure is a metal cast, fairly crudely polychromed, and almost certainly dates from the late nineteenth century (information kindly supplied by Yves Gagneux via Jean-René Gaborit).

24. Palmer, p. 46 and fig. 20.

25. The inscription was only recently revealed. *Pedro de Mena* 1989, p. 64, cat. no. 22 (h. 95.5 cm). A closely similar, though smaller figure (h. 64 cm) had been sold in Berlin in 1932 (Stumm, pl. XI, lot 48).

26. *Pedro de Mena*, 1989, p. 86, cat. no. 33. Other eighteenth-century versions are in the convent of the Descalzas Reales, in Valladolid, and in the Cathedral at Ciudad Rodrigo respectively; *ibid.*, pp. 88–91, cat. nos. 34 and 35.

27. *Ibid.*, pp. 92–3, cat. no. 36 (version attributed to Esteban de Agreda (1759–1842), and dated to after 1814), and *Louvre: Nouvelles Acquisitions*, p. 50 (marble version made in 1872 by Zacharie Astruc, exhibited in Madrid in 1877). See also Orueta, 1914, p. 163. Cf one sold in the von Stumm Sale, lot 49 (Stumm, pl. XI), which appears to be nineteenth century.

28. I am grateful to Mª Rosario Fernández for her helpful comments on this point.

25. ST SEBASTIAN

PAINTED AND GILT BOXWOOD

CASTILE; about 1700–1750

Inv. no. 175–1864

H. 19.3 cm.

Provenance
Bought by John Charles Robinson from don José Calcerrada, Madrid in 1863 for £4.

Condition
The hair, flesh and parts at least of the tree-trunk have been re-painted; some of this later paint has flaked to reveal an earlier surface layer, which was evidently much damaged. Some of the paint on the tree trunk is also missing, revealing the white ground beneath. The surface of the gold designs around the base is damaged in places. The drapery has flaked slightly, and it is likely that re-painting has occurred here too. Two cracks through the left arm and the tree trunk behind suggest that this part of the composition broke off and was re-fixed.

St Sebastian leans with twisted torso against a tree trunk, his left arm bound with a double gold cord above his head to one branch, his right hand stretched out behind another branch, holding part of his loincloth, or perhaps grasping the tree trunk (the thick paint layer means that it

is difficult to see which). He stands on his right leg, his left leg bent. Six arrow wounds are to be seen on his body, one on each limb, and two on his torso. Foliate designs in gold are to be seen on the ground around the tree, but the damaged surface means that these are unclear.

Although some of it has been extensively restored, the distinctive polychromy on this piece, particularly the treatment of the bark of the tree with striated lines of gold scratched through the colour is reminiscent of Castilian sculpture of the sixteenth century.[1] One of the most famous precedents is Alonso Berruguete's *St Sebastian* made for the S. Benito altarpiece (*c.* 1527–32) in Valladolid.[2] Here however the slender proportions of the body and mannered pose suggest a date into the eighteenth century. A slightly earlier statuette of St Jerome in the Cathedral Museum at Ávila exhibits the same delicate gold lines on the tree trunk.[3]

BIBLIOGRAPHY
Inventory 1864, p. 14.
Inventory 1852–67, p. 71.
Riaño, p. 7.
Loan Exhibition, p. 126, no. 808.

NOTES
1. Some of the restored gold may be painted over the colour, rather than scratched through. I am grateful to Richard Cook for his comments on this.
2. Martín González *Valladolid* 1983, p. 28, fig. 19. Cf cat. no. 11.
3. Inv. no. 50; unpublished. The figure is labelled as seventeenth-century.

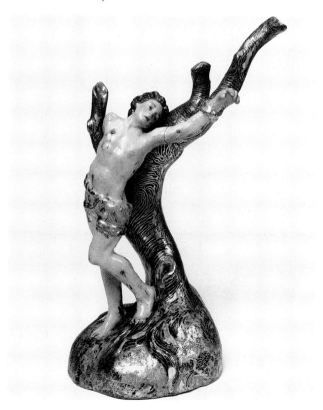

ALEXANDRO (ALEJANDRO) CARNICERO

(b. Iscar (Valladolid) 1693–d. Madrid 1756)

Carnicero trained under José de Larra (Lara) Domínguez (*c.* 1665–1729) in Salamanca. Most of his working life was spent in Salamanca and Madrid respectively; he worked in wood and stone, and also made engravings of his own sculpture. Between 1726 and 1731 he collaborated with José de Larra and others on the choirstalls of Salamanca Cathedral, and he probably completed the choirstalls at Guadalupe between 1742 and 1744. His other work in Salamanca includes stone medallions of the heads of kings for the Royal Pavilion in the Plaza Mayor, carved between 1730 and 1732. From 1745 to 1750 he was working on four wood figures for the organ-case (now dismantled) in León Cathedral. He was in Madrid from 1749 onwards, where he had been commissioned to do three stone statues of Spanish Kings for the Royal Palace.

BIBLIOGRAPHY
Ceán Bermúdez I, pp. 258–9; Martín González 1983, pp. 436–44; Velasco; Rivera.

26. CHRIST BEARING HIS CROSS

PAINTED AND GILT PINEWOOD AND HOLM OAK VENEERED
CROSS; GLASS EYES; BRASS AND GOLD THREAD

BY ALEXANDRO CARNICERO

SALAMANCA; about 1720–56

Inv. no. 102–1864

H. 76.2 cm. W. 36.8 cm. L. 99 cm.

See plate 9

Provenance
Bought by John Charles Robinson from García Pérez, Salamanca for 3000 reals (£31 11s 6d) in 1863.

Condition
Some paint has been lost at the fingers and knuckles of the left hand, and on the right elbow. A crack runs from the left foot up into the legs and robe. The end of the nose has been broken and replaced. The gilding on the robe is slightly worn all over. An early repair was recorded in the Museum records: 'Refixing large brass. 1 Feb. 1865'. This presumably refers to the brass fittings on the cross, which are now slightly corroded. The woven girdle at the waist may be a nineteenth-century addition. The crown of thorns may also be later. The ends of the base, behind the feet and in front of the hands respectively, appear to have been trimmed, revealing the bare timber.

Christ falls beneath the cross which is held on his right shoulder. The figure and base are made up of several pieces of wood fitted together; the joins are in places visible, and some re-touching has occurred. Some woven material stuck to the left shoulder may be an early repair. A crown of thorns of brass bound with brass wire encircles his head. His left arm is stretched out on the rocky ground before him; he leans on his right knee, his left leg extended behind. The face is probably a mask: glass eyes are fitted into it, almost certainly from behind; the half-open mouth reveals his teeth and tongue. A plaited rope of brass thread with tasselled ends is tied round the neck, and a woven belt, probably of gold thread over silk, with tassels of a different design, fastens around the waist over a carved

belt, now partly hidden by the woven one, supporting the idea that the woven one is a later addition. The robe is elaborately painted and gilded in the *estofado* technique[1] with naturalistic designs of flowers, including daffodils, tulips and carnations; these suggest a date of *c.* 1725–30.[2] The veneered wood cross (of holm oak)[3] with brass fittings is fixed by a large screw into Christ's back; the cross may have been re-polished in the nineteenth century, or may even be a later replacement.

Both in painting and sculpture, representations of Christ falling beneath his cross were widespread in Spain in the seventeenth and eighteenth century, partly as a result of spiritual writings of the Franciscans.[4] The subject was often used for processional figures (*pasos*), (see below). The present piece was identified by Jennifer Montagu as deriving from one of the bronze versions of this subject by Alessandro Algardi (1598–1654).[5] She points out that the drapery on the left arm and on the back, as well as the extended left foot, 'could not have been derived from any other image of the fallen Christ.' The original Algardi model is dated by Montagu to around 1650.[6] Another almost certainly Spanish version of the subject in painted wood displayed in the Chapter Room at the Descalzas Reales in Madrid was also noted by Montagu.[7] The figure in Madrid is smaller than cat. no. 26, and closer in size to the Algardi bronzes (whose heights vary from about 15 cm to 27.5 cm); it is labelled 'Granada School'.[8] Other bronze versions in Spain are to be seen in the Monastery of the Capuchins, Toledo, and in the Museum of Decorative Arts, Madrid.[9]

The attribution to Carnicero dates back to the time of acquisition by the Museum, when Robinson described the piece as: '"Paso" a painted wood statuette of Christ bearing his cross by Carnicero.'[10] The style of the work accords with known pieces by Carnicero, such as the lifesize figure of Christ in polychromed wood in the Chapel of the True Cross in Salamanca, or the *Pietà* group in the cathedral at Coria (Cáceres).[11] However it has also been suggested that it could be by Carnicero's master, the Salamanca sculptor José de Larra Domínguez.[12] A

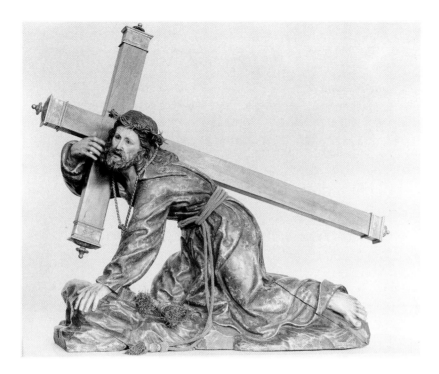

comparison is provided by the *paso* figure of *Christ carrying the Cross* by José de Larra in the church of S. Julián in Salamanca.[13] This is a life-size dressed figure (*imagen de vestir*). Christ's pose, and the type of cross (with brass fittings) are analogous to the present piece. It should however be noted that cat. no. 26 is about half life-size, and therefore unusually small for a *paso* figure.[14] Unlike the figure by de Larra, it is a complete wood sculpture, with highly detailed polychromed designs on the robe. Comparisons of the heads of the two figures are not close enough to justify an attribution to de Larra.

Carnicero is however reported to have executed figures for Holy Week processions. Writing in 1800, less than fifty years after Carnicero's death, Ceán Bermúdez noted: 'Executó el paso de los azotes a la columna y otros que sacan en procesion por semana santa en aquella ciudad.'[15] Carnicero is the probable author, given the analogies with other works by this artist, and the attribution to him at the time of its acquisition. The purpose of the figure remains uncertain; despite the evidence that Carnicero is known to have produced *paso* figures, its size suggests that it was a devotional piece intended for a side-altar, rather than a processional figure.

BIBLIOGRAPHY

Inventory 1864, p. 8.
Inventory 1852–67, p. 70.
Art-Journal, p. 282.
Riaño, p. 7.
Loan Exhibition, p. 125, no. 798.
Baker 1984, p. 345, fig. 6.
Montagu, p. 324, II.D.2.
Nicolau Castro 1990, p. 5.

NOTES

1. See the introductory essay on Materials and Techniques.
2. I am grateful to Paul Harrison and Clare Browne for their comments on the decorative details of this piece.
3. I am grateful to David Davies for his comments on the wood.
4. See Orozco Díaz 1971, pp. 245–6. The article discusses the iconography of this subject mainly during the seventeenth century, with reference to the works of José de Mora (1642–1724) and José Risueño (1665–1732).
5. Montagu, p. 324, II.D.2.
6. *Ibid.*, p. 322. One of the versions catalogued by Montagu (cat. no. 11.C.10) was auctioned at Christie's, London, 16 December 1986, lot 35 (bought in).
7. *Ibid.*, pp. 324–5, II.D.3. Inv. no. 0611262. See also Nicolau Castro 1990, p. 5. I am grateful to Mª Jesús de Herrero for giving me the information held by the Patrimonio Nacional on this piece, as well as for letting me have the reference to the article by Nicolau Castro.
8. Montagu also notes a polychromed terracotta version of the same composition in the Liebieghaus, Frankfurt, but points out that the modelling is somewhat heavy (Montagu, p. 324, II.D.1).
9. Nicolau Castro 1990, pp. 4–5, and figs. 4–6.
10. Robinson Reports, Vol. I, Part V. Shortly after acquisition, an anonymous article in the *Art Journal* condemned this piece as 'absurd and useless' (see Introduction p. 3, and bibliography for this entry).
11. For the figure of Christ, see Bizagorena 1982, p. 149. For the *Pietà* group, see Martín González, 1983, p. 443, fig. 215.
12. This was suggested to me by Jesús Urrea.
13. See Rodríguez Ceballos 1986, figs. 20–1.
14. Cf the slightly earlier seventeenth-century figures catalogued in *Gregorio Fernández* 1986 (eg p. 51, cat. no. 9). Orozco Díaz suggested a small (measurements not given) polychromed wood version of Christ falling beneath the Cross in Úbeda (Jaén), attributed to José de Mora might be a model for a larger work formerly in Úbeda, but now lost (Orozco Díaz 1971, p. 234 and pl. II.)
15. Ceán Bermúdez, I, p. 258.

Madrid

The presence of the Court in Madrid had a profound effect on the art produced there. (The Court was briefly based in Valladolid 1601–6, but was permanently in Madrid thereafter.) Royal patronage influenced the type of sculpture commissioned, and the contexts in which it was seen. Sculptors at the start of their careers from Italy and Northern Europe came to seek work elsewhere in Spain, but in Madrid the lavish commissions were given to already renowned Italian artists such as Pompeo Leoni (*c.* 1530–1608) and Pietro Tacca (1577–1640). During the sixteenth century, the magnificent gilt bronze figures executed by Leoni and others commissioned by Philip II for the Royal Basilica of El Escorial just outside Madrid were without parallel elsewhere in Spain. Equally public sculpture, such as the equestrian figure of Philip IV of 1640 in the Plaza de Oriente in Madrid, cast by Pietro Tacca, and eighteenth-century garden sculpture, exemplified by the figures made for royal palaces in and around Madrid, was rarely seen beyond the orbit of the capital. At the same time, small-scale courtly pieces, such as the terracottas made by Luisa Roldán (cat. no. 27) and small scenes in wax, were also in demand, particularly in the late seventeenth and early eighteenth century. José de Mora and later Roldán came to Madrid and each petitioned successfully to be Court Sculptor (*escultor de Cámara*), a title which gave prestige, although no income.

Following the establishment of the Bourbon dynasty in Spain in 1701, French and Italian art and artists began to play a more prominent role, even more so after the foundation of the Royal Academy (Real Academia de Bellas Artes de San Fernando) in Madrid in 1752. Like other European academies, the teaching, awards of prizes, travelling scholarships and honours affected the type and style of sculpture produced. Predominantly classical subjects and styles were favoured, and many aspiring sculptors spent time in Rome (cf cat. no. 29).

LUISA ROLDÁN ('LA ROLDANA')
(b. Seville 1652–d. Madrid 1706)

Luisa Roldán trained in the studio of her father, Pedro Roldán (1624–1699) in Seville. Her birth and death dates (previously thought to be 1656 and 1704 respectively) have recently been established as 1652 and 1706.[1] Her commissions included wood figures and reliefs for altarpieces in Seville and Cádiz, but she is particularly renowned for her polychromed terracotta groups, which prefigure rococo porcelain groups of the eighteenth century. In about 1686 she left Seville for Cádiz. By this time she had set up her own workshop, her husband Luis Antonio de los Arcos (d. 1702/3), whom she had married in 1671, acting as polychromist. She was exceptional as a woman both in being a sculptor and running her own workshop. Her success and ambition led her to Madrid in about 1688, when she petitioned Charles II for the post of Court sculptor (*escultor de Cámara*). This was finally granted in 1692, although without emoluments. When Philip V came to the throne in 1701 her title was renewed. Many of her small terracotta groups were made during her Madrid period, and some were signed with her prestigious title. She spent the last two years of her life working for a private patron, producing a large number of small terracotta groups.[2]

BIBLIOGRAPHY
Palomino *Lives*, pp. 341–2; Ceán Bermúdez IV, pp. 235–9; Gilman 1964; García Olloqui; Martín González 1983, pp. 177–84.

NOTES
1. She was baptised on September 8th, 1652, and died on January 10th, 1706. Catherine Hall-van den Elsen has established these dates through unpublished documentary sources (Hall-van den Elsen 1992, pp. 31 and 156). I am grateful to Catherine Hall-van den Elsen for giving me this and other information on the artist.
2. Hall-van den Elsen 1992.

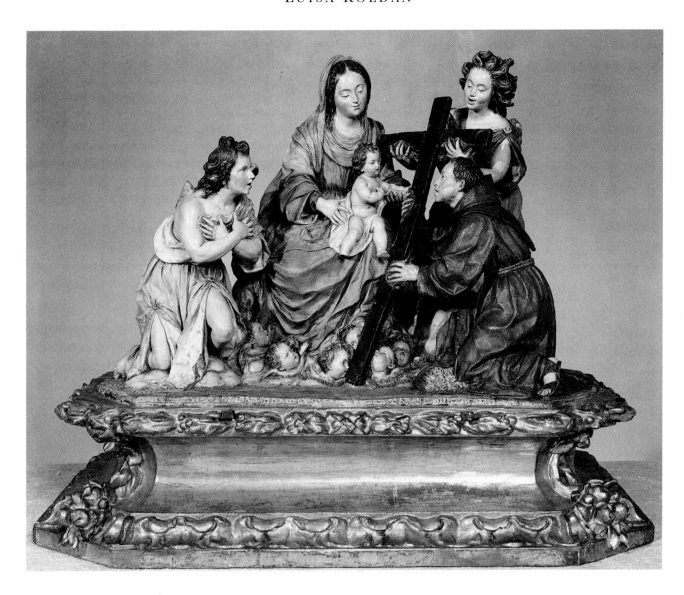

27. THE VIRGIN AND CHILD WITH ST DIEGO OF ALCALÁ

PAINTED TERRACOTTA ON A PAINTED AND GILT WOOD BASE

BY LUISA ROLDÁN

MADRID; about 1690–95

Inv. no. 250–1864

H. 51 cm (with base) 36 cm (without base).

W. 66 cm (with base) 54.5 cm (without base).

D. 41.5 cm (with base) 31.5 cm (without base).

See plate 10

Provenance

Bought by John Charles Robinson from Soriano, Madrid, in 1864 for 530 reals (£5 11s 7d).

Condition

The group has suffered some damage in the past: the cross held by the saint has been broken and repaired (a photograph taken

in 1925 shows the damaged cross, and other parts of the piece which were subsequently re-painted to conceal small areas of flaking paint, such as the robes of the saint and the Virgin). Parts of the floor area in front of the group, painted to resemble glazed blue and white terracotta tiles, also seem to have been re-painted. Other areas of damage include the missing wings of the standing angel, and the broken left wing of the kneeling one. One foot of the Christ Child is missing, the other is chipped; the Virgin's head is cracked at the back, and the adhesive visible at the neck indicates that the head was broken off and re fixed. The work is apparently unsigned, although it is conceivable that a re-painted area conceals a signature. On the back, between the Virgin and the angel on her left is a filling of fired terracotta; following the original painting of the group (after firing) the filler must have pulled away from the main body of the clay. This indicates that the two figures were joined when the clay was leather-hard, although not sufficiently well to prevent this subsequent damage, probably due to slight changes of conditions which caused the filler and the clay on the rest of the group to react differently, and so cause tension. As Catherine Hall-van den Elsen has pointed out, the conservation

undertaken since 1925 means that evaluation of the polychromy is problematic.[1] However there are substantial areas of what seems to be original paint, notably on the angels, the cherubim, and the saint, although his hair, and the cloth with which he holds the cross have been re-touched. Much of the colour on the Virgin's hair, flesh and robes is original, although some re-painting has occurred on the back of her robe. The paint on the Christ child is original, although the white cloth has been re-touched. The present slightly dulled matt surface of the colours may not resemble the original appearance of the polychromy, which is likely to have been more vivid. Some areas have been varnished, and this has subsequently become discoloured. The gilding on the base seems to have been consolidated with wax.[2] Two triangular metal fixings are screwed into the front of the base; the purpose of these is uncertain.

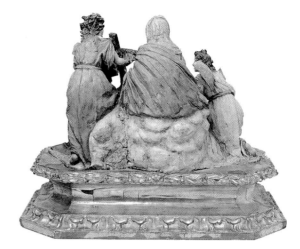

Back of cat. no. 27.

The Virgin and Child are shown presenting the cross to a kneeling Franciscan saint, almost certainly St Diego of Alcalá, accompanied by two angels, one kneeling, one standing. Six cherubim nestle around the Virgin's feet. All the figures except the saint rest on clouds, indicating that this is an ecstatic vision experienced by the saint, as has been suggested by Catherine Hall-van den Elsen.[3] The polychromed and partially gilt terracotta group is set on a gilt wood base, which is almost certainly original.

The identity of the Franciscan saint has been the subject of some discussion. When first acquired in 1864, Robinson described it as follows: 'Group in painted terracotta St Francis attended by two angels, kneeling before the Virgin & Child. Spanish 17th century sculpture. The subject represented by this group is of most frequent occurrence in Spanish art. It is conventionally designated a 'Portiuncula' in reference to a legend of St Francis commemorated in divers manners in all the Franciscan convents of Spain.'[4]

The legend referred to by Robinson took place outside the Convent at Portiuncula when St Francis, tempted by lust, rolled himself in a bed of thorns. The Virgin and Christ then appeared in a vision, and the thorns were miraculously transformed into roses.[5] Rose petals can be seen in the folds of the saint's habit.

This identification of the subject was maintained when the group was published, eight years after its acquisition by the Museum.[6] In 1930 however, in her catalogue of the collection of the Hispanic Society, Gilman Proske referred to the present group, and suggested that the saint could be St Anthony of Padua, and, if so, that the piece was possibly identical with a group previously in the Franciscan Convent of the Conception at Toledo.[7] In the two *Ars Hispaniae* volumes which mention the piece (XVI and XVII), the saint is confusingly referred to as St Francis (XVI) and St Anthony of Padua (XVII) respectively. This has

unfortunately led some scholars to believe there are two groups by Roldán in the Museum. A third interpretation was introduced in Gilman Proske's later series of articles on Luisa Roldán, when she proposed that the figure may represent St Diego of Alcalá.[8] This was also put forward orally by Professor Alfonso Emilio Perez Sánchez.[9] García Olloqui implies that there are two groups in the Victoria and Albert Museum: one St Anthony, and one Apparition of the Virgin to St Diego of Alcalá.[10] The identification of the saint as St Diego of Alcalá is certainly plausible. He was a Franciscan monk, one of whose miracles occurred when he was accused by a fellow monk of stealing bread from the convent to give to the poor. When his robes were searched, the hidden bread was miraculously transformed into roses.[11] As noted above, rose petals are to be seen in the folds of the habit of the saint in cat. no. 27. The inconsistency in the present representation is the fact that in the legends of this saint no apparition of the Virgin is recorded. Conversely, his youthful, beardless appearance here resembles the slightly earlier representations of St Diego of Alcalá by Pedro de Mena and Alonso Cano respectively, whereas St Francis is usually shown with a beard in Spanish sculpture and painting (cf cat. nos. 24 and 66 in this collection).[12] For this reason, the saint in the present group is more likely to be St Diego of Alcalá.

The attribution of the group has also presented problems. In November 1913, the Conde de las Almenas suggested to the Museum that the artist was Pedro Roldán (the father of Luisa Roldán).[13] Gilman Proske was the first to attribute the group to Luisa Roldán, when she catalogued the works by that artist in the collection of the Hispanic Society.[14] In her later *Connoisseur* articles she stated that it was likely to be a

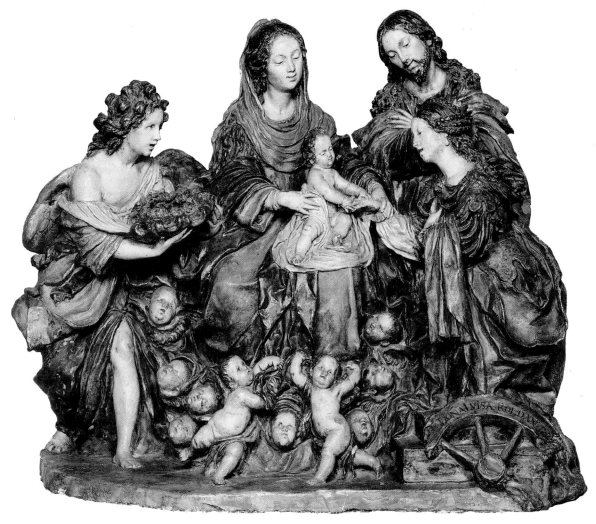

Figure 10. The Mystic Marriage of St Catherine, *polychromed terracotta. By Luisa Roldán. Hispanic Society of America, New York.*

workshop product, as its quality was ostensibly lower than autograph works.[15] Sánchez-Mesa Martín and others have supported the attribution to Luisa Roldán. Comparisons with signed works by the artist reveal similar characteristics. The composition and facial features of the figures in cat. no. 27 strongly recall those of her signed *Mystic Marriage of St Catherine* at the Hispanic Society, in particular the faces and poses of the Virgin and of the angel on the Virgin's right in each group (see fig. 10). Otero also believes that the present group is a workshop adaptation of this autograph work.[16] Despite this view, and that of Gilman Proske, the quality of the present piece does not suggest that it is by a different hand from pieces known to be autograph, although arguably a degree of workshop collaboration must have occurred in all Roldán's output, including signed works. Hall-van den Elsen states that she believes the present work is autograph, and notes that comparisons with signed

works (notably the New York *Mystic Marriage*) confirm this.[17] The similarity of cat. no. 27 with the *Mystic Marriage* could be explained by the use of moulds for certain details. Measurements were taken to test out this hypothesis. The overall dimensions are similar, but not identical.[18] Comparable details, such as the faces of the Virgin and of the angels on the Virgin's right in each piece were also measured.[19] The results were inconclusive, both because they were only measured manually, and because the small differences might be explained by the inaccuracies of this method of measuring, and possibly by shrinkages during firing. It seems therefore possible, though not certain, that moulds could have been used for analogous parts of different groups made in Luisa Roldán's workshop. More likely is the possibility that moulds were used for repeated parts of the same group. On the present piece, the heads of the cherubim have the same dimensions as one another. Similarly, on the *Mystic*

Marriage group, the cherubim (which differ in appearance and size from those on cat. no. 27) also measure the same as one another.[20]

The date of the work is uncertain. Only four of Roldán's terracottas are known to be signed and dated: 1691, 1692, 1699 and 1701 (or possibly 1704) respectively.[21] The present work is undocumented and undated. On the assumption that the saint represented was St Diego of Alcalá, Catherine Hall-van den Elsen suggested a possible connection of this group with the convent at Alcalá de Henares, which is dedicated to this saint. Roldán was working there from 1697 to 1701 on a commission for Carlos II.[22] However the same author has also proposed that stylistically this group accords more closely with works executed around 1691–2 (the New York *Mystic Marriage* and the *Repose on the Flight into Egypt* dated 1691 in the collection of the Condesa Ruiseñada at San Sebastián).[23] She points out the similarity of composition of the complex groups, and the details of the bent toes of the male figures in the New York group and the angels to the left in the present one and the Ruiseñada groups.[24] During her research, she found a letter from Luisa to Charles II, in which she mentions an attached list of eighty works completed over the previous ten years, although unfortunately the list has been lost.[25] For the above stylistic reasons, the present piece is dated to approximately 1690–1695.

BIBLIOGRAPHY

Inventory 1864, p. 20.
Inventory 1852–67, p. 37.
Riaño, p. 1.
Loan Exhibition, p. 113, no.708.
Gilman 1930, p. 294, note 2.
Ars Hispaniae XVI, 1963, p. 311.
Ars Hispaniae XVII, 1965, p. 46.
Sánchez-Mesa Martín 1967, p. 327.
Gilman 1964, pp. 269–70, and p. 273, fig. 19.
García Olloqui 1977, p. 66.
Valdivieso 1980, p. 188.
Baker 1984, p. 343 and fig. 8.
Trusted, 1993, pp. 327–30 and pl. IV.
Williamson 1996, p. 143.

NOTES

1. Hall-van den Elsen MA, p. 103.
2. I am grateful to Charlotte Hubbard for her comments on the condition of this piece.
3. Hall-van den Elsen, *op.cit.*, p. 100.
4. Robinson Reports Vol. I, Part III. The 'Portiuncula' mentioned by Robinson refers to St Francis's restoration of the church of St Mary of the Angels, called the Portiuncula, near Assisi (see Hall-van den Elsen *op.cit.*, p. 132).
5. Réau, III.1, pp. 530–1. Mâle, 1932, p. 478–80. See also Ford 1869, p. 177 for a somewhat biased (anti-Catholic) account of the legend. For an illustration of Murillo's painting of this subject, now in the Wallraf-Richartz Museum, Cologne, see Stoichita, fig. 19.
6. Riaño, *loc.cit.* in the bibliography for this entry.
7. Gilman, 1930, *loc.cit.* in the bibliography for this entry.
8. Gilman 1964, *loc.cit.* in the bibliography for this entry.
9. See Sanchez-Mesa Martín 1967, p. 327, note 5.
10. García Olloqui, pp. 66 and 68.
11. Réau, III.1, p. 385, and Mâle, pp. 487–8.
12. I am grateful to Manuel Arias for his comments on this. The figures by Alonso Cano and Pedro de Mena are in Granada (Museum of Fine Arts, and the church of the convent of St Anthony Abbot). See *Alonso Cano Centenario*, II, plates XVI and LXXVI. For other representations of the saint, cf the painting by Ribera in Toledo Cathedral, dating probably from *c.* 1640, although with a later date of 1648 inscribed on it (Pérez Sánchez, p. 121 and p. 120, fig. 184). An unattributed early eighteenth-century statuette is in the National Museum of Sculpture in Valladolid (inv. no. 786); he is shown with two keys at his wrist (Wattenberg 1963, p. 263 and García de Wattenberg 1984, p. 59). See also LCI, 6, pp. 54–5.
13. Victoria and Albert Museum records.
14. Gilman, 1930, *loc.cit.* in the bibliography for this entry.
15. Gilman 1964, *loc.cit.* in the bibliography for this entry.
16. Valdivieso, *loc.cit.* in the bibliography for this entry.
17. Hall-van den Elsen MA, p. 98:
'Entre las obras en barro atribuídas a Luisa Roldán y no firmadas, la más conforme al estilo de la escultora es la de la colección del Victoria and Albert Museum . . .'
She reaffirms the attribution on p. 100.
18. The dimensions of the *Mystic Marriage* are: height: 36.5 cm; width: 45 cm; depth: 29.5 cm. This group lacks a base. The greater width and depth of the present piece are at least partly explained by the floor area around the figures, which is much shallower in the *Mystic Marriage* group.
19. The measurements of the face of the Virgin of cat. no. 27 are h. 50 mm; w. 38 mm. Those of the Virgin in the *Mystic Marriage* are h. 42 mm; w. 32 mm. Those of the face of the angel of cat. no. 27 are h. 42 mm; w. 31 mm, while those of the angel in the *Mystic Marriage* are h. 40 mm; w. 29 mm.
20. The underside of the *Mystic Marriage* group is hollowed out, and the larger individual figures appear to have been made separately, and then joined together in a leather-hard state, the joins strengthened by straw. I am grateful to Constancio del Alamo for enabling me to look at this piece, and for his comments on its construction. Unfortunately, it is not possible to examine the underside of the present group without removing the elaborate base. However, the join between the Virgin and the angel on her left suggests each was made separately (see the comments on the *Condition* above, p. 71).
21. Gilman, 1964, p. 202; de la Banda y Vargas, p. 266; García Olloqui, p. 98; Hall-van den Elsen, 1989, pp. 294–5.
22. Martín Gonzáles, 1983, p. 180. Hall-van den Elsen MA, p. 99.
23. For the Ruiseñada group, see Gilman 1964, fig. 7.
24. Personal communication, 1990.
25. Personal communication, 1990.

JULIÁN DE SAN MARTÍN

(b. Valdelacuesta (Burgos) 1762–d. Madrid 1801)

Julián de San Martín enrolled as a pupil at the Real Academia de Bellas Artes de San Fernando in Madrid in 1779, winning prizes in 1781 and 1784. He was awarded the title of *Académico de Merito* in 1786, with his relief of *The Martyrdom of St Sebastian*, and became Director of Sculpture at the Academy in 1797. He was a productive sculptor, whose works are primarily in churches in Madrid, but he also executed pieces for Pamplona, Segovia and elsewhere in Spain.

BIBLIOGRAPHY

Viñaza, III, pp. 352–3; Thieme-Becker, XXIX, p. 410; Azcue Brea, pp. 291–2.

28. BEATA MARIANA DE JESÚS

PAINTED TERRACOTTA

AFTER JULIÁN DE SAN MARTÍN

CASTILE (MADRID); about 1790

Inv. no. 105–1864

H. 44.3 cm. W. of base 13.7 cm. D. of base 12.3 cm.

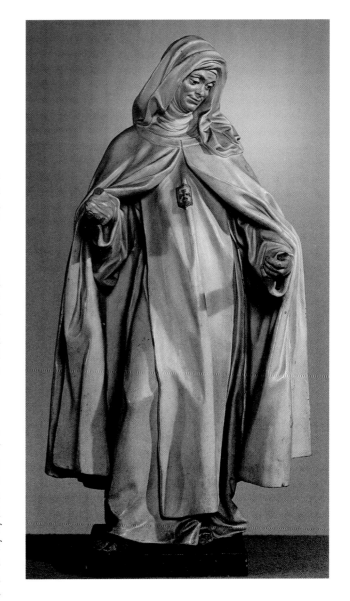

Provenance
Bought from Pérez Minguez, Valladolid, for £6 16s 10d. Robinson made a hasty pencilled half-illegible note about its purchase in Valladolid at the time: '. . .– afterwards to doctor dealer in antiquities – got one of the Museum series of the Berruguete/ [?saints] [cat. no. 11] . . . & 'beata Mariana terracotta'.[1]

Condition
The thumb and all the fingers of her right hand are missing, and the thumb of her left hand is also broken off (if, as seems likely, she was once holding a cross, the left hand may have been damaged when this was lost). There are a few other minor chips, and some slight surface damage to the paint, as well as signs that the present paint layer is not the earliest, but otherwise the piece is in good condition. A faint circular mark at the back of the piece near the hem of the robe may indicate where a label was formerly attached.

The figure stands, leaning on her left leg, her right leg bent, with her arms outstretched; she almost certainly originally held a cross in her left hand.[2] She wears the flowing white habit of the Order of Our Lady of Mercy (the Mercedarians), with a shield bearing a Maltese cross painted in red on her chest; this may have been re-painted at a later date. It is likely to have been originally the coat of arms of the Mercedarian Order: four stripes on a field of gold, a Maltese cross, and the crown of Aragon.[3] She has sandalled feet, just visible beneath her robe. She looks down, turning her head to her left. A hole in the back of her head may have held a halo, or possibly a crown of thorns.[4] The figure is integral with the rectangular socle, and a hole underneath the socle seems to have been made for firing purposes. (Firing cracks are visible around the hole).

The figure was identified as Beata Mariana on

acquisition in 1864, but this seems to have been forgotten, for by 1881 it was called simply a 'Carmelite nun', and subsequently thought to be St Teresa; not until 1966 was it again correctly identified.[5] Beata Mariana (born Mariana Navarro y Romero) (1564/5–1624) was born in the parish of Santiago in Madrid, and spent most of her life in that city. She lived a life of extreme abstinence, helping the sick, and joined the Order of Our Lady of Mercy (the Third Franciscan Order) in the church of Santa Barbara, Madrid, in 1613. She was beatified in 1783.[6] Many images of her survive in the form of engravings as well as sculpture, all apparently dating from the second half of the eighteenth century, around the time of her beatification. The present piece is probably a reduced version of the life-sized polychromed wood statue (height 1.75 m) by Julián San Martín, which is in the parish church of Santiago in Madrid (see fig. 11).[7] The face of this piece is based on a death-mask, which was preserved with her body in the convent to which she belonged. This figure holds a crucifix in her left hand; the present terracotta version almost certainly originally had the same attribute. Other sculpted versions extant in Spain include a figure in the Mercedarian convent of the 'Góngoras' in Madrid, attributed to Juan Pascal de Mena;[8] and two others in the convents of the Mercedarian Order in Toro (Zamora) and Marchena y Osuna (Seville) respectively;[9] another variant image of Beata Mariana (a bust) is in the National Museum of Sculpture at Valladolid.[10] All of these are in polychromed wood, rather than terracotta.

A number of the many engravings of Beata Mariana, mostly produced soon after her beatification, show her in a similar pose to the present figure, and three of these may be taken from the figure by Julián de San Martín in Madrid.[11] One, by Juan Fernando Palomino (d. 1793), is dated 1790, and gives a likely approximate date for the present piece.[12]

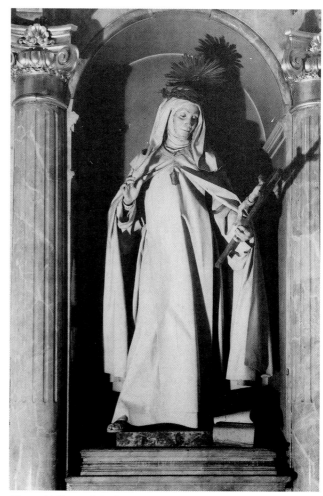

Figure 11. Beata Mariana, *polychromed wood. By Julián de San Martín. Church of Santiago, Madrid. Ampliaciones y Reproducciones Mas (Arxiu Mas).*

BIBLIOGRAPHY
Inventory 1864, p. 8.
Inventory 1852–67, p. 70.
Riaño, p. 3.
Loan Exhibition, p. 115, no.719.

NOTES
1. Robinson Ashmolean, Box 1, file 6 (Valladolid folder).
2. In many of the prints depicting Beata Mariana, and in at least one other sculpted version (in the church of Santiago, Madrid), which was probably the source for the present figure, she is shown holding a cross. For references, see below.
3. For the coat of arms of the Mercedarians, see *Catholic Encyclopaedia*, IX, pp. 669–70.
4. Cf the engravings of Beata Mariana, cited below. The other sculpted versions do not have crowns of thorns.
5. Robinson identified it as Beata Mariana in his Reports. In the 1881 Loan Exhibition its title was less specific (*Loan Exhibition*, p. 115, no. 719). It was described as St Teresa in later museum records. The correct identification was supplied by María Teresa Ruiz Alcón of the Tesoro Artístico, Madrid (Museum records, Registered Papers 66/2537).
6. *Leyenda de Oro*, I, pp. 613–17. I am grateful to Mª Rosario Fernández González for this reference, and for other valuable help in the compiling of this entry. See also García Vega, pp. 406ff., and *Bibliotheca Sanctorum*, VIII, pp. 1146–7.
7. Tormo, 1972, p. 83: 'En el presbiterio, a derecha, y deambulatorio izquierdo, la imagen repetida de la mercedaria Beata Mariana de Jesús'. See also Serrano Fatigati, 1910, p. 153; Gómez-Moreno 1951, p. 171 and pl. CXLIX, fig. 278; and *Exposición Conmemorativa* 1986, p. 207 (illustrated).
8. Tormo, p. 189. See also Bonet Correa, pl. 47.
9. I am grateful to Mª Rosario Fernández González for this information.
10. Inv. no. 253. See Antón, pp. 97–102 (there wrongly dated seventeenth century), and Wattenberg 1963, pp. 272–4 (there dated *c.* 1760).
11. *Arte y Devocion* p. 37 (no. 35), p. 95 (no. 93), p. 96 (no. 94).
12. For Palomino's engraving, see *ibid.*, no. 94. The artist was the great-nephew of the writer Antonio Palomino (1653–1725).

29. ST LUCY

TERRACOTTA

MADRID(?); about 1750–1780

Inv. no. A.63–1930

H. 27.5 cm.

Provenance

Given by Dr W. L. Hildburgh F.S.A. in 1930. Acquired by the donor in Barcelona in 1919.

Condition

The head has been broken off and repaired; repairs are also evident on the front edge of the cloak and the upper part of the socle. A label on the back in the donor's handwriting records: 'Terracotta sketch for a Figure of St Lucy. Barcelona '19.'

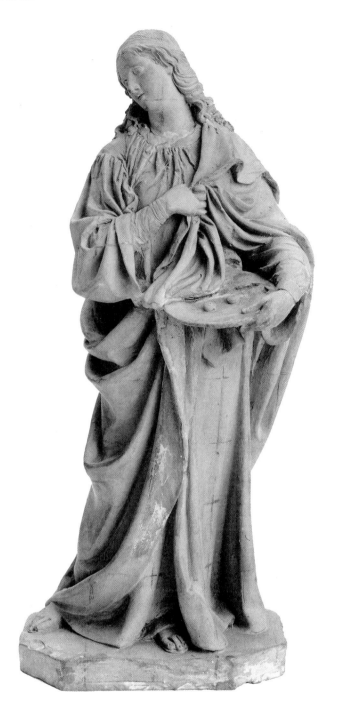

St Lucy stands looking to her right, resting on her left leg, her right one bent behind her.[1] In her left hand she holds a dish with two eyes on it, while her left hand grasps her cloak. She has long hair down to her shoulders, held in a hairband, and wears a hooded cloak over a dress and sandalled feet, just visible beneath the hem of her dress. The figure is made from a solid piece of terracotta, the surface of which is marked with squares and lines in pencil, as if it was to be scaled up for a larger work, perhaps a monumental marble, as yet unlocated.

As noted above, this piece could have been a model for a life-size statue; if so, it is a rare exception, as few models for Spanish sculpture are extant.[2] The survival of this one may be due to its being produced by an academician, and at a time when there was greater recognition of the value of sculptors' models. It is less typically vernacular than the other Spanish works in the collection, showing the influence of Italian and French sculpture, again suggesting it was produced within the Academy. Comparable works by Isidro Carnicero (1736–1804) are in the Royal Academy of Fine Arts (Real Academia de Bellas Artes de San Fernando) in Madrid.[3]

NOTES

1. For St Lucy, see LCI, 7, pp. 415–20, and Farmer, p. 270.

2. See introductory essay on Materials and Techniques.

3. These are terracotta figures of Susannah (after Duquesnoy), St Bibiana (after Bernini), and St Matthew (after Camillo Rusconi); see Pita Andrade, p. 63, and Azcue Brea, pp. 187–8 and 190–1.

Andalusia

The principal cities of the southern region of Spain were Seville and Granada. Although much interchange of artists and styles existed between these two centres, each had distinctive features, and certain sculptors were prominent in one rather than the other; for this reason, they are treated separately within this section. In addition, the sculpture produced for the Canary Islands tends to be Andalusian in style (cf cat. no. 32). Málaga had a flourishing industry of terracotta during the late eighteenth and early nineteenth century, and this is represented by one piece in the collection (cat. no. 33).

30. CRUCIFIX

PAINTED BOXWOOD IN LATER GLAZED CASE

ANDALUSIA; about 1650

Inv. no. 166–1864

H. of cross 22.5 cm. W. of cross 14.5 cm. H. of figure 13 cm.

Provenance
Bought by John Charles Robinson for 800 reals (£8 8s 5d) from Ramón Oliva in Zamora in 1863.

Condition
The crucifix is presently placed in a glazed wood case lined with black velvet, with small white specks; the case and lining postdate the acquisition of the object in 1864. There are some minor paint losses and chips, notably on the nose, rib-cage and knees, and some of the thorns at the front of the crown of thorns are missing. What seems to be a run of glue mixed with blood-coloured paint can be seen on the right arm and hand, but the piece does not seem to have been substantially re-painted. Although the existing case is later, the crucifix may have long been protected by a case, and so was preserved in relatively good condition. The case has twelve modern metal screws at the back holding the crucifix and fittings in place. In addition two blobs of sealing wax have been fixed to the back of the case; each holds a coil of wire which supports the cross at two points, and each is stamped 'VR [Victoria Regina] SOUTH KENSINGTON MUSEUM SCIENCE AND ART DEPARTMENT', indicating that the case pre-dates 1901.

Christ is suspended from the cross, his eyes closed, with no wound in his side, the palms of his hands and his feet (the right foot placed over the left) fixed by three wooden pegs. Two similar pegs hold the INRI scroll on the cross above his head. The pegs seem to be contemporary with the figure. The joints at the shoulders show that the arms are two separate pieces of wood adjoined to the body. The nipples also seem to have been added separately. The cross is fashioned as a rugged tree trunk with peeling bark. Although some of the brown-coloured wood has been left bare, the combination of black and white pigment on the cross, painted in irregular rings, is reminiscent of a silver birch tree. These rings are discontinued below Christ's feet.

When accessioned in 1864, Robinson wrote of this piece: 'Carved and painted wood Crucifix – ascribed to Alonzo [*sic.*] Cano. Spanish 17th century sculpture of unusually delicate & highly finished execution. Entire height 9 inches.'[1] This report suggests that at that time the crucifix was uncased (9 inches is equivalent to 23 cm; the height of the case is 30.8 cm). Robinson's attribution seems to be substantially correct, in that it is probably contemporary with the work of Alonso Cano (1601–1667), and was almost certainly made in Andalusia, although it is unlikely to be by Cano himself.[2] Although purchased in Zamora (north west of Madrid, near the Portuguese border), the work probably originates from Andalusia.

This small figure is technically typical of seventeenth-century Andalusian wood sculpture in that it is a virtuoso piecing together of wood, from such small elements as the thorns fitted into the crown, the nipples, and the pegs holding body and scroll, to the larger parts such as the arms joined to the body, and the illusionistic cross itself. The face, hands and feet are meticulously carved. It is notoriously difficult to attribute crucifix figures, due to the relatively narrow range of iconographic variants for the subject matter. The facial type of the Christ figure and the style of loincloth imply that it must date from the mid-seventeenth century. The size suggests parallels with ivories; such finely worked pieces in wood are comparatively rare.[3] However one explanation of the small scale may be that this piece was originally held by a lifesize figure of a saint; a similarly finely-worked crucifix was made for Pedro Roldán's *St Ignatius Loyola* now in the National Museum of Sculpture in Valladolid,[4] and for Pedro de Mena's *St Mary Magdalene*, housed in the same museum (see fig. 12).[5] Although there are no clear signs that the cross was once fixed in any way within the hand of such a figure, the fact that the painted birch-like rings stop just below Christ's feet suggests that the lower part of the central stem was perhaps concealed by a hand holding it.

BIBLIOGRAPHY

Inventory 1864, p. 13.
Inventory 1852–67, p. 18.

NOTES

1. Robinson Reports, I, Part I, p. 144. See Introduction, p. 6.
2. Cf the treatment of the face of St Paul by Cano in Granada Cathedral (*Alonso Cano Centenario*, II, pl. XIX), and his crucifix surmounting the retable at the church of St Mary at Lebrija (Seville) (M. E. Gómez-Moreno, 'En torno al Retablo de Lebrija', *ibid.*, I, pp. 214–15 and plates 82–3). Both these pieces are much larger than the present one, but nevertheless provide appropriate stylistic comparisons.
3. Cf the slightly earlier ivory crucifix attributed to the circle of the Granada sculptor Pablo de Rojas (*c.* 1560–after 1607) in the Museum of Fine Arts, Granada. *Escultura en Andalucía*, pp. 96–9.
4. Inv. no. 1126.
5. *Pedro de Mena* 1989, p. 101.

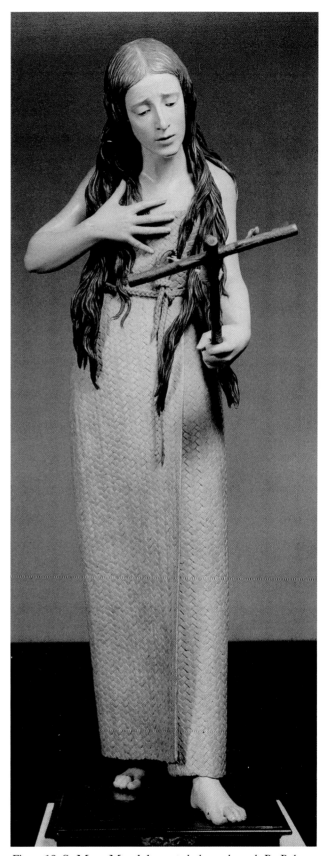

Figure 12. St Mary Magdalene, *polychromed wood. By Pedro de Mena. Museo del Prado, Madrid.*

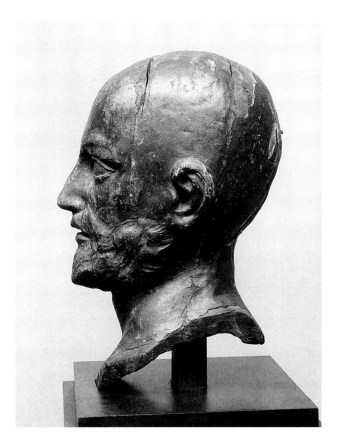

Florentine, middle of the sixteenth century, and was so published in Maclagan and Longhurst's *Catalogue of Italian Sculpture* in 1932. It was however omitted from Pope-Hennessy's 1964 catalogue of Italian sculpture, and is recorded as Spanish in Museum records, although it has not been subsequently published. Its facial features recall the works of Alonso Cano (1601–1667) and of Pedro de Mena (1628–1688), and it may well have been produced in Granada or Seville during the mid-seventeenth century.[1] Without iconographical attributes it is difficult to identify the subject; the beard and moustache suggest it could be a Jesuit saint such as St Ignatius Loyola or St Francis Borgia.[2]

BIBLIOGRAPHY
Maclagan and Longhurst, p. 139.

NOTES
1. Cf Alonso Cano's *S. Pedro Alcantara* in the Museum of Fine Arts, Granada, and Pedro de Mena's *S. Diego de Alcalá* in the church of the convent of St Antony Abbot in Granada (*Alonso Cano Centenario*, II, pls. XVII and LXXVI).
2. Cf the statues of these saints by Juan Martínez Montañés (1568–1649) in the University Church in Seville (Gilman 1967, pp. 76–8 and figs. 86, 88, 89 and 91).

31. HEAD OF A JESUIT SAINT

PAINTED LIMEWOOD (OR PERHAPS POPLAR) AND CANVAS

ANDALUSIA; about 1650–1700

Inv. no. A.2–1916

H. 33 cm. D. 17.5 cm.

Provenance
Given by A. G. B. Russell Esq., Rouge Croix in 1916.

Condition
There has been much paint loss, and the wood appears to have been stained brown. Some of the original paint has been consolidated; there are signs of overpainting in some areas, notably the eyes and beard. The pink flesh colour also appears to be later painting over an original cream colour. In addition there are signs of woodworm damage. The head is of three hollowed pieces, consisting of the face, the centre, and the back of the head, the joins strengthened with canvas. A gash in the back of the head may be a natural fault in the timber, which would have been concealed if the figure had worn a cap or wig.

The head is of a young man with a beard and moustache. The way in which it is made suggests that it was formerly part of a dressed figure (an *imagen de vestir*). It would have been fixed to a dressed dummy, and would probably have worn a wig or head-covering.

When first acquired, the head was described as

32. HEAD OF A MALE SAINT (CHRIST?)

PAINTED ALDER

ANDALUSIA/THE CANARIES?; about 1650–1700

Inv. no. A.118–1920

H. 28.7 cm.

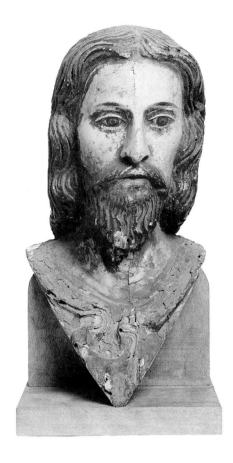

Provenance
Given by Frank Green Esq. of the Treasurer's House, York in 1920. Perhaps previously in South America (see below).

Condition
The piece has been subject to former insect attack; tunnels made by a large worm run through the length of the hair. The back and a join running up through the centre of the piece show signs of previous damp. The paint is flaking in some areas, and the costume has been overpainted. A filled hole in the back of the head may have been intended for a fixing for a halo. The base of the piece tapers into a v-shaped point, probably because the head has been sawn from what may have been a bust or a full-length figure.

The bearded head, probably Christ, is shown with his mouth slightly open; the hair and facial features are stylised. The original bright colours of the collar are just visible beneath the later overpaint.

When first acquired by the Museum, Eric Maclagan of the Department of Architecture and Sculpture, wrote: 'This is a painted wooden head of Christ, from S. America; Spanish work of the 17th (or even perhaps 18th) century. It looks as if it had been made to stick into a rough figure dressed in real clothes. I do not think it particularly interesting, but I suppose we had better accept it from Mr Green.'[1]

Although there are parallels with sculpture from Spanish America, such as an eighteenth-century figure of Christ from Salta, Argentina,[2] the type of wood implies the piece is European,[3] and it is probably a provincial Andalusian piece, or perhaps comes from the Canaries.[4] It is likely to date from the second half of the seventeenth century. Maclagan's comments noted above may imply that it had been previously exported to South America.[5]

NOTES
1. Minute of 6 August 1920. Museum papers: Frank Green Nominal File.
2. Gori and Barbieri, p. 38, fig. 22.
3. It is almost certainly the European alder *Alnus glutinosa* (L.). I am grateful to Josephine Darrah for analysing and identifying the wood.
4. Cf the dressed figure of a male saint in the church of the former Franciscan convent at Garachico, Tenerife (Calero Ruiz, unnumbered plate), and the figure of Christ by Fernando Estévez in the church of El Salvador, Santa Cruz de La Palma (Fuentes Pérez, fig. 25).
5. Cf. cat. no. 40.

SALVADOR GUTIÉRREZ DE LEÓN

(b. Málaga 1777; d. Málaga 1838)

Salvador Gutiérrez de León is thought to have spent the whole of his life in Málaga, and is most renowned for his small-scale terracotta figures, some of which formed nativity groups, while others illustrated local costumes. He also carved in wood, and his two life-size figures of St John the Evangelist and Mary Magdalene are in the trascoro of Málaga Cathedral. His son Rafael (1805–1855) worked with him, and continued running the workshop after his father's death.

BIBLIOGRAPHY

Ossorio y Bernard I, p. 325; Llordén, pp. 329–33; Pérez and Romero, p. 29, fig. 30 and p. 30.

33. A SHEPHERD BOY

PAINTED TERRACOTTA

SIGNED 'LEON'

BY SALVADOR GUTIÉRREZ DE LEÓN (1777–1838)

MÁLAGA; about 1810–1838

Inv. no. 325–1866

H. 19.6 cm.

See plate 11

Provenance
Bought by John Charles Robinson in Madrid in 1865 for 4s 2d.

Condition
The right forefinger is missing, as are two of the left fingers (forefinger and little finger), and the tips of the two middle left fingers. There is a casting flaw in the base. The paint seems to be original, although the white shirt showing at the left shoulder may be a later re-paint, and on the hat there is slight damage, probably another casting flaw, and a small area of repainting. The underside of the base has been slightly hollowed out.

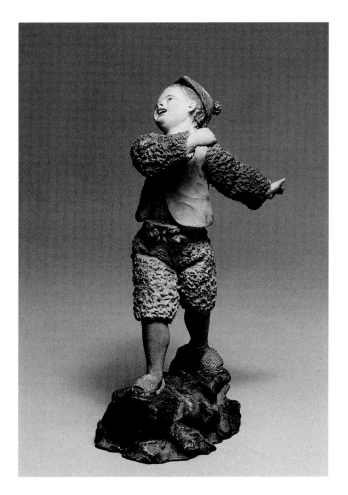

The young boy stands on a rocky base, with his right foot forward looking upwards, his mouth slightly open, showing his teeth. Both his hands gesture behind him, and the now-broken forefingers may have been pointing. He wears a yellow jerkin over a pink shirt laced at the front (although the left sleeve visible at the shoulder has been painted white), and a yellow belt with two pouches. His outer sleeves and breeches have a textured surface to simulate sheepskin, and he has a distinctive hat with two pom-poms. He wears rope sandals on his feet. In costume he resembles a description of a Spanish shepherd made by Francis Carter, an English traveller in Spain in the late eighteenth century: 'A Spanish shepherd is a most respectable figure; in the hottest as well as in the coldest seasons his dress is the same: a leather-waistcoat, short and laced before, upon which he wears a sheep's-skin with its fleece . . . his feet are always bare, and shod with hempen sandals; the Montero, or

Spanish cap, is both warm and convenient.'[1] Although the costume probably reflects what was worn by Andalusian shepherds in the first half of the nineteenth century, the pose of the figure suggests it is part of a narrative, and it probably came from a group representing the *Annunciation to the Shepherds*, or perhaps the *Adoration of the Shepherds* (see below).

The present piece forms part of the tradition of clay figures made to be sold to relatively wealthy visitors to the area in the late eighteenth and early nineteenth

century. In his autobiography, John Ruskin (1819–1900) – whose father was a London wine-merchant with Spanish contacts – recalled that as a child in South London (presumably during the 1820s) he played with 'Spanish . . . baked clay figures, painted and gilded by untaught persons who had the gift; manufacture mainly practised along the Xeres coast . . . then flourishing', which his parents had brought back from Spain.[2] The precursors of such figures are the Neapolitan crib-groups; by the late seventeenth century small-scale terracotta nativity groups were being produced in Spain, for example by Luisa Roldán (1652–1706), and the type was perfected by Francisco Salzillo (1707–1783) in Murcia.[3] Robinson purchased the present figure in Madrid some years after the flourishing of the manufacture of such pieces, when their intrinsic interest as finely modelled works was appreciated, as well as their specific associations with Málaga. The local clay is slightly yellow (as is the clay of the present figure), and particularly suited to modelling and firing. In 1780 Carter remarked, 'Malaga yields a clay, which is inimitable for the composition of images, as it not only receives and preserves every impression, but maintains itself without cracking in the oven, where they obtain an hardness and solidity equal to porcelain. The Spanish colour and varnish them very highly.'[4]

This is the only signed Spanish piece of sculpture in the collection. The signature 'Leon' is on the back beneath the figure's left heel. On acquisition Robinson noted that the sculptor was 'a celebrated modeller in this style', and called it 'Spanish, early present century'. In 1957 in correspondence Peter Winckworth identified the sculptor as one of a school of clay-modellers active in Málaga during the late eighteenth and early nineteenth century, and cited a number of early references made by English travellers at that time.[5] Winckworth named the sculptor 'Rafael Guitérrez de León Atane',[6] which was presumably a misspelling for Rafael Gutiérrez de León (1805–1855), a successful local sculptor.[7] Widdrington noted

however that the clay figure manufacturer León had died by 1843,[8] and the early references to the León who made the clay figures show that although Rafael was a member of the workshop, it was his father Salvador who ran the studio, and was the sculptor to be primarily identified with such figures. For this reason, although Rafael collaborated with his father, the present figure is more likely to be primarily the work of his father.[9]

BIBLIOGRAPHY

Inventory 1852–67, p. 28.
Riaño, p. 3.
Loan Exhibition, p. 115, no.723.
Baker 1984, fig. 4.

NOTES

1. Carter, II, p. 419.
2. J. Ruskin, *Præterita* II (1886–7), in E. T. Cook and A. Wedderburn (eds), *The Works of John Ruskin*, XXXV, London, 1908, p. 348. I am grateful to Xanthe Brooke for this reference.
3. Cf cat. nos. 27 and 54. See Sánchez Moreno 1983, pp. 78–79 and 174–83 and F. Flores Arroyuelo, 'Del *Presepio Napoletano* y del *Belén* de Salzillo' in *Salzillo* 1983, pp. 144–52.
4. Carter, II, p. 417.
5. Registered papers held at the Victoria and Albert Museum; see also Winckworth, pp. 106–8.
6. *Ibid.*, p. 106.
7. See Ossorio y Bernard, I, p. 325. Here the figures of St John and Mary Magdalene in Málaga Cathedral are erroneously ascribed to Rafael; they are in fact by his father Salvador.
8. Widdrington 1844, I, pp. 306–7.
9. A slightly larger painted terracotta figure of a *Contrabandista* (h. 40 cm) signed 'Leon' is in the collection of the Hispanic Society of America, inv. no. LD 146 (unpublished); stylistically it is analogous to the present work, and it too is believed to be by Salvador de León. In the same collection is a pair of terracottas, the *Bolero Dancers* inv. nos. D863 (h. 31.7 cm) and D864 (h. 32.7 cm) (both unpublished), which are also convincingly attributed to Salvador de León, although these are unsigned. I am grateful to Constancio del Alamo for the information on these pieces.

Seville

The capital of Andalusia, Seville had important naval links with the Spanish colonies; works of sculpture, such as those by Juan Martínez Montañés (cf cat. nos. 37 and 40) were exported from the city to South America, and the wealth deriving from overseas possessions led to innumerable commissions for sculpture as well as architectural projects and painting.

The tradition of sculpture in terracotta was established in Seville by the late fifteenth century through the work of artists such as Lorenzo Mercadante de Bretaña, Pedro Millán (cat. no. 34), and by the immigrant Florentine sculptor Pietro Torrigiani (1472–1528). However during the second half of the sixteenth century wood sculpture was far more common, and a distinctively Sevillian style,

classicizing and at the same time naturalistic, was established (cat. no. 35).

By the early seventeenth century the more emotive and powerful work of Juan Martínez Montañés (cat. no. 37) and Juan de Mesa (1583–1627) respectively dominated the field. Among the most important sculptors of the second half of the seventeenth century wood were Pedro Roldán, and later his daughter Luisa (cf cat. no. 27). Once again terracotta came into vogue (cat. no. 39).

Although eighteenth-century Sevillian sculpture is barely represented in the collection (cf cat. no. 41), the rich altarpieces produced by artists such as Pedro Duque Cornejo (1678–1757) continued the flourishing baroque tradition established by Pedro Roldán.

PEDRO MILLÁN
(b. Seville (?) about 1450/5; d. after 1515)[1]

Pedro Millán was active in Seville from 1487 (when a document refers to his wife's purchase of a house) to 1515, and was almost certainly native to the city. His teacher is unknown, although Ceán Bermúdez stated that he was the pupil of Nufro Sánchez (active in Seville 1464–1505). No documentary evidence survives to corroborate this. His work was certainly influenced by the terracotta sculpture of Lorenzo Mercadante de Bretaña (active in Seville 1454–1467). Millán specialized in terracotta, a material particularly favoured for sculpture in Seville. As well as the work discussed below, his pieces include two prophets on the *Baptism* portal of Seville Cathedral, the *Virgin of the Pillar* in Seville Cathedral, *Christ Man of Sorrows* and the *Entombment*, both in the Museum of Fine Arts in Seville, and the glazed terracotta roundels on the portal of Santa Paula in Seville. Apart from a lost *Lamentation* group (thought by Pérez-Embid to be possibly in Leningrad), the *St George* is the only known work by Millán outside Spain.

BIBLIOGRAPHY
Ceán Bermúdez, III, p. 154; Gestoso y Pérez; *Ars Hispaniae* VIII, pp. 367–73; Pérez-Embid.

NOTE
1. Professor Jesús Palomero has recently discovered a documentary reference indicating that Pedro Millán acted as godfather at the baptism of Juana, daughter of Juan de Roças (Rozas) the architect's assistant (*aparejador*) of Seville Cathedral, on 27 December, 1515. (Archivo Parroquial del Sagrario, Libro I de Bautismos (1515–24), 27 recto). I am most grateful to Professor Palomero for giving me this previously unpublished reference.

34. ST GEORGE (PREVIOUSLY KNOWN AS ST MICHAEL)

PAINTED TERRACOTTA

BY PEDRO MILLÁN

SEVILLE; around 1487–1515

Inv. no. A.6–1943

H. 91 cm. W. 26 cm.

See plate 12

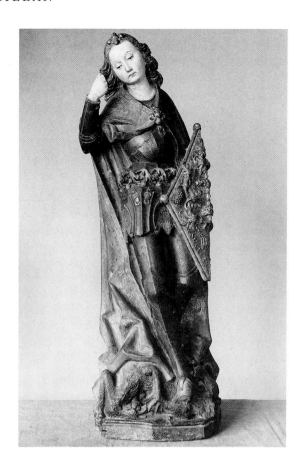

Provenance

Said to come from the Dominican Convent of S. Florentina at Écija (Seville) (see Hernández Díaz 1951, *loc.cit.* in bibliography for this entry); Don José de Irueta Goyena Collection, 1884–before 1923; 'Private Collection, Seville' (so described in von Loga 1923, *loc.cit.* in bibliography for this entry) (perhaps Irueta Goyena Collection) 1923–before 1927; whereabouts unknown 1927–1943 (Pijoan, *loc.cit.* in bibliography for this entry (1927) says it 'has now been carried off to a foreign land'; Rafols, *loc.cit.* in the bibliography for this entry (1942) described it as forming part of a North American collection); sold by P. Pelosi at Sotheby's, London, 16th April, 1943, lot 98; bought by Dr H. Burg (£60); bought from Dr Burg by the National Art-Collections Fund 1943 (£400) and presented by the Fund to the Victoria and Albert Museum in 1943.

Condition

The hollow figure was probably cast from a piece mould. The terracotta is approximately 2.5 cm thick, and the top of the figure has been filled with plaster infill, perhaps to prevent a breakage occurring, or to give extra support where a fault was visible. The present polychromy is not original, and is the result of heavy overpainting. The statue was cleaned and some later paint removed shortly before the Museum acquired the figure in 1943, and was cleaned again at the Museum in 1955. At that time it was noted that the cloak (but no other part of the figure) was coated with white ground, the painted border on the ground being of a different design from the modelled border underneath. Some of the cloak is covered in later brown paint. Minute remains of an original colouring of brilliant blue (perhaps ultramarine) can be seen in the border of the cloak. Parts of the statue have been damaged: the lance is missing, as are the fingers and thumb of the right hand, and the toes of the right foot.

The youthful saint is shown wearing armour under a cloak held by an elaborate clasp, and trampling a dragon-like creature underfoot. The armour is probably Milanese, dating from about 1480.[1] His shoulder-length hair is held by a band adorned with a fillet, decorated with a rosette similar to the clasp holding his cloak.[2] He leans towards his right, and originally held a lance in his right hand, which entered the dragon at his feet, and with which he appeared to support himself; this is now missing, and has been since the figure was first published in 1884.[3] On the shield, a cross standing on a crown of thorns surrounded by a vine is depicted in relief, imagery evoking the Passion of Christ. Previously described as *St Michael*, the iconography suggests the more likely identification is *St George*, primarily because

the saint is without wings.[4] Both St George and the Archangel Michael may be shown as young warrior-saints overcoming a dragon; sometimes the former is shown on horseback, or with the princess, and sometimes the latter is shown holding scales. Either one may be depicted (as here) standing unaccompanied, defeating the dragon with a lance. However, only exceptionally is Michael shown wingless.[5] It has previously been argued that Pedro Millán portrays angels without wings, for example in his figure-group of *Christ as Man of Sorrows supported by angels*.[6] This does not seem a sufficiently strong reason for calling this figure *St Michael*. Neither is there any known early reference to the piece as St Michael (it was first claimed as such only in 1884 by Gestoso, without any discussion), and for the reasons outlined above, it seems more likely that it represents St George.

The work is signed in gothic lettering: 'põ millã' on the lower part of the shield. The same signature appears on other works by Pedro Millán: on the girdles of two seated monks near the jambs of the West Door of Seville Cathedral, and on the Virgin of the Pillar also in Seville Cathedral.[7] Stylistically, the closest piece to the present one is the *Christ as Man of Sorrows supported by angels* (referred to above) in the Museum of Fine Arts in Seville.[8] This is also signed, though in a slightly different form: 'Põ Millán, ymaginero'. Both the figure of Christ and that of St George appear to lean back to their right, while the features, hair

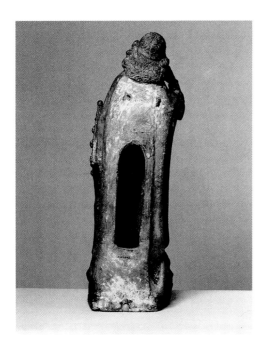

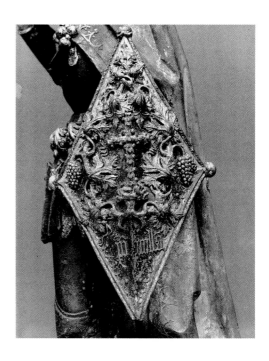

and headdress of St George strongly recall those of the two angels supporting the Christ figure. Although Gestoso dated the present figure to *c.* 1480–86, Pérez-Embid rightly stated that adequate reasons were not given for this. None of Millán's works is securely dated, and the present piece can only be put within his period of known activity (1487–1515).

BIBLIOGRAPHY

Gestoso y Pérez, frontispiece, and pp. 48–57.
Dieulafoy, pl. LX and p. 150.
von Loga, pp. 14–15, pl. 7.
Pijoan, p. 446, fig. 696.
Thieme-Becker, XXIV, 1930, p. 561.
Rafols, p. 525.
Thring, pp. 253–5.
NACF 1943, p. 11 (no. 1319), and unnumbered illustration on p. 10.
Gómez-Moreno 1951, p. 62.
Hernández Díaz 1951, p. 327, note 541.
Ars Hispaniae, VIII, p. 368.
Pérez-Embid, pp. 41, 42, 54, 66, 73–6, pl. 19, 20.
Escultura en Andalucía, p. 13.
Reyes y Mecenas, p. 391.
Pareja López and Megía Navarro 1990, pp. 359–60 and p. 357, fig. 332.
Pareja López 1991, p. 78.
Yarza Luaces, p. 304.
Trusted 1993, pp. 321–3, pl. I.

EXHIBITED

Grosvenor House Antiques Fair (National Art-Collections Fund 80th Anniversary Exhibition), Grosvenor House Hotel, Park Lane, London, June 10th–19th, 1983, no. 9.

NOTES

1. I am grateful to Anthony North for this information; he particularly noted the fluted thigh defences, and the accuracy of the straps holding the shield.

2. Cf the rosettes on the circlet worn by the figure of *St Agnes* attributed to Millán in the Royal Monastery of St Agnes, Seville; *Reyes y Mecenas*, p. 391, cat. no. 130.

3. See Gestoso y Pérez, frontispiece.

4. See LCI, 6, p. 380: 'Unter d. ca 55 Drachenkämpferhll. nimmt Georg n.d. Erzengel Michael i. Abendl. d.1. Platz ein, alle anderen hll. Reiter verdrängend.' See also the whole entry on St George in this volume (pp. 366–90), and *ibid.*, 8, pp. 256–66, for the entry on the Archangel Michael. The figure was described as St George in the Sotheby's sale catalogue (see Provenance), and a letter from Sir Eric Maclagan to Sir Robert Witt, Chairman of the National Art-Collections Fund, of 7th June 1943, a copy of which is held at the National Art Collections Fund, notes, 'It is generally described as St Michael, but I am inclined to think in spite of the long hair that it must be intended for St George.' In subsequent publications it is nevertheless described as St Michael, e.g. Thring, pp. 253–5; *Ars Hispaniae*, VIII, p. 368; Pérez-Embid, pp. 41, 42, 54, 66, 73–6. M. E. Gómez-Moreno, who mistakenly believed it to be in America, calls it St George or St Michael (Gómez-Moreno 1951, p. 62). Cf also the late fifteenth-century Spanish figure in polychromed wood of the winged *St Michael* in the Art Museum of the University of Princeton (accession no. 44–100), and the slightly later Castilian statue of St. George in the Cloisters Museum, New York (inv. no. 53.65).

5. Depictions of St Michael without wings include: a painting (School of Castile, *c.* 1465) showing St Michael without wings, but holding a pair of scales, which was in the Collection don José Lazaro. (Photograph in the Warburg Institute Photograph Library). A German terracotta sketch-model attributed to J.S.B. Pfaff of about 1780 in the Landesmuseum in Mainz (inv. 0, 1398) also shows St Michael without wings (conquering a devil rather than a dragon). Other known sculptural representations of the saint which appear to lack wings have in fact lost them, and slots remain in the back of the figure. Cf the fourteenth-century French wood *St Michael* in the Victoria and Albert Museum, inv. no. 526–1895 (Williamson 1988, pp. 118–21, cat. no. 34).

6. Thring, p. 253.

7. Pérez-Embid, figs. 2 and 3, and fig. 10.

8. *Ibid.*, fig. 11, and Pareja López 1991, pp. 82–3.

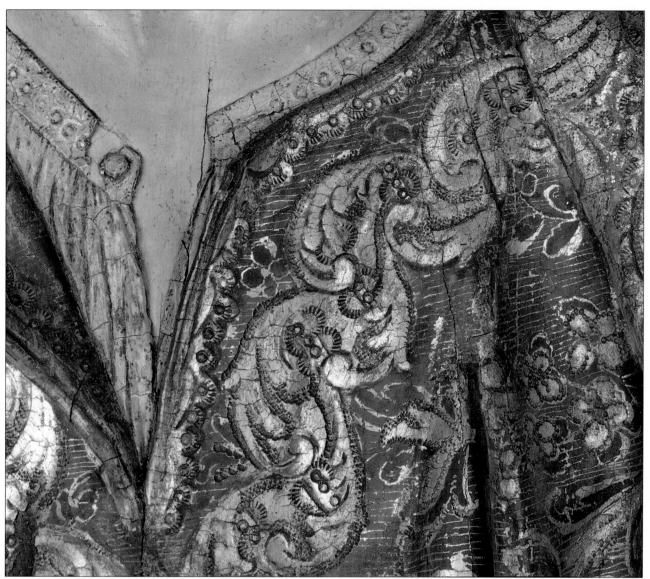

Plate 1. Detail of surface decoration, St Joseph *by Francisco Salzillo (cat. no. 54).*

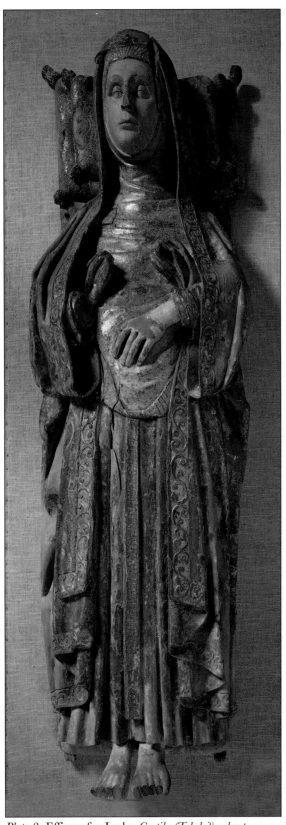

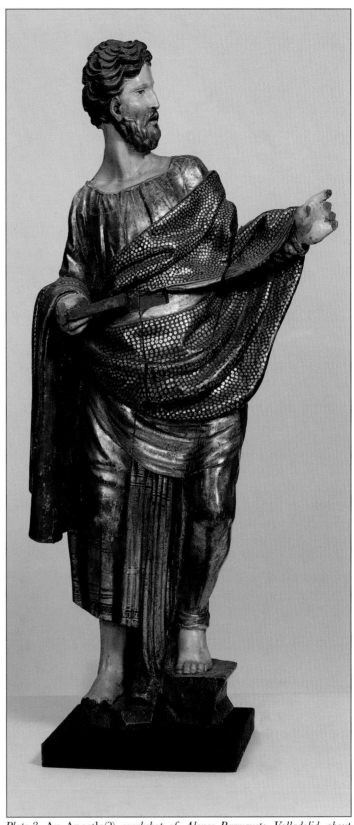

Plate 2. Effigy of a Lady, *Castile (Toledo?), about 1490–1510 (cat. no. 2).*

Plate 3. An Apostle(?), *workshop of Alonso Berruguete, Valladolid, about 1526–33 (cat. no. 11).*

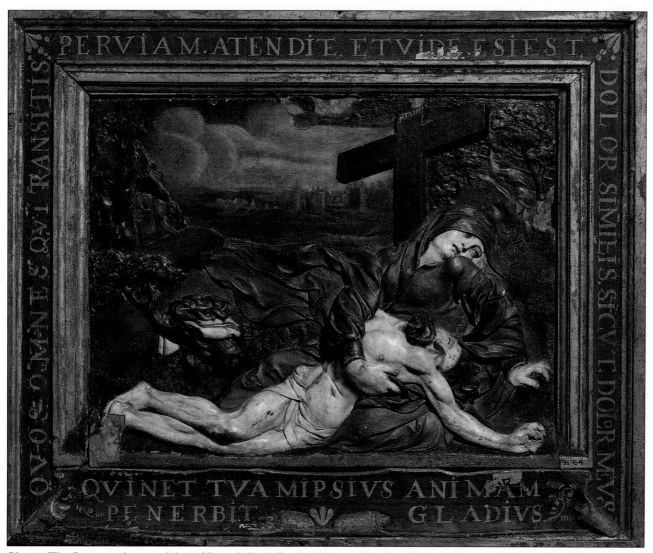

Plate 4. The Lamentation, *workshop of Juan de Juni, Castile (Salamanca?), about 1540–50 (cat. no. 14).*

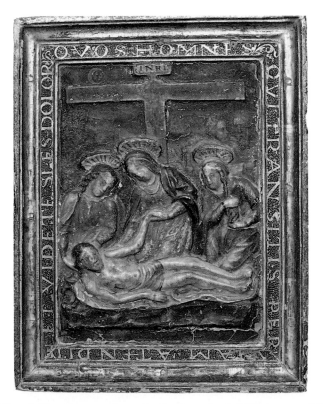

Plate 5. The Lamentation, *Castile, frame dated 1567 (cat. no. 15).*

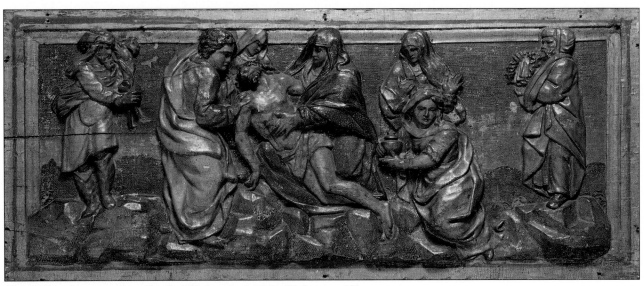

Plate 6. The Lamentation, *Castile (Toledo), about 1560–70 (cat. no. 18).*

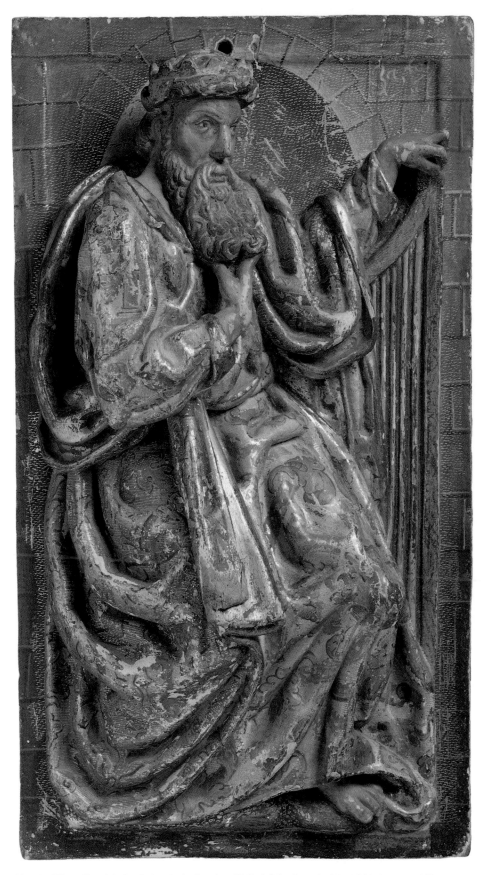

Plate 7. King David, *by Pedro de la Cuadra, Valladolid, about 1590–1610 (cat. no. 19).*

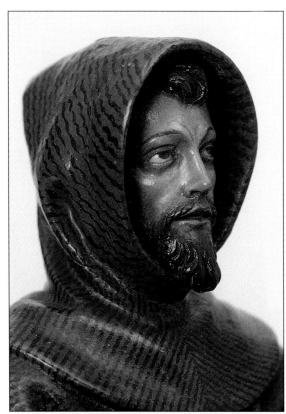

Plate 8. St Francis of Assisi, *after Pedro de Mena, Castile, about 1720–40 (cat. no. 24).*

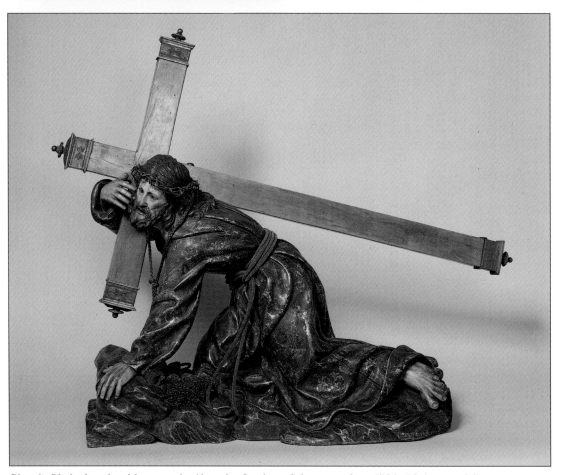

Plate 9. Christ bearing his cross, *by Alexandro Carnicero, Salamanca, about 1720–56 (cat. no. 26).*

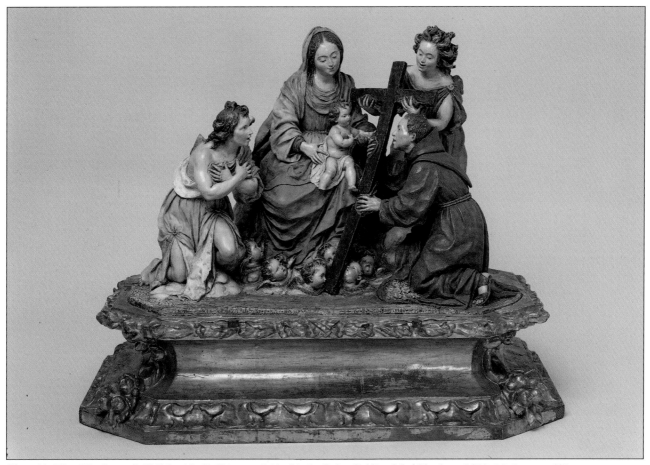

Plate 10. The Virgin and Child with St Diego of Alcalá, *by Luisa Roldán, Madrid, about 1690–95 (cat. no. 27).*

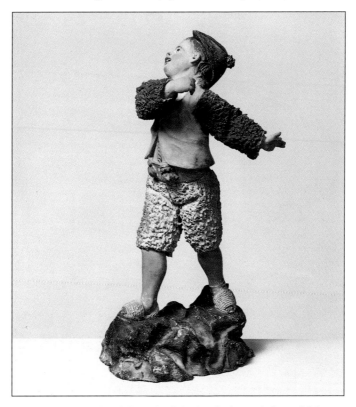

Plate 11. A Shepherd Boy, *by Salvador Gutiérrez de Léon, Málaga, about 1810–38 (cat. no. 33).*

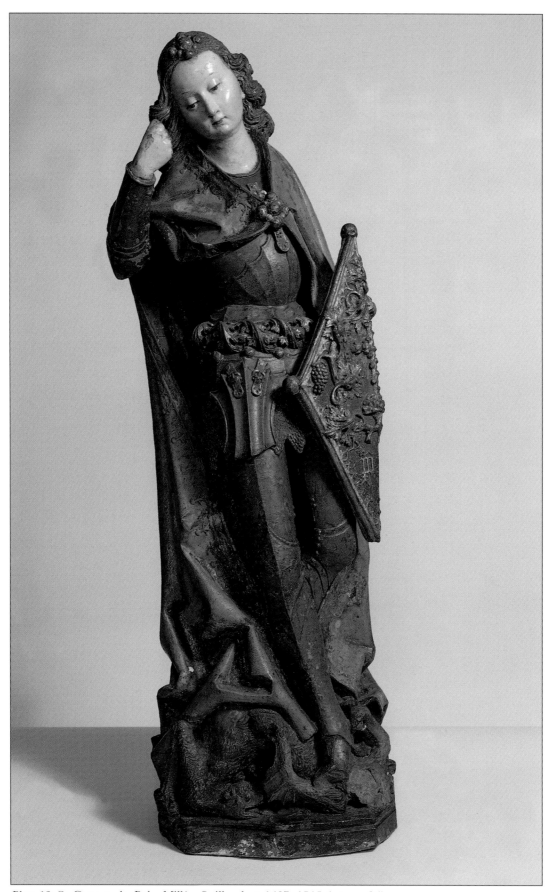

Plate 12. St George, *by Pedro Millán, Seville, about 1487–1515 (cat. no. 34).*

Plate 13. The Virgin and Child, *Seville, about 1650–1700 (cat. no. 38).*

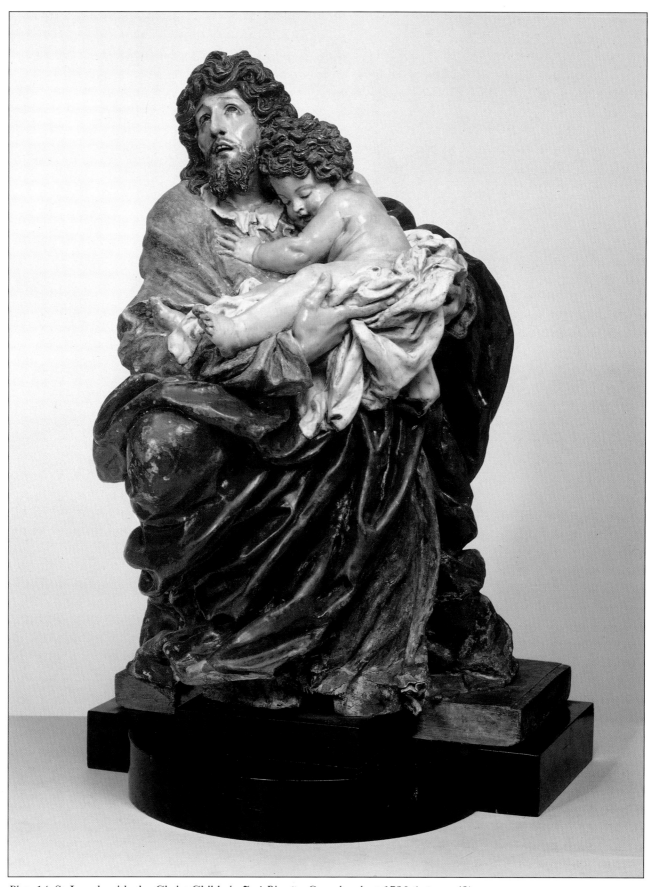

Plate 14. St Joseph with the Christ Child, *by José Risueño, Granada, about 1720 (cat. no. 42).*

Plate 15. The Christ Child or the Infant St John the
Baptist, *circle of José Risueño, Granada,
about 1700–35 (cat. no. 43), (front).*

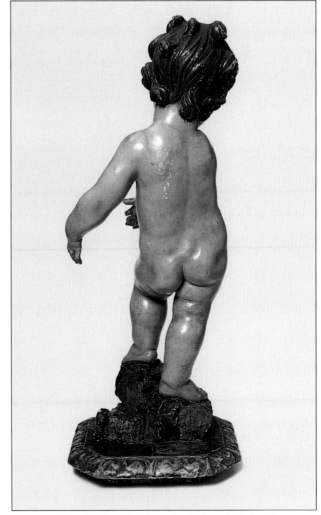

Plate 16. The Christ Child or the Infant St John the
Baptist, *circle of José Risueño, Granada,
about 1700–35 (cat. no. 43), (back).*

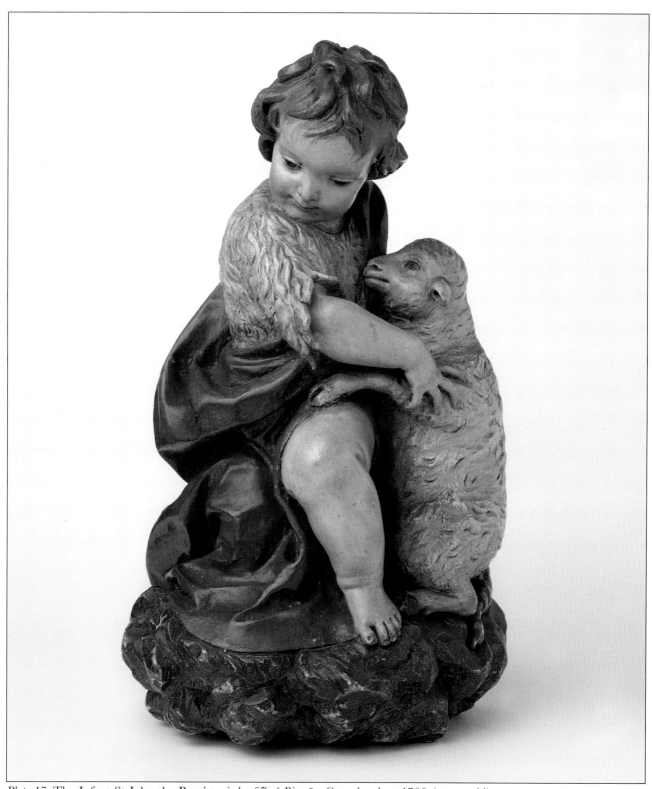

Plate 17. The Infant St John the Baptist, *circle of José Risueño, Granada, about 1700 (cat. no. 44).*

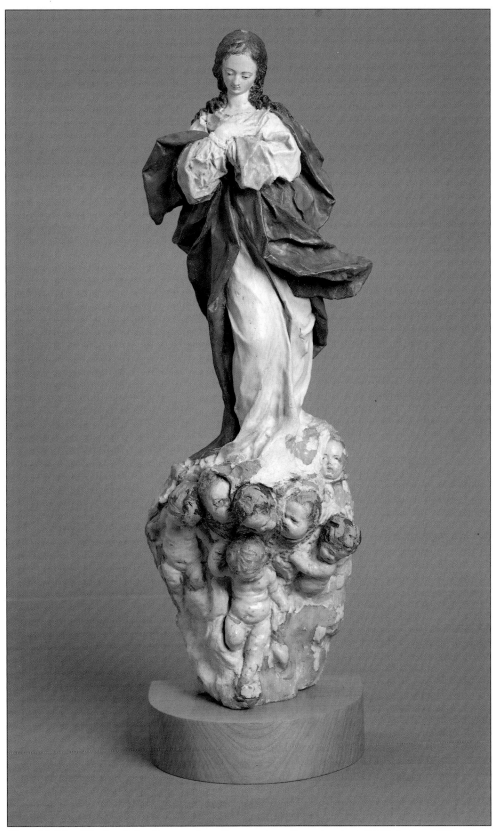

Plate 18. The Virgin of the Immaculate Conception, *Granada, about 1700 (cat. no. 48).*

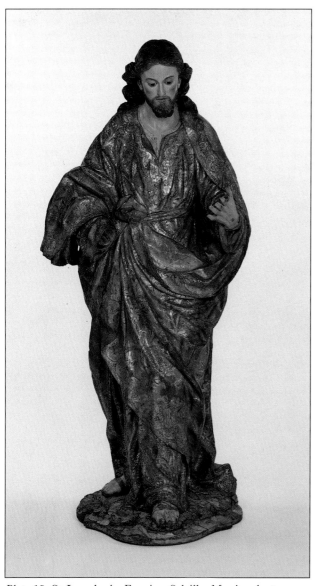

Plate 19. St Joseph, *by Francisco Salzillo, Murcia, about 1760–70 (cat. no. 54), (front).*

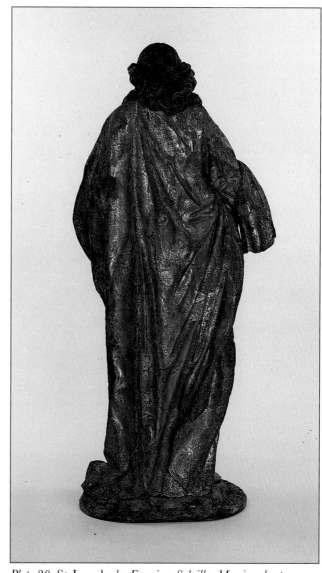

Plate 20. St Joseph, *by Francisco Salzillo, Murcia, about 1760–70 (cat. no. 54), (back).*

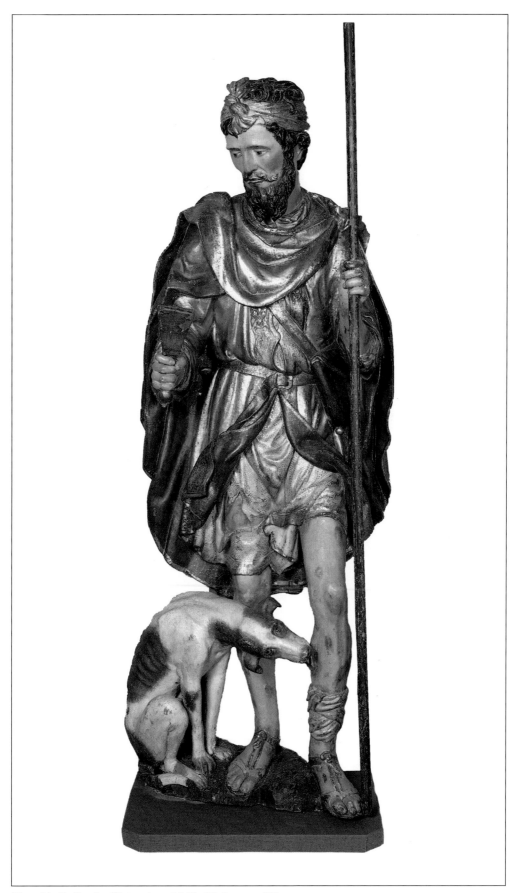

Plate 21. St Roch, *Rioja, about 1540–50 (cat. no. 60).*

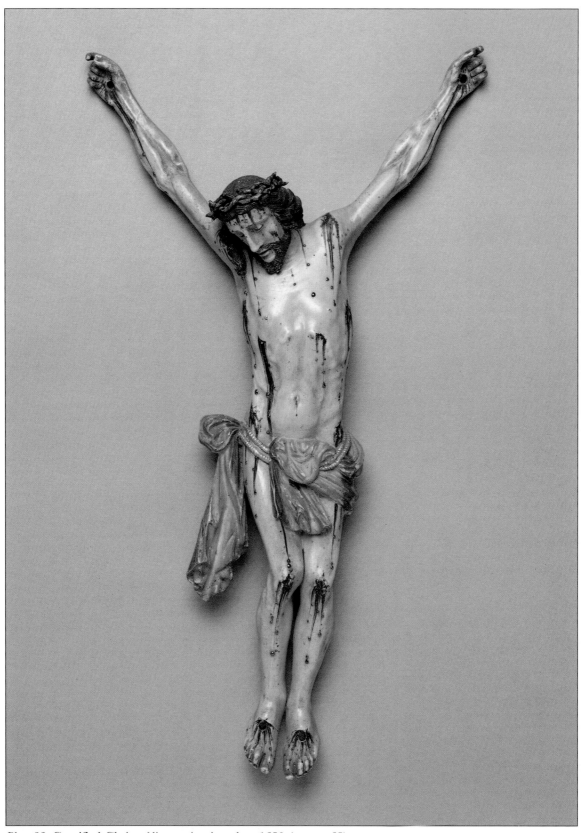

Plate 22. Crucified Christ, *Hispano-America, about 1650 (cat. no. 65).*

35. MOURNING FEMALE FIGURE (PROBABLY THE VIRGIN)

PAINTED AND GILT LIMEWOOD

SEVILLE; about 1550

Inv. no. A.7–1960

H. 126 cm.

Provenance
Bought from Messrs Barling of Mount Street Ltd, 111–112 Mount Street, London, W1 in 1960 for £500.

Condition
The whole figure has been overpainted: the robe, veil and left foot are gilded over red bole. The lining of the cloak may be tarnished silver. It is uncertain whether the present surface reflects the original colours. The back is relatively plainly carved, and has a thick layer of terracotta-coloured paint. The right hand is missing,[1] as is the tip of the right foot. There are some holes in the back, some of them probably signs of former insect infestation. A larger hole and slightly smaller hole have been drilled into the top of the head; the larger one may have been used for the fixing of a halo. A hook is fixed into the centre of the back; an old label glued to the back is inscribed '11'. The underside of the base has a carved hollow depression and a dowel hole.

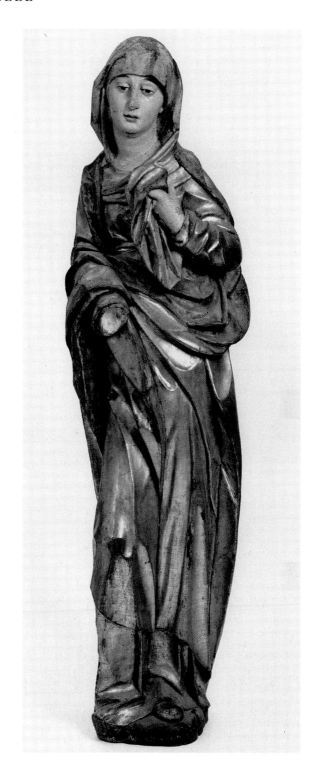

The figure stands resting on her left leg, her left foot just visible, her right foot stepping forward. She holds her veil with her left hand, and looks solemnly downwards, her head inclined slightly to her left.

If the existing polychromy reflects an original gold colouring, this figure is unlikely to have been a representation of the Virgin Mary (who is generally dressed in red and blue, with a white veil in scenes of the Passion), and could be one of the mourning Marys from a Lamentation group. If however the authentic colours were red and blue, it was almost certainly part of a crucifixion group, probably from an altarpiece. When acquired it was thought to be by a follower of Alonso Berruguete (*c.* 1489–1561),[2] and certainly its naturalistic yet classicizing style recalls aspects of his work and that of his followers. However much closer comparisons are provided by sculptors active in Seville in the second half of the sixteenth century.[3] The seated *Virgin of Peace* of 1577–8 by Gerónimo Hernández (*c.* 1540–1586) in the church of the Holy Cross in Seville exhibits the same grave classicism in the thick folds of drapery, and in the Roman nose and mouth of the Virgin,[4] while the *Virgin and Child* by the same sculptor in the parish church of Guillena (Seville) reflects the pose and drapery of the present figure.[5] The *Virgin and Child* (*Virgen de las Fiebres*) of about 1565 in the church of St Mary Magdalene, Seville shows similar features.[6] The more static pose of cat. no. 35 implies it is slightly earlier in date than these comparisons; it was almost certainly produced in Seville around 1550.

NOTES
1. This loss unfortunately occurred in about 1971; the Museum photograph taken in 1960 shows both hands.
2. Museum records.
3. I am grateful to Jesús Urrea for originally suggesting this piece may come from Seville.
4. Palomero Páramo, pl. II.
5. Hernández Díaz 1951 *Hispalense*, pl. XLV, fig. 51.
6. *Ibid.*, pl. XII, fig. 12.

36. ST CECILIA

PAINTED AND GILT OAK

SEVILLE; about 1610–30

Inv. no. 378–1890

H. 38.2 cm.

Provenance
Bought for £13 13s in 1890 (W. Maskell Sale, Christies, London, 25 July, 1890, lot 91).

Condition
This piece has been extensively re-painted, particularly the hair, flesh and cloak. Some of the paint on the robe and the underside of the organ has flaked off in the past, and has been consolidated. A layer of varnish has been applied. The figure is dowelled into a square socle, parts of which, including one corner, have been broken off and replaced. The right hand is missing, and the dowel hole for it has been plugged.[1]

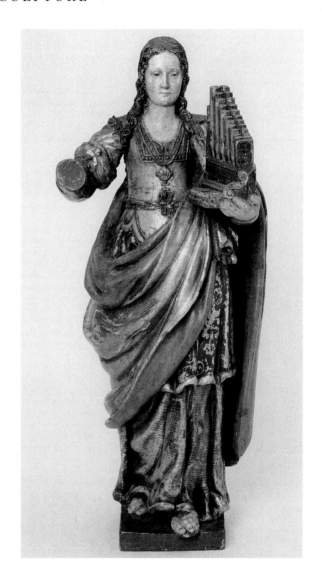

St Cecilia, looking slightly downwards, steps forward on her left foot, her right leg bent behind. She holds her right arm out; in her left she holds a small portable organ, similar to those found in fifteenth- and sixteenth-century paintings.[2] She is wearing a yellow bodice with a low square neck, short sleeves looped back above the elbow to reveal their blue lining, and a scalloped lower edge. The bodice has a decoration of rosettes at the shoulder, a decorated neckline, and a red ribbon as a girdle tied in a bow at the waist. A jewelled pendant is suspended round her neck, and the edge of a shift shows at her neckline. She wears a short skirt of blue and gold, with long, close-fitting sleeves of the same material showing through her bodice, and an under-petticoat striped in red and gold. Over the dress is a red and gold cloak lined with blue, with a turned-down collar; she has sandals on her feet.[3] Parts of the costume are worked in *estofado*, probably a later restoration, but likely to be close to the original decorative effect.

This statuette was almost certainly a single devotional work, rather than an element from an altarpiece; a seventeenth-century drawing in the National Library in Madrid shows a devotee of Sts Cosmas and Damian praying to two statuettes of approximately the same size as the present piece.[4] Although in scale and pose the figure recalls South Netherlandish figures of the sixteenth century, it is stylistically in accord with pieces made in Spain, particularly Andalusia, in the early seventeenth century. Work by the Seville sculptor Juan de Mesa (1583–1627) provides parallels, such as his larger *Virgin and Child* (the *Virgen de las Cuevas*) of 1624 in the Museum of Fine Arts, Seville, where the drapery and pose correspond to those of cat. no. 36; the delicate facial features of his *St John the Baptist* of the same date in the same museum are comparable with the face of the present figure.[5] The distinctive courtly costume recalls those in the series of female saints painted by Francisco de Zurbarán (1598–1664), for example his *St Margaret* of c. 1634–5 in the National Gallery, London.[6]

BIBLIOGRAPHY
Maskell, pl. XXXII, fig. 1.

NOTES
1. A Museum photograph of 1921/2 shows the hand present, but this was almost certainly a nineteenth-century restoration, subsequently removed.
2. For example a fifteenth-century painting of an angel with a portable organ from the church of S. Lorenzo el Real, Toro (Zamora) (*Edades de Hombre* 1991, p. 183, cat. no. 111), and an early sixteenth-century painting by the Maestro de Osma in the Capilla del Tesoro in the Cathedral of Burgo de Osma (*ibid.*, p. 143, cat. no. 73). This iconography establishes the identity of the saint. See LCI, 5, pp. 457–63.
3. I am grateful to Clare Brown for her detailed comments on the costume.
4. Angulo and Pérez Sánchez II, p. 45, no. 236 and pl. LXIV.
5. For the *Virgin*, see *Escultura en Andalucía*, pp. 62–3. For the *St John the Baptist*, see Hernández Díaz 1983, pp. 111–13, fig. 6.
6. Brown 1973, pp. 104–7, pls. 23 and 24.

JUAN MARTÍNEZ MONTAÑÉS

(b. Alcalá la Real (Jaén) 1568; d. Seville 1649)

Martínez Montañés trained in Seville, but also spent some time in Granada, probably working under Pablo de Rojas (1549–*c.* 1610?) in about 1579. Popularly known as '*el dios de la madera*' (the god of wood), Montañés executed wood sculpture which is remarkable for its technical brilliance. He also perfected a number of iconographical types which became seminal images. He was apparently both a profoundly religious man, whose altarpieces and figures closely followed the tenets of the Council of Trent, and an arrogant and temperamental artist. Settling in Seville in 1587, he executed numerous altarpieces and individual figures of saints, some for the city, and others exported to South America. He designed the architectural frameworks of his altarpieces, but was not a painter. Among the polychromists he worked with was the artist and theorist Francisco Pacheco (1564–1644). In 1635 he was called to the Court in Madrid to model the bust of Philip IV, which was sent to Florence to be used for the bronze equestrian portrait of the King cast by Pietro Tacca (1577–1640), which is now opposite the Royal Palace in Madrid. Among his most important works are the crucifix figure in Seville Cathedral (the *Cristo de la Clemencia*) of 1603, and his *St Dominic* of 1605, made for the Convent of Portaceli and now in the Museum of Fine Arts, Seville. This, like his later figure of *St Jerome* of 1609–13 from the altarpiece made for the monastery of Santiponce, Seville, are clearly in the tradition of the terracotta figure of *St Jerome* by Pietro Torrigiano (1472–1528), originally made for the church of the Royal Monastery of Guadalupe in 1526, and now also in the Museum of Fine Arts, Seville. Martínez Montañés's figure of the Christ child made for the confraternity of the Holy Sacrament in 1606 codified an existing type, and was widely emulated by later Andalusian artists. Similarly his *Virgin of the Immaculate Conception* made in the same year for the church of Santa María de la Consolación, El Pedroso (Seville) was reproduced in variant forms by himself and others (see below).

BIBLIOGRAPHY

Palomino *Lives*, pp. 106–7; Ceán Bermúdez III, pp. 84–94; Gilman 1967; Martín González 1983, pp. 131–53; Hernández Díaz 1987.

37. THE VIRGIN OF THE IMMACULATE CONCEPTION

PAINTED LEAD

AFTER JUAN MARTÍNEZ MONTAÑÉS

SEVILLE; about 1630–50

Inv. no. A.48–1956

H. 48 cm.

Provenance
Bequeathed by Dr W. L. Hildburgh F.S.A. in 1955.

Condition
The paint on the face and hands (perhaps a later paint layer) is peeling in places; vestiges of polychromy are to be seen on the drapery (an ochre colour, probably not original) and hair (some gold is visible at the back). On the inner fold of the left side of the cloak are the remains of a red and gold design. The bottom of the figure, which would have originally been a bulbous support made up of two cherubim on clouds, has been dented inwards, so that one of the cherubim is now hidden underneath the figure, the soft metal flattened through having been placed upright on a flat surface. The figure is a thin hollow cast, and the surface of the lead is damaged in a number of places; a crack is visible in the robe beneath the figure's left arm, and on the hair on her right shoulder, and holes (probably casting flaws), some plugged, occur on the front and back. In the centre of the back is the head of a nail, probably the remains of a

fixing for a halo. A screw on the top of the head suggests the figure may have been suspended. Around the screw head the lead is roughly cast.

The Virgin stands with her hands clasped, looking downwards. She rests on her right leg, stepping forward with her left. She wears a high-waisted robe under a cloak, whose edges are punched with a simple design. As remarked above, two cherubim would originally have formed a support for her; these are now partly hidden through having been dented inwards. The tips of the crescent moon are visible on the base. The back of the figure is relatively plain. The downward glance of the Virgin, and the lack of finish on the top of the head indicate that this piece was intended to be seen from a low viewpoint.

The figure is based on the work of the Seville sculptor Juan Martínez Montañés. One of his poly-chromed wood versions of the same subject dating from about 1621–6 is on an altarpiece in the church of Santa Clara, Seville;[1] an earlier variant of 1606–8 is on the altarpiece in the church of Our Lady of Consolation, El Pedroso.[2] Another (attributed) variant of about 1630 is in the church of the Annunciation at the University of Seville.[3] His most accomplished version is the figure of 1628–31, known as *La Purísima*

in Seville Cathedral.[4] The present piece is closest to the 1633 version, which has comparable drapery and two cherubim. Lead has been mined in the region of Seville since Roman times, and the tradition of lead sculpture in Seville, along with the stylistic comparisons noted above imply that this piece must have been made in that city.[5] Reduced lead variants after Montañés and other sculptors were produced in Andalusia and Castile relatively frequently during the mid-seventeenth century. Jesús Palomero has drawn attention to the almost industrial production of replicas in wood and bronze as well as lead after Montañés's Christ child. These popularised the images produced by the sculptor. Being relatively cheap, they were not individually commissioned, but could be sold at fairs, as well as being exported in some numbers to the Spanish colonies from Seville. A lead *Virgin of the Immaculate Conception* of about the same date was recorded in a Mexican collection in 1935, and was almost certainly imported in the seventeenth century from Andalusia.[6] Diego de Oliver in particular was renowned as a master of casting lead figures of the Christ child ('*maestro basiador de niños de plomo*').[7] Surviving examples of such pieces include a lead statuette of the Christ child in the church of St Michael, Valladolid; this is also close in size to the present work (h. 47 cm).[8] Another lead *Christ Child* (h. 50 cm), believed to be from Granada, and dating from *c.* 1625–50 is in the Convento de las Descalzas Reales in Valladolid.[9] A slightly smaller polychromed lead *Christ Child* (h. 41 cm) after Juan de Mesa is in the Convento de Santa Isabel, Valladolid.[10] A painted lead figure of the *Christ Child* is also in the Metropolitan Museum of Art, New York.[11]

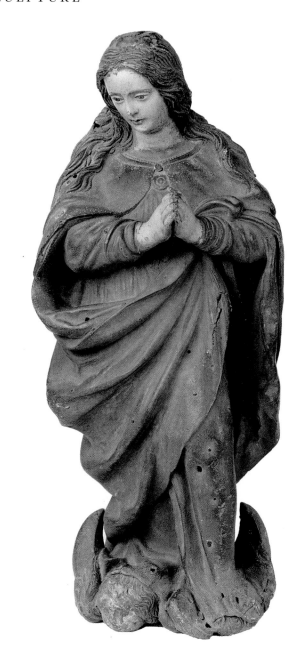

NOTES

1. Hernández Díaz 1987, p. 210, fig. 239.
2. Gilman 1967, figs. 148, 150–1, and pp. 104–5, and *ibid.*, figs. 9, 27 and 28 and pp. 47–9. Hernández Díaz 1987, pp. 120–1, figs. 95–6.
3. Hernández Díaz 1987, fig. 308.
4. Gilman 1967, figs. 175–6 and pp. 117–18. Hernández Díaz 1987, pp. 221–3, figs. 251–4.
5. I am grateful to Anthony North for his advice on this.
6. Angulo Iñiguez 1935, p. 9.
7. Entry by Jesús Palomero on the lead Christ child after Juan de Mesa in the forthcoming catalogue of post-medieval sculpture in the Museo Marés, Barcelona. I am grateful to Jesús Palomero for kindly letting me see his draft entry prior to publication.
8. *Pequeña Escultura*, (unnumbered pages). A similar piece, although almost double the size (height 81.3 cm) was auctioned at Sotheby's New York, January 11th, 1994, lot 162.
9. Martín González and Plaza Santiago, p. 99 and pl. CXII, fig. 319.
10. *Arte en las Clausuras*, no. 10.
11. Inv. no. 64.164.244. I am grateful to Johanna Hecht for giving me access to this piece.

38. THE VIRGIN AND CHILD

PAINTED AND GILT WOOD (PROBABLY BOXWOOD)
ON OAK SOCLE
SEVILLE; about 1650–1700
Inv. no. 172–1864
H. 21.2 cm. W. 8.5 cm. D. 6.4 cm.
See plate 13

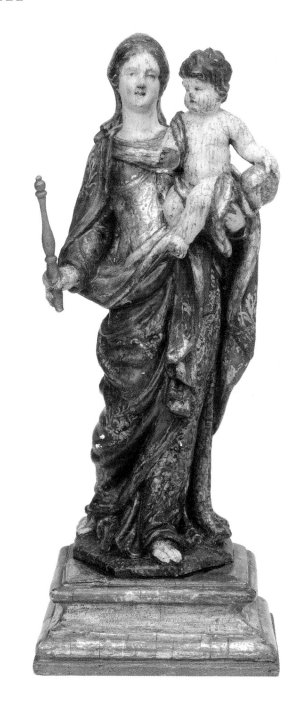

Provenance
Bought by John Charles Robinson from Evans, Paris for 70
Francs (£2 16s.) in 1863.

Condition
The Virgin's right forefinger is damaged, and the lower part of
the sceptre below the hand seems to be make-up. The Child's
hand appears to have been broken off and re-stuck, while the
socle includes a piece of wood apparently added on at the
bottom. The figures have been re-painted, notably on the
sceptre, the hair of both, the back of the Virgin's robe and her
bodice; flaking paint has been consolidated. The paint is
missing on the Christ Child's right hand and nose. Much of the
gold leaf on the socle is missing, revealing the red bole beneath.

The Virgin stands on her left leg, with her right leg bent
behind her. She holds the Christ Child on her left hip,
and a sceptre in her right hand; Christ holds an orb in
his left hand. Christ's right hand is extended in blessing.
He is nude, except for some drapery which falls around
his right shoulder and hip. The Virgin wears a pale blue
headdress with a gold border, and an underdress of
crimson glaze over silver leaf, with raised gold designs;
the burnished gold bodice has a raised design below the
gold. The blue (perhaps smalt) overdress is decorated
with gold edging and fleur-de-lys designs. These too are
raised, rather than *sgrafiado*.[1] She has sandalled feet, and
stands on an integral base, painted green, which is
dowelled into its rectangular moulded socle; it is carved
and painted at the back, implying that it was intended to
be seen in the round. Although the wood has not been
conclusively identified, its appearance suggests it is box.

The piece was dated to about 1640 and assigned to
Seville when it was first acquired. The graceful pose
and the swing of drapery recall mid-seventeenth-
century Andalusian sculpture, for example the much
larger *Virgin and Child* by Pedro de Mena (1628–1688)
in the parish church of Purchil (Granada).[2] But the
faces are more reminiscent of the small, delicately
featured figures by Luisa Roldán (1652–1704), and
although the similarities do not warrant an attribution
of the present group to the circle of Roldán, it is more
likely to come from Seville (where she trained and
worked before moving to Madrid), and to date towards
the end of the seventeenth century.[3]

BIBLIOGRAPHY
Inventory 1864, p. 14.
Inventory 1852–67, p. 71.
Riaño, p. 7.
Loan Exhibition, p. 126, no. 806.

NOTES
1. I am grateful to Josephine Darrah for her comments on the
polychromy of this piece.
2. *Alonso Cano Centenario*, II, cat. 90, pl. XCIII.
3. Cf cat. nos. 27 and 39 in the present collection, and the
face of the Virgin in Roldán's *Rest on the Flight into Egypt* in the
Hispanic Society of America (Gilman 1964, fig. 18).

39. CHRIST CHILD

PAINTED TERRACOTTA
SEVILLE; about 1700
Inv. no. 319–1864
H. 13.9 cm.

Provenance
Bought by John Charles Robinson in 1863 from Marin, Granada for £1 1s.

Condition
The two forefingers of the right hand (probably raised in blessing) are missing; the left hand may once have held a cross which is now lost. The piece has probably been substantially re-painted; there is also evidence of damage at the right shoulder joint. The noses of the cherubim have been rubbed. A nut on top of a screw fixes the figure to the cloud-base; this probably dates from the nineteenth century.

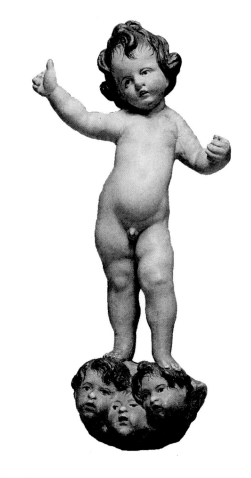

This diminutive nude figure stands on a blue cloud-base with three cherubim. He rests on his right leg, his left leg stepping slightly forward, his right hand raised, and his left arm bent. As stated above, he was probably blessing and originally held a cross.

This piece was almost certainly intended for private devotion, perhaps in a convent, and is unlikely to come from a larger ensemble.[1] It was called by Robinson 'School of Alonso Cano',[2] and indeed recalls pieces associated with this artist.[3] The delicacy of the features however imply it is more closely allied to the style of Luisa Roldán (1652–1706), such as the cherubim to be seen in her *Virgin and Child with St Diego of Alcalá* (cat. no. 27), as well as to roughly contemporary works produced in Andalusia, such as the *Virgin of the Immaculate Conception* in the present collection (cat. no. 48).[4]

BIBLIOGRAPHY
Inventory 1864, p. 26.

Riaño, p. 3.
Loan Exhibition, p. 115, no.721.

NOTES
1. Cf figures of the Christ child recorded in convents in the Netherlands; see van Os, pp. 100–3. See also the entry for cat. no. 23.
2. *Inventory* 1864, p. 26. See Introduction, p. 6.
3. Cf the figure by Cano in the Fernández Canivell collection, Málaga (*Alonso Cano Centenario*, II, pl. XXIII).
4. Cf also the slightly larger seventeenth-century Seville bust of the infant St John the Baptist in the Museum of Fine Arts, Seville (*Escultura en Andalucía*, pp. 74–5, no.19).

40. THE VIRGIN

PAINTED AND GILT ALDER

SEVILLE; about 1650–1700

Inv. no. A.12–1932

H. 86 cm.

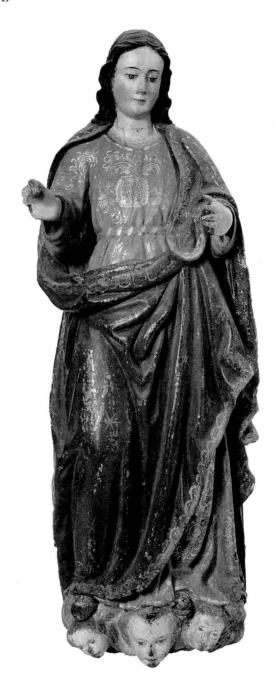

Provenance
Given by Mr Frank Green of Ashwick, Dulverton, Somerset in 1932. Formerly on loan to the Museum. Perhaps from South America (see below).

Condition
Some chips to the wood and paint losses are evident on the noses of the three cherubim, the edges of the Virgin's cloak and her fingers. Surface cracks are visible on her neck and left wrist. The hands are separately dowelled in. Two fingers of the right hand, and the little finger on the left are missing. There are woodworm holes, especially on the back of the figure, and signs of insect attack and perhaps damage from damp at the base of the figure. On the top of the head is a hole, presumably for a halo; one partly filled rectangular hole under the base was presumably for a dowel to fix the figure to a socle.

The Virgin stands upon three cherubim nestling in clouds; she rests on her left leg, stepping slightly forward on her bent right one. In her right hand she holds what may be a pomegranate or other fruit, although its damaged condition means that it is difficult to identify securely. She looks towards her left hand, which may have once supported the Christ child (see below). She has a doll-like face, accentuated by eyelashes painted in only on the lower eyelids, and long wavy hair running down her back. She wears a red dress and green belt, both decorated with raised gold designs painted in what is probably gold mixed with white ground.[1] Over the dress she wears a cloak painted blue over gold with gold star-shaped designs. The reverse of the figure is more summarily carved and polychromed.

When first taken on loan in 1920 Eric Maclagan of the Department of Architecture and Sculpture described it as from South America, and called it 'Spanish 17th or 18th century work of fairly good quality'.[2] On its acceptance as a gift twelve years later, the then curator, R. P. Bedford wrote: 'The wood figure of the Virgin – probably Spanish-American work of the 17th century – is not a very important object and we have not exhibited it for the last year or so. It is, however, different from anything we have got in our collections & I am inclined to recommend that we accept it.'[3]

Although published in 1933 as the *Virgin of the Immaculate Conception*,[4] the present figure more probably

represents the Virgin from what was once a group of the *Virgin and Child*, the Christ child being supported on the Virgin's left hand. No specific attributes of the Immaculate Conception are evident, while conversely the direction of the Virgin's glance, the fruit she holds in her right hand, and her pose all suggest she once held a Child. The present piece is clearly indebted to Sevillian sculpture of the seventeenth century, in particular the work of Juan Martínez Montañés (1568–1649), and despite the difference in subject matter, it is reminiscent of his *Virgin of the Immaculate Conception* in Seville Cathedral of 1631.[5] Conversely the technique of the raised gold decoration on the dress, along with the doll-like features of the face are analogous to Hispano-American work, and the face and pose are close to that of the Virgin in a seventeenth-century Hispano-American piece depicting the *Virgin and Child* in Cuzco, Peru.[6] Nevertheless the use of alder (probably *Alnus glutinosa* L.)[7] for the present work suggests that it is likely to be European, although Maclagan's comments on its provenance noted above may indicate that it was exported to South America and later brought back to Europe. Spanish, especially Sevillian sculpture is known to have been exported to Hispanic America from the late sixteenth century onwards.[8]

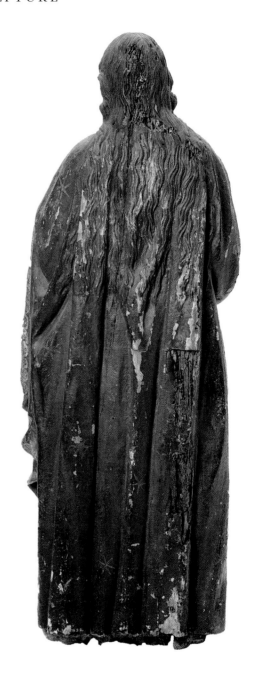

BIBLIOGRAPHY

Review 1932, p. 50.

NOTES

1. Cf the designs on cat. no. 68.
2. It is unclear whether Maclagan meant that it had a provenance from South America (rather than that it was probably made there), but this is possible. Minute of 6 August 1920; Museum records (Frank Green Nominal File). Cf cat. no. 32.
3. Minute of 9 February 1932; Museum records (Frank Green Nominal File).
4. *Review* 1932, *loc. cit.* in the bibliography for this entry. It was also described as 'Spanish(?) late sixteenth century'.
5. Gilman 1967, figs. 175–9 and pp. 117–18. See also the entry for cat. no. 37.
6. Gori and Barbieri, p. 65, fig. 59.
7. I am grateful to Josephine Darrah for her comments on the wood.
8. Angulo Iñiguez 1935, pp. 9ff. See also Martín González 1984, p. 179 and Estella Marcos 1990, pp. 93–6.

41. ST PHILIP NERI

PAINTED AND GLAZED TERRACOTTA, WITH GLASS BEADS,
LINEN AND SILK
SEVILLE; about 1700–1730
Inv. no. 103–1864
H. 18 cm. W. 10.2 cm.

Provenance
Bought by John Charles Robinson from Soriano, Madrid for
£1 1s in 1863.

Condition
Some of the material around the base is missing or torn;
otherwise the piece is in good condition.

The bearded saint is shown in the form of a bust, but
including his arms and hands. He holds a string of
black rosary beads made of glass in his right hand, and
wears a black soutane and biretta. A tear can be seen
falling from his left eye. The painted terracotta bust is
set onto a white glazed terracotta base; a coarse linen
has been used to cover the join. The upper part of the
piece (the figurative element) was apparently modelled
from a pink clay, while the lower half (the relatively
plain socle) is of a yellower clay, glazed like Spanish
faience ware. The two parts seem to have been joined
when the piece was first made; there are no signs of a
later break or glue.[1] The socle appears to have been
once covered all over in black silk; only some of this
now survives.[2] On the inside of the socle is painted in
black the word 'Phot', or possibly 'Pliot'; the
significance of this is uncertain; cf cat. no. 49, where a
similar inscription appears on the underside.

St Philip Neri (1515–1595) was the founder of the
Congregation of the Oratory, and spent most of his life
in Rome; he was canonized in 1622.[3] He is usually
represented as a fairly elderly white-bearded man, often
holding a rosary, as here.[4] Many of the seventeenth-
century works portraying him derive from his death-
mask in the Oratory of Sta Maria in Vallicella in
Rome.[5] A relief by Pedro de Mena (1628–1688) in the
choirstalls of Málaga Cathedral is another of the
relatively few known representations of the saint in
Spanish sculpture.[6] The combination of a painted
terracotta figure with a glazed base covered in material
is highly unusual, and I have been unable to find
parallels in sculpted or ceramic examples.[7] A larger
version of a bust of S. Diego de Alcalá (h. 54 cm) in the
church of the Magdalene in Valladolid is stylistically
comparable, although it is likely to date from the
seventeenth century, somewhat earlier than the present
piece.[8] The features of the bust, as well as the material

from which it is made suggest a Seville origin, and a
probable date of the early eighteenth century.

BIBLIOGRAPHY

Inventory 1864, p. 8.
Inventory 1852–67, p. 6.
Riaño, p. 1.
Loan Exhibition, p. 113, no. 705.

NOTES
1. I am grateful to Robin Hildyard for his comments on this.
He noted that the pink clay was probably easier to model, and
so more suitable for figurative work.
2. The black dye in the silk was almost certainly responsible
for its deterioration. I am grateful to Clare Browne for her
comments on this.
3. Farmer, pp. 314–15.
4. Réau, III, III, pp. 1072–1073. See also LCI, 8, p. 208.
5. See Hofstede for a discussion of some of these images.
6. See Ferrando Roig, pp. 108–9.
7. I am grateful to Reino Liefkes and Victoria Oakley for their
comments on this.
8. *Pequeña Escultura*, unnumbered pages.

Granada

Granada was famously the last bastion of the Moors in Spain, and was reconquered by Ferdinand and Isabella in 1492. Following this victory, during the first third of the sixteenth century major architectural and sculptural projects were carried out, notably the re-building of the Cathedral and the construction of the *Capilla Real* (Royal Chapel), which was to be the mausoleum of Ferdinand and Isabella, and of their daughter Juana and her consort Philip I (the parents of Charles V). Italian Renaissance styles dominated, both in the marble tombs and the architecture of the cathedral.

During the seventeenth century painted wood and terracotta sculpture in a more vernacular style flourished, epitomised by expressive baroque freestanding pieces such as the many busts and half-length figures of *Christ as Ecce Homo* and the *Mourning Virgin* respectively, executed by, among others, the Hermanos García (García brothers), Pedro de Mena (cf cat. no. 24), and José de Mora (cat. no. 46). The major artist in Granada from 1652 onwards was however Alonso Cano, with whom Pedro de Mena worked, and whose achievements in painting and sculpture were seminal influences (cf cat. no. 48).

A number of important works in Granada were commissioned in the late seventeenth and early eighteenth century, notably the sculptural decoration of the Charterhouse (*Cartuja*), an elaborate confection of painting, painted and gilt wood sculpture, and stucco carried out by a team of artists including Pedro Duque Cornejo (also active in Seville), José Risueño (cf cat. nos. 42, 43, and 44), and José de Mora (cat. no. 46).

JOSÉ RISUEÑO
(b. Granada 1665; d. Granada 1732)

Risueño was active as a painter and sculptor, and appears to have spent his whole life in Granada. His sculptural work is in the tradition of such predecessors as Alonso Cano (1601–1667), Pedro de Mena (1628–1688), the Mora family and the García brothers. Risueño's friendship with the Archbishop of Granada, Martín de Ascargorta, led to commissions for work at the Cathedral, the Abbey of Sacro Monte, the *Cartuja*, and other religious foundations in Granada. The polychromed wood figures and reliefs he produced for the high altar of S. Ildefonso in Granada in 1720 form the basis for many other attributions to him. The polychromed terracottas thought to be by Risueño are neither signed nor documented, but Ceán Bermúdez remarked on his achievements in terracotta, and extant pieces, such as the one in the present collection, have points of comparison with documented works in stone and wood.

BIBLIOGRAPHY

Ceán Bermúdez, IV, pp. 200–2; Sánchez-Mesa Martín, 1972; Martín González, 1983, pp. 419–27.

42. ST JOSEPH WITH THE CHRIST CHILD

PAINTED TERRACOTTA, PINEWOOD AND FABRIC
BY JOSÉ RISUEÑO
GRANADA; about 1720
Inv. no. 313–1864
H. 50 cm. W. 32 cm. D. 41 cm.
See plate 14

Provenance
Bought in 1863 by John Charles Robinson from Marin of Granada for £4 8s 5d.

Condition
The object was conserved in 1959, when some later painting was removed, notably on the garments, where there was an undercoating of white under a layer of pigment which gave the appearance of fired enamel. The flesh pigments were thought to be original; there are some areas of missing paint, especially at the back. More recent analysis confirms that most of the existing paint is original (see below). The toes of the left foot of the Christ Child are damaged, and the second toe is missing.

St Joseph is shown dressed in an abundance of swirling drapery, kneeling forward on his left knee, his right knee raised. He supports the naked Christ child with both hands on a cream-coloured cloth, whilst looking up to heaven, his face apparently reflecting a presentiment of the Passion. The Christ child looks downwards, and presses his left hand on St Joseph's chest. St Joseph's robe is a mixture of shades of lilac; his cloak is red, and the collar of his shirt is the same cream colour as the cloth in which he holds the Child. The figures are on an irregularly shaped wooden block overlaid with fabric, and dressed with slip. This forms the lower part (approximately 6cm) of St Joseph's robe. Another rectangular block of wood forms the base (a modern wooden base painted black sits beneath this). It is unknown whether the wood and fabric were added to conceal damage, such as severe firing faults, at the time the figure was made, or whether the additions were intended to adjust the angle and height of the piece. It seems unlikely that the hybrid construction was envisaged when it was first designed,[1] but the paint on the fabric and wood appears to be contemporary with that on the terracotta, which itself seems to be original, implying the additions were made after the terracotta was fired, but before it was painted.[2]

When first acquired by the Museum in 1864, this piece was attributed to the School of Alonso Cano, and dated to about 1670.[3] Gómez-Moreno first attributed it to Risueño in 1926, when he summarily rejected it as a work by Cano, and this attribution has been generally accepted since that time.[4] As noted above, Risueño's terracottas are unsigned and undocumented, and works in this material have been attributed to him on the basis of stylistic comparisons with his known works in wood and stone. Three other terracotta variants of *St Joseph and the Christ Child*, comparable in style to the present piece, have been attributed to Risueño: one in a private collection in Granada, previously in the Convent of St Anthony, Granada;[5] another in the Convento de las Angustias at Priego, Córdoba;[6] and a third in the church of the Trinity, Córdoba.[7] A wood version of the same subject, documented as Risueño's, is on the retable of the high altar of the church of S. Ildefonso in Granada, which he was working on from 1720 onwards.[8] Like the figures of Sts Peter and Paul from the same altarpiece, the thick horizontal folds of drapery on this figure bear comparison with cat. no. 42. Similarly the chubby body of the child held by the wood *St Joseph* in Granada is analogous to the present one. Sánchez-Mesa Martín also noted resemblances between the present piece and Risueño's documented stone relief of the *Annunciation* on the main portal of the cathedral at Granada, which was commissioned in 1717.[9] The arguments in favour of the present piece being by Risueño as outlined above seem conclusive. The dating is less easy to ascertain. Sánchez-Mesa Martín believed that this *St Joseph* must have been produced within what he designated as Risueño's third and final period (1712–32), and suggested a date of about 1717, because of its similarities with the stone roundel.[10] A date around 1720 seems most likely, because of the even closer parallels with the wood group on the high altar of S. Ildefonso dating from 1720 onwards.

BIBLIOGRAPHY
Inventory 1864, p. 25.
Inventory 1852–67, p. 71.
Riaño, p. 3.
Loan Exhibition, p. 115, no. 720.
Garnelo y Alda, p. 307. (Reproduction of oil painting of 313–1864 by the article's author, which is there attributed to Alonso Cano).
Gómez-Moreno Martínez, p. 214.
Orozco Díaz, 1939–41, p. 103, unnumbered plate between pp. 96 and 97.
Martínez Chumillas, pp. 307–8, and fig. 223 (there wrongly said to be of wood).
Orozco Díaz, 1956, pp. 76, 79 (illustrated) and 81.
Sánchez-Mesa Martín, 1967, p. 330.
Ibid., 1972, pp. 77, 202, cat. 52, pl. 18, fig. 3.
El Greco to Goya, cat. no. 78 (there dated to around 1700).
Martín González, 1983, p. 423.
Baker 1984, pp. 343 and 346, fig. 7.
Williamson 1996, p. 144.

JOSÉ RISUEÑO

NOTES

1. A combination of wood and terracotta was however also used for Risueño's *St Joseph and the Christ Child* in the Convento de las Angustias, Priego, Córdoba (Sánchez-Mesa Martín 1972, pp. 197–8, cat. 48, pl. II), and wood, fabric and terracotta were apparently used for his *Virgin and Child* in the same location (*ibid.*, 1991, p. 60, fig. 29; see also *ibid.* 1972, p. 197, cat. 47, pl. 18.2, although there this piece is catalogued as just painted terracotta).

2. I am grateful to Josephine Darrah and Hannah Eastwood for undertaking analysis of paint samples which confirmed that the existing paint is likely to be original.

3. *Inventory*, 1864, p. 25; see also Riaño, p. 3.

4. Gómez-Moreno 1926, p. 214.

5. Sánchez-Mesa Martín, 1972, pp. 200–1, cat. 51, pls. 27 and 28.

6. *Ibid.*, pp. 197–8, cat. 48, pl. II. See note 1.

7. *Ibid.*, p. 184, cat. 36, pl. 19.1.

8. *Ibid.*, p. 221, cat. 68, pl. 44, 1 and 2. See also Gallego y Burín, 1982, p. 262.

9. Sánchez-Mesa Martín, 1972, pp. 209–10, cat. 56, pl. 29.

10. *Ibid.*, p. 202.

43. THE CHRIST CHILD OR THE INFANT ST JOHN THE BAPTIST

PAINTED PINEWOOD AND GLASS EYES

CIRCLE OF JOSÉ RISUEÑO

GRANADA; about 1700–1735

Inv. no. 104–1864

H. of figure and socle: 56.8 cm.

H. of figure and rocky base without socle: 53.2 cm.

W. of socle: 23 cm. D. of socle: 20 cm.

See plates 15 and 16

Provenance
Bought by John Charles Robinson from Soriano in Madrid in 1863 for 8 dollars (£1 13s 8d).

Condition
A crack runs down the left side of the Child's face and hair (see below), and the tips of two fingers are lost on the right hand. In places small areas of paint are missing, particularly on the left shoulder-blade, hair, fingers and toes, but there is no sign of overpainting. A scratch is visible on the right shin. A filled hole in the top of the head probably indicates where the top of the block of wood was fixed while it was being carved. The rocky base is damaged at the back, and a nail sticking out in this area almost certainly indicates where a lamb was once attached (see below). The head of another nail is visible at the front of the rocky base; this no doubt fixes it to the socle. Some paint has been lost on the decorated socle on which the figure is set; the socle itself is probably not original to the figure (see below).

The nude infant stands, leaning on his right leg, with a twisted torso, his head turned to his right and looking

downwards, his bent left leg resting on a rock. His arms are outstretched to his left, and probably originally held a lamb. The figure is set on a rough rocky base, and the whole is fixed to a low socle (an irregular octagon) with a decorative painted and gesso border. The underside of the overhanging border of the socle is painted to imitate marble; the remains of a painted design visible on the upper surface of the socle suggest that originally another piece may have been set on it. The bottom is unpainted, and a bolt holding the figure is visible. The face is a hollow mask set into the head; the mouth is hollow (painted teeth are visible), and the glass eyes have been set in from behind. The crack down the left hand side of the face indicates the join of the mask on this side. The pupils are in relief, giving the eyes more depth, especially when they are lit from below. The nostrils seem to be deeply drilled holes.

This devotional figure is of a relatively common

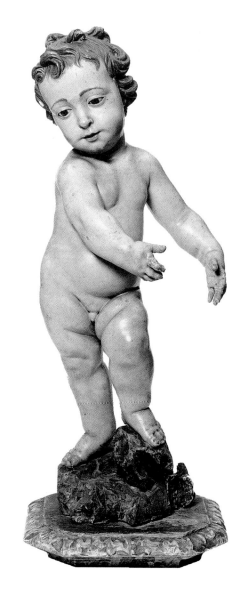

type produced in Andalusia from the late sixteenth century onwards. It may represent the Christ Child or the infant St John the Baptist.[1] On acquisition, the piece was attributed to the 'School of Seville?' by Robinson.[2] Similar nude figures of the infant Christ are associated with the Seville sculptors Juan Martínez Montañés (1568–1649),[3] and Gerónimo Hernández (c. 1540–1586).[4] Such figures were also produced by Pedro de Mena (1628–1688) and Alonso Cano (1601–1667), who worked primarily in Granada.[5] The twisting torso and slightly heavier features of the present figure parallel even more closely the work of the slightly later Granada sculptor José Risueño. The smaller figure of the infant St John the Baptist (cat. no. 44) in the present collection is broadly similar. Much more closely comparable is a statuette almost identical in size in the convent of Santa Paula (although owned by the monastery of S. Jerónimo), Granada attributed to Risueño.[6] The Granada figure rests his left hand on a lamb standing next to him. The gesture of the present figure, as well as the present condition of the rocky base suggests that it once included a lamb in a similar position, and that the back of the base was damaged when it was removed. The decorative socle was probably added after the damage had occurred (perhaps as late as the nineteenth century). As noted above, the paint remaining on the socle implies it may have been used for a different piece originally.

BIBLIOGRAPHY
Inventory 1852–67, p. 70.
Inventory 1864, p. 8.
Riaño, p. 7.
Loan Exhibition, p. 125, no. 799.

NOTES
1. In Sánchez-Mesa Martín 1972, the analogous figure by Risueño cited below is captioned beneath the plates as 'Niño Pastor' (pls. 14 and 15), but catalogued in the text with a question mark as the infant St John the Baptist (pp. 178–9).
2. Robinson Reports I, Part 1, pp. 144ff.
3. Cf the figure of the naked Christ Child in the confraternity of the Holy Sacrament in Seville; Gilman 1967, figs. 31 and 32.
4. Cf the figure of the naked Christ dating from about 1581–2 in the church of St Mary Magdalene, Seville; Palomero Páramo, pl. V.
5. For example the *Infant St John the Baptist* by Pedro de Mena in the convent of St Catherine of Zafra, Granada, and the *Christ Child* by Alonso Cano in the Fernández Canivell collection in Málaga (*Alonso Cano Centenario*, II, pls. 76 and 15).
6. The position of the arms, the facial expression and the hair all differ slightly. The height of the Granada version is given as approximately 60 cm.; Sánchez-Mesa Martín 1972, pp. 178–9 and pls. 14 and 15, and *ibid.* 1988, pl. XVIII.

44. THE INFANT ST JOHN THE BAPTIST

PAINTED PINEWOOD
CIRCLE OF JOSÉ RISUEÑO
GRANADA; about 1700
Inv. no. 171–1864
H. 27 cm. W. 17cm.
See plate 17

Provenance
Bought by John Charles Robinson from the Canon Cepero Collection, Seville for 750 reals (£7 18s.) in 1863.[1]

Condition
Some overpainting is evident, notably on the hair, the red cloak, the green base, and the white fleecy jacket, as well as the lamb. A clear varnish has been applied to the face, legs and hair. The left knee has been damaged in the past, and has been touched in.

The infant St John grasps a lamb standing on its hind legs to his left side. He half-kneels, resting on his right knee, his body twisted round. He wears a white lambskin shirt, with a red cape over it. The group is on a base painted green, and roughly carved to resemble foliage. A large hole is drilled in the underside of the base, perhaps to contain a dowel. The underside of the base is fully carved and painted. A photograph taken in 1925 (shown here) shows the piece at that date standing on a wood socle. The downward glance of St John implies that the piece may have been originally placed above the viewer.

When it was first acquired, Robinson assigned this piece to Alonso Cano (1601–1667).[2] It has not however been included in the literature on Cano, and its style indeed is at odds with the known work of this artist. The twisting pose of the figure, and the tenderness of expression recall rather the work of José Risueño of Granada.[3] There are many parallels with works associated with this artist: the head recalls the head of the Christ child in the *St Joseph with the Christ Child* in the present collection (cat. no. 42); a similar turning figure is seen in the *Infant St John (or Christ Child)* in the convent of Santa Paula, Granada;[4] the thick folds of the cloak recall the figure of *Mary Magdalene* in Granada Cathedral;[5] the lamb is paralleled by one in another accompanying a figure of the *Young St John* in the church of St Francis, Priego, Cordoba.[6] The present figure should also be compared with the *Infant St John or Christ Child* here (cat. no. 43). The subject suggests parallels with the work of Bartolomé Esteban Murillo (1617–1682), although the youthful St John the Baptist and lamb was a popular theme in Spanish painting and sculpture throughout the seventeenth century.[7] The present figure was probably a single devotional piece, rather than an element in a larger ensemble.

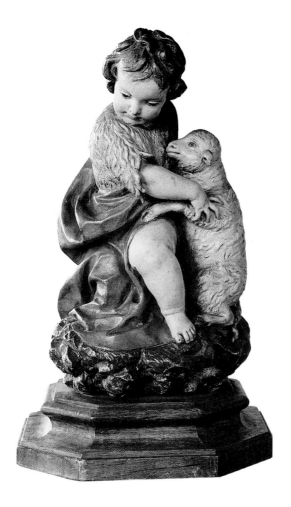

45. ST JOHN OF GOD

TERRACOTTA WITH GLASS EYES
GRANADA; about 1650–1700
Inv. no. 176–1864
H. 16.5 cm. W. 12.5 cm.

Provenance
Bought by John Charles Robinson (as a head of 'a saint or martyr') from Baur in Paris in 1863 for £4.

Condition
A firing crack runs along the right jaw, and another one runs from the left ear through the cheek and corner of the left eye and forehead. On the right shoulder there has been a break and repair. The original right eye has been lost and a replacement inserted; it has been painted on the outside, whereas the colour of the left eye seems to be integral to the glass.[1] The figure presently rests on a modern wood base. The head is hollow, and the top of the head is missing, perhaps because it was originally destined to be part of an *imagen de vestir*, and would therefore have had a fabric covering of some kind.[2] A pencil mark inside reads (?) 'Dr MORERA'; the significance and date of this are uncertain. It may be a nineteenth-century inscription recording a former owner's name.

The young man's head is tilted slightly to his left and down, his half-open mouth and wrinkled brow giving him a troubled expression. Because the piece is open at the back, the structure of the sculpture can be studied, in particular the way the glass eyes have been inserted. These are small globes of glass fixed in with wax.[3] Although the right eye must be a replacement (see above), the left eye is entirely intact. The surface of the terracotta appears never to have been painted, and this, combined with the inserted glass eyes is strange; it may imply that the piece is unfinished, perhaps

BIBLIOGRAPHY
Inventory 1864, p. 14.
Inventory 1852–67, p. 71.
Riaño, p. 7.
Loan Exhibition, p. 125, no. 805.
Baker 1984, p. 344, fig. 5.

NOTES
1. For Canon Cepero, see J. M. Palomero Páramo, 'La Colección Escultórica . . .' in Moreno Mendoza, p. 49.
2. J. C. Robinson Reports, I, Part V. Robinson described it as 'the work of Alonzo (*sic.*) Cano . . . school of Granada, 1st half of the 17th century'. See also Introduction, p. 6.
3. I am grateful to Jesús Urrea for suggesting this.
4. This piece is owned by the monastery of S. Jerónimo, although housed in the convent of Santa Paula; Sánchez-Mesa Martín 1972, cat. no. 31, pp. 178–9, pls. 14 and 15.
5. Orozco Díaz 1956, p. 80, pl. 16.
6. Sánchez-Mesa Martín 1972, cat. no. 44, pp. 193–4, pl. 23, 1 and 2.
7. For comparative examples by Murillo, see Angulo Iñiguez, III, pls. 54–5 (cat. no. 342), pls. 185–6 (cat. no. 335), pls. 399–400 (cat. no. 337). A reclining figure in polychromed wood of the young St John the Baptist, also probably from Granada and dating from the late seventeenth century is in the Bowes Museum, Barnard Castle, inv. no. X1 (unpublished). I am grateful to Bryan Crossling for sending me photographs of this piece.

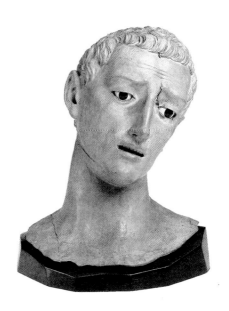

because the firing cracks were considered unacceptable. The features are finely modelled, and the quality and treatment of the subject matter suggests analogies with the work of Alonso Cano (1601–1667), in particular his polychromed wood head of St John of God in the Museum of Fine Arts in Granada.[4] This head represents the same saint, who was particularly appropriate for Granada.[5] St John of God (1495–1550) was born in Portugal, but went to Andalusia in the 1530s, having served in the Spanish army as a young man. After working as a shepherd, then as a pedlar and bookseller, he rented a house in Granada to look after the sick and the poor. After his death his followers took vows, and formed a religious order, the Brothers Hospitallers.[6]

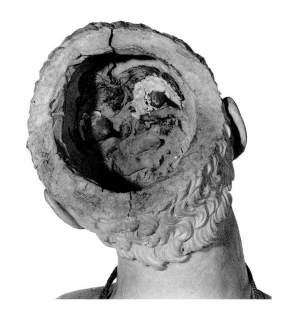

BIBLIOGRAPHY

Inventory 1864, p. 14.
Inventory 1852–67, p. 38.
Riaño, p. 2.
Loan Exhibition, p. 114, no. 710.

NOTES

1. The glass eyes were probably made by a specialist in this art. See introductory essay on Materials and Techniques. For a later reference to glass eye-makers of the early nineteenth century working in Italy, see Zanetti, p. 138. I am grateful to Reino Liefkes for this reference.

2. When acquired, Robinson wrote that it was an '*imagen in vestia*' (Robinson Reports, I), and when it was catalogued by Riaño in 1872, it was described as 'HEAD. Coloured terra cotta, of a saint or martyr, with glass eyes; adapted to be fastened to a draped lay figure.' (Riaño, *loc. cit.*). The same description was used for the catalogue of the Loan Exhibition in 1881. The adjective 'coloured' must be an error, as the piece appears never to have been painted.

3. This is reminiscent of the fixing method for the eyes of a figure by Pedro de Mena of the young St John the Baptist in the church of S. Antón, Granada. See B. Hasbach and C. Garrido, 'Technique and Restoration of Three Sculptures by Pedro de Mena' in *Madrid Congress* 1992.

4. See *Alonso Cano Centenario*, II, pp. 54–5, cat. no. 16 and pl. XXIV. This head was also formerly part of an *imagen de vestir*.

5. Cf the figure of St John of God attributed to José Risueño in the Imperial Church of St Matthias, Granada; Sánchez-Mesa Martín 1972, cat. no. 53, pp. 202–6, pls. 30 and 31.

6. Farmer, p. 234.

JOSÉ DE MORA

(b. Baza (Granada) 1642–d. Granada 1724)

José de Mora came from a family of Andalusian sculptors, and was distantly related to others, among them Pedro de Mena (1628–1688). José was the son of the sculptor Bernardo de Mora (1614–1684), and the elder brother of the lesser known sculptor Diego de Mora (1658–1729). Bernardo de Mora's wife, Damiana López, was the niece of Alonso de Mena (Pedro de Mena's father). Bernardo de Mora moved to Granada in 1650, where he worked with his wife's cousin, Pedro de Mena, and with Alonso Cano (1601–1667), following the latter's arrival in the city in 1652. José was to work with his father and brother Diego until his departure for Madrid in about 1666. His first known pieces, made in collaboration with his father, were statues for the façade of the church of the Virgen de las Angustias in Granada in 1665. He left for the court in Madrid probably in the following year. There he collaborated with the designer and architect Sebastián de Herrera Barnuevo (1619–1671). Following Herrera's death José de Mora was created court sculptor (*escultor de Cámara*) in 1672. Among the works he completed in Madrid was a pair of busts of Christ and the Virgin for the Convento de las Maravillas. He had gone back to Granada several times during the period he resided in the capital, and returned definitively in 1680. He then rejoined his father's and brother's workshop until his father's death in 1684. The following year he married a distant cousin, and, according to his contemporary Palomino, thereafter became a recluse. His wife died in 1704, and the sculptor himself declined in mental health after this date, dying insane twenty years later. Many of José de Mora's works have been subsequently lost, and are known only through contemporary references. Of his surviving works the most celebrated are the figure of the *Soledad* (Mourning Virgin) in the church of Santa Ana, Granada of 1671, and the two statues of St Bruno in the *Cartuja*, Granada. The sculptor specialized in polychromed wood, and seems to have generally undertaken the painting of his sculpture himself.

BIBLIOGRAPHY

Palomino, *Lives* pp. 384–6; Ceán Bermúdez III, pp. 180–3; Gallego y Burín, 1925; Orueta, 1927; Magaña Bisbal; Martín González, 1983, pp. 223–34; *Escultura en Andalucía*, pp. 140–5.

46. THE VIRGIN OF SORROWS

PAINTED PINEWOOD, IVORY AND GLASS

BY JOSÉ DE MORA

GRANADA; about 1680–1700

Inv. no. 1284–1871

H. 48.5 cm. W. 49 cm. D. 29 cm.

See frontispiece

Provenance
Bought from G. Bracho through W. R. Steet in 1871 for £4.

Condition
The work was conserved in 1976. At that date the polychromy was analysed (see below). The sculpture is in relatively good condition, with no notable breaks or restorations. Some of the original paint has been lost (see below). There is no evidence that the present bust ever included arms and hands, although Aurenhammer believed a comparable bust by Pedro de Mena in Vienna may once have been a half-length.[1]

The Virgin is shown wearing a blue veil over her head, and a dark olive green/brown robe worn beneath this. The robe's original appearance would have been an olive green lustre, achieved by the use of gold powder (rather than gold leaf) combined with a mixture of

yellow iron oxide and black pigment. The blue veil is a smalt blue, and would also have had a more lustrous sheen when it was first painted. This might have been achieved by dusting on with a brush smalt (powdered blue frit or glass) over the still wet paint surface.[2] Brown ringlets of hair fall down on either side of her face, which is a pale flesh colour. These locks of hair are ingeniously made from what are in effect corkscrews of wood-shavings. The head and eyes are cast downwards, and the mouth, downturned at the corners, is half-opened. X-rays have revealed that the head is made from a piece of wood separate from the neck and shoulders, and that the veil is separate from both. The face is carved as a mask, with the eyes, teeth and tongue pushed in from behind, before the veil was fitted around with small nails.[3] The teeth appear to be ivory, and the eyes are likely to be glass, although it has not been possible to ascertain whether this is the case. The veil is made from pieces of wood carefully curved round and fitted together. White ground was used to fill in the joints, and some of this was detected when small paint samples were taken during conservation in 1976. The piece is intended to be seen in the round: the veil is carved in naturalistic crumpled folds at the back.

Shortly before the work was acquired in 1871, a

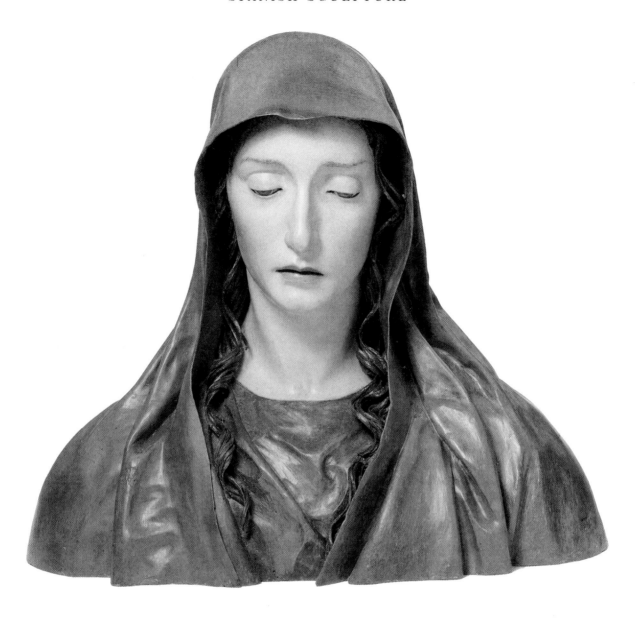

Report written by the Art Referee, Sir Matthew Digby Wyatt, described it as follows:

'Spanish XVII:centy

This capital head & bust of the "Virgen de los dolores", the *favourite* Spanish type, should certainly be bought. It is full of character, and cheap – since I have seen many of much less merit for which much higher prices have been asked in Spain. It looks very much like the work of Montañes (*sic.*) and is both interesting, and rare of such artistic merit (*sic.*). Strongly recommended.'[4]

The subject, known in Spain as the *Virgen de la Soledad*, or *Dolorosa*, shows the mourning Virgin alone after Christ's entombment either, as here, in the form of a bust, or as a half-length figure, including her arms and hands, or occasionally as a full-length figure, sometimes an *imagen de vestir*. The iconography seems to have first appeared in Spanish sculpture in the mid-sixteenth century.[5] Often a bust or half-length figure of Christ as Man of Sorrows is paired with such a depiction of the Virgin.[6] The use of busts or half-lengths probably derives from fifteenth-century Netherlandish paintings, particularly the work of Dieric Bouts (*c.* 1420–1475) and his son Albert Bouts (*c.*1460–1549), perhaps transmitted through engravings.[7] Towards the end of the fifteenth century Spanish paintings of the subject appeared, such as the work of Paolo da San Leocadio (1447–1519).[8] In addition to the painted or engraved sources, the reliquary bust is likely to have influenced the form.[9]

The associations of these, containing physical relics of the saints depicted, must have added to the already powerful verisimilitude to be seen in the images of the Virgin and Christ.

As indicated above, many sculpted versions of this subject are known, most of them from Andalusia, including works attributed to the two brothers Jerónimo Francisco and Miguel Jerónimo García (the Hermanos García),[10] José de Mora, and José Risueño (1665–1732). The most famous are those produced by Pedro de Mena (1628–1688).[11] From 1950 until now, the present bust was associated with this sculptor, to whom it was first ascribed in 1923.[12] The attribution to the Seville sculptor Juan Martínez Montañés (1568–1649) originally suggested by Digby Wyatt, was however current within the Museum until 1950, when a letter from Xavier de Salas, then Director of the Spanish Institute in London, claimed that cat. no. 46 'cannot be by [Montañes] but is possibly by Pedro de Mena who was . . . a pupil of Alonso Cano. Cano himself was . . . a follower of Montañés.' Aurenhammer also noted the bust as a work by Pedro de Mena in 1954.[13]

The present work is not inscribed, and its provenance is unknown before 1871. The virtuoso carving of the wood, particularly the corkscrew ringlets of hair and the naturalistically crumpled veil, do provide points of comparison with the works of Pedro de Mena.[14] However the parallels are iconographic and technical, and stylistically the morose downward glance of the present bust, the aquiline nose, heavy-lidded eyes, and full lips recall the work of his younger contemporary, José de Mora. Apart from the facial features, the present piece does not have an inner white veil under the blue headdress; the works by Pedro de Mena always seem to include this extra head covering, while it has been noted that those associated with José de Mora generally do not.[15] The corkscrew ringlets are however exceptional; these are not seen in other works by José de Mora, although they are used for the hair of the *Virgin of the Immaculate Conception* of about 1650 by his father Bernardo de Mora (1614–1684).[16]

A number of busts of the sorrowing Virgin have been convincingly given to José de Mora, the attributions mainly stemming from his documented life-size figure of the kneeling, mourning Virgin now in the church of Santa Ana in Granada, dating from 1671.[17] Four of these busts in particular are closely similar in style to the present work, and suggest that he is the author (see fig. 13).[18] Although precise dating is difficult, the present work is likely to have been produced during the 1670s, the decade following the figure of the *Soledad* in Granada cited above.

Figure 13. The Mourning Virgin (Virgen de la Soledad), *polychromed wood. By José de Mora. Museo Nacional de Escultura (Valladolid). Ministerio de Cultura.*

BIBLIOGRAPHY

List 1871, p. 106.
Riaño, p. 5.
Loan Exhibition, p. 120, no. 757.
Maskell, p. 212, plate XXXIII.
Mayer 1923, fig. 107.
Miller, p. 117 and pl. 138.
Aurenhammer, p. 125, note 82 and p. 127, note 91.
El Greco to Goya, cat. no. 75.
Baker 1984, fig. 1, p. 340.
Williamson 1996, p. 142.

NOTES

1. Aurenhammer, p. 127.
2. I am grateful to Josephine Darrah for her detailed analysis of the polychromy, and to John Larson, who conserved the piece in 1976, for information about the construction and materials.
3. Cf Sánchez-Mesa Martín, 1971, pl. 3.
4. Art Referee Report no. 17563. 25th April 1871; held in the National Art Library, Victoria and Albert Museum.
5. A *Virgen de la Soledad* depicting the Virgin after Christ's entombment, was commissioned from Gaspar Becerra in 1565 for the Convento de la Victoria in Madrid; see *Pedro de Mena* 1989, p. 56. This piece, destroyed by fire in 1936, was a kneeling figure, commissioned by a widow, and dressed in widow's robes (it was an *imagen de vestir*). It became a popular type throughout Spain. See *Pequeñas Imágenes*, pp. 37–9 and p. 71 for a discussion of the iconography.
6. A pair of busts of the *Virgin of Sorrows* and *Ecce Homo* respectively by Pedro de Mena is in the Cistercian Convent at Málaga. Although these pieces are now in the cloisters, they are

documented as having been intended to be placed one on either side of the High Altar; Orueta 1914, p. 249.

7. Cf Friedländer, plates 74–8, and van Os, p. 46, fig. 10. A Flemish terracotta bust of the *Mourning Virgin* dating from 1470–90 (itself probably based on a painting by a follower of Rogier van der Weyden) is in the Thyssen Collection. Such pieces may also have been imported to Spain; see Radcliffe, Baker and Maek-Gérard, pp. 418–23, cat. no. 83. I am grateful to Paul Williamson for drawing my attention to this.

8. For example his two panels of *Christ* and the *Virgin* of *c.* 1480–85 in the Prado, Madrid; *Osuna*, pp. 118–23, cat. nos. 6 and 7.

9. Cf Aurenhammer, pp. 113–26, and Orozco Díaz, 1963, pp. 235–41.

10. These sculptors, apparently twins, were active in Granada in the mid-seventeenth century. See Orozco Díaz, 1934, pp. 1–18, and *Escultura en Andalucía*, pp. 92–3, where further bibliography is cited.

11. There are more than eighteen surviving versions associated with Pedro de Mena, including two in the Convent of the Descalzas Reales in Madrid, one in the Accademia de Bellas Artes in Madrid, one in the monastery of St Joachim and St Anne in Valladolid, two in the Museo de Bellas Artes in Granada, one in Cuenca Cathedral, one in Málaga Cathedral, one in the Dreifaltigskirche in Vienna, and one in the Iglesia de la Profesa in Mexico City. For further examples see Orueta 1914 (*passim.*), Angulo Iñiguez 1935, Aurenhammer, pp. 126–7, Martín Gonzáles, 1983, p. 219, *Pedro de Mena* 1989, pp. 34,38,42,46, *Pedro de Mena Centenario*, cat. nos. 34–8, Fernández Lopez, pp. 428–30. Cf also what appears to be a nineteenth-century pastiche of the type (present whereabouts unknown) sold in 1932: *Stumm*, cat. no. 192.

12. Mayer 1923, fig. 107. It had not however been cited in Orueta's monograph on the artist, published in 1914.

13. Aurenhammer, p. 125, note 82, and p. 127, note 91.

14. The full-length *Mater Dolorosa* in the church of S. Pablo, Málaga (Orueta 1914, p. 226, figs. 111 and 112), and the half-length *Mater Dolorosa* in the Convent of the Carmelitas Descalzas, Alba de Tormes (*Pedro de Mena* 1989, frontispiece, p. 8) both have similar corkscrew locks of hair.

15. *Pedro de Mena*, 1989, p. 60.

16. I am grateful to Domingo Sánchez-Mesa Martín for pointing this out. The figure by Bernardo de Mora is in the church of S. José, Granada; see Sánchez-Mesa Martín 1991, p. 234, fig. 149.

17. See also Gallego y Burín, 1925, pp. 152–63, figs. 25–31. This figure was inspired by Gaspar Becerra's work (see note 5 above), which José de Mora possibly knew through Alonso Cano's painted copy (*ibid.*, fig. 24).

18. These works are: a bust of the Virgin in a private collection in Salamanca (*Pedro de Mena*, 1989, p. 60, cat. no. 20), one in the Museum of Fine Arts, Granada (*Escultura en Andalucía*, pp. 142–3, cat. no. 41), one in the church of Santa Isabel, Granada (Martín González, 1983, fig. 98), and one in the National Museum of Sculpture, Valladolid (Fig. 13 here) (*Pedro de Mena*, 1989, pp. 56–7). Palomino also noted in 1724 that Mora executed two half-length images of an *Ecce Homo* and *Virgin*, which were then in the church of the Santísima Trinidad in Granada (Palomino, *Lives*, p. 385). I am grateful to Mª Rosario Fernández González for initially suggesting that cat. no. 46 could be by José de Mora.

47. CRUCIFIX

PAINTED PINE WOOD CROSS; LIMEWOOD OR POPLAR FIGURE, WITH HAWTHORN CROWN AND FABRIC SOAKED IN SIZE
BY JOSÉ DE MORA
GRANADA; about 1670–1700
Inv. no. 323–1864
H. of figure 48 cm. H. of cross (excluding base) 89 cm.

Provenance
Bought by John Charles Robinson in 1863 from Cipriano Aguilar, Granada for £25 5s 3d.

Condition
The black base is modern, as are the screws holding the figure to the cross. The figure and cross have been re-painted, but are otherwise in good condition. Drips of discoloured paint or varnish are visible on the torso and on the left arm. Small discoloured blue-grey patches on the limbs and torso may be colour from the original paint layer showing through. The paint on the loincloth is slightly rubbed, and a patch of missing paint reveals that the loincloth seems to be made of cloth previously soaked in size, then coated in white ground and paint.[1] The second 'I' of the inscription INRI painted on the scroll nailed above Christ's head is partially smudged.

Christ is suspended from the cross with his left leg crossed over his right, and both feet held by one nail; he has no wound in his side. His hands are clenched, and his head is tilted back. He leans on his right shoulder, while his eyes look upwards; his open mouth reveals his teeth and tongue. The crown of thorns (made from real thorns) is painted red. The cross is carved and painted to simulate bark (cf cat. no. 30). A brass eye at the top of the cross is likely to have been used for suspension; two holes drilled in to the ends of the crossbar are probably later, but may also have been used for suspension purposes.

The face of Christ recalls the work of a number of sculptors working in Granada in the mid- to late seventeenth century, such as Jerónimo Francisco and Miguel Jerónimo García,[2] and more particularly José de Mora.[3] The high quality of carving seen here in the subtle modelling of the torso and limbs, along with the distinctive aquiline nose and anguished facial expression is typical of Mora's work. The fact that the perizonium appears to be made from fabric soaked in size (*tela encolada*) further suggests that cat. no. 47 is by this sculptor, as it was a technique he is known to have employed.[4] Mora's larger *Crucified Christ* (*Cristo de la Expiración* or *Cristo de la Misericordia*) of 1673–4 in the church of S. José in Granada is stylistically analogous, and also has a loincloth made of *tela encolada*.[5] For these

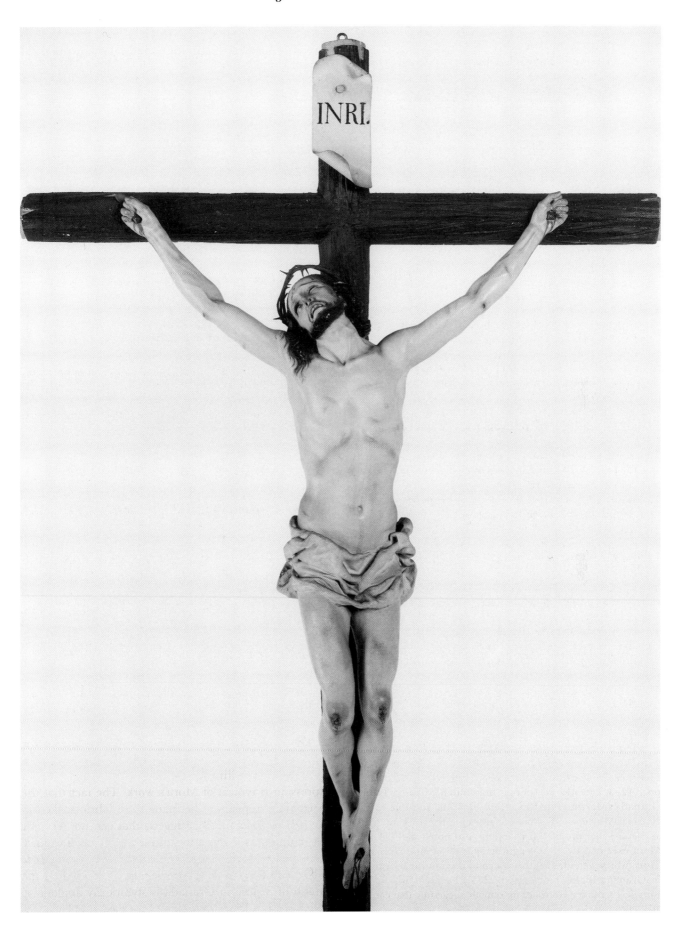

reasons this piece is likely to have been produced by José de Mora, probably during the last third of the seventeenth century.

BIBLIOGRAPHY

Inventory 1864, p. 26.
Inventory 1852–67, p. 18.
Art-Journal, p. 282.
Riaño, p. 6.

NOTES

1. I am grateful to Richard Cook for his comments on the loincloth.
2. Cf the *Ecce Homo* by these brothers in the church of SS Justus and Pastor, Granada (Martín González 1983, p. 189, fig. 80). Cf also the anonymous papier-maché bust in the Convento de PP. Agustinos Filipinos, Valladolid, thought to be Granada, dating perhaps from the early seventeenth century (*Pedro de Mena* 1989, pp. 26–7, cat. no. 3). Cf also two approximately comparable crucifixes catalogued as 'Spanish eighteeenth century' sold at Sotheby's New York, 12th January, 1993, lots 87 and 88.
3. I am grateful to Domingo Sánchez-Mesa Martín for this suggestion. Cf the bust of the *Ecce Homo* by José de Mora in the Museum of Fine Arts in Granada; *Escultura en Andalucía*, pp. 144–5, cat. no. 42.
4. See Gallego y Burin 1925, p. 105.
5. Gallego y Burin 1925, pp. 139–46 and figs. 11–13. Sánchez-Mesa Martín 1991, pp. 238–9 and figs. 151–2.

48. VIRGIN OF THE IMMACULATE CONCEPTION

PAINTED TERRACOTTA

GRANADA; about 1700

Inv. no. 320–1864

H. 48 cm.

See plate 18

Provenance

Bought by John Charles Robinson from Guzman, Granada in 1863 for £1 1s.

Condition

The polychromy, fragmentary in parts, was consolidated in 1981 to prevent further deterioration of the surface. There are signs that some of the paint, particularly the blue of the Virgin's robe, has been re-touched at an earlier date. A hole in the top of the head would probably have originally held a halo. The reverse has a raw, flattened surface, with what appear to be imprints of the grain of timber, and of tool-marks where the figure may have been prised from the surface on which it had been worked. It is likely therefore that the piece was laid down flat on a piece of wood while it was being modelled, although the modelling of the billowing robe at the sides could not have been carried out while it was supported at the back, as this part of the terracotta would have been inaccessible. This probably means that after the preliminary modelling stage it was removed from the wood, and worked on further. The unfinished reverse suggests it was designed to be set against a backing, or in a niche.

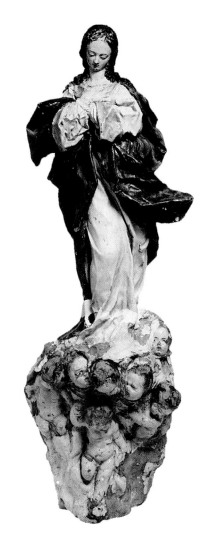

The young Virgin stands looking downwards, resting on her left leg, her right leg stepping forward; she has long brown hair with small curls falling over her shoulders. Her hands are crossed over her breast, her robes billowing out. She wears a blue cloak over a white robe with broad pink borders at the sleeves and collar; at her neck is a white chemise. These colours, a blue cloak over a white dress, were those favoured by Pacheco for representations of the Virgin of the Immaculate Conception.[1] She stands on a tapering base supported by cherubs in white and pale blue clouds, three shown almost in full-length, and four whose heads alone are seen.

The *Virgin of the Immaculate Conception* was a widely popular theme in Spanish painting and sculpture in the seventeenth and early eighteenth century.[2] This small-scale terracotta version of the subject has had a number of attributions since its arrival in the Museum. When first acquired it was thought to be by José Risueño of Granada (1665–1732), although it was incongruously dated to the second half of the sixteenth century. Although it is clearly later in date than the sixteenth century, Risueño's known works do not correspond stylistically.[3] At the time of the compilation of Maclagan's and Longhurst's *Catalogue of Italian Sculpture* in 1932 it was considered to be a reduced copy after Pierre Puget (1620–1694) by an Italian artist.[4] Although the figure by Puget from which this was thought to be derived is of the same subject, it is likely to be some thirty or so years earlier (it was executed in 1670), and there are many differences in composition and style.[5] The present piece was not included in Pope-Hennessy's *Catalogue of Italian Sculpture* in 1964. In 1967 Sánchez-Mesa Martín ascribed it to Luisa Roldán,[6] but in my view the comparative material was not convincing, and for this reason the ascription cannot be supported. When exhibited in 1981, it was described as related to the works of Luisa Roldán, likely to be from Seville, and to date from about 1700. Although this is about the right date, the diminutive head, billowing outline of the figure, and delicate facial features are indebted to the work of Alonso Cano; one of his most famous works is a larger version in polychromed wood of the same subject dating from

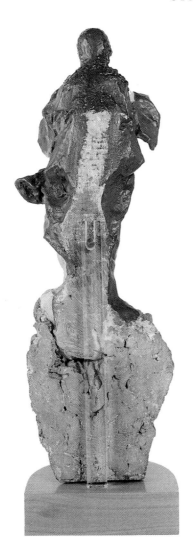

1665/6.[7] The tradition of working in terracotta in Andalusia was strong in the early eighteenth century, and this figure was probably produced by a follower of Cano in Granada.[8]

BIBLIOGRAPHY

Inventory 1864, p. 26.
Inventory 1852–67, p. 71.
Riaño, p. 2.
Loan Exhibition, p. 115, no. 722.
Maclagan and Longhurst, p. 163.
Sánchez-Mesa Martín, pp. 326–8 and pl. I.
El Greco to Goya cat. no. 77, fig. 129.
Baker 1984, p. 342, fig. 3 and p. 343.

NOTES

1. Pacheco II, p. 211. I am grateful to David Davies for pointing this out.
2. For a discussion of the iconography, see Ajmar and Sheffield, pp. 46–51, and Stratton 1994.
3. *Inventory* 1864, p. 26 and Riaño, p. 2.
4. Maclagan and Longhurst, *loc.cit.* in the bibliography for this entry. A note in Maclagan's handwriting in the Museum registers recorded 'The composition is closely similar to that of a group by Puget, made in 1670, in the Oratory of St Philip Neri at Genoa: Gaz. d. Beaux Arts, 4me sér. XII, 1914/6, pp. 14–17.'
5. The figure by Puget is illustrated in the article [by Smouse] cited by Maclagan; see Smouse, plate on p. 17. For a more recent reference see *Puget* 1994, pp. 92–3, fig. 13. See also *Salzillo* 1983, p. 134, fig. 7.
6. Sánchez-Mesa Martín, *loc. cit.* in the bibliography for this entry.
7. This is in the sacristy of Granada Cathedral. See *Alonso Cano Centenario*, II, p. 50, no. 3 and PL. XI.
8. Comparable pieces include a Virgin sold in the Stumm Sale (Stumm, pl. 10, lot 190), and a polychromed wood Virgin in the Museo Marés, Barcelona, no. 2029 (*Catálogo Marés*, pp. 71–2 and p. 126; there attributed to José de Mora, mistakenly in my view).

49. ST FRANCIS XAVIER

PAINTED WOOD (PROBABLY PINE) AND GLASS EYES; FABRIC
DIPPED IN SIZE

GRANADA; about 1750–1800

Inv. no. 107–1864

H. (with base) 57.8 cm. H. (figure only) 51.3 cm.

W. of base 23.1 cm. D. of base 19.9 cm.

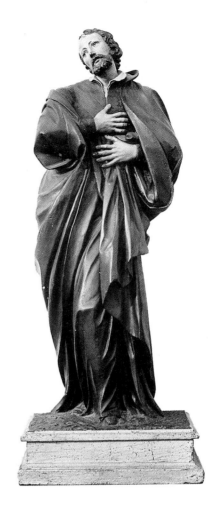

Provenance
Bought by John Charles Robinson from Soriano, Madrid in
1863 for £3 19s.

Condition
Much of the paint on the drapery seems to be later, although it
is likely to imitate the original colour; the paint on the face may
be original. A fold of drapery below the figure's left arm seems
to be of material dipped in size; it may be a later repair. Some
damage is evident on the back of the hood, and on the drapery
over the left elbow; the nose is slightly rubbed. Otherwise the
piece is in good condition. The sides of the base have been
painted white, and this paint is now peeling. Written in black
ink on the underside of the base is a half-legible word
'Pho...d(?)'. The meaning of this is uncertain; it may be a
reference to the piece being photographed, perhaps before it
entered the Museum in 1864, although the letters do not
suggest a Spanish word; cf cat. no. 41, which has the same
provenance, and a comparable cryptic inscription written in a
similar hand.

The tonsured and bearded saint rests on his right foot,
stepping forward with his left. He clasps his hands to
his breast, the right one above the left, and inclines his
head to his right, looking slightly upwards, his mouth
half-open. He is dressed in a voluminous black cloak
over a black soutane with a white shirt collar showing.
The figure is set on a socle with an upper surface
probably made from white ground thickened with size
to resemble roughened ground. The darkened green
colouring of this is possibly a later re-paint, the original
being more probably a lighter green. Although it is
carved in the round, the relatively plain drapery at the
back suggests the piece was intended to be seen only
from the front. The face is a hollow mask joined to the
back of the head, with the glass eyes and probably
tongue and teeth (which are visible through the open
mouth) fitted from behind.

 This devotional figure represents St Francis Xavier
(1506–1551), a Jesuit missionary of Spanish descent.
One of the first followers of St Ignatius Loyola, he
was canonized in 1622.[1] Although no symbols are
evident here, the dress, appearance and gesture
accord with known representations of the saint.[2] The
swinging stance of the figure and the voluminous

drapery tapering down towards the feet are
reminiscent of larger-scale works produced in
Granada under the influence of Alonso Cano and
Pedro de Mena, and the present piece may even be a
reduced version of a life-size statue.[3] The figure can
be compared with eighteenth-century Andalusian
sculpture, such as that of the Seville sculptor
Cristóbal Ramos (1725–1799)[4] or the Granada
sculptor Torcuato Ruiz del Peral (1708–1773).[5] The
bland pose and facial expression suggest the figure is
a relatively late work made in the tradition of Cano,
and likely to date from the second half of the
eighteenth century.

BIBLIOGRAPHY
Inventory 1852–67, p. 70.
Inventory 1864, p. 9.
Loan Exhibition, p. 125, no. 800.
Riaño, p. 7.

NOTES
1. An exhaustive account of his life, based on his
correspondence, is given in Schurhammer. See also Réau, III, I,

pp. 538–41, Farmer, pp. 449–50, Hall, pp. 133–4, and LCI, 6, pp. 326–7.

2. Cf the polychromed wood figure in Cádiz Cathedral; Ferrando Roig, p. 116.

3. Cf Cano's *Virgin of the Immaculate Conception* in Granada Cathedral (*Alonso Cano Cantenario* II, pl. XI), and Pedro de Mena's *St Louis* in Málaga Cathedral (*ibid.*, pl. LXXXV), and the much larger figure of St Apollonia, thought to be from Córdoba, and dating from the eighteenth century, now in the Museo de Arte de Ponce, Puerto Rico (acc. no. 63. 0434). (Stratton, p. 182). For a reduced version of a life-size figure, cf the *Beata Mariana* (cat. no. 28).

4. Cf the figure of St Cayetano of about 1774 in the church of St Catherine, Seville; Montesinos Montesinos, pl. 8.

5. Cf the facial types of the *Pietà* group by Ruiz del Peral in Santa María de la Alhambra, Granada (*Ars Hispaniae* XVII, p. 78, figs. 59 and 60).

Catalonia, Valencia and Murcia

The sculpture produced in these regions running along the East coast of Spain, while not homogeneous, can usefully be considered in one section. As in Aragon, alabaster was sometimes used for altarpieces and reliefs, such as the sixteenth-century trascoro of Barcelona Cathedral (cf cat. no. 52), but wood was more common. Damián Forment (*c.* 1486–*c.* 1540) was active in Catalonia, and the Italianate quality of his work influenced pieces produced in Barcelona during the sixteenth century. From the medieval period onwards sculpture was produced for the wealthy Catalan monasteries of Montserrat and Poblet (cf cat. no. 51 and cat. no. 55).

Because of the geographical position of this part of Spain, ties with Italy were strong. Valencia and Barcelona in particular had strong trade links with Genoa. Spanish artists went to Italy, such as the early sixteenth-century sculptor Bartolomé Ordóñez, a Spanish sculptor who is first recorded in Naples in 1517, and who was then documented in Barcelona in 1519, dying soon after in Carrara. Later artists, for example Nicolás Salzillo (d. 1727) (father of Francisco; cf cat. no. 54) came to Murcia from Capua. Other Italian, French and Netherlandish artists were active in this part of Spain, particularly during the seventeenth century. The presence of the Alsatian sculptor Nicolás de Bussy (1651–1706) in Valencia and Murcia at the end of the seventeenth century was of great importance in the development of eighteenth-century sculpture in both cities, particularly the work of Francisco Salzillo (cat. no. 54). The Vergara family of sculptors and painters were the leading artists active in Valencia during the eighteenth century (cf cat. no. 53).

50. ST MICHAEL

BOXWOOD AND SILVER
CATALONIA(?); about 1490–1500
Inv. no. 138–1879
H. (including cross and base) 12.2 cm. H. of figure 10.6 cm.

Provenance
Bought from John Charles Robinson in 1879.[1]

Condition
The silver lance/cross and base are severely tarnished. The wood figure is attached with two old fixings to the base, and two modern brass screws. The left thumb is broken off, and the top of the left wing has been broken and re-fixed; there is also a repair under the left arm. The devil's hip is damaged. The surface of the wood is coated with varnish.

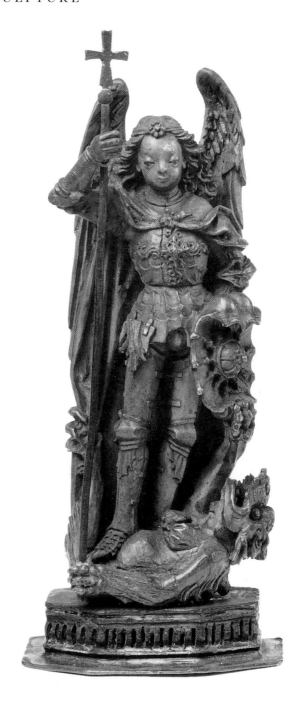

St Michael stands with his bent right arm upraised; a lance surmounted by a cross is fixed to his right wrist by means of a wire bangle; this may have been fixed on after the thumb was broken, and the hand could no longer hold it securely. The lance/cross may itself be a later replacement. His right foot tramples the dragon-type devil (with wrinkled breasts), which in turn grasps the base of the staff with its right forefoot and St Michael's shield with its left. Its hind leg clings to St Michael's robe. The saint stares straight ahead; his round face with its disproportionately large eyes is boyish. He wears elaborate armour and a fillet round his head with a decorative stud in its centre, similar to the arms and headband worn by Pedro Millán's *St George* (cat. no. 34). The style of armour dates from about 1460–70, and although it may be German, this does not preclude the figure being Spanish, as such armour was frequently shown in contemporary Spanish, particularly Catalan painting.[2] The shield or buckler on the present figure is particularly complex in its shape and decorative detail, and differs markedly from that of the *St George*.[3] The back of the figure is only summarily carved, and a dowel hole with a thread mark has been drilled in the middle of the back, probably for a later screw-fixing.

The figure's small size and the virtuoso carving, along with the silver base and staff, suggest it was intended for a treasury, although the fact that it is relatively unworked at the back indicates it may have been fixed in a setting, rather than having been a freestanding figure.[4] Although, as noted above, there are distant parallels with the Millán *St George*, it is unlikely to be from Seville. When acquired, it was dated to about 1490–1500 and ascribed to the sculptor of the stalls of Toledo Cathedral, at that time thought

to be Juan de Borgoña; there is no reason to associate it stylistically with Toledo, but the date is likely to be correct.[5] This means that it is probably slightly later than the style of the armour (about 1460–70; see above). The late Gothic style recalls the approximately contemporary angels on the outside of the late fifteenth-century Exchange, *La Lonja* (1482–98) in Valencia.[6] No closely comparable pieces are known to me; the similarity of the armour to certain Catalan paintings suggest it may be from Catalonia.

BIBLIOGRAPHY

List 1879, p. 13.
Loan Exhibition, p. 126, no. 814.

NOTES

1. Like cat. no. 7, this was one of 301 Spanish objects (including silver and textiles) bought from Robinson for a total price of £6,800 in 1879. They represented 'acquisitions he has made from time to time on his travels in Spain' (minute from Sir Philip Cunliffe Owen to Edward J. Poynter, 19 May 1879. John Charles Robinson Nominal File, Vol. I. Victoria and Albert Museum Registry). See Introduction, p. 7.

2. I am grateful to Anthony North for his comments on the armour and the references cited here. He has noted in particular the pinched waist and hanging tassets, and the flamboyant applied cross on the breastplate. For parallels in contemporary painting and monumental sculpture, see Riquer, figs. 161 and 167.

3. This is of a type often depicted on mid-fifteenth-century Spanish soldiers. See Riquer, fig. 245.

4. For a brief discussion of collections at the end of the fifteenth century and the early sixteenth century, see Morán and Checa, pp. 29–53. One of the most important of such collections in Spain at this time was that of Cardinal Mendoza, although this consisted primarily of coins, medals cameos and precious stones. See also Lenaghan, pp. 201–9 and pp. 414–71.

5. *List* 1879, p. 13. The stalls are now attributed to Master Rodrigo Alemán, probably a Flemish artist, who was working at Toledo in 1487/9 (Gilman 1951, p. 197).

6. See Garin 1959, pp. 77–83. I am grateful to Fernando Benito for drawing my attention to this building.

51. THE VIRGIN OF MONTSERRAT

MARBLE

BARCELONA; about 1600–1620

Inv. no. 291–1870

H. 52 cm. W. 44.5 cm. D. 21 cm.

Provenance

Purchased on 10th June 1870 from Juan Facundo Riaño, through Messrs McCracken for £10.[1]

Condition

Parts of the two crowns are missing, as are both crosses from the tops of the two orbs. Christ's right thumb and the tips of his two right fingers are lost. Small chips are evident on the carved rocks behind. One of the feet of the base is missing, and others are damaged.

The enthroned Virgin and Child, each wearing a crown and holding an orb, are shown against a background of the distinctive rocky mountain of Montserrat (the name meaning 'sawn mountain'). The Christ Child, seated cross-legged, raises his right hand in blessing. A procession of pilgrims is depicted wending its way towards the monastery, and elsewhere individual pilgrims, hermits and monks are seen in pathways along the mountainside. Hermitages, wayside chapels and crosses, trees and bushes are scattered over the rocky background. The work is carved in the round, and although it is less detailed at the back, it was evidently to be seen from behind as well as from the front. A small image of a bird (a crane or stork?) with a snake in its beak, probably symbolizing the triumph of Christian good over evil, is to be seen at the lower left of the Virgin, and an image of a snake and a flower on the lower right almost certainly has a similar connotation.[2] The rim of the integral base is carved at the front with stylized foliage, and lobes; at the back it is plain. It rests on seven (originally eight) squat feet. The marble is hollowed out underneath, so that there is an interior cavity, approximately 8 cm deep, probably to make the piece less heavy and more stable on its feet.

The cult image of the Virgin of Montserrat, originally dating from the twelfth century, but much restored, is housed in the renovated Monastery of Santa María, Montserrat (Barcelona), and has been the object of pilgrimages from at least the fifteenth century to the present day.[3] Although the figures of the Virgin and Child in the present piece do not resemble that image, the form of the mountain is accurately based on Montserrat, and many analogous compositions of the Virgin are to be seen in engravings, paintings and sculpture, many of which are in the Museum at Montserrat.[4] Representations of the composition are also known in other Spanish locations, as well as elsewhere in Europe, and Hispano-America.[5] A number of pieces are housed in the Museo Marés in Barcelona, including a slightly larger polychromed and gilt wood group, which is dated to the seventeenth century.[6] Another wood version by Juan de Muniategui (active 1595–d. 1612) is on the altarpiece of the Virgin of Montserrat in the church of S. Pedro de Valverde (Monforte), Galicia.[7] A coral group was listed in the 1576 inventory of the collection of Philip II.[8]

The two versions closest to cat. no. 51 are a marble piece in a private collection in Granada, and one in Valencia. The work in Granada was exhibited and published in the journal *Museum* in 1912.[9] It was dated to the fifteenth century, but is more likely to be late sixteenth or early seventeenth century, although echoing an earlier style. The version in Valencia was originally in the church of the Convento de la Merced in that city, and is now in the Valencian Museum of Fine Arts.[10] Like cat. no. 51, both these versions show the Virgin and Child in the foreground placed in front of a backdrop of the mountain of Montserrat, with no attempt to depict the middle ground, or to create a consistent perspective within the background scenes. Such a composition must derive from an engraved source, rather than a sculptural one.[11]

While it is virtually certain that the present piece was made in the region of Barcelona, because of its connection with the monastery of Montserrat, a more precise attribution is difficult to establish, since the composition was so frequently reproduced. The facial type, with finely carved and widely spaced features, along with the scroll-like curls of the Virgin's hair, recalls French and Franco-Spanish sculpture of the late fifteenth century, and is in the tradition of such figures as the mid-fifteenth century terracotta figure of St Eulalia, attributed to Antonio Claperós the Elder (active 1440–1460), now in Barcelona Cathedral.[12] The rocky background, though in a primitive style, lacking strict perspective, recalls such seventeenth-century works as the relief showing *The Agony in the Garden* on the *trasaltar* (back of the altar) by Pedro Alonso de los Ríos of 1679 in Burgos Cathedral.[13] The flowing robes of the Virgin also suggest parallels with seventeenth-century pieces, such as Agustin Pujol's *Virgin of the Immaculate Conception* of 1623 in Verdú (Lérida).[14] Apart from these stylistic parallels, the form of the crown worn by the Virgin in cat. no. 51 pre-dates the distinctive crown sent from Mexico in the first third of the seventeenth century,[15] giving an *ante quem* for the carving, while the church seen in the background of the present work is the new church built at Montserrat in about 1599, giving a *post quem*.[16] For these reasons, while incorporating fifteenth-century features, this piece must date from the early seventeenth century.

BIBLIOGRAPHY

List 1870, p. 27.
Loan Exhibition, p. 113, no. 709.
Nigra sum, p. 47 (illustrated), p. 235, p. 266, and p. 300.

NOTES

1. Riaño (1829–1901), who was based in Madrid, was to write the *Catalogue of Art Objects of Spanish production in the South Kensington Museum* published in 1872 (see Bibliography), and was the most important adviser to the Museum on Spanish art following Robinson's departure as Art Referee in 1867. See Introduction pp. 7–8.

2. See de Vries 1976, p. 116, where the crane is identified as an image of 'the good and diligent soul'. A snake attacked by an eagle is seen as the 'chthonic female spirit vanquished by the spirit' (*ibid.*, p. 414). Cf the discussion of a similar image in Giovanni Bellini's painting *The Madonna of the Meadow* in Wind 1950, p. 350.

3. See Boix, and Verrié 1950, p. 83.

4. See *Montserrat* 1981 and *Nigra sum*.

5. Teresa Macià, Curator of the Museum at Montserrat has compiled a list of these images. I am grateful to her for letting me have a copy of this.

6. See *Catálogo Marés*, p. 89, no. 60, and p. 132 (illustrated).; the measurements given are 88 x 114 cm. For illustrations of engravings of similar compositions, see frontispiece to *Compendio Historial o Relacion breve . . . del Portentoso Santuario . . . de Nuestra Señora de Monserrate,*

Barcelona, *c.* 1756; Verrié, *op.cit.*, p. 43; and Albareda 1974, for illustrations of engravings dating from the sixteenth century onwards on unnumbered plates. See also Ajmar and Sheffield, p. 44, fig. 6.

7. Vila Jato, pp. 310–11.

8. Moran and Checa, p. 112.

9. Marín, p. 247 (illustrated), and p. 253.

10. Garín 1955, pp. 191–2, no. 613.

11. See *Montserrat* 1981, especially pls. I, III, IV. Cf also the anonymous early seventeenth-century painting in the Convento de Portaceli in Valladolid, given to the monastery by don Rodrigo Calderón in 1616. See Martín González 1988, pl. XIV. This painting shows the Virgin of Montserrat hovering in the sky beside the mountain, above the Monastery.

12. For an illustration of this figure, see Liaño Martínez 1983, p. 76, fig. 57. See also Thieme-Becker, VII, p. 42.

13. *Ars Hispaniae XVI*, fig. 289.

14. Martín González, 1983, p. 327, fig. 150.

15. See *Montserrat* 1981, pl. VIII. The crown is also to be seen in a painting of the *Virgin of Montserrat* of *c.* 1640 by J. A. Ricci (1600–1681) in the Museum of Montserrat; *Nigra sum*, pp. 118–19, cat. no. 32., *Nigra sum*, p. 248.

16. I am grateful to Padre Josep de C. Laplana, Director of the Museum at Montserrat, and to Teresa Macià, Curator of the Museum, for this information. I am indebted to both of them for their extensive help on the question of images of the Virgin of Montserrat.

52. THE CHRIST CHILD KNEELING BEFORE THE INSTRUMENTS OF THE PASSION

ALABASTER

CATALONIA(?); about 1650

Inv. no. A.83–1937

H. 12.6 cm. W. 9.3 cm. D. 1.7 cm.

Provenance

Given by Dr W. L. Hildburgh F.S.A. in 1937. Purchased by the donor in Barcelona in 1919.

Condition

The top right corner and part of the right side are broken off. Christ's halo is damaged, and his face is badly rubbed.

Christ is depicted as a young boy kneeling with his arms crossed over his chest, wearing a loose shirt. Behind is the fragment of a scroll, perhaps once inscribed. He gazes at the instruments of the Passion displayed before him: the cross, scourge, column, nails, crown of thorns, sponge, lance, and dice.

The subject of the young Christ gazing at the instruments of the Passion is relatively unusual.[1] The stylized nature of the carving, in particular the curled hair of Christ, and the thick halo, suggest this is likely to

be a provincial piece. The provenance and material indicates that it may be Catalan.[2] Unfortunately the poor quality of the relief (both its condition and the carving) means that it is difficult to give a precise attribution.

NOTES

1. For an iconographic discussion of the instruments of the Passion, or *Arma Christi*, see LCI 1, pp. 183–6, and for the Christ Child and the Passion, see *ibid.*, 2, pp. 401–2. Cf cat. no. 23.
2. Cf the earlier alabaster relief of *The Entombment* by Pedro Moreto, cat. no. 56.

53. ST SEBASTIAN

BOXWOOD

VALENCIA (PROVINCE); about 1700–20

Inv. no. 90–1864

H. 26 cm (without socle) 32 cm (with socle).

Provenance

Bought by John Charles Robinson from don José Calcerrada in Madrid for 100 francs (£4) in 1863.[1]

Condition

Small parts of the figure are missing, such as the right thumb tip, some of the binding for the saint's right hand, and the arrows. The top of the tree-trunk is slightly chipped. Otherwise the piece is in good condition.

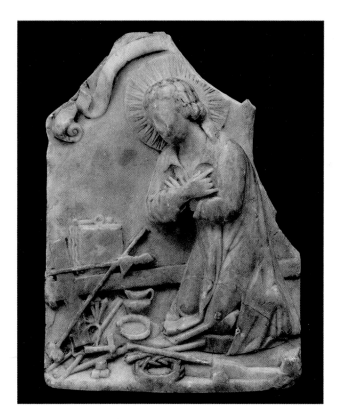

St Sebastian, a youth with long flowing hair, stands tied to a tree with distinctive lopped and truncated branches, his right arm tied towards the right above his shoulder, and his left tied away from his body at the hip. He leans on his right leg, with his left leg bound behind him, the foot lifted from the ground. His head is upturned to the right, the anguished eyes cast upwards. He wears a white loincloth knotted at the hip. The figure and tree stand on a dark blue base. The five holes in the torso, arms and legs must have been once fitted with arrows. A tongue-shaped part of the base slots into place, and, along with the tree and the figure, which are integrally carved with this tongue, it can be removed by sliding it out from the base. A hole drilled into the base must have once held a pin to secure this; this is now missing. The gilt socle onto which the base is fixed is probably not original.

When first acquired, Robinson described this figure as being 'probably of the Valencian School'.[2] However, in 1871 it was said to have been made in the Philippine Islands.[3] When it was published in 1881 it was described simply as 'Spanish'.[4] Comparisons with works from the Philippines do not support the attribution to this Spanish colonial area. Most of the

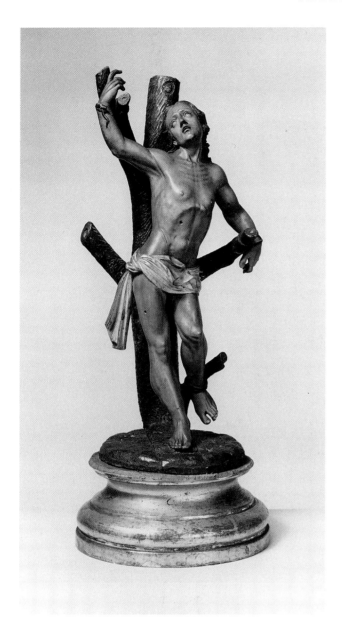

figure of St Sebastian dating from *c.* 1681 and attributed to Antonio Borja (*c.* 1661–1719), in the church of S. Isidoro in Oviedo provides a stylistic parallel,[6] but Robinson's suggestion that the piece might be from the region of Valencia is perhaps the most likely solution. A larger polychromed wood figure of the Resurrected Christ (h. 80 cm), dating from the eighteenth century, in Castellón (about fifty miles north of Valencia) is stylistically analogous to the present piece.[7] The sensitively portrayed faces, as well as the poses and proportions are similar in both. Although it is on an even larger scale than the piece in Castellón, and was made farther south, a life-size figure of St Sebastian, dating from before 1720 in the church of S. Bartolomé in Murcia, attributed to the Murcian artist Nicolas Salzillo (*c.* 1683–1727) is also comparable.[8] Closer still in style is a boxwood head of S. Pascual Bailón by Ignazio Vergara (1715–1776), formerly in the cathedral of Cádiz, and now in the Museum of Fine Arts in Valencia; this piece exhibits similar fine features and hair,[9] as does an unattributed boxwood figure of St Sebastian dating from the early eighteenth century in the same museum.[10] These parallels suggest that the present figure is likely to come from the region of Valencia, and to date from the early eighteenth century.

BIBLIOGRAPHY
Inventory 1864, p. 7.
Inventory 1852–67, p. 70.
Loan Exhibition, p. 125, no. 797.

NOTES
1. The purchase is first recorded in the Robinson Reports, I, no. 334, p. 101 (260). Minute to Henry Cole from John Charles Robinson, stamped 5 January 1864.
2. Robinson Reports, Vol. I, Part 1, pp. 144ff.
3. Mr Cole's Memo 40667, 27th October 1871, and Riaño's Report 37495, 5th October 1871. (Museum Registers 1864, p. 72).
4. *Loan Exhibition, loc.cit.* in bibliography for this entry.
5. See Trota José, p. 20, and the illustrations of statuettes of saints, e.g. those on pp. 89–92.
6. Formerly in the chapel of the hospital of St Sebastian, Oviedo; Ramallo Asensio 1985, pp. 326–7 and figs. 211 and 212. I am grateful to Jesús Urrea for mentioning this figure.
7. Codina Armengot, p. 41, fig. 7.
8. Sánchez Moreno 1983, p. 41. See also *Salzillo* 1983, p. 238, cat. no. E–11.
9. Inv. no. 2922. Unpublished.
10. Garín 1955, p. 112, no. 332.

surviving sculpture from there is of ivory, and stylistically distinct from the present piece.[5] This figure is unusual in its moderate use of polychromy: the skin colour appears to be a wash surface on the wood, rather than painted. Traces of paint representing blood remain round some of the holes which must have been once fitted with arrows, but otherwise the piece is restrained in terms of colour. The lack of paint on the hair means that the fine carving is clearly visible. A larger and slightly earlier

FRANCISCO SALZILLO
(b. Murcia 1707–d. Murcia 1783)

Francisco Salzillo was the son of the sculptor Nicolás Salzillo (d. 1727), who came originally from Capua, and had settled in Murcia in 1695. Francisco took over the workshop at his father's death, and was to spend his entire working life in Murcia, sculpting devotional images and *pasos* (processional groups). These he and his workshop also painted, and sometimes adorned with glass eyes, eyelashes, hair and drapery. A devout man, Salzillo's most important works are the processional groups he produced between 1736 and 1777 for the *Cofradía de Nuestro Padre Jesús Nazareno* of Murcia; they are housed in the church of Jesus in Murcia, now the Salzillo Museum. Salzillo established an Academy in his own house in the mid-1760s; this was the predecessor of the *Escuela Patriótica de Dibujo* set up in 1779 under his directorship. Although influenced by the work of the French sculptor Nicolas de Bussy (1650/1–1706), who had settled in Murcia in about 1688, Salzillo's dramatic and naturalistic figures exemplify the vernacular baroque tradition of Spanish sculpture following the Counter-Reformation.

BIBLIOGRAPHY
Ceán Bermúdez VI, pp. 25–32; Pardo Canalis; Sánchez Moreno 1983; *Salzillo* 1973; *Salzillo* 1977; *Salzillo* 1983; Belda Navarro.

54. ST JOSEPH

PAINTED AND GILT WALNUT WITH EYELASHES AND GLASS
EYES ON PINE BASE
BY FRANCISCO SALZILLO
MURCIA; about 1760–70
Inv. no. A.2–1956
H. 145 cm.
See plates 1, 20 and 21

Provenance
Bought from Mr H. Baer, 6, Davies Street, London, W1 in 1956 for £150.

Condition
The right hand is missing (the dowel remains).[1] The fingertips of the left hand are lost. These were perhaps damaged when the Christ Child, which was almost certainly once held in the saint's arms was removed. The right little toe is damaged, and the toenail is missing. A fill, which has been re-painted, is visible on the forehead. The polychromed surface and white ground is missing in places, and some overpainting is in evidence. The paint was consolidated and cleaned in 1995.[2]

The bearded St Joseph stands, looking downwards, with flowing shoulder-length hair, his arms held out as if he were once carrying something (almost certainly the Christ Child). Eyelashes are inserted over glass eyes. He is dressed in a tunic of blue and gold, with a rich pattern, partly formed by the use of punches and chiselled lines on raised white ground. The lines were made with a chisel into the white ground before the bole was applied, while the punch marks were made later into the gold leaf. Some of the punches are painted with coloured translucent

glazes directly over the gilding, giving the impression of small inset precious stones. The chemise worn under his tunic is of white ground placed over the painted flesh. A reddish brown and gold cloak is caught over his right arm. His sandalled feet are visible beneath his robes; the sandals are formed of strips of fabric painted blue for the straps. The figure is fully carved and finished at the back. On the back of the head is a contemporary metal fixing with holes which must have been used to affix a halo. The figure is fixed by more than twenty-five flat-headed nails onto the separate pine base, which is of a curved cartouche-like form. Three dowel-holes underneath the base, one with a metal screw-fitting just visible, must have been used to fix the base and figure to a plinth.

Representations of St Joseph and the Christ Child were widely popular in Spain in the seventeenth and eighteenth century.[3] Although unsigned and undocumented, comparison with the works of the Murcian sculptor Francisco Salzillo suggests that he is the author of this piece. The scale of the figure, the diagonal flow and red-brown colouring of the robes, and the facial features are all typical of his work.[4] The face of St Joseph parallels Salzillo's head of Christ from the *Last Supper* group of 1763 in the Museo Salzillo in Murcia,[5] as well as the faces of the smaller figures of St Joseph in Salzillo's nativity scenes (*Belen*) in the same museum.[6] His *St Joseph and the Christ Child* (undated) in the church of S. Andrés in Murcia is particularly close in style and composition to the present work.[7] Although a later version (1809–10) of this composition by Salzillo's pupil, Roque López y López (1747–1811) is known, cat. no. 54 seems to be an authentic work by Salzillo himself.[8] The stylistic

parallels with the St Joseph from the *Last Supper* noted above suggest a date during the 1760s for the present piece.

NOTES

1. This hand is visible in photographs dating from 1956, but was reported missing in 1965.
2. I am grateful to the conservator, Charlotte Hubbard for her illuminating comments on the surface of the figure.
3. Cf the figure group by Risueño, cat. no. 42, and Salzillo's *St Joseph and the Christ Child* of about 1732–35 in the church of the Clares in Murcia (Sánchez Moreno, pp. 118–19 and unnumbered illustration on p. 170).
4. I am particularly grateful to Cristóbal Belda for his comments on the attribution.
5. Sánchez Moreno, p. 131, and unnumbered illustration on p. 107. See also Belda Navarro, pp. 32–5.
6. See *Salzillo* 1977, illustrations on p. 26 and p. 36.
7. *Salzillo* 1973, no. 92 (unnumbered pages).
8. The figure by López is in the church of St Bartholomew, El Pozuelo. See García-Saúco Beléndez, pp. 162–3.

Navarre and Aragon

The workshop of Damián Forment (*c.* 1486–*c.* 1540) in Zaragoza, the capital of Aragon, created in effect a school of sculpture in North East Spain, which had an impact throughout the sixteenth century. Forment was a native of Valencia, and he executed work in that city, as well as at Huesca, Pamplona and Poblet (cf cat. no. 55). He specialized in alabaster altarpieces, and reliefs and figures in this material are characteristic of the region, partly because of the existence of alabaster quarries (cf cat. nos. 55, 56 and 61). Forment's work, and pieces produced in Aragon in the wake of his activity are permeated by French and Italian influences, but he is also known to have used engravings by Dürer as sources for compositions. His followers include Pedro Moreto (cat. no. 56), Gabriel Joly (cat. no. 57), Hans Bolduch, Arnao de Bruselas (cat. no. 62) and the Beaugrant family (cat. no. 61). During the second half of the sixteenth century the strong classical forms associated with the Romanist style were to be seen in the work of Juan de Ancheta, Gaspar Becerra and others (cat. no. 58). As with the other regions of North East Spain, after the sixteenth century the sculpture produced in this part was of lesser importance, and is not represented in the present collection.

55. ALLEGORICAL HEAD

ALABASTER
ARAGON(?); about 1530
Inv. no. A.163–1922
H. 37.7 cm. W. 21.5 cm. D. 15 cm.

Provenance
Given by Dr W. L. Hildburgh F.S.A. in 1922. Said to be from the Monastery at Poblet (see below).

Condition
The nose, chin and eyelids are damaged, and the bottom edge is chipped. Small pieces of cement are in the hair. Minor chips are visible elsewhere. Saw-marks on the back may indicate that the piece was removed from a larger ensemble.

This idealised head of a woman looks slightly downward. She has long wavy hair, parted in the centre, and wears a broad headband, and the upper edge of her bodice is visible. Scrolled devices on either side of, and beneath, frame the head in a cartouche-like surround.

The subject of this relief and its original context are unclear: although reminiscent of a funerary effigy, it is more likely to be allegorical, and may well have been a corbel or have had another similar architectural function. Pencilled on the back of the relief is the following: 'Said to be from a village near Poblet, and probably from the Monastery'. It cannot be established whether this piece

did indeed come from the Royal Monastery of Poblet.[1] It is close in style to Castilian sculpture of the first third of the sixteenth century, such as the head of the figure of St Catherine on the altar to that saint in Ávila Cathedral, designed by Vasco de la Zarza (d. 1524), and completed in 1529 by Juan Rodríguez (active 1520–1543) and others (see fig. 1 on p. 2).[2] However the material and style suggest this piece may be a mid-sixteenth-century work from Aragon, perhaps Zaragoza; it recalls the alabasters produced by Pedro Moreto (active 1530–1555),[3] as well as the work of Gabriel Joly (active 1515–d. 1538), such as his *Mourning Virgin* of 1536–8 from the high altar of Teruel Cathedral.[4] The work of Damián Forment (*c.* 1486–

c. 1540) is also comparable, for example the faces of the figures in his *Adoration of the Shepherds* and *Lamentation* reliefs from the altarpiece of 1512 at the Cathedral of the Pilar, Zaragoza.[5]

NOTES

1. For Poblet, see Finestres y Monsalvo, and Guitert y Fontseré.
2. Parrado del Olmo *Ávila* 1981, pp. 98–101 and pl. VII, fig. 12.
3. Cf cat. no. 56.
4. Weise 1957, I, pl. 77 and pp. 32–6.
5. *Ibid.*, pls. 2 and 3, and p. 12.

PEDRO MORETO

(active 1530–1555)

Pedro Moreto was the son of the Florentine architect and sculptor Juan de Moreto (active 1513–d. 1551), who was first recorded in Spain in 1520. Pedro trained in the workshop of his father, and was also clearly influenced by the work of the Aragonese sculptor Damián Forment (*c.* 1486–*c.* 1540). His most important work is the altarpiece for the Chapel of S. Bernardo in La Seo, Zaragoza. He collaborated on this with Forment's foremost disciple, Juan de Liciere (1520–1590), and with Bernardo Pérez (active 1550–1556). He also worked with Pérez on the alabaster tomb of don Lope de Marco in the monastery of Veruela. The retable at Ibdes of 1555, on which he collaborated with Juan de Salamanca (active 1555–1563), is his last known work.

BIBLIOGRAPHY

Ars Hispaniae XIII, p. 260; Weise 1957 I, p. 50.

56. THE ENTOMBMENT

ALABASTER WITH TRACES OF COLOUR AND GILDING

WORKSHOP OF PEDRO MORETO

ZARAGOZA; about 1555

Inv. no. A.2–1965

H. 19.6 cm. W. 23.8 cm. D. 2.5 cm.

Provenance
Bought from French & Company Inc, 978, Madison Avenue at 76th Street, New York 21, N.Y. for 600 U.S. dollars (£214 15s 4d) (Hildburgh Fund).

Condition
The reverse suggests that the relief was broken in four large pieces, and repaired; a layer of glue at the back holds it together. The top right corner has been broken and replaced with filler. Fragments of red material suggest it was originally backed onto a mount covered in this fabric. Black paint also survives on some of the glue, as do fragments of brown paper. The pitted

surface of the back implies that the relief may have once been keyed into a support. On the back is a painted yellow circle with the figures 578 (partly rubbed) painted in blue inside. On the front, a small diagonal crack can be seen at the lower lefthand corner, while a long diagonal crack extends from the top left down through to the fainting Virgin. A horizontal crack runs from the left, through the left leg of Joseph of Arimathaea to Christ's body.

Christ is being lowered into the tomb, supported by Mary Magdalene, who holds him under his arms. A bearded figure (probably Joseph of Arimathaea) stands on the left, holding the crown of thorns in his outstretched left hand. The fainting figure of the Virgin Mary is held at Christ's feet by St John. The veiled heads of the other two Marys are visible behind the Virgin, and the heads of two bearded men can be seen behind St John; a fifth male head is shown behind the outstretched arm of Joseph of Arimathaea. The

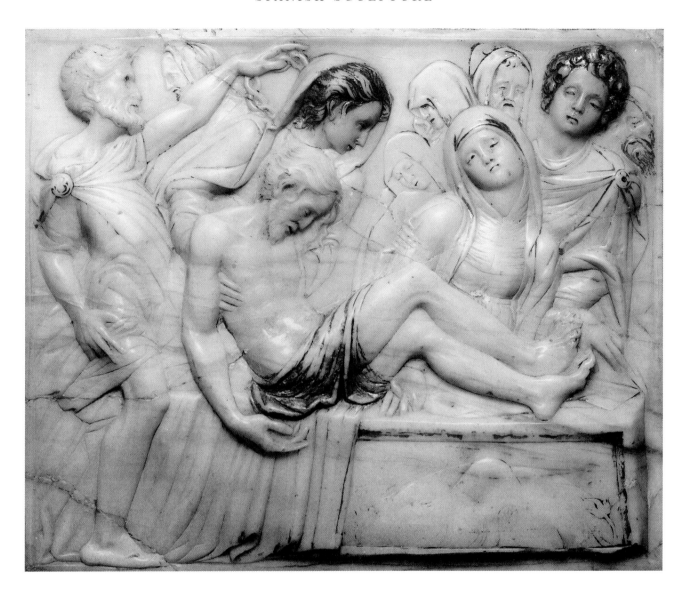

sarcophagus is carved with an elemental landscape of hillocks and tufts of grass, the left end hidden by a shroud. Traces of gilding and colour remain on the relief, seen for example on Christ's loincloth, Mary Magdalene's hair, St John's hair, and the veil of the Virgin. The stigmata are indicated by holes drilled into Christ's left hand and right foot.

The composition is based on an etching by Francesco Mazzola, called Parmigianino (1503–1540).[1] Italian sources were used relatively frequently in Spanish sculpture: for example, Pedro de Mena (1628–1688) drew on a print based on a painting of 1591 by Francesco Vanni (1563–1610) for a group of the *Virgin adoring the Child*.[2] In the present work, the differences between the print and the relief illustrate how the source was adapted by the sculptor. The proportions of the bodies have shrunk, and the heads in the background have been altered. What is apparently a relief of hills on the side of the sarcophagus in the marble is probably a

misreading of the foliage growing in front of the tomb in the print. The closest stylistic analogies of the carving are with the work produced by Pedro Moreto at Zaragoza, whose father Juan de Moreto was Florentine, and who was indeed one of the artists responsible for introducing Italian Renaissance ideas into Spain.[3] Some of the elements found in the wood reliefs from altarpieces by Pedro Moreto are to be seen in the composition of cat. no. 56: the figure on the left with a brooch on his shoulder is echoed in reverse by a figure from a work at Ibdes (Zaragoza), completed in 1555;[4] the figures of the fainting Virgin, Joseph of Arimathaea, and the Christ supported by the Magdalene are also seen in the altarpiece at Santa María la Mayor, Soria.[5] The awkwardness of the composition as seen in the present relief, particularly in the placing of the heads in the background, can be echoed in some of Moreto's works, such as his reliefs of *The Flagellation* and *The Taking of Christ* for the high altar at Ibdes.[6] For parallels with

works in alabaster, the reliefs in the Chapel of St Bernard, La Seo, Zaragoza, documented as being by Pedro Moreto's workshop, show similar treatment of drapery and the nude.[7] The original function of the present relief is uncertain. The bevelled edge and scratches along the sides may indicate that it was set into a larger ensemble (the scratches made when it was removed from its framework), and it could have been part of a predella of a small altarpiece. It may however have been a small devotional piece in its own right.

<div align="center">NOTES</div>

1. Bartsch, Vol. 32 (formerly Vol. 16, part 1), p. 11, 5–I (8). I am grateful to David Ekserdjian for pointing this out.
2. Urrea 1989, p. 366 and p. 368, fig. 5.
3. See Abbad Ríos 1950, p. 64, *Escultura en Aragón*, pp. 250–1, and Weise 1957, II, p. 38.
4. See Weise 1957 II, pl. 49b, and Abbad Ríos 1957, I, pp. 245–6 and II, fig. 728.
5. Weise 1957 II, pl. 63.
6. Abbad Ríos 1950, p. 65 and pl. IV.
7. Weise 1957 II, pl. 68–78, especially pl. 76 and 77.

57. HEAD OF A BEARDED SAINT OR PROPHET

WALNUT

ARAGON; about 1535–50

Inv. no. 92–1864

H. 31 cm. W. 14cm.

Provenance
Bought in 1863 by John Charles Robinson from Ramón Oliva in Zamora for £4 (100 reals).

Condition
Remains of white ground and colour on different parts of the surface, but particularly on the eyes, hair and beard, suggest that this head was once painted. There is a vertical split down the left side of the forehead, and through the right side of the beard; the right eyelid is slightly chipped. Other minor cracks are visible elsewhere. Two holes at the bottom and one hole at the top have been drilled through; these probably date from after it was removed from its original context, and these would have been used for fixing it, perhaps to a wall. A further area of damage and blocked hole in the centre of the back seem earlier, implying this may have been its original point of fixing. Holes and areas where the wood seems to have crumbled away on the lower left side and underneath the base indicate former woodworm attacks. The remains of a circle of glue on the reverse probably indicate a former Museum label.

The bearded man looks down, with a slightly mournful expression, his mouth half-open, and his teeth and tongue visible. The piece is flat at the back, and under the beard (where his chest would be) the wood is finished off in a way suggestive of termination in an architectural form.

As suggested above, this head was probably originally coloured, although it may have been monochrome, rather than naturalistically finished. The carving is of high quality, but at the same time relatively broad, probably because the polychromy would have picked out further detail. The flat reverse and lack of fragmentary suggestions of drapery imply that it is more likely to have been a decorative head, complete in its own right, rather than part of a whole figure. It could have been fixed to an altarpiece, the downward look suggesting it was positioned fairly high up. Although described on acquisition as a saint, it may represent a prophet.

When first acquired, Robinson described this piece as 'Head or mask of a saint in carved wood, a fragment of a statue . . . Style of Becerra. Circa 1560 – small life size.'[1] Robinson's proposed attribution to the circle of Becerra suggests the figure comes from Castile; Gaspar Becerra (1520–1568) had spent time in Italy, where he had been greatly influenced by Michelangelo's work in Rome, and

<div align="center">125</div>

he is now considered as one of the originators of the Romanist style of sculpture in Spain.[2] Although a crucified Christ in Zamora Cathedral has been attributed to him, Becerra's most important work is his altarpiece of 1558–1562 at Astorga, about twenty-five miles west of León.[3] However this head seems to be more in tune with what was being produced further east, in Aragon in the second quarter of the sixteenth century. The features are relatively delicate, and the heavily lidded eyes, hair and beard are reminiscent of the work of the Aragonese sculptor Gabriel Joly (active 1515–d. 1538). The saints he executed for the high altarpiece of the church of S. Pedro at Teruel, probably dating from 1535–8, exhibit the same fine facial features and curly hair, while the form of the beard of one is particularly close to that of the present piece.[4] Margarita Estella has remarked in correspondence that Joly tended to sculpt more aquiline noses; this is certainly true, and precludes an ascription to Joly himself.

BIBLIOGRAPHY

Inventory 1864, p. 7.
Inventory 1852–67, p. 38.
Riaño, p. 6.
Loan Exhibition, p. 123, no. 783.

NOTES

1. Robinson Reports, I, pp. 144ff.
2. See *Ars Hispaniae*, XIII, p. 168, *Escultura del Siglo XVI*, pp. 68–9, Barrio Loza, pp. 17–18, and Velado Graña. See also entry for cat. no. 18.
3. For the Astorga altarpiece, see Velado Graña, *Ars Hispaniae*, XIII, p. 175, fig. 148, and Checa, 1983, p. 234, fig. 192.
4. Weise 1957, II, pls. 78–83 and pp. 36–7. See the righthand illustration on pl. 79 for an analogous beard. See also Ibáñez-Martín, pls. 20, 43 and 44.

58. ST MICHAEL

LIMEWOOD

NAVARRE OR ARAGON; about 1560–80

Inv. no. A.107–1929

H. 72 cm. W. 40.2 cm. D. 2.8 cm.

Provenance
Given by Dr W. L. Hildburgh F.S.A. in 1929. Acquired by the donor in San Sebastián in 1921.

Condition
The panel is made up of four pieces of wood butt-jointed; a split is apparent in the top of one of the central ones. There are signs of woodworm damage, and minor chips elsewhere. Remains of white ground and polychromy indicate that the relief was originally painted. The stepped edge suggests it was fitted into a larger ensemble, probably an altarpiece. A label on the back in the donor's handwriting reads: 'Large wood panel. Relief of St Michael. San Sebastián' 21'. The number '1369' is inked direct on to the back; the significance of this is uncertain.

The classically armed and winged St Michael stands on the vanquished devil, his uplifted right arm holding a sword, and his left arm a shield, which the devil grasps with its left foreclaw. The devil's right foreclaw is reaching for the saint's left leg, while its left hind claw clings to his cloak.

The heavy forms seen here are typical of work produced in Navarre and Aragon in the second half of the sixteenth century, where the predominant style was that of those Spanish sculptors known as Romanists, so called because they were greatly influenced by contemporary sculpture being produced in Rome,

particularly the work of Michelangelo.[1] Juan de Ancheta (active 1565–d. 1588) was one of those who codified the style in this part of Spain, and a number of figures from his altarpieces are comparable with the present *St Michael*. His archangel Gabriel in the *Annunciation* group of about 1580 on the altarpiece of St Michael in La Seo, Zaragoza shows a similar contrapposto and heavy folds of drapery.[2] An angel on the altarpiece in the Trinity Chapel of Jaca Cathedral (1572–5) has thick hair, heavy facial features, and broadly feathered wings, all of which are to be seen in the present piece.[3] Although the works at Zaragoza and Jaca respectively are of alabaster, the forms are directly comparable to cat. no. 58. Other sixteenth-century wood sculpture from Northern Spain is clearly related in style, such as the work of Juan Fernández de Vallejo (active 1566–d. 1600), who was active in Rioja,[4] as well as the sculpture of the high altars of the church at Lapoblación, the church of St John at Estella, and the church of Santa Clara at Briviesca.[5] The provenance of the present piece suggests it may be from San Sebastián, and there are some parallels with the reliefs on the high altar of 1583 in the church of St Vincent in that city.[6] However the classical forms and solid anatomy seen in all these comparative pieces are not sufficiently close to the present work to warrant an attribution to a specific artist, or even to an exact location within Navarre or Aragon.

NOTES

1. Weise 1957, II, pp. 65–6. Cf also the entry for cat. no. 18.
2. Camón Aznar 1943, figs. 22 and 23 and p. 55, and Weise 1957 II, p. 68.
3. Weise 1957 II, pl. 132.
4. Barrio Loza 1981, pp. 148–74, especially plates 55, 65, 70 and 72.
5. For illustrations of the reliefs at Lapoblación and Estella respectively, see Uranga Galdiano, figs. 119–21, and figs. 226–7. For Briviesca, see Weise 1957 II, pl. 90.
6. Weise 1957 II, pp. 95–6 and pls. 230–4, 236, 238.

59. ST ROSE OF LIMA KNEELING BEFORE CHRIST, THE VIRGIN AND ST JOSEPH

ALABASTER

ARAGON; about 1675–1700

Inv. no. 8365–1863

H. 21.5 cm. W. 15.5 cm.

Provenance
Given by the Revd Arthur Cazenove in 1863.

Condition
The piece is badly chipped. St Rose's right hand and her left thumb are missing, as are the top of Christ's cross, and the head of the dove. The faces are worn, and the noses damaged. Brown stains on the surface may be the results of over-cleaning in the past. The lower left corner of the relief is missing, and there is a break at the centre of the lower edge. A hole has been drilled in the top. On the back of the relief is a patch of glue and a small area of green paint; the surface is slightly scratched.

St Rose of Lima, wearing a scapular, kneels before Christ and the Virgin, behind whom stands St Joseph. St Joseph holds a flowering branch, the Virgin a garland of roses, and Christ a cross (now broken). Behind the figure of St Rose is a simple study, with shelves holding tablets, books and a pen and inkwell. Above in clouds on the left are angels, one playing a lute; on the right are God the Father, and the Holy Spirit in the form of a dove. Remains of green and red polychromy are evident on the cherubim in the sky, the garland of roses and the flowering branch.

St Rose of Lima, born Isabel Flores y Oliva, (1586–1617) was the first saint of America, and was named patron of Peru, all of America, the Indies and the Philippines.[1] She joined the Third Order of St Dominic, and inflicted extreme forms of penance on herself, living as a recluse in a garden hermitage. The scene represented by the relief presumably takes place outside her hermitage. The flowering branch carried by St Joseph, and the garland held by the Virgin identify the saint as St Rose. Her beatification of 1668 was celebrated by a marble figure carved by Melchor Caffá (c. 1630/5–after 1669) in Rome in 1669, and installed in the church of Santo Domingo in Lima in 1670.[2] A statuette of her dating from the early eighteenth century is in the convent of Santa Paula in Valladolid.[3] A more elaborate gilt and polychromed wood figure dating from the second half of the eighteenth century is in the Museum of Colonial Art in Quito.[4] The colonial subject here might suggest it was made in Hispanic America, but the material and style imply it is from Aragon. A relief of the *Nativity* in a private collection, dating from the second half of the sixteenth century and attributed to the workshop of Damián Forment, although earlier in date, is comparable in style.[5] The date of St Rose's canonisation (1671) gives an approximate likely date *post quem* for cat. no. 59, although it reflects the style of the late sixteenth century, and for this reason is probably a provincial work. Unfortunately nothing is known of its provenance before it was given to the Museum.[6] It was almost certainly intended for private devotion.

BIBLIOGRAPHY

Inventory 1852–67, p. 45.
Loan Exhibition, p. 114, no. 716.

8365·'63.

NOTES

1. *Catholic Encyclopaedia*, XII, pp. 673–4. See also LCI, 8, pp. 286–7, p. 349, and *Converging Cultures*, pp. 168–9.

2. Angulo Iñiguez *Hispano-Americano*, II, pp. 347–8 and fig. 322. The composition is strongly reminiscent of Bernini's figures of *St Teresa* and *Blessed Ludovica Albertoni*. I am grateful to Martin Maynard for drawing my attention to Caffá's work in Lima.

3. *Pequeña Escultura*, unnumbered pages. This is thought not to be Castilian, but is probably Spanish.

4. Palmer, plate 11 and pp. 79–80.

5. *Escultura en Aragón*, pp. 352–3.

6. According to the records held by the Church Commissioners the donor was never a missionary, again suggesting that the piece is unlikely to be colonial.

Rioja and the Basque region

Rioja is bordered by Castile, the Basque region, Aragon and Navarre. A number of important altarpieces were executed during the mid-sixteenth century in and around the capital Logroño, at Alberite, S. Vicente de la Sonsierra, and elsewhere. These illustrate the fusion of styles resulting from Rioja's position at a geographical crossroads: the influence of Castile through work executed to the west in Burgos and Valladolid by Vigarny, Berruguete and others can be seen (cf cat. nos. 8, 9, and 11), as well as that of the more Italianate style of the Aragonese workshop of Damián Forment (c. 1486–c. 1540) in Zaragoza. Forment's high altarpiece for the cathedral at Santo Domingo de la Calzada, begun in 1537, had great influence on altarpieces in the region. The workshop of Arnao de Bruselas was also of importance (cf cat. no. 62) similarly the work of Gabriel Joly (active 1515–d. 1538) (cf cat. no. 57). During the second half of the sixteenth century Romanism, with its monumental, classicising forms, indebted to the high Renaissance in Rome, especially the work of Michelangelo, was the dominant style. The high altarpiece (1551–1559) of the church of Santa Clara, Briviesca (on the borders of Castile and Rioja) by Pedro López de Gámiz and others epitomizes this style. The sixteenth century was the most important in terms of sculptural activity in this region, and the present collection does not contain sculpture of a later date from this part of Spain.

Like Rioja, the Basque region was subject to a number of divergent influences, including that of Damián Forment. Here however the foreign immigrants from France and the Netherlands (themselves subject to other influences from within Spain) were dominant; Bilbao had important French and Netherlandish trading connections. The Beaugrant family (cf cat. no. 61) Hans de Bolduch and Arnao de Bruselas (also active in Rioja) (cf cat. no. 62) were the leading sculptors during the sixteenth century. These artists promulgated a style more indebted to Netherlandish and German Renaissance sculpture, dominated by intense naturalistic and expressionist figures, and twisting draperies and compositions. Although analogous to the work of the Castilian sculptor Juan de Juni (cat. no. 14), the Basque style was distinctive, perhaps because of the stronger Northern element. Altarpieces in Bilbao, Portugalete and Valmaseda epitomise these trends. Later sculpture is of less importance in this region, and is not represented in the collection.

60. ST ROCH

PAINTED AND GILDED WOOD

RIOJA; about 1540–50

Inv. no. A.66–1951

H. 136 cm.

See plate 22

Provenance

Given by Dr W. L. Hildburgh F.S.A. in 1951. Formerly in the possession of Maurice Harris, of the Spanish Art Gallery, when it was being offered at a price of 'about £300'.[1] It was sold on the dispersal of works of art from the Spanish Art Gallery, and bought by H. Baer of Davies Street, from whom it was bought by Dr Hildburgh for £125.

Condition

This object was cleaned and conserved in 1983. There are minor chips, notably on the hound's tail, the integral base, and the edges of the cloak. The left foot and back of the base are damaged. The lining of the tunic and cloak show remains of silver leaf, which would have probably been glazed to prevent tarnishing.[2] Some paint is missing on the left hand, the staff and the borders of the tunic.

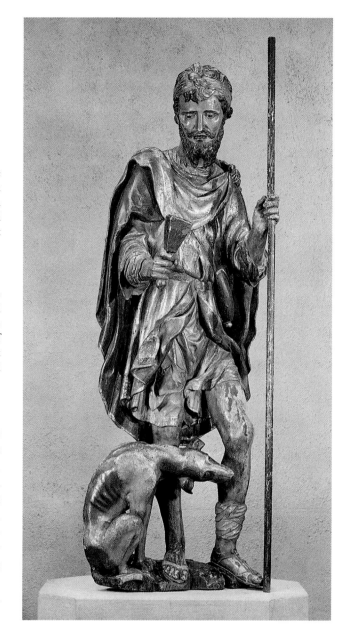

St Roch is shown looking downwards and slightly to his right. His mouth is slightly open, and his teeth and tongue visible. He wears sandals, a coat with a belt and buckle, over which a cloak is knotted at the left shoulder, and carries a pouch at his left side, strapped over his right shoulder. His left ankle is bandaged, and a dog, sitting on its haunches, is licking a sore on the saint's left leg. He wears a bandanna tied round his head, and holds a clapper in his right hand, and a staff in his left. The piece is flat at the back (supported by a modern strut), and unpainted, suggesting that it was originally intended to stand against a pillar; a ring is screwed in at the back for fixing.

The subject of the legendary St Roch (1295/1350–1379) was popular in French, Netherlandish and Spanish sculpture from the late fifteenth century onwards.[3] Roch was born at Montpellier into a wealthy family, but became a hermit, and spent much of his life as a pilgrim in Italy; while in Piacenza he caught the plague and was fed in the woods by a dog. He was also reputed to have miraculously cured sufferers of the plague.[4] His cult originated at his birthplace, Montpellier, and spread to Italy and elsewhere in Europe before he was officially canonized in the seventeenth century.[5] The present figure shows him with his customary attributes: dressed as a pilgrim, accompanied by his dog, who licks one of his pestiferous sores, and carrying a clapper to warn others of his infection.[6] The white bandanna round his head was also traditionally worn by lepers.[7] Other roughly contemporary polychromed wood figures of the saint as pilgrim include the early sixteenth-century *St Roch* in the Metropolitan Museum of Art (the Cloisters), New York, ascribed to Manche, Normandy,[8] the statue by Veit Stoss in the church of Santa Maria Annunziata, Florence,[9] a Spanish figure of *c.* 1520–30 in the Musée des Arts Décoratifs, Paris,[10] and another Spanish figure in the Musée des Arts Décoratifs du Château, Saumur.[11] Manuel Gómez Moreno saw the present piece in 1951, and orally attributed it to Burgos.[12] Shortly afterwards, on a visit to the Museum in 1952 Josép Gudiol i Ricart ascribed it to Valladolid.[13] More closely comparable than works in either Valladolid or Burgos are figures made slightly further East, for example in Logroño,

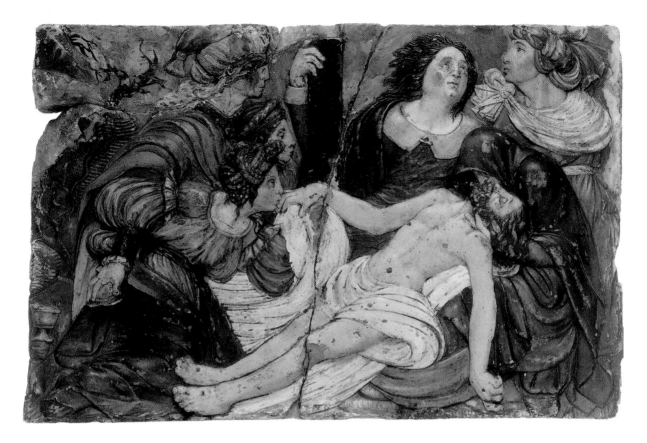

Rioja, almost certainly executed by sculptors working in the wake of Felipe Vigarny (*c.* 1470–1542) and Diego de Siloe (*c.* 1490–*c.* 1553), such as the relief of St Luke at Foncea (Logroño).[14] Also analogous is the figure of an Apostle from the high altarpiece of the parish church of Grañon (Logroño) of about 1544.[15] Here the pose and face of the figure are paralleled.

BIBLIOGRAPHY

Réau, III,3, p. 1159.
Schmitz-Eichhoff, p. 310 and p. 398, notes 733–4, and fig. 383.

NOTES

1. Maurice Harris was one of the sons of Lionel Harris, who had established the Spanish Art Gallery in London in the early years of the century. See cat. no. 4, note 5.
2. I am grateful to Josephine Darrah for her comments on this.
3. LCI, 8, pp. 275–7.
4. Farmer, pp. 373–4.
5. Mollaret and Brossollet, p. 90.
6. For a full discussion of the cult of St Roch, see Mollaret and Brosselet, pp. 80–96.
7. Schmitz-Eichhoff, p. 398, note 734.
8. Inv. no. 25.120.239 a,b. Rorimer, p. 202.
9. Rasmussen, p. 115, figs. 68 and 69.
10. Inv. no. Pe 402. This figure is unpublished. I am grateful to Monique Blanc for this information.
11. Schmitz-Eichhoff, p. 310.
12. Museum records.
13. *Ibid.*
14. Weise 1929, pp. 146–57 and fig. 48.
15. Weise 1957 I, pl. 152 and pp. 61–2.

61. THE LAMENTATION

PAINTED ALABASTER

BASQUE REGION/RIOJA; about 1540–1570

Inv. no. A.102–1929

H. 26.3 cm. W. 44 cm. D. 2.9 cm.

Provenance
Given by Dr W. L. Hildburgh F.S.A. in 1929. Acquired by the donor in Madrid in 1921.[1]

Condition
The relief has two major breaks: cracks run through the centre and at the upper left corner. These have been repaired with epoxy glue. The central vertical crack runs up through Christ's left leg, and the knee is missing; the crack through the left corner has disfigured the face of the turbanned man on the left of the cross, and part of the lizard on the left is missing. The brightly-coloured paint is later, and a varnish layer, partly removed, is evident. A note made soon after acquisition indicates that the relief was at one time repaired with plaster (now removed), and that it was in a wood frame (also no longer present).[2]

Christ lies at the foot of the cross, his head held by the Virgin, while Mary Magdalene kisses his hand; she holds the top of the ointment jar in her right hand, with the jar behind her. Another Mary grasps the cross looking upwards, while the head of a third is visible behind Mary Magdalene. Two figures with elaborate headdresses (Joseph of Arimathaea and Nicodemus) are placed at either side of the cross. On the left, bare branches of trees on a hillside are carved in relief and painted. A lizard crawls up behind the figure of Mary Magdalene.

This relief, although now damaged and re-painted, is stylistically related to sculpture from North East Spain produced in the mid-sixteenth century, and recalls particularly the style of the Beaugrant family of sculptors, who originated from the Netherlands, and were active particularly in the Pays Basque and Rioja in the mid-sixteenth century.[3] The crowded composition and mannered folds of the shroud in the present relief can be compared with the relief of the *Entombment* of about 1555 in the Diocesan Museum at Calahorra attributed to the sixteenth-century sculptor Juan de Beaugrant (d. 1559/60).[4] Another analogous work from the Beaugrant workshop is the *Lamentation* group of *c.* 1545 in the collegiate church of Santa María in Cenarruza.[5] The turbanned figure seen in profile on the right is paralleled by a figure on the right of *The Burial of St Stephen* from the high altarpiece in the church of St Stephen, Abalos (Rioja), about 1550–1555, again attributed to Juan de Beaugrant and others.[6] The wood relief of the *Entombment* on the predella of the mid-sixteenth century altarpiece by Andrés de Araoz in the Capilla de Santo Cristo in the church of S. Severino in Valmaseda (Basque region) is also comparable.[7] The present relief may be from an altarpiece, although it is more likely to be an individual devotional piece, probably originally framed.[8]

NOTES

1. Museum records.
2. The writer of the note also mistakenly believed the relief to be marble. 'The paint is much darkened, the surface chipped and has been repaired with plaster before the last re-painting, which treats the wood frame as one piece with the marble.'; Museum records.
3. *Ars Hispaniae*, XIII, p. 205, and *Beaugrant* 1985 (unnumbered pages). Cf also the altarpiece attributed to the workshop of the Beaugrant family sold at Sotheby's London, 21st April, 1988, lot 59.
4. Barrio Loza 1984, p. 127, cat. no. 19. Juan was the brother of Guiot de Beaugrant (active 1520s–d. 1549/50) and Mateo de Beaugrant (dates unknown). All three brothers worked as sculptors in Spain; *Beaugrant* 1985 (unnumbered pages).
5. *Beaugrant* 1985, cat. no. 10.
6. Barrio Loza 1984, p. 37, cat. no. 1.
7. Weise 1957 I, p. 78 and pl. 136.
8. Cf cat. no. 14. The wood frame on the present piece mentioned above was almost certainly later, but perhaps replaced an original one.

62. FIGURE HOLDING SYMBOLS OF THE PASSION

PINEWOOD

RIOJA (CIRCLE OF ARNAO DE BRUSELAS); about 1550–60
Inv. no. A.13–1920
H. 53 cm. W. 22 cm.

Provenance
Given by A. G. B. Russell Esq. Rouge Croix, through the National Art-Collections Fund in 1920.

Condition
The panel has been virtually stripped of its original polychromy and gilding, traces of which are however evident in the remains of gilding in the cherubim in the top corners, and in fractional remains of polychromy and white ground in the hair and nostrils of the figure. A wax finish appears to have been given to the surface. The nose and toes of the figure are slightly chipped, and the cherubim at the top have been rubbed, or possibly were only summarily carved, as the original surface colour and gilding would have supplied detail missing in the carving. The stepped edge at the bottom of the panel is damaged and shows signs of woodworm, as does the back of the panel.

The robed, androgynous figure seen in three-quarters view, stands in a shell-niche, with the right foot forward, the toes visible beneath the hem. The left hand holds a fluted column, and the right hand a small scourge. Above are two cherubim, one in each corner above the niche. On the border above is a grotesque mask with tendrils transmogrified into tongued monsters extending from its mouth. The panel has a stepped edge running round all four sides, suggesting it was once slotted in to a larger ensemble. Although provisionally identified as *Faith* when first acquired by the Museum, the symbols of the scourge and column imply that a more accurate interpretation is of a figure (perhaps an angel without wings) holding instruments of the Passion. The pose of the figure and stepped edge of the panel could signify that it flanked a scene of the Crucifixion to our right, while another similarly sized panel with a figure matching it symmetrically in pose, so also looking inwards to the putative Crucifixion, could have been positioned on the other side. This, along with the comparatively small size of the present panel suggests that it was almost certainly one of the subsidiary elements in a much larger altarpiece.

The relief is reminiscent of the sculpture carved during the mid-sixteenth century in Castile in the wake of Alonso Berruguete (*c.* 1489–1561).[1] However the rippling drapery and facial type are closer in style to the work of sculptors working in Rioja, who were themselves influenced by Castilian sculpture of the first

third of the sixteenth century. In particular it recalls the work of Arnao de Bruselas (active *c.* 1545–1565).[2] Comparative pieces by this artist include the figure of St John the Evangelist in the relief of the *Lamentation* of about 1552–63 from the high altarpiece in the church at Alberite,[3] and a relief of the same saint from the mid-sixteenth century choirstalls of the cathedral of La Redonda, Logroño.[4] Although cat. no. 62 cannot be definitively assigned to Arnao de Bruselas, it must have been carved by an artist in his circle.

NOTES

1. For a general survey of this topic, see Parrado del Olmo *Palencia* 1981, and *ibid. Ávila* 1981.
2. I am grateful to Jesús Mª Parrado del Olmo for the suggestion that this relief is likely to be from Rioja.
3. Ruiz 1981, pl. 87, and Weise 1957 I, pl. 212 and pp. 69–70.
4. Ruiz 1981, pp. 37–9 and pl. 155.

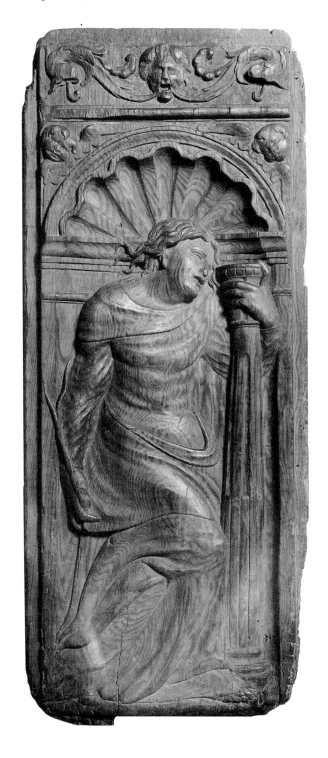

Italo-Spanish and Franco-Spanish Pieces

63. THE RISEN CHRIST

PAINTED LIMEWOOD
ITALO-SPANISH(?); about 1530–50
Inv. no. 516–1872
H. 137 cm.

Provenance
Bought from Signor C. Ferrario in London in 1872 for £10.

Condition
The tip of the right forefinger is missing, and there are cracks on the right foot and right shoulder blade; some of the paint is flaking, and there has been some re-touching of the paint. Old woodworm holes are evident.

Christ stands, resting on his left foot, his right leg slightly bent. He looks downward, raising his right hand in blessing. He is naked but for a gold cloak draped around his body, and the stigmata and wound in his side are evident. The nipples appear to have been carved separately and set into the chest.[1] The figure is fully carved and painted at the back; it is set on a later rectangular base.

This piece was bought as Neapolitan, the then Art Referee Matthew Digby Wyatt commenting that he believed it to be Neapolitan under Spanish influence through the Aragonese sovereigns.[2] This view was followed by Maclagan and Longhurst, who published it in their catalogue of Italian sculpture as 'Neapolitan under Spanish influence'.[3] Pope-Hennessy included it in his catalogue as 'Neapolitan', although he remarked in the brief catalogue entry, 'surviving Campanian wooden sculptures . . . offer no direct analogies for its style.'[4]

The unusually short torso and the downward glance of the figure imply that it was intended to be set above the eye-level of the observer; it was probably part of a Resurrection group. Stylistic analogies are hard to find; it may have been produced by a Spanish sculptor working in Italy.

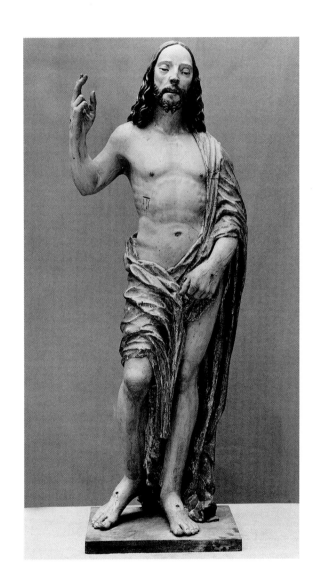

BIBLIOGRAPHY
Maclagan and Longhurst, p. 125.
Pope-Hennessy, II, pp. 498–9 and III, p. 314, fig. 523.

NOTES
1. Cf cat. no. 21.
2. Art Referee's Report 9875 (held in the National Art Library, Victoria and Albert Museum).
3. Maclagan and Longhurst, p. 125.
4. Pope-Hennessy II, pp. 498–9.

64. HEAD OF ST JOHN THE BAPTIST

MARBLE

FRANCO- OR ITALO-SPANISH; about 1630–1660

Inv. no. A.34–1910

L. 27 cm.

Provenance
Bought from Mirza Khan of 1 Coptic Street Bloomsbury, London in 1910 for £150.[1]

Condition
The back of the head has been roughly hollowed out in the centre, while the outer circumference of the back is smooth, as if it has been cut away. Although it is probable that the reverse of the head was originally flat, two truncated holes into the back at the edges, which may have been used for fixing, support the idea that a slice of marble has been removed from the back of the object, perhaps when it was taken off a charger. The end of the neck also appears to be cut across, and a later hole has been drilled into it, into which a long metal dowel is inserted so that the head can be displayed upright. The lower right tendril of hair has been broken off and re-fixed. There are minor scratches and chips, but otherwise the piece is in good condition.

The slightly under life-size bearded head represents the decapitated St John the Baptist. He is shown with closed eyes as if dead, the lips slightly open and teeth visible. The flattened back and fixing points (see above) suggest the head was once fixed to a dish or charger.

Decapitated heads of St John the Baptist were depicted in late medieval sculpture, and the type probably originated in Italy or Germany.[2] In Castilian sculpture of the seventeenth and eighteenth century severed heads, usually St Paul or St John the Baptist, were portrayed relatively frequently.[3] Sixteenth-century examples are also known, such as the head of St John the Baptist attributed to Juan de Juni (c. 1507–1577) of about 1545 in Valladolid, and one in Seville signed and dated 1591 by Gaspar Núñez Delgado (active 1576–1606).[4] Juan Martínez Montañés (1568–1649) produced two decapitated images of the same saint for two altarpieces, one of about 1607 in Lima, one of about 1632 in Seville.[5] A head of St John the Baptist by Juan de Mesa (1583–1627) in the Museum of Seville Cathedral exhibits a similar profile.[6] The facial features and tendrils of hair are reminiscent of the work of the Castilian sculptor Gregorio Fernández (c. 1576–1636).[7] All of these parallels are however of wood or terracotta, and both the material and style of the present piece are unusual.[8] In particular the drilling of the hair and the idiosyncratic way in which

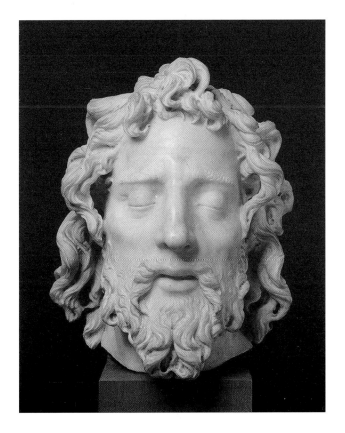

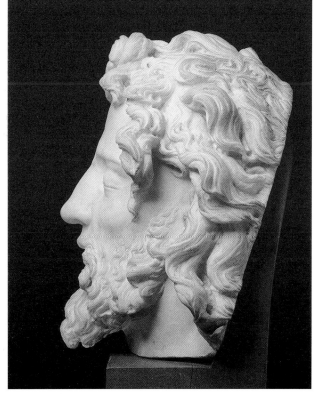

the eyebrows are delineated with upright strokes are without direct parallels. The use of marble implies that the piece may be French or Italian, and it could be by a Spanish (perhaps Andalusian) sculptor working in France or Italy. A comparable piece is the marble head of St John the Baptist attributed to Christophe Veyrier (1637–1689) in the Musée Granet, Aix–en–Provence.[9]

NOTES

1. Arthur Banks Skinner of the Department of Architecture and Sculpture, noted that the original price was £180; he tried to buy the piece for £120, but 'the lowest price is £150' (Museum records: Registered Papers 10/2419M).

2. See J. M. Palomero Páramo's entry on the head by Núñez Delgado in the Museum of Fine Arts Seville, in Moreno Mendoza, pp. 150–1. For a medieval German example in the Victoria and Albert Museum, see Williamson 1988, cat. no. 55.

3. Cf the work of Villabrille y Ron (1663–1732) (Martín González 1983, pp. 375–7), and the later eighteenth-century sculptor Felipe Espinabete (Martín González 1958, pp. 350–5); also the two heads of SS Paul and John the Baptist respectively in the Hispanic Society (Gilman 1930, pp. 299–306), the head of St John the Baptist in the Los Angeles County Museum of Art (Stratton 1993, pp. 150–1, cat. no. 36), and the eighteenth-century head of St John the Baptist attributed to the circle of Juan Pascal de Mena in the Monastery of Santo Domingo el Antiguo, Toledo (Nicolau Castro 1991, fig. 202). For a brief survey of the theme see Martín González 1957.

4. For the piece by Juan de Juni see Martín González 1974, p. 158, fig. 123, and *Pequeña Escultura* (unnumbered pages). For the one by Nuñez Delgado see *Escultura en Andalucía*, pp. 32–4, and Moreno Mendoza, pp. 150–1.

5. Gilman 1967, figs. 110–11. Eric Maclagan noted at the time of acquisition that 'this head suggests the work of such Spanish artists as Montañes' (Museum records; Registered Papers 10/2419M).

6. Sánchez-Mesa Martín 1991, p. 43, fig. 16. I am grateful to Domingo Sánchez-Mesa Martín for commenting on this parallel.

7. Cf the figure of St John the Baptist on the high altar at Plasencia (Martín González 1980, pl. 87b), and the innumerable figures of the Dead Christ (*ibid.*, pls. 162–72).

8. One reference suggests Fernández did occasionally work in marble; Martín González 1980, p. 51 and p. 58, note 38.

9. *Puget* 1994, pp. 360–1, cat. no. 160.

Hispano-America and Goa

Christopher Columbus first set out from Palos for the Indies in 1492, and by the end of the sixteenth century Mexico, and most of Central and South America (with the exception of Brazil, which had become part of the Portuguese empire) was under the rule of Spain. Wealth in the form of gold and silver, as well as items such as pearls and sugar were imported from the Indies to Spain, primarily to the port of Seville. Goods, including works of art, were also exported from Seville to the colonists and missionaries in the New World (cf cat. no. 40 and the entry for cat. no. 37). Some sculpture also seems to have been carved by immigrant Spanish artists in South America using local materials; the exotic wood used for two pieces in the present collection suggests they were made in South America (cat. nos. 66 and 67).

Goa on the West coast of India was discovered by Vasco da Gama in 1498, and became part of the Portuguese Empire. Ivory in particular was carved by local sculptors, but with Christian subjects for their European customers. Although ivories are not covered by the present catalogue, two objects which are made of both wood and ivory have been included (cat. nos. 68 and 69). When wood was used, it seems again to have been worked locally, sometimes by local craftsmen.

65. CRUCIFIED CHRIST

PAINTED LEAD WITH GLASS INSETS
HISPANO-AMERICA(?); about 1650
Inv. no. A.68–1926
H. 33.6 cm.
See plate 23

Provenance
Bequeathed in 1926 by Lieut. Col. G. B. Croft-Lyons.

Condition
Small areas of paint are missing, notably on the loincloth, the backs of the hands, and the heels (parts of the object which would have rubbed against the cross). Some re-touching of the paint is evident on the shoulder joints, the back of the left arm, and on the soles of the feet. The painted drops of blood on the back, face, torso, and hands and feet may also have been re-touched, likewise the gold cord holding the loincloth. Holes have been drilled through the hands and feet, although the original cross on which the figure was suspended is now missing.

The dead Christ is shown as if suspended from the cross by four nails (the original nails and cross are missing), his legs uncrossed, and his head resting on his right shoulder. His eyes are closed, and his mouth half-open; he has a wound in his side. Red glass droplets are set into the lead to simulate drops of blood; these were possibly inserted by dripping molten glass onto the lead figure.[1] The crown of thorns is painted green.

This small devotional piece may be a reduction of a life-size crucifix, but more probably derives from an ivory prototype. Ivory carvings seem to have inspired sculpture in other materials particularly in South America,[2] while lead was employed relatively frequently during the seventeenth century to reproduce popular images.[3] The use of four (rather than three) nails to hold the crucified Christ was the iconographical type approved by the Sevillian painter and theorist Francisco Pacheco (1564–1644).[4] In the present figure this use of four nails is particularly striking in that the legs are uncrossed.[5] The inserted glass droplets recall the fictile glass tears sometimes seen on the cheeks of wood busts and figures of the *Virgen Dolorosa*.[6] Although it is difficult to attribute it with any precision, the distinctive heavy facial features, along with the static pose and relatively elaborate loincloth suggest that cat. no. 65 dates from the middle third of the seventeenth century, and may come from South America, or perhaps the Philippines. A Hispano-

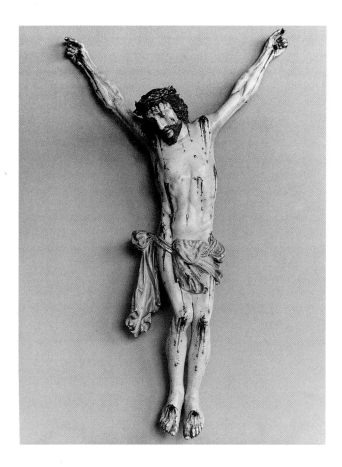

Filipino ivory crucifix with four nails of about 1700 attributed to Fray Juan de los Santos in Manila is broadly comparable,[7] while a wood crucifix in Cuzco, Peru also has four nails, and exhibits similar facial features.[8]

NOTES

1. I am grateful to Diana Heath for her comments on this.
2. See Angulo Iñiguez *Hispanoamericano*, II, 326.
3. Cf cat. no. 37.
4. Pacheco II, pp. 362–99. (Correspondence between Pacheco and Francisco de Rioja, Pacheco's letter dating from 1620.)
5. Cf for example the *Cristo de la Clemencia* by Juan Martínez Montañés of 1603 in Seville Cathedral, where four nails are used, but the legs are crossed; Gilman 1967, pl. 15.
6. For example the bust of the *Virgen Dolorosa* by Pedro de Mena in the monastery of St Joachim and St Anne, Valladolid (*Pedro de Mena* 1989, p. 34, cat. no. 7).
7. Estella Marcos 1984, I, fig. 197 and II, pp. 176–7, cat. no. 360.
8. Kelemen 1951, pl. 15b and p. 52. I am most grateful to Margarita Estella for drawing my attention to this comparative work, and for her helpful comments on the possible origins of the present piece.

66. ST FRANCIS OF ASSISI

PAINTED AND GILT SPANISH CEDAR

HISPANO-AMERICA; about 1700

Inv. no. A.32–1924

H. 33 cm.

Provenance

Given by Dr W. L. Hildburgh F.S.A. in 1924.

Condition

A dowel-hole has been drilled into the underside of the integral socle, along with two pairs of smaller holes. A small hole is drilled into the centre of the figure's chest, and a modern tack-head with a length of silk attached is fixed into the centre of the back. Small drops of candle-grease are visible on the figure. Some areas of paint are missing, but generally the figure is in good condition.

The bearded tonsured St Francis stands on his left foot, his right leg slightly bent. He is bare-footed and holds his palms up, revealing the stigmata. His mouth is slightly open, and he looks upwards. He wears a hooded cloak over his habit and knotted cincture, all of which are elaborately decorated with *estofado* and punched designs.[1] The figure stands on an integral rounded base.

The pose and stylized facial features of this piece, notably the high cheekbones, recall Spanish and

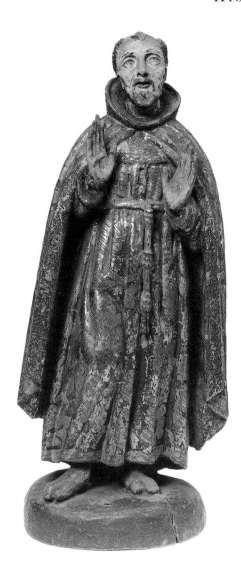

67. BUST OF A SAINT(?)

PAINTED SPANISH CEDAR
HISPANO-AMERICA; about 1700
Inv. no. A.66–1953
H. 57.5 cm.

Provenance
Bequeathed by Marmaduke Langdale Horn of 'Michaels', Stoke Charity, Hampshire in 1953.

Condition
Slight chips and paint losses have occurred, and varnish has been applied over the paint. A cavity in the right shoulder probably indicates where a block of wood would have fitted. Many small metal nails protrude from the shoulders, chest and head; almost certainly these were to affix articulated arms, and carved wood drapery. At the back is an irregular rectangular opening, within which is a drilled hole. Dowel holes are visible in the right and left shoulders, as well as other smaller drilled holes. A label inside the left shoulder reads: 'B 178 A. S. & C.'; the significance of this is uncertain.

This bust of a gaunt middle-aged man with sallow skin and black hair must have been originally part of a life-size figure. It is made up of several solid pieces of wood fitted together: a piece of wood has been let into the left side of the face, and another to the left side of the chest. Drapery probably carved from wood, and perhaps a wig or other head-covering were likely to have adorned the figure. Comparably-made figures with wood drapery and articulated arms representing the Jesuit martyrs (for this subject, see below) are in the Museum of Fine Arts, Seville.[1] The present piece could well have been a processional figure. The previous owner also bequeathed papers to the Museum stating that the bust was by Juan Martínez Montañés (1568–1649); the owner believed it to represent one of the three Jesuit saints martyred in Japan in 1597, and canonized in 1627.[2] This ascription cannot now be accepted, and the bland portraiture combined with the lack of attributes mean that it is difficult to indicate with any certainty the identity of the subject, but the bust is allied in style to seventeenth-century Sevillian sculpture. It does indeed echo some of the figures by Martínez Montañés, such as the head of his *St Ignatius* of about 1610 in the church of the University of Seville, and the head of his *St Bruno* of about 1634 in the Museum of Fine Arts in Seville.[3] However the type of wood used (*Cedrela odorata* L.), closely related to mahogany, is restricted to South America, which suggests this piece must be Hispano-American, although strongly influenced by early seventeenth-century Andalusian work.[4] It was perhaps made in South America by an immigrant Sevillian sculptor.[5]

Portuguese colonial figures.[2] The rich polychromy of the costume is also paralleled by pieces made in Hispano-America, such as a Virgin from Cuzco, Peru and a Christ Child from Córdoba, Argentina.[3] The type of wood used (*Cedrela* sp.) grows throughout South America (except Chile), but not in Europe, so supporting the likely non-European origin of the piece.[4] Probably influenced by seventeenth-century Sevillian sculpture, this is almost certainly a devotional figure made in Latin America.[5]

NOTES

1. See introductory essay on Materials and Techniques.
2. Indo-Portuguese ivories of the same subject are close in pose; see *Luso-Oriental*, pp. 161–3, figs. 213–15 and fig. 217. The features correspond to figures from Hispano-America; see Gori and Barbieri, especially p. 60, figs. 44 and 45.
3. Gori and Barbieri, p. 65, fig. 59 and p. 66, fig. 63.
4. I am grateful to Josephine Darrah for her comments on this.
5. For a comparative piece inspired by an Andalusian prototype see *Camino hacia Arcadia*, pp. 97–8.

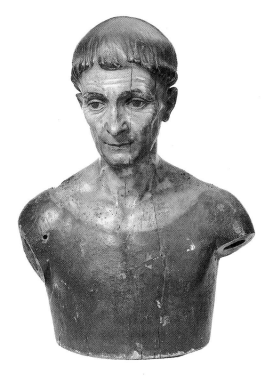

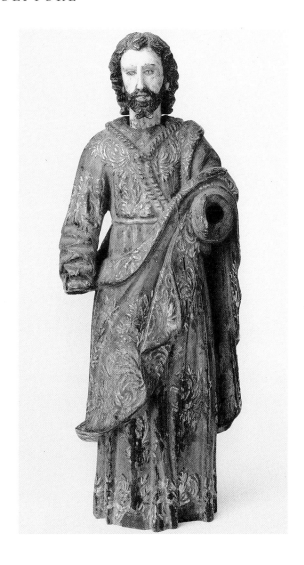

NOTES
1. Hernández Díaz 1983, pp. 79–80, and *Ars Hispaniae*, XVI, p. 144 and p. 146, fig. 119.
2. Museum papers: letters on the nominal file of Marmaduke Langdale Horn. For the three saints, see Testore, pp. 327–30.
3. Gilman 1967, figs. 86 and 188.
4. I am grateful to Josephine Darrah for her comments on the wood.
5. For immigrant Seville sculptors to Lima, see Angulo Iñiguez *Hispano-Americano* II, pp. 330–45.

68. MALE SAINT

PAINTED HARDWOOD AND IVORY
INDO-PORTUGUESE (GOA); about 1650
Inv. no. A.64–1927
H. 21.4 cm.

Provenance
Given by Dr W. L. Hildburgh F.S.A. in 1927.

Condition
Both hands are missing. The left sleeve is damaged. The socle is missing, and a modern dowel protrudes from the base; two restored pieces of wood at the front indicate where the feet (now lost) were originally positioned. There is a crack in the back; in addition a hole has been drilled in the back. The figure is covered with a thick varnish.

The bearded saint stands with his left arm bent, and the forearm extended. He wears a long robe concealing his feet, and decorated with a raised foliate decoration, probably

formed from gilded white ground. The ivory face and hair are painted. Although it has not been possible to analyse the wood, it is a hardwood, probably non-European.[1]

The combination of ivory and hardwood suggest that this piece is colonial. The unusual raised decoration on the wood confirms this, as do the facial features, which are slightly stylized, and reminiscent of Indo-Portuguese ivories from Goa.[2] The identity of the saint is impossible to establish. It could have been an individual figure, or more likely from a group of Christ and the Twelve Apostles.

NOTES
1. I am grateful to Josephine Darrah for her comments on this.
2. Cf two figures of St Anthony of Padua in private collections in Portugal with similar raised decoration; *Luso-Oriental*, pp. 156–7, figs. 207 and 208.

69. ST BENEDICT

EBONY PARTLY GILDED, AND PAINTED IVORY

INDO-PORTUGUESE (GOA); about 1750–1800

Inv. no. 166–1866

H. 34.5 cm.

Provenance
Bought from Señor Silva in Lisbon by John Charles Robinson in 1865 for £3 11s 1d.

Condition
The wood is coated in wax; the gilding on the edges of the book is later. A mitre shown on the base in a photograph of 1903 is now missing. A hole has been drilled into the top of the head, almost certainly for a halo. A crack running down the centre of the beard and the face is a natural flaw in the ivory. Another crack runs through one of the oval hollows on the back of the socle. The underside of the socle is roughly chiselled, but not fully hollowed out.

The tonsured bearded saint stands resting on his right foot, his left leg bent and stepping forwards. He carries a book in his left hand, and holds his right hand up, as if holding a crozier, which is now missing. A hole in the top of the socle indicates where the base of the crozier would have been fixed. He wears a pectoral cross, and stands on an elaborate ebony socle carved with four oval hollows and three fleshy clusters of acanthus leaves of ivory.

When first acquired, the saint was identified as St Anthony of Lisbon (more commonly known as St Anthony of Padua), but this was clearly erroneous, and Longhurst's suggestion that it is St Benedict is far more plausible. St Benedict is usually represented with a long beard, often wears the black habit of his Order,

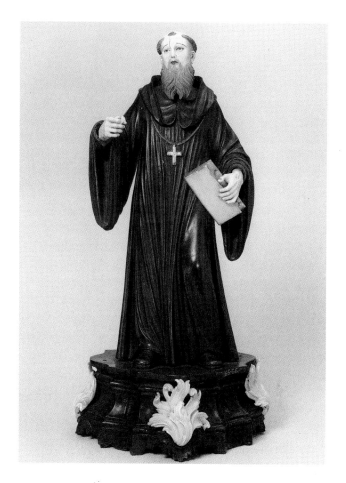

and is shown with a mitre and pastoral staff (both originally included in the present piece).[1]

The style and provenance of this work strongly suggest that it is Indo-Portuguese, produced in Goa. The Rococo features of the base and the soft facial features of the saint support a date of the second half of the eighteenth century. Close analogies are provided by three figures in the Palácio Ajuda, Lisbon (*St Francis Xavier*, *St Carlo Borromeo*, and *St Rita of Cassía*), all of which are of ebony and ivory, have comparable facial features and drapery, and are on similar socles. They are believed to be possibly Indo-Portuguese, and to date from the second half of the eighteenth century.[2] A figure of St Francis Borgia (also thought to be Indo-Portuguese) in a private collection in Lisbon is also comparable.[3]

BIBLIOGRAPHY
Inventory 1852–67, p. 28.
Loan Exhibition, p. 118, no. 750.
Longhurst II, p. 111.

NOTES
1. Hall, pp. 44–5.
2. *Luso-Oriental*, p. 172, fig. 229, p. 176, fig. 237, and p. 189, fig. 258. See also *Expansao Portuguesa*, p. 186, fig. 554.
3. *Expansao Portuguesa*, p. 183, fig. 545.

Jet Carvings

Five jet carvings were acquired in 1926, but the bulk of the material was given to the Museum by Dr W. L. Hildburgh F. S.A. in 1953, a number of years after the most important early studies of the subject had appeared. In two publications which appeared in 1985 and 1986 respectively, references to the present collection are made, although no indications are given of its size and quality.[1]

Although jet is proverbially black, the geological group to which it belongs is known as brown coal or lignite, the two other kinds of coal being anthracite and bituminous coal. All coal is fossilized vegetable matter, found in seams in the earth, the degree of carbonization dictating the type of coal.[2] In structure, jet is a particularly dense type of coal, and can be carved and polished. The English form of the word derives ultimately from the Latin *lapis gagates*, the phrase used by Pliny.[3] In his *Natural History*, he states that jet can (amongst other things) drive away snakes, as well as cure tooth-ache. Medicinal and indeed magical qualities were thought to be inherent in the substance from earliest times, perhaps partly because when rubbed it becomes electrified and can attract small particles. Jet is found in different parts of Europe (as well as in North America), but the two richest regions in quantity and quality are the Asturias in northern Spain, and Whitby, Yorkshire, in North East England. In the vicinity of these two areas distinctive traditions of working the material grew up.

Although many Spanish jets are inextricably connected with the pilgrims who, over the course of six hundred years or more, from the twelfth to the eighteenth century, visited the shrine of St James at the Cathedral of Santiago de Compostela, jet carvings of differing functions were made both before and after this era, amulets being the most common. The tradition of working the material in Spain probably began during the period of Arab rule. The Arab physician and naturalist Benbuclaris, who was at the court of Ahmed Almostaín in Zaragoza from 1085 to 1109, was the first writer to mention jet in Spain, and noted that it was hung round the necks of infants to guard against the evil eye.[4] This superstitious use of jet was initially the most important one. At first it was the substance itself that was thought to be effective against evil, but later the form of the amulet became as important. The shape favoured was a fist with the thumb held between the forefinger and second finger, this gesture deriving ultimately from ancient Egypt, and denoting insult in Roman times.[5] This image is likely to have first appeared in Spain in the thirteenth century; it became known later as the *higa*.[6] The *higa* was proscribed by the Church in the medieval period, mainly because of obscene connotations, rather than the superstition attached.[7] Despite this official condemnation, amulets carved into this shape can be seen worn by royal children in court portraits of the seventeenth century.[8]

The carvings in jet of greatest artistic interest are those linked with the pilgrims coming to Santiago. Pilgrim badges, also known as *insignia* or *signacula* made of jet, as well as badges made of lead, pewter, shell and other materials were sold to those who had come to worship at the shrine of St James.[9] They served as a sign that the pilgrim had achieved the goal of the pilgrimage, and were probably felt to be imbued with a protective or spiritual power endowed by the saint, not unlike the protection afforded by the amulets. The first pilgrim badges were likely to have been sea shells found on the shores of Galicia. Later they were manufactured in base metals and jet, and during the twelfth century the *Cabildo de los Concheros* (guild of shell-merchants) was established in Santiago.[10] In 1200 Archbishop Suárez de Deza decreed that the *Concheros* could only sell their shells through the Church. Later Papal decrees during the thirteenth century, limiting the sale of *insignia*, were primarily designed to ensure that the income from such sales was shared by the Church, as well as to curtail the trade of so-called fake badges, which had not received the Church's blessing, but which were sold to unsuspecting pilgrims on their way to and

from the shrine.[11] Until the early fifteenth century, the jet-workers formed part of the guild of the *Concheros*, but they broke away from them at about this time (probably around 1410, although the exact date is unclear), and founded a separate guild, known as the Confraternity of Our Lady, and later, in the sixteenth century, as the Confraternity of St Sebastian.[12] The ordinances of the confraternity, which were formally drawn up in 1443, as well as later regulations and additions dating from the sixteenth century, were published in full and discussed by Osma in 1916.[13] These ordinances were mainly concerned with the quality of the raw material, which was imported to Santiago from the Asturias, and with ensuring that the practice of the craft was confined to members of the guild. Probably all the surviving Spanish jets dating from the fifteenth to the eighteenth century were produced by members of the guild. For this reason, all the jets in the present collection are assumed to have been carved in Santiago.

Jet carvings are recorded in a number of inventories of the thirteenth and fourteenth century, and in cabinets of curiosities or *Kunstkammern*, but few of these objects are known to survive.[14] As there seem to be no signed or dated jets, dating must be based on style alone.[15] This is, however, problematic: the tradition of carving was closer to folk-art than to contemporary sculpture, and tended to be conservative; features which might seem to indicate a fifteenth-century origin for example could continue up to the seventeenth century. Because the art of jet carving tended to be repetitious, the same compositions often recur. Apparently closely similar pieces are not necessarily by the same artist, and indeed the identities of the jet-workers responsible for specific pieces remain unknown.[16] The iconography of the portrayal of St James has been closely studied, and a chronology for the treatment of this subject has been suggested, with a particularly close analysis of medieval images.[17] Unfortunately this chronology is of limited help with the jets in the collection of the Victoria and Albert Museum, as only four pieces represent St James, and they date from after the early sixteenth century. For these reasons, the datings given below are broad, and until further evidence emerges, they must remain to some extent tentative.

The collection can be broadly divided into five main subject groups: St James the Greater; the Crucifixion and scenes associated with the Passion; the Virgin Mary; St Anthony of Padua; and miscellaneous subjects. The first four categories are frequently seen in other collections of jet, and parallels are cited whenever possible. St Anthony (1195–1231) was a popular subject for jet-workers in Santiago probably because he was born not far away, in Lisbon, and studied at Coimbra.[18]

As indicated above, the prime function of carved jets seems to have been to signify that pilgrims had completed their journeys, and reached the shrine of St James. Many seem to have formed beads for rosaries, although only a few rosaries survive complete.[19] In other cases individual carved beads have been preserved, including a number listed below. One pax also forms part of the collection (cat. no. 79); this may however have been for display rather than for use, as there are few signs of wear on it.

70. ST JAMES THE GREATER (ROSARY BEAD)

JET
About 1520–1650
Inv. no. M.813–1926
H. 7.1 cm. W. 4 cm.

Provenance
Bequeathed by Lieut. Col. G. B. Croft-Lyons in 1926.

Condition
The jet is unworked on the reverse, and chipped at the side. The shell at the bottom is damaged, and there are scratches at the top.

The oval relief depicts the bearded St James dressed as a pilgrim. He is shown standing, holding a book (the Gospels) in his left hand, and a staff in his right. He wears a knee-length robe and cloak, along with a hat, to which a shell is attached. A gourd and a triangular pouch are represented fixed to his staff. Through the top a hole has been drilled, while the base terminates in the form of a scallop shell. This piece seems to be a fragment of what was once a two-sided relief, with perhaps a crucifix figure carved on the missing side (cf cat. no. 73). If this was so, it was almost certainly intended as a decorative bead for a rosary.[20] Osma's discussion of the iconography of the costume of St James suggests that cat. no. 70 must date from after the beginning of the sixteenth century.[21] Although the carving is relatively crude, and therefore difficult to date, its static frontal form suggests that it dates from before the mid-seventeenth century.

BIBLIOGRAPHY
Europalia, pp. 305–6, no. 229.

71. ST JAMES THE GREATER (CAP BADGE?)

JET WITH SILVER MOUNTS
About 1600–1700
Inv. no. A.16–1953
H. 4.7 cm. W. 3.4 cm.

Provenance
Given by Dr W. L. Hildburgh F.S.A. in 1953. Acquired by the donor in Vienna before 1917.

Condition
The mounts are slightly tarnished, and there are some minor chips on the surface of the jet.

The mounts of this piece include a metal loop at the back, probably so that it could be secured as a badge to a cap. They are in the form of crossed staves behind a scalloped frame for the jet relief. For similar crossed staves, though of bone, see the pilgrim's hat formerly belonging to Stefan Praun of Nuremberg, now in the Germanisches Nationalmuseum, Nuremberg.[22] The half-length figure of St James is shown bearded, wearing a hat adorned with a shell, and holding a book (the Gospels) and a gourd in his left hand, and a staff in his right. The silver mounts suggest the piece is seventeenth-century, although again the crudity of the jet carving precludes a more exact date.[23]

BIBLIOGRAPHY
Hildburgh, 1917, fig. 1.
Europalia, p. 306, no. 232.

72. HEAD OF ST JAMES THE GREATER (PART OF A STATUETTE OR PENDANT?)

JET

About 1600–1700

Inv. no. A.17–1953

H. 2.8 cm. W. 2.1 cm.

Provenance
Given by Dr W. L. Hildburgh F.S.A. in 1953. Acquired in Burgos by the donor.

Condition
The piece is damaged at the base. The surface of the jet is dulled at the front, and shiny on the reverse, suggesting that the piece has been continually rubbed at the back, which in turn implies that it might have been worn at one time, perhaps attached to a chain or a rosary, using fixings that are now lost.

St James is shown in the form of a bust, bearded and wearing a hat with a shell attached, and holding a staff on his right side. Although in 1985 I proposed that this was a complete work on a small scale, by analogy with a jet in the British Museum (inv. no. 1921, 1–1 3), (see Bibliography for this entry) the damage at the base indicates rather that it might in fact be a fragment of a full-length figure. Whether or not this is the case, the rubbing noted above also suggests that the piece may have been designed to be worn in some way, perhaps suspended from a chain. Other than rosaries, no close parallels can be found for this form of adornment. The facial features imply a seventeenth-century date.

BIBLIOGRAPHY
Europalia, p. 306, no. 231.

73. THE CRUCIFIXION AND ST JAMES THE GREATER (ROSARY BEAD)

JET

About 1600–1700

Inv. no. A.12–1953

H. 5.4 cm. W. 4.3 cm.

Provenance
Given by Dr W. L. Hildburgh F.S.A. in 1953.

Condition
The piece is chipped at the top and bottom, and on the figure of St James; the whole is badly rubbed.

The oval bead, carved on both sides, with a scalloped decoration around the edge, depicts on one side the full-length figure of St James, and on the other a stylised crucifixion. St James is shown as a pilgrim, bearded, and wearing a hat and knee-length robe. He holds a book and staff. The damage at the top of the piece may mean that at one time a loop was affixed, or carved integrally from the jet, so that it could be attached to a rosary.[24]

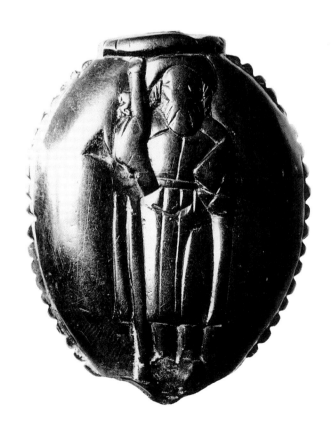

Reverse of cat. no. 73

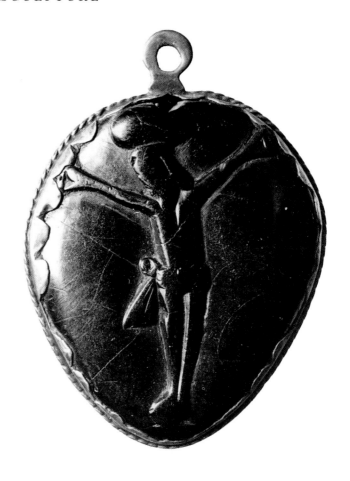

74. THE CRUCIFIXION AND PILGRIM STAFF AND SHELL (PENDANT, PERHAPS FROM A ROSARY)

JET MOUNTED IN SILVER
About 1600–1700
Inv. no. M.812–1926
H. 5.4 cm. W. 4 cm.

Provenance
Bequeathed by Lieut. Col. G. B. Croft-Lyons in 1926.

Condition
The jet is rubbed, the surface of the crucifixion is dulled, while the reverse depicting the shell and staff is shiny. The silver mount is tarnished.

The obverse shows the crucified Christ, and the reverse a pilgrim staff and shell. The simple style of carving means that this piece is particularly difficult to date. Christ's halo is clumsily perched on his head, and the hands and feet are only broadly suggested. The silver mounts are probably seventeenth-century, and this is the most likely date for the jet carving. Similar pieces are in the Instituto Valencia de Don Juan,[25] and in the Archaeological Museum, Madrid.[26] It may have originally served as a pendant for a rosary.[27] The shiny surface of the reverse suggests that this side received more rubbing through the jet being worn.

BIBLIOGRAPHY
Europalia, p. 306, cat. no. 230 (illustrated in reverse).
Franco Mata 1986, p. 160, note 233 and p. 166, cat. no. 6.
Ibid. 1989, p. 325, note 74.

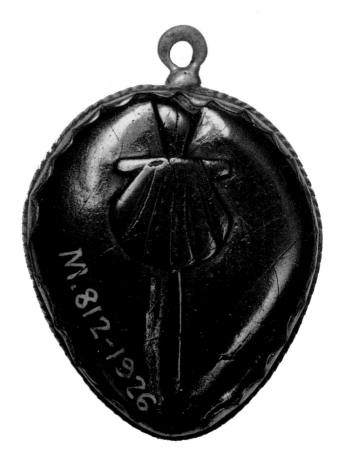

75. THE CRUCIFIXION AND THE HEAD OF THE VIRGIN (PENDANT, PERHAPS FROM A ROSARY)

JET

About 1600–1700

Inv. no. A.15–1953

H. 5 cm. W. 2.9 cm.

Provenance

Given by Dr W. L. Hildburgh F.S.A. in 1953. Acquired in Burgos by the donor before 1917.

Condition

The piece is damaged at the base, and at the top, where a fixing may have been once attached. The jet is much rubbed; the surface showing the crucifixion is shiny, while that showing the Virgin is dull.

The crucifix figure is broadly depicted (cf cat. no. 74), and the proportions of the body are highly

distorted, with a shortened torso and elongated arms; a stylised skull is carved at the foot of the cross. The bust of the Virgin is shown in profile with a crescent moon at the base, and a stylized cherub beneath. The Virgin is similarly crudely depicted, with a heavy halo, resembling a bun, and a costume with a high pleated neck, this perhaps implying a seventeenth-century date. Like cat. no. 74, the carving is too crude to permit an exact dating, but the crescent moon shown with the Virgin, recalling the imagery of the Immaculate Conception, also suggests that this piece dates from the seventeenth century, when such iconography was popular in Spain. The pearled edge suggests that this may have been a bead for a rosary.[28]

BIBLIOGRAPHY

Hildburgh 1917, fig. 1 and p. 3.

Osborne, p. 510, fig. C.

76. Crucifix

Jet with silver mounts
About 1700–1800
Inv. no. A.21–1953
H. 10.1 cm. W. 6.6 cm.

Provenance
Given by Dr W. L. Hildburgh F.S.A. in 1953. Acquired by the donor in Lucerne.

Condition
The silver on the right arm of the cross (at Christ's left hand) is damaged, and the engraved design on this differs from the other engraved patterns visible on the same side on the other arms, although similar to the patterns seen on the reverse; this suggests it has been misplaced after a repair. Otherwise the piece is in good condition.

On one side of the cross Christ is depicted over a skull and cross-bones, with the inscription INRI. On the

other side of the cross the Virgin Mary is depicted over a winged cherub and a cross, with the inscription MARIA. One ring is fixed to the top of the cross, while a smaller one is seen at the foot, implying that the cross was suspended at the top, with perhaps another attachment below, such as a small pendant or bead. The carving is broad, and therefore difficult to date with any exactitude, although the slightly greater degree of fluency in the figures may mean it is eighteenth- rather than seventeenth-century. Comparative pieces include the elaborate crucifix in Pontevedra, which is dated to the late sixteenth century,[29] and cat. nos. 74 and 75, which are much cruder, but which also seem slightly earlier in style than the present one.

BIBLIOGRAPHY
Osborne, p. 510, fig. D.

77. HEAD OF CHRIST (VERA ICON)
PART OF A STATUETTE OF
ST VERONICA

JET

About 1600–1700

Inv. no. A.14–1953

H. 5 cm. W. 3.5 cm.

Provenance

Given by Dr W. L. Hildburgh F.S.A. in 1953. Acquired by the
donor in Madrid.

Condition

The piece is chipped at the edges, and unworked, or perhaps
fragmentary at the back. The forehead and chin of the face are
damaged.

This is almost certainly a fragment from a statuette of
St Veronica; the left hand of the saint is suggested, but
hidden behind the cloth, while the right hand is
missing. The features of Christ though damaged
suggest a seventeenth-century date. A similar piece
(unpublished) is in the Instituto Valencia de Don Juan
in Madrid (inv. no. 4.326).[30]

78. PART OF A CRUCIFIX FIGURE

JET

About 1600–1700

Inv. no. A.13–1953

H. 9.3 cm.

Provenance

Given by Dr W. L. Hildburgh F.S.A. in 1953. Acquired by the
donor in Toledo before 1917.

Condition

The present piece is evidently a fragment of a crucifix figure;
the arms and legs are missing, the nose is damaged, and there
are chips elsewhere, notably on the loincloth. A metal pin in the
left shoulder, and a hole in the right shoulder suggest that the
arms were originally dowelled in. Six holes drilled underneath
may indicate where the bottom half of the figure was fixed. It
seems likely that the figure was made of separate pieces of jet
joined together, and this is why it was more vulnerable to
damage. Twenty-one small holes drilled into the crown of
thorns almost certainly held thorns, perhaps made of metal, or
possibly wood.

Despite its fragmentary condition, this is one of the
most impressive jets in the collection. The anatomy of

the body is subtly conveyed, and the drapery is similarly suggested in a fluent manner. Unlike many of the surviving Spanish jets, this one seems to be by a sculptor aware of carved work in other materials such as wood, rather than a craftsman with a poor grasp of sculptural traditions. A slightly smaller and more crudely carved crucifix figure in the Instituto Valencia de Don Juan was dated by Osma to the late sixteenth or early seventeenth century.[31] That carving has articulated arms, and copper wire is used for the crown of thorns; both these features may have been present in cat. no. 78 when it was complete (see comments on the condition above). Broadly comparable with the work of early seventeenth-century Castilian sculptors such as Gregorio Fernández (*c.* 1576–1636), this piece is likely to have been produced during the seventeenth century. The crucifix by Fernández in Laguna de Duero, Valladolid is comparable in style.[32]

BIBLIOGRAPHY

Hildburgh 1917, p. 2 and fig. 1.

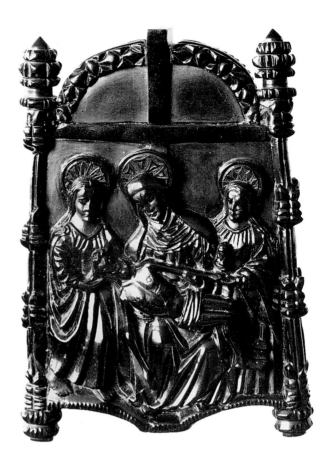

79. THE LAMENTATION OVER THE DEAD CHRIST (PAX)

JET

About 1550–1600

Inv. no. A.65–1926

H. 10.2 cm. W. 7.3 cm. (approximately)

Provenance

Bequeathed by Lieut. Col. G. B. Croft-Lyons in 1926. Acquired by the donor before 1917.

Condition

Scratches are present around the edges. A hole has been drilled into the back about 11mm down from the top. Further down, another hole has been drilled into the back, 2.5cm up from the base, which connects with the channel formed by a third hole drilled underneath, into the base. These must have been used for fixings; perhaps the pax was displayed on a separate stand made of wood or metal. The reverse is notably more shiny than the slightly dulled surface of the front.

The Virgin is shown with the dead Christ on her knees, seated between Mary Magdalene, who holds a pot of ointment on the right, and another Mary, who supports Christ's head, on the left. The figure of Christ is smaller proportionately than the other figures. The whole is framed by columns surmounted by finials; the columns have crudely-carved decorative rings placed at different points on each of the columns. A jet pax showing the Virgin and Child with two angels is in the Instituto Valencia de Don Juan.[33] Osma also illustrated two jet paxes from other collections in his catalogue, one in the Franciscan convent in Santiago, probably dating from the first half of the sixteenth century or slightly earlier, and one in the Cathedral of Santiago dating from the second half of the sixteenth century.[34] The present piece is similar in composition to both of these, and it resembles in form the pax in the Cathedral. This indicates that it probably dates from the second half of the sixteenth century. Its relative lack of wear suggests that it may have been for display purposes rather than for liturgical use.

BIBLIOGRAPHY

Hildburgh 1917, fig. 4.

80. THE VIRGIN OF THE IMMACULATE CONCEPTION

JET

About 1650–1700

Inv. no. A.64–1926

H. 11 cm. W. 4.5 cm.

Provenance

Bequeathed by Lieut. Col. G. B. Croft-Lyons in 1926. Acquired by the donor before 1917.

Condition

Two holes have been drilled into the back, and a surface crack extends between them. The holes form a channel within the jet, to which some fixing was almost certainly attached. There are signs underneath of a former fixing for a socle, which has since been lost, and the head is a little damaged at the back. The reverse is more shiny at the front, possibly suggesting it has received more rubbing, although the size of this piece suggests it was unlikely to have been worn.

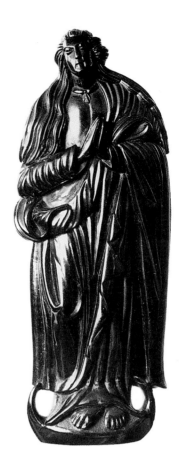

The Virgin is shown with her hands clasped together in prayer, standing on the crescent moon. The figure is carved in the round, with a rosette represented on the back of the hair. Although the first church in Spain dedicated to the Virgin of the Immaculate Conception dates from 1484,[35] the iconographical type became widespread in Spanish painting and sculpture during the seventeenth century (cf cat. nos. 37 and 48). Other similar figures are in the Instituto Valencia de Don Juan, the Archeological Museum in Madrid, and in the Museum at Pontevedra.[36] As Franco Mata remarks,[37] the image is iconographically similar to the figures of the Virgin of the Immaculate Conception by Gregorio Fernández (*c.* 1576–1636).[38] This would imply that the present piece dates from the second half of the seventeenth century.

BIBLIOGRAPHY

Hildburgh 1917, fig. 5.

81. THE VIRGIN OF THE IMMACULATE CONCEPTION (MEDALLION)

JET

About 1700–1750

Inv. no. A.20–1953

Diameter 8.3 cm.

Provenance
Given by Dr W. L. Hildburgh F.S.A. in 1953.

Condition
At the back in the centre is a plugged hole, and signs of turning, suggesting the jet was fixed to a turntable when it was being worked. The reverse is shiny, while the obverse is dulled.

The Virgin of the Immaculate Conception is shown with a child supporting her on stylised clouds and a half-moon. A stylised mandorla surrounds the Virgin, and leaves are carved around the edge. The iconography of this piece implies it derives from seventeenth-century painting and sculpture. According to Filgueira Valverde, the iconography suggests this type to be the Virgin of Guadalupe, devotion to which was propagated at Santiago by Archbishop Monroy (born 1634; archbishop 1686–1715), who had been born in Mexico.[39] A painting of this subject is in the Chapterhouse at Santiago,[40] and a chapel dedicated to the Virgin of Guadalupe (the paintings of which date from 1653) is in the monastery of the Descalzas Reales in Madrid.[41] Hispano-American versions of the subject in polychromed wood are known, such as an eighteenth-century figure in the Museo Cabañas, Caapucú and one in the Carlos Combino collection, Asunción,[42] and other examples in wood are in Valladolid and

Cariñena (Zaragoza),[43] while a comparable jet medallion exists in the Instituto Valencia de Don Juan.[44] The original function of the present piece is uncertain; perhaps it was simply displayed and handled like a medal. The decorative motifs of the leaves seen here and the shape of the whole imply a slightly later date than the other jet *Virgin of the Immaculate Conception* in the collection (cat. no. 80).

82. THE VIRGIN AND CHILD

JET

About 1600–1700

Inv. no. A.10–1953

H. 13.4 cm. W. 3.8 cm.

Provenance
Given by Dr W. L. Hildburgh F.S.A. in 1953. Acquired in Venice by the donor.

Condition
A plugged hole in the base suggests that the figure was probably at one time attached to a socle. There are horizontal breaks at the neck, and below the waist, and the Virgin's crown is slightly damaged, but the piece is generally in good condition.

The Virgin stands resting on her left leg, with her right leg bent and slightly forward. She cradles the Christ Child on her left arm. The figure is carved in more

detail at the front, although it is worked at the back, implying it was to be seen in the round. Despite the simple composition, which is reminiscent of fifteenth-century figures, the style of the drapery suggests that this figure is more likely to date from the seventeenth century. It is comparatively fine, and no close parallels can be found among jets in other collections.

83. ST ANTHONY OF PADUA (PERHAPS ONCE PART OF A PENDANT)

JET

About 1600–1700

Inv. no. A.11–1953

H. 3.6 cm. W. 2.9 cm.

Provenance
Given by Dr W. L. Hildburgh F.S.A. in 1953. Acquired by the donor in Burgos.

Condition
Damage to the base and back suggests that this piece is a fragment (see below). The faces are badly rubbed, and the definition of the features has been lost. The piece is shiny on the reverse, and dulled on the front, implying that the back was polished by rubbing, and that the piece may have been worn. A plugged hole in the back probably held a fixing.

St Anthony of Padua, shown in half-length, holds a stylized lily in his right hand, and in his left, the Christ Child, who holds an orb. Beneath the figures is a flat panel with the scratched inscription 'SANT', the remains of what must

have been the full title 'S[.]ANTONIO', indicating that a large portion of the piece has been lost. Many other jet images of St Anthony are known, some very close to the present piece. A parallel is provided by the jet amulet mounted in silver in the Hispanic Society of America,[45] and this may be similar to the original form of the present piece. Other jets depicting the same subject are in Madrid, Pontevedra and Berlin.[46] The piece in New York is dated to the seventeenth century, which is a probable date for cat. no. 83. St Anthony was popularly depicted with the Christ Child in seventeenth-century painting.[47]

BIBLIOGRAPHY
Osborne, p. 510, fig. B.

84. ST ANTHONY OF PADUA (PERHAPS A PENDANT)

JET

About 1670–1720

Inv. no. A.18–1953

H. 8.8 cm. W. 9.9 cm.

Provenance
Given by Dr W. L. Hildburgh F.S.A. in 1953.

Condition
The top pendant loop is broken, and one of the decorative bridges between the petals of the design is missing.

The pierced relief depicts St Anthony kneeling, being blessed by the Christ child, who holds an orb, and sits on a table with a fringed edging, probably an altar table.

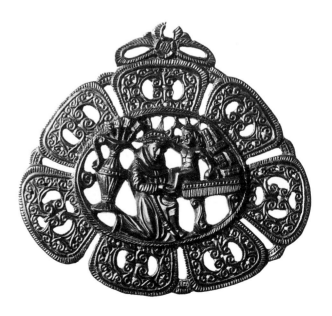

Behind the Christ child are what appear to be stylised bricks or perhaps books. Both figures have crudely carved haloes. To the left is a tall vase of flowers, probably lilies. The pierced surround is carved in a flower-like form with stylized arabesques. St Anthony was popularly represented in jet carvings from the sixteenth century onwards (cf cat. no. 83). Pierced work in jet was also relatively common.[48] The present carving may have served as a decorative pendant, more closely allied to jewellery than the other jets discussed. The framework suggests it dates from the late seventeenth or early eighteenth century.

BIBLIOGRAPHY

Osborne, p. 510, fig. A.

85. A SKULL (ROSARY BEAD?)

JET

About 1580–1630

Inv. no. A.66–1926

H. 3.1 cm. W. 3.3 cm.

Provenance

Bequeathed by Lieut. Col. G. B. Croft-Lyons in 1926. Acquired by the donor before 1917.

Condition

There is damage at the base. A hole is drilled through the middle, implying that the piece was once threaded, perhaps as part of a rosary.

The skull is broadly carved, and a wing (or possibly elongated shell) is shown at each side. A similar jet skull thought to date from the sixteenth to seventeenth century is in Berlin.[49] Jet skulls were mentioned in the will of the jet-worker Pedro Fernández del Arrabal, who died in 1574.[50] A skull set in to base metal is in the Instituto de Valencia de Don Juan.[51] Osma proposed that this might be a rosary bead. The drilled hole in the present piece suggests that this was its original function. The iconography is clearly primarily a *memento mori*, with the wings (if they are wings) perhaps representing the transitory nature of life. If they are shells they are evidently a reference to St James. The object is difficult to date, but given the comparisons mentioned above, and the reference to such objects in a sixteenth-century will, the piece is likely to be from the late sixteenth or early seventeenth century.

BIBLIOGRAPHY

Hildburgh 1917, p. 3.

86. A FOOL'S HEAD

JET

About 1550–1700

Inv. no. A.19–1953

H. 7.2 cm. W. 3.6 cm.

Provenance

Given by Dr W. L. Hildburgh F.S.A. in 1953.

Condition

The nose is damaged, as is the rim of the base. Minor scratches occur elsewhere.

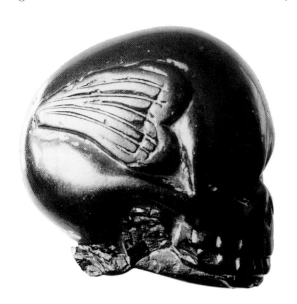

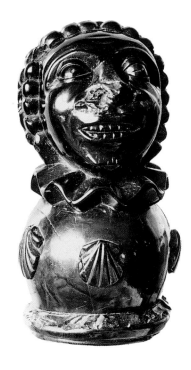

The grinning head is set onto an integral bulbous base, on which are carved three shells. A smooth disc is carved on the back. The stylized tightly-curled hair and large nose may indicate that the head represents a Moor. The clown-like ruff and the facial expression, with its toothy grin and wrinkled forehead, suggest that this is a playful piece, representing a fool. The shells around the base are the only visible link with St James, and no parallel carvings in jet are known. Its precise function is uncertain; it is possible that it was the pommel of a jester's stick (the rim on the base could have been damaged when it lost its original fixing). It may have been connected in some way with the Feasts of Fools when 'the holiest offices and orders were made matters of the lightest jesting'. References to such festivities occur from the thirteenth to the seventeenth century.[52] Dating is particularly difficult; stylistically, it is almost certainly post-medieval, but it seems likely to date from before the eighteenth century.

BIBLIOGRAPHY

Europalia, p. 307, cat. no. 234 (illustrated in reverse).
Santiago Camino p.465, no. 150.

NOTES TO JET CARVINGS

1. These are *Europalia* and Franco Mata 1986. The pioneering catalogue of the collection of jet in the Instituto Valencia de Don Juan in Madrid by the founder of that collection, still the most thorough study of the subject, was published in 1916 (Osma). Earlier publications include two notices in the *Archaeological Journal* (Keller and Fortnum). Also preceding Osma's study is that by Villa-Amil y Castro of 1899. The major relevant publications following Osma are Hispanic Society Jet 1926; *Ibid.*, 1930; Ferrandis Torres; Gilman 1930, pp. 153–82; and Filgueira Valverde. By far the most important recent article is Franco Mata 1986, where further literature is cited. The same author has published two further studies (Franco Mata 1989 and Franco Mata 1991). See also the survey of the subject by Gómez-Tabanera, published in 1993. I am grateful to Dr Fernando López Alsina for the last three references. The exhibition catalogue *Europalia* includes information on jet, especially pp. 300–7 (five catalogue entries by the author of the present article are on jets from the Victoria and Albert Museum). See also Penny 1992, pp. 159–64.

2. OED, VIII, p. 223, and *ibid.*, VI, p. 309. See also *Encyclopaedia Britannica* (Macropaedia, IV), p. 773.

3. The discussion of jet appears in Book XXXVI, xxxiv. See Pliny, X, pp. 113–15. The Latin *lapis gagates* derives from the Latin name of a river in Lycia (Asia Minor), the Gagae or Gages, where the mineral was believed to have been first found. The Spanish word for jet, 'azabache', is probably of Persian origin; see Osma, p. 1, note 4, and Franco Mata 1986, p. 135, note 54.

4. Quoted in Osma, pp. 3–4.

5. *Ibid.*, p. 6. Franco Mata 1986, p. 139. See also MacGregor, pp. 250–1.

6. Osma, p. 7. *Higas* in coral, gold and porcelain are illustrated in Franco Mata 1986, figs. 3–5 and 22. A *higa* of rock crystal is illustrated in Osma, p. 21.

7. Franco Mata 1986, p. 139. Moorish associations also led to disapproval, and Charles V banned certain symbols of hands with Islamic connotations. See Osma, p. 11, note 2.

8. For example the portrait of Don Alonso and Doña Margarita, attributed to Bartolomé Ordóñez in the Instituto Valencia de Don Juan, Madrid. See Franco Mata 1986, p. 135, fig. 2.

9. See *Europalia*, especially pp. 308–18.

10. Gómez-Tabanera, pp. 501 and 503.

11. Osma, pp. 39–42, and Franco Mata 1986, p. 141.

12. See Osma, pp. 71–2, and p. 215. Filgueira Valverde, p. 10 (this author records that the guild was known as the Confraternity of Our Lady until 1523), and Villa-Amil y Castro 1899, p. 192. Jet objects were certainly carved for pilgrims long before the formation of the guild. In the inventory of the Dukes of Burgundy of 1365 is recorded 'une coquille noire, de Saint Jacques, garnie d'or et ung boton de perles au bout', while a 'croix de Jayet' is mentioned in the inventory of Charles VI of France in 1399. See Villa-Amil y Castro 1899, pp. 188 and 190.

13. Osma, pp. 65–164. The ordinances were first published in part by López Ferreiro in 1895 (Osma, p. 65, and Filgueria Valverde, p. 10).

14. For early inventories, see note 12 above, and Osma, pp. 68–9. A jet cross (now much restored) in the Cathedral of Santiago is almost certainly to be identified with one mentioned in an inventory of 1529, while a pax, also in the Cathedral, was listed among the objects donated to the Treasury by Fray Jerónimo Román (d. 1597) (*ibid.*, pp. 138–9). A fragmentary jet *higa* first recorded in Elias Ashmole's collection in 1656 survives in the Ashmolean Museum (MacGregor, pp. 249–51, no. 190, fig. 55). A statuette of St James now in Berlin (Staatliche Museen der Preussischer Kulturbestiz) was originally in the Brandenburg Kunstkammer, and was recorded in 1838 (acquired in Cairo, and said to have come from Jerusalem). See Schottmüller, pp. 199–200, no. 451. I am grateful to Christian Theuerkauff for confirming this.

15. A jet in Berlin is inscribed with the date 1404, but this is a later addition. Schottmüller, p. 202, no. 459.

16. Osma discusses inventories and the records of jet-workers based on his archival research, but none of these can be linked to known surviving objects (Osma, pp. 103ff. and pp. 167–74).

17. Osma, pp. 43–64, and Franco Mata 1986, pp. 150 4.

18. Farmer, p. 23.

19. See Osma, p. 211, where one is illustrated.

20. Cf Osma, pp. 211–12.

21. Osma, p. 58.

22. Franco Mata 1986, p. 133, fig. 1.

23. I am grateful to Anna Somers Cocks for her advice on the dating of the silver.

24. See Osma, pp. 211–12; cf cat. no. 70.

25. Osma, p. 220, no. 50.

26. Franco Mata 1986, p. 155, fig. 21 and p. 166, cat. no. 6.

27. Osma, pp. 211–12, no. 33.

28. *Ibid.*, p. 211.

29. Filgueira Valverde, pp. 14–15.

30. I am grateful to Cristina Partearroyo for this information.

31. Osma, p. 207, no. 27.

32. Martín González, 1980, pl. 134.

33. Osma, p. 203, no. 20.

34. *Ibid.*, p. 138.

35. Franco Mata 1989, p. 322.

36. Osma, p. 219, no. 47 and p. 228, no. 66; Franco Mata 1986, p. 151, figs. 15–17 and pp. 158–60; Filgueira Valverde, pl. II, no. 679.

37. *Op. cit., loc. cit.*

38. For example see Martín González 1980, pl. 15.

39. For the Mexican origins of the image, see Sebastián, pp. 236–8 and p. 420.

40. Filgueira Valverde, p. 12.

41. Sebastián, pp. 226–8.

42. *Camino hacia la Arcadia*, pp. 164–7.

43. Trens, p. 71, fig. 28 and p. 73, fig. 30. See *ibid.*, pp. 68–74 for a discussion of the theme.

44. Osma, p. 231, no. 71.

45. Gilman 1930, p. 169, pl. LXVIII, no. D803.

46. Osma, pp. 222 and 223, nos. 54 and 56; Filgueira Valverde, pp. 12–13 and pl. III; Schottmüller, p. 201, no. 457.

47. Cf LCI, 5, pp. 219–25.

48. Cf Franco Mata 1986, figs. 42–4, and Osma, pp. 204–5, nos. 23–4.

49. Schottmüller, p. 202, no. 460.

50. Osma, p. 115.

51. *Ibid.*, p. 214, no. 38.

52. See Sparrow Simpson, pp. 472–3, note e. I am grateful to Paul Williamson for this suggestion.

BIBLIOGRAPHY AND BIBLIOGRAPHICAL ABBREVIATIONS

Abbad Ríos 1950 F. Abbad Ríos, 'Seis Retablos Aragoneses de la Época del Renacimiento', *AEA*, XXIII, 1950, pp. 53–71.

Abbad Ríos 1957 F. Abbad Ríos, *Catálogo Monumental de España: Zaragoza*, Madrid, 1957.

AEA Archivo Español de Arte (up to 1937 known as *Archivo Español de Arte y Arqueología*).

Agapito y Revilla 1913 J. Agapito y Revilla, 'Valladolid. Los Retablos de San Benito el Real', *Boletín de la Sociedad Castellana de Excursiones*, Año XI, no. 129, 1913, pp. 193–206 and *ibid.*, no. 130, pp. 217–28.

Agapito y Revilla 1926 J. Agapito y Revilla, *Las Cofradías, las Procesiones y los Pasos de Semana Santa en Valladolid*, Valladolid, 1926.

Ajmar and Sheffield 1994 M. Ajmar and C. Sheffield, 'The Miraculous Medal: An Immaculate Conception or not', *The Medal*, no. 24, Spring 1994, pp. 37–51.

Albareda 1974 A. M. Albareda, *Historia de Montserrat*, (revised J. Massot i Muntaner), Montserrat, 1974.

Alonso Cano Centenario **1968** *Centenario de Alonso Cano en Granada* (2 vols), (essays and exhibition catalogue), Granada, 1968.

Anderson 1969 R. M. Anderson, 'El Chapín y otros zapatos a fines', *Cuadernos de la Alhambra*, no. 5, 1969, pp. 17–41.

Anderson 1979 R. M. Anderson, *Hispanic Costume 1480–1530*, New York, 1979.

Angulo Iñiguez 1935 D. Angulo Iñiguez, 'Dos Menas en Méjico', *AEA*, XI, 1935, pp. 131–52.

Angulo Iñiguez *Hispano-Americano* 1945–56 D. Angulo Iñiguez, *Historia del Arte Hispanoamericano* (3 vols), Barcelona, 1945–56.

Angulo Iñiguez 1981 D. Angulo Iñiguez, *Murillo* (3 vols), Madrid, 1981.

Angulo and Pérez Sánchez I 1975 D. Angulo and A. E. Pérez Sánchez, *A Corpus of Spanish Drawings*, I (1400–1600), London, 1975.

Angulo and Pérez Sánchez II 1977 D. Angulo and A. E. Pérez Sánchez, *A Corpus of Spanish Drawings*, II (1600–1650), London, 1977.

Antón 1936–9 M. L. Antón, 'Una nueva adquisición de nuestro Museo Nacional de Escultura. Busto de la Beata Mariana de Jesús', *BSAA*, V, 1936–9, pp. 97–102.

Ara Gil 1977 C. J. Ara Gil, *Escultura Gótica en Valladolid y su Provincias*, Valladolid, 1977.

Ara Gil and Parrado del Olmo 1994 C. J. Ara Gil and J. M. Parrado del Olmo, *Catálogo Monumental de la Provincia de Valladolid* XI, *Antiguo Partido Judicial de Tordesillas* (2nd ed), Valladolid, 1994.

Ars Hispaniae VIII **1956** A. Durán Sanpere and J. Ainaud de Lasarte, *Ars Hispaniae, VIII: Escultura Gótica*, Madrid, 1956.

Ars Hispaniae XIII **1958** J. M. Azcárate, *Ars Hispaniae, XIII: Escultura del Siglo XVI*, Madrid, 1958.

Ars Hispaniae XVI **1963** M. E. Gómez-Moreno, *Ars Hispaniae, XVI: Escultura del Siglo XVII*, Madrid, 1963.

Ars Hispaniae XVII **1965** F. J. Sánchez Cantón, *Ars Hispaniae, XVII: Escultura del Siglo XVIII*, Madrid, 1965.

Art-Journal **1865** 'Rival Museums: The British Museum and the Museum at South Kensington', *The Art-Journal*, 1865, IV, pp. 281–3.

Arte en las Clausuras **1983** *Arte en las Clausuras de los Conventos de Monjas de Valladolid* (exhibition catalogue), Museo Nacional de Escultura, Valladolid, 1983.

Arte y Devoción **1990** *Arte y Devoción: Estampas de Imágenes y retablos de los Siglos XVII y XVIII en Iglesias Madrileñas*, Real Academia de Bellas Artes de San Fernando (Calcografía Nacional), Madrid, 1990.

de Atienza 1948 J. de Atienza, *Nobiliario Español*, Madrid, 1948.

Aurenhammer 1954 H. Aurenhammer, 'Zwei Werke des Pedro de Mena in Wien', *Alte und Neue Kunst*, III, 2, 1954, pp. 111–32.

Ávila **1983** M. Gómez-Moreno, *Catálogo Monumental de la Provincia de Ávila* (ed. revised by A. de la Morena and T. Pérez Higuera), Ávila, 1983.

Azcue Brea 1994 L. Azcue Brea, *La Escultura en la Real Academia de Bellas Artes de San Fernando (Catálogo y Estudio)*, Madrid, 1994.

Baker 1982 M. Baker, 'A Glory to the Museum: The Casting of the Pórtico de la Gloria', *V&A Album*, I, London, 1982, pp. 101–8.

Baker 1984 M. Baker, 'Spain and South Kensington. John Charles Robinson and the Collecting of Spanish Sculpture in the 1860s', *V&A Album*, III, London, 1984, pp. 340–9.

Baker 1988 M. Baker, 'The Establishment of a Masterpiece: the Cast of the Pórtico de la Gloria in the South Kensington Museum, London, in the 1870s', *Actas Simposio Internacional sobre 'O Pórtico da Gloria e a Arte do Seu Tempo'*, Santiago de Compostela, 1988, pp. 479–89.

de la Banda y Vargas 1968 A. de la Banda y Vargas, 'Una Obra Madrileña de "La Roldana" en el Convento de las Teresas de Sevilla', *Goya*, no. 82, 1968, p. 266.

Barrio Loza 1981 J. A. Barrio Loza, *La Escultura Romanista en la Rioja*, Madrid, 1981.

Barrio Loza 1984 J. A. Barrio Loza, *Los Beaugrant en el Contexto de la Escultura Manierista Vasca* (exhibition catalogue), Museo de Bellas Artes, Bilbao, 1984.

Bartsch 1978–92 *The Illustrated Bartsch* (ed. H. Zerner), New York, 1978–1992.

Baxandall 1980 M. Baxandall, *The Limewood Sculptors of Renaissance Germany*, New Haven, 1980.

Bayley 1981 S. Bayley, *The Albert Memorial: the Monument in its Social and Architectural Context*, London, 1981.

***Beaugrant* 1985** *Los Beaugrant: Escultura en Vizcaya 1533–1560* ed. J. A. Barrio Loza (exhibition catalogue), Museo de Bellas Artes de Bilbao, Bilbao, 1985.

Belda Navarro 1992 C. Belda Navarro, *La Ultima Cena, de Francisco Salzillo* (exhibition catalogue: Pabellón de Murcia, Exposición Universal Seville), Murcia, 1992.

***Bibliotheca Sanctorum* 1961–70** *Bibliotheca Sanctorum* (13 vols), ed. Pontificia Universitá Lateranense, Rome, 1961–70.

Bizagorena 1982 F. de Bizagorena, *Salamanca: su Historia, su Arte, su Cultura*, Salamanca, 1982.

Bober and Rubinstein 1986 P. P. Bober and R.O. Rubinstein, *Renaissance Artists and Antique Sculpture: A Handbook of Sources*, London, 1986.

Boix 1974 M. M. Boix *What is Montserrat* (translated K. Lyons), Montserrat, 1974.

Bonet Correa 1984 A. Bonet Correa, *Iglesias Madrileñas del Siglo XVII*, (2nd ed.), Madrid, 1984.

Borchgrave d'Altena 1959 Comte J. de Borchgrave d'Altena, 'Statuettes Malinoises', *Bulletin des Musées Royaux d'Art et d'Histoire du Cinquantenaire*, Séries 4, Année 31, 1959, pp. 2–98.

Bosarte 1978 I. Bosarte, *Viage Artístico á Varios Pueblos de España*, (1804), Madrid, 1978.

Brown 1973 J. Brown, *Francisco de Zurbarán*, New York, 1973.

BSAA *Boletín del Seminario de Estudios de Arte y Arqueología* (Universidad de Valladolid).

Caamaño Martínez 1966–67 J. M. Caamaño Martínez, 'Francisco Giralte', *Goya*, no. 76, 1966–67, pp. 230–9.

Calero Ruiz 1987 C. Calero Ruiz, *Escultura Barroca en Canarias (1600–1750)*, Tenerife, 1987.

***Camino hacia la Arcadia* 1995** *Un Camino hacia la Arcadia: Arte en las Misiones Jesuíticas de Paraguay* (exhibition catalogue), Casa de América, Madrid, 1995.

Camón Aznar 1943 J. Camón Aznar, *El Escultor Juan de Ancheta*, Pamplona, 1943.

Camón Aznar 1980 J. Camón Aznar, *Alonso Berruguete*, Madrid, 1980.

Candeira y Pérez 1959 C. Candeira y Pérez, *Alonso Berruguete en el Retablo de San Benito el Real de Madrid*, Valladolid, 1959.

Carducho 1979 V. Carducho, *Diálogos de la Pintura* [1633] (ed. F. Calvo Serraller), Madrid, 1979.

Carter 1780 F. Carter, *A Journey from Gibraltar to Malaga* (2 vols), London, 1780.

***Castilla y León* 1989** *Escultura de Castilla y León siglos XVI–XVIII*, (exhibition catalogue), Museo e Instituto 'Camón Aznar', Zaragoza, 1989.

***Catálogo Marés* 1979** *Catálogo Museo Federico Marés*, Barcelona, 1979.

***Catholic Encyclopaedia* 1967–79** *The New Catholic Encyclopaedia* (17 vols), New York, 1967–79.

Ceán Bermúdez 1800 J. A. Ceán Bermúdez, *Diccionario historico de los más ilustres profesores de las Bellas Artes en España* (6 vols), Madrid, 1800.

Cedillo 1920 Conde de Cedillo, 'La iglesia de San Pedro de Ocaña', *Madrid: Sociedad Española de Excursiones (Boletín)*, XXVIII, 1920, pp. 32–8.

Cedillo 1959 Conde de Cedillo, *Catálogo Monumental de la Provincia de Toledo*, Toledo, 1959.

Checa 1983 F. Checa, *Pintura y Escultura del Renacimiento en España 1450–1600*, Madrid, 1983.

Cheetham 1984 F. Cheetham, *English Medieval Alabasters*, Oxford, 1984.

Cloulas 1991 A. Cloulas, 'La Sculpture Funéraire dans l'Espagne de la Renaissance: Le Mécénat Royal', *Gazette des Beaux-Arts*, CXVIII, 1991, pp. 61–78.

Cloulas 1992 A. Cloulas, 'La Sculpture Funéraire dans l'Espagne de la Renaissance: Le Mécénat Aristocratique', *Gazette des Beaux-Arts*, CXX, 1992, pp. 97–116.

Cloulas 1993 A. Cloulas, 'La Sculpture Funéraire dans l'Espagne de la Renaissance: Les Commandes Ecclésiastiques', *Gazette des Beaux-Arts*, CXXI, 1993, pp. 139–63.

Codina Armengot 1946 E. Codina Armengot, *Inventarios de las Obras del Museo Provincial de Bellas Artes y de las Colecciones de la Excelentísima Diputación de Castellón*, Castellón, 1946.

Comstock 1927 H. Comstock, 'Fragments from a Spanish Gothic Tomb', *International Studio*, LXXXVII, 1927, pp. 30–6.

Converging Cultures 1996 *Converging Cultures: Art and Identity in Spanish America* (exhibition catalogue), ed. D. Fane, The Brooklyn Museum, New York, 1996.

Conway 1882 M. D. Conway, *Travels in South Kensington*, London, 1882.

Corporation of London 1895 *Catalogue of Drawings by Old Masters, Mediaeval Jewelry and Antique Statues*, Corporation of London Art Gallery, London, 1895.

Cruzada Villaamil 1862 Cruzada Villaamil, 'Documentos relativos al retablo de la Iglesia de S. Benito el Real en Valladolid', *El Arte en España*, Madrid, 1862, pp. 147–53.

Cumberland 1782 R. Cumberland, *Anecdotes of Eminent Painters in Spain* (2 vols), London, 1782.

Davies 1992 H. E. Davies, *Sir John Charles Robinson (1824–1913): his role as a connoisseur and creator of public and private collections* (D. Phil.) Oxford University, 1992. (Copies held in the Department of Prints and Drawings, Ashmolean Museum, Oxford, and at the Bodleian Library, Oxford).

Dennis 1839 G. Dennis, *A Summer in Andalucía* (2 vols), London, 1839.

Dieulafoy 1908 M. Dieulafoy, *La Statuaire Polychrome en Espagne*, Paris, 1908.

DNB 1927 H. W. C. Davis and J. R. H. Weaver (eds), *The Dictionary of National Biography 1912–1921*, Oxford, 1927.

Doshi 1983 S. Doshi (ed.), *Goa: Cultural Patterns*, Bombay, 1983.

Echeverría Goñi 1990 P. Echeverría Goñi, *Policromía del Renacimiento en Navarra*, Pamplona, 1990.

El Greco to Goya 1981 *El Greco to Goya: The Taste for Spanish Paintings in Britain and Ireland* (exhibition catalogue), National Gallery, London, 1981.

Elliott 1983 J. H. Elliott, *Imperial Spain 1469–1716*, Harmondsworth, 1983 (slightly revised version of edition first published 1963).

Encyclopaedia Britannica *The New Encyclopaedia Britannica* (30 vols), Chicago, 1973–4.

Enggass and Brown 1970 R. Enggass and J. Brown, *Italy and Spain 1600–1750*, Englewood Cliffs, 1970.

Escultura en Andalucía 1984 *La Escultura en Andalucía Siglos XV a XVIII* (exhibition catalogue), Museo Nacional de Escultura, Valladolid, 1984.

Escultura en Aragón 1993 M. I. Alvaro Zamora and G. M. Borrás Gualis (eds), *La Escultura del Renacimiento en Aragón* (exhibition catalogue), Museo e Instituto de Humanidades Camón Aznar, Zaragoza, 1993.

Escultura en Valladolid 1985 *La Escultura en Valladolid hacia 1600*, (exhibition catalogue) Caja de Ahorros Popular de Valladolid, 1985.

Escultura del Siglo XVI 1987 *Escultura del Siglo XVI en Castilla y León*, (exhibition catalogue), Museo Nacional de Escultura, Valladolid, 1987.

Estella Marcos 1984 M. M. Estella Marcos, *La Escultura Barroca de Marfil en España* (2 vols), Madrid, 1984.

Estella Marcos 1990 M. M. Estella Marcos, *Juan Bautista Vázquez el Viejo en Castilla y America*, Madrid, 1990.

Europalia *Santiago de Compostela: 1000 ans de Pèlerinage Européen*, Europalia 85 España, (exhibition catalogue), Ghent, 1985.

Evans 1992 M. Evans, *The Sforza Hours* (The British Library), London, 1992.

Expansao Portuguesa 1991 *A Expansao Portuguesa e a Arte do Marfim* (exhibition catalogue), Fundacao Calouste Gulbenkian, Lisbon, 1991.

Exposición Conmemorativa 1986 J. F. Vicente (ed.), *Exposición Conmemorativa del Primer Centenario de la Diocesis Madrid-Alcalá*, Madrid, 1986.

von Falke 1893 J. von Falke, *Holzschnitzereien: eine Auswahl aus der Sammlung des K.K. Österreich. Museums*, Vienna, 1983.

Farmer 1987 D. H. Farmer, *The Oxford Dictionary of Saints* (second edition), Oxford, 1987.

Fernández 1986 *Gregorio Fernández y la Semana Santa de Valladolid* (exhibition catalogue), Museo Nacional de Escultura, Valladolid, 1986.

Fernández Lopez 1988 J. Fernández Lopez, 'Una Nueva Dolorosa attribuible a Pedro de Mena', *BSAA*, LIV, 1988, pp. 428–30.

Fernández del Hoyo 1991 M. A. Fernández del Hoyo, 'Datos para la Biografia de Juan de Juni', *BSAA*, LVII, 1991, Valladolid, pp. 333–40.

Ferrandis Torres 1928 J. Ferrandis Torres, *Marfiles y Azabaches Españoles*, Barcelona, 1928.

Ferrando Roig 1950 J. Ferrando Roig, *Iconografía de los Santos*, Barcelona, 1950.

Filgueira Valverde 1943 J. Filgueira Valverde, 'Azabaches Compostelanos del Museo de Pontevedra', *El Museo de Pontevedra*, II, 1943, pp. 7–22.

Finestres y de Monsalvo 1947–49 J. Finestres y de Monsalvo, *Historia del Real Monasterio de Poblet* (5 vols), Barcelona, 1947–48. (See also Guitert y Fontseré).

Ford Letters 1905 *The Letters of Richard Ford 1797–1858* (edited by R. E. Prothero), London, 1905.

Ford 1845 R. Ford, *A Handbook for Travellers in Spain* [1845] (ed. I. Robertson) (3 vols), London, 1966.

Ford 1869 R. Ford, *A Handbook for Travellers in Spain*, Part II (fourth edition), London, 1869.

Fortnum 1879 C. D. E. Fortnum, 'On a signaculum of St James of Compostella', *Archaeological Journal*, XXXVI, 1879, pp. 33–7.

Franco Mata 1986 M. A. Franco Mata, 'Azabaches del Museo Arqueológico Nacional', *Boletín del Museo Arqeológico Nacional (Madrid)*, IV, 1986, pp. 131–67.

Franco Mata 1989 M. A. Franco Mata, 'El azabache en España', *Compostellanum: Sección de Estudios Jacobeos*, XXXIV, nos. 3–4, 1989, pp. 311–35.

Franco Mata 1991 M. A. Franco Mata, 'Valores artísticos y simbólicos del azabache en España y Nuevo Mundo', *Compostellanum: Sección de Estudios Jacobeos*, XXXVI, nos. 3–4, 1991, pp. 467–531.

Franco Mata 1993 M. A. Franco Mata, *Catálogo de la Escultura Gótica (Museo Arqueológico Nacional)* 2nd edition, Madrid, 1993.

Friedländer 1968 M. J. Friedländer, *Dieric Bouts and Joos van Gent (Early Netherlandish Painting III)*, (tr. H. Norden) Leyden, 1968.

Fuentes Pérez 1990 G. Fuentes Pérez, *Canarias: El Classicismo en la Escultura*, Tenerife, 1990.

Gallego y Burín 1925 A. Gallego y Burín, *José de Mora: su Vida y su Obra*, Granada, 1925.

Gallego y Burín 1982 A. Gallego y Burín, *Granada: Guia Artistica e Historica de la Ciudad*, (ed. F . J. Gallego Roca), Granada, 1982.

García Chico 1960 E. García Chico, *Pedro de la Cuadra*, Valladolid, 1960.

García Chico 1962 E. García Chico, *La Cofradía Penitencial de la Santa Vera Cruz*, Valladolid, 1962.

García de Wattenberg 1984 E. García de Wattenberg, *Museo Nacional de Escultura. Guía de Visitante*, Valladolid, 1984.

García Olloqui 1977 M. V. García Olloqui, *'La Roldana'*, Seville, 1977.

García-Sauco Beléndez 1985 L. G. García-Sauco Beléndez, *Francisco Salzillo y la Escultura Salzillesca en la Provincia de Albacete*, Albacete, 1985.

García Vega 1985 B. García Vega, 'Estampas de Imágenes Vallisoletanas', *BSAA*, LI, 1985, pp. 393–410.

Garín 1955 F. M. Garín Ortiz de Tarranco, *Catálogo-Guia del Museo Provincial de Bellas Artes de San Carlos*, Valencia, 1955.

Garín 1959 F. M. Garín Ortiz de Tarranco, *Valencia Monumental*, Madrid, 1959.

Garnelo y Alda 1913 J. Garnelo y Alda, 'Alonso Cano', *Por el Arte*, I, no. 8, Madrid, 1913, p. 307.

Gestoso y Pérez 1884 J. Gestoso y Pérez, *Pedro Millán*, Seville, 1884.

Gillerman 1989 D. Gillerman (ed.), *Gothic Sculpture in America I: The New England Museums*, New York, 1989.

Gilman 1930 B. I. Gilman, *Catalogue of Sculpture (Sixteenth to Eighteenth Centuries) in the Collection of the Hispanic Society of America*, New York, 1930.

Gilman 1932 B. I. Gilman, *Catalogue of Sculpture (Thirteenth to Fifteenth Centuries) in the Collection of the Hispanic Society of America*, New York, 1932.

Gilman 1951 B. Gilman Proske, *Castilian Sculpture Gothic to Renaissance*, New York, 1951.

Gilman 1964 B. Gilman Proske, 'Luisa Roldán at Madrid', *Connoisseur*, CLV, nos. 624–6, February–April, 1964 pp. 128–32, pp. 199–203, and pp. 269–73.

Gilman 1967 B. Gilman Proske, *Juan Martínez Montañés Sevillian Sculptor*, New York, 1967.

Godenne 1963 W. Godenne, *Préliminaires à l'Inventaire Général des Statuettes d'Origine Malinoise Présumées des XVe et XVIe Siècles*, Malines, 1963.

Godenne 1969 W. Godenne, *Préliminaires à l'Inventaire Général des Statuettes d'Origine Malinoise Présumées des XVe et XVIe Siècles*, Malines, 1969.

Godenne 1973 W. Godenne, *Préliminaires à l'Inventaire Général des Statuettes d'Origine Malinoise Présumées des XVe et XVIe Siècles*, Malines, 1973.

Golden Age 1980 *The Golden Age of Spanish Art*, (exhibition catalogue) Nottingham University Art Gallery, 1980.

Gómez-Moreno 1925 M. Gómez-Moreno, *Catálogo Monumental de España: Provincia de León*, (1906–1908), Madrid, 1925.

Gómez-Moreno 1926 M. Gómez-Moreno, 'Alonso Cano Escultor', *AEA*, II, 1926, pp. 117–214.

Gómez-Moreno 1937 M. E. Gómez-Moreno, 'El Pleito de Alonso Cano con el Cabildo de Granada', *AEA*, XIII, 1937, pp. 207–33.

Gómez-Moreno 1941 M. Gómez-Moreno, *Las Aguilas del Renacimiento Español*, Madrid (reprint of 1941 edition), 1983.

Gómez-Moreno 1942 M. E. Gómez-Moreno, 'Isidro de Villoldo, Escultor', *BSAA*, VIII, 1942, pp. 141–50.

Gómez-Moreno 1951 M. E. Gómez-Moreno, *Breve Historia de la Escultura Española* (2nd ed.), Madrid, 1951.

Gómez-Moreno 1963 M. Gómez-Moreno, *Diego Siloe* (ed. J. M. Gómez-Moreno Calera), Granada (reprint of 1963 edition), 1988.

Gómez-Moreno 1974 M. E. Gómez-Moreno, 'Un San Francisco de Mena en Antequera', *AEA*, XLVII, 1974, pp. 68–70.

Gómez-Tabanera 1993 J. M. Gómez-Tabanera, 'Azabache, "piedra de virtud" astur en la ruta jacobea', Anexo II in *El Camino de Santiago. Retablo Estelar del Apostol* (ed. F. Torroba Bernaldo de Quiros), Oviedo, 1993, pp. 471–516.

Gori and Barbieri 1993 I. Gori and S. Barbieri, 'Tecnicas y Caracteristicas Esteticas, Estilisticas, e Iconograficas de la Imaginería de los Siglos XVII–XX en el Territorio Argentino', *Zeitschrift für Kunsttechnologie und Konservierung*, 7, Vol. 1, 1993, pp. 1–73.

Greenwood 1989 M. Greenwood, 'Victorian Ideal Sculpture . . .' in P. Curtis (ed.), *Patronage and Practice: Sculpture on Merseyside*, Liverpool, 1989, pp. 50–6.

Gregori 1973 M. Gregori, *L'Opera Completa di Zurbarán*, Milan, 1973.

Guitert y Fontseré 1955 J. Guitert y Fontseré, *Historia del Real Monasterio de Poblet*, VI, Barcelona, 1955. (See also Finestres y de Monsalvo).

Hall 1980 J. Hall, *Dictionary of Subjects and Symbols*, (revised edition), London, 1980.

Hall-van den Elsen MA C. Hall-van den Elsen, *La Vida y las Obras de Luisa Roldán*, (unpublished MA thesis) La Trobe University, Melbourne.

Hall-van den Elsen 1989 C. Hall-van den Elsen, 'Una Valoración de dos Obras de Luisa Roldán', *Goya*, no. 209, March–April, 1989, pp. 291–5.

Hall-van den Elsen 1992 C. Hall-van den Elsen, *The Life and Work of the Sevillian sculptor Luisa Roldán with a Catalogue Raisonné* (unpublished Ph D thesis), La Trobe University, Melbourne, 1992.

Harris 1964 E. Harris, 'Sir William Stirling-Maxwell and the History of Spanish Art', *Apollo* LXXIX, 1964, pp. 73–7.

Harris 1967 E. Harris, 'Velázquez and Charles I', *Journal of the Warburg and Courtauld Institutes*, XXX, 1967, pp. 414–20.

Hernández Díaz 1951 J. Hernández Díaz *et al.*, *Catálogo Arqueologico y Artistico de la Provincia de Sevilla*, Seville, 1951.

Hernández Díaz *Hispalense* J. Hernández Díaz, *Imaginería Hispalense del Bajo Renacimiento*, Seville, 1951.

Hernández Díaz 1967 J. Hernández Díaz, 'Estudios de Iconografia Sagrada', *Anales de la Universidad Hispalense*, XXVII, Seville, 1967.

Hernández Díaz 1983 J. Hernández Díaz, *Juan de Mesa*, Seville, 1983.

Hernández Díaz 1987 J. Hernández Díaz, *Juan Martínez Montañés*, Seville, 1987.

Hernández Perera 1954 J. Hernández Perera, 'Iconografia Española: El Cristo de los Dolores', *AEA*, XXVII, 1954, pp. 47–62.

Hildburgh 1917 W. L. Hildburgh, ['Jet Carvings Produced at Santiago de Compostela'], *Journal of the Society of Antiquaries* (2nd series) XXIX, 1917, pp. 1–6.

Hill 1930 G. F. Hill, *A Corpus of the Italian Medals of the Renaissance before Cellini* (2 vols), London, 1930.

Hirst and Dunkerton 1994 M. Hirst and J. Dunkerton, *Making and Meaning: The Young Michelangelo* (exhibition catalogue), National Gallery, London, 1994.

Hispanic Society Jet 1926 *Jet in the Collection of the Hispanic Society of America*, (Hispanic Notes and Monographs) The Hispanic Society of America, New York, 1926.

Hispanic Society Jet 1930 *Jet in the Collection of the Hispanic Society of America*, The Hispanic Society of America, New York, 1930.

Hispanic Society Handbook 1938 *Hispanic Society of America Handbook. Museum and Library Collections*, New York, 1938.

Hofstede 1967 J. Müller Hofstede, 'Rubens' Bildnis des Hl. Philipp Neri', *Kunstgeschichte Studien für Kurt Bauch* (ed. M. Lisner and R. Becksmann), Munich, 1967, pp. 171–80.

Hull 1872 E. Hull, *A Treatise on the Building and Ornamental Stones of Great Britain and Foreign Countries*, London, 1872.

Ibáñez-Martín 1956 J. Ibáñez-Martín, *Gabriel Yoly*, Madrid, 1956.

Igual Ubeda 1964 A. Igual Ubeda, *Cristos Yacentes en las Iglesias Valencianas*, (Cuadernos de Arte 13), Institución Alfonso El Magnanimo, Valencia, 1964.

Igual Ubeda and Morote Chapa 1945 A. Igual Ubeda and F. Morote Chapa, *Obras de Escultores Valencianos del Siglo XVIII*, Castellón de la Plana, 1945.

Inventory **1864** *Inventory of the Objects forming the Art Collection of the Museum at South Kensington. Supplement no. 1 for the year 1864*, London, 1864.

Inventory **1852–67** *Inventory of the Objects in the Art Division of the Museum at South Kensington . . . For the years 1852 to the end of 1867*, I, London, 1868.

Janson 1937 H. W. Janson, 'The Putto with the Death's Head', *Art Bulletin*, XIX, 1937, pp. 423–49.

Juan de Juni y su Época *Juan de Juni y su Época* (exhibition catalogue), Museo Nacional de Escultura, Valladolid, 1977.

Kauffmann 1973 C. M. Kauffmann, *Victoria and Albert Museum Catalogue of Foreign Paintings* (2 vols), London, 1973.

Keleman 1951 P. Keleman, *Baroque and Rococo in Latin America*, (2 vols.) New York, 1951.

Keller 1869 [F. Keller], 'Antiquities and Works of Art Exhibited', *Archaeological Journal*, XXVI, 1869, pp. 179–81.

Kubler and Soria 1959 G. Kubler and M. Soria, *Art and Architecture in Spain and Portugal and their American Dominions 1500 to 1800*, Harmondsworth, 1959.

Lázaro López 1993 A. Lázaro López, *Museo del Retablo: Iglesia de San Esteban*, Burgos, 1993.

LCI W. Braunfels (ed.), *Lexikon der Christlichen Ikonographie* (8 vols.), Freiburg im Breisgau, 1974.

Lenaghan 1993 P. Lenaghan, *The Arrival of the Italian Renaissance in Spain: the Tombs of Domenico Fancelli and Bartolomé Ordónez*, (dissertation, New York University), Ann Arbor, 1993.

Leyenda de Oro **1865** *La Leyenda de Oro*, I, Barcelona, 1865.

Liaño Martínez E. Liaño Martínez, *La Catedral de Barcelona*, León, 1983.

List **1870** *List of the Objects in the Art Division, South Kensington Museum acquired during the year 1870*, London, 1871.

List **1871** *List of the Objects in the Art Division, South Kensington Museum acquired during the year 1871*, London, 1872.

List **1879** *List of the Objects in the Art Division, South Kensington Museum acquired during the year 1879*, London, 1880.

Llordén 1960 A. Llordén, *Escultores y Entalladores Malagueños Ensayo Histórico Documental Siglos (XV–XIX)*, Ávila, 1960.

Loan Exhibition *Catalogue of the Special Loan Exhibition of Spanish and Portuguese Ornamental Art, South Kensington Museum* (exhibition catalogue), London, 1881.

von Loga V. von Loga, *Spanische Plastik*, Munich, 1923.

Longhurst M. H. Longhurst, *Catalogue of Carvings in Ivory* (2 vols), London, 1929.

Louvre: Nouvelles Acquisitions **1992** *Musée du Louvre: Nouvelles Acquisitions du Département des Sculptures 1988–1991*, Paris, 1992.

Luis Elvira **1990** *Estatuaria Española Renacentista: Luis Elvira Anticuario* (exhibition catalogue), contributions by L. Elvira, B. Hasbach Lugo and I. Rodríguez López, Castellón, 1990.

Luso-Oriental B. Ferrao de Tavares e Távora, *Imaginária Luso-Oriental*, Lisbon, 1983.

MacGregor 1983 A. MacGregor (ed.), *Tradescant's Rarities*, Oxford, 1983.

Maclagan and Longhurst E. Maclagan and M. Longhurst, *Catalogue of Italian Sculpture Victoria and Albert Museum*, London, 1932.

Madrid Congress 1992 *Conservation of the Iberian and Latin American Cultural Heritage. Preprints of the Contributions to the Madrid Congress, 9–12 September 1992* (eds H. W. M. Hodges, J. S. Mills, P. Smith), London, 1992.

Magaña Bisbal 1952 L. Magaña Bisbal, 'Una Familia de Escultores: los Mora', *AEA*, XXV, 1952, pp. 143–57.

Mâle 1932 E. Mâle, *L'Art Religieux après Le Concile de Trente*, Paris, 1932.

Marín 1912 D. Marín, 'Exposición de Arte Historico, Granada', *Museum* II, 1912, pp. 241–73.

Martín González 1953 J. J. Martín González, 'La Policromia en la Escultura Castellana', *AEA* XXVI, 1953, pp. 295–312.

Martín González 1957 J. J. Martín González, 'Cabezas de Santos Degollados en la Escultura Barroca Española', *Goya*, XVI, 1957, pp. 210–13.

Martín González *Castellana* 1959 J. J. Martín González, *Escultura Barroca Castellana*, Madrid, 1959.

Martín González *Castellana* 1971 J. J. Martín González, *Escultura Barroca Castellana* (Segunda Parte), Madrid, 1971.

Martín González 1971 J. J. Martín González, 'El Museo diocesano y catedralicio de Valladolid', *Goya*, 101, March–April, 1971.

Martín Gonzáles 1974 J. J. Martín González, *Juan de Juni Vida y Obra*, Madrid, 1974.

Martín González 1980 J. J. Martín González, *El Escultor Gregorio Fernández*, Madrid, 1980.

Martín González 1983 J. J. Martín González *Escultura Barroca en España, 1600–1770*, Madrid, 1983.

Martín González *Catálogo* 1983 J. J. Martín González, *Catálogo Monumental de la Provincia de Valladolid* XIII, *Monumentos Civiles de la Ciudad de Valladolid*, Valladolid, 1983.

Martín González *Valladolid* 1983 J. J. Martín González, *El Museo Nacional de Escultura de Valladolid*, León, 1983.

Martín González 1984 J. J. Martín González, *El Artista en la Sociedad Española del Siglo XVII*, Madrid, 1984.

Martín González 1988 J. J. Martín González, 'Bienes Artísticos de don Rodrigo Calderón', *BSAA*, LIV, 1988, pp. 267–92.

Martín González and Plaza Santiago 1987 J. J. Martín González and F. J. de la Plaza Santiago, *Catálogo Monumental de la Provincia de Valladolid* XIV (Parte Segunda), *Monumentos Religiosos de la Ciudad de Valladolid (Conventos y Seminarios)*, Valladolid, 1987.

Martín González and Urrea Fernández 1985 J. J. Martín González and J. Urrea Fernández, *Catálogo Monumental de la Provincia de Valladolid*, XIV (Parte Primera), *Monumentos Religiosos de la Ciudad de Valladolid*, Valladolid, 1985.

Martínez Chumillas 1948 M. Martínez Chumillas, *Alonso Cano: estudio monográfico de la obra del insigne racionero que fue de la catedral de Granada*, Madrid, 1948.

Martí y Monso J. Martí y Monso, *Estudios histórico-artísticos relativos principalmente á Valladolid*, Valladolid, 1898–1901.

Maskell A. Maskell, *Wood Sculpture*, London, 1911.

Mayer 1923 A. L. Mayer, *Spanische Barockplastik*, Munich, 1923.

Mayer *Siloe* 1923 A. L. Mayer, 'El Escultor Gil de Siloe', *Boletín de la Sociedad Española de Excursiones*, XXXI, 1923, pp. 255–6, and unnumbered illustrations.

Mayer 1925 A. L. Mayer, 'A Dispersed Masterpiece from the Studio of Gil de Siloe', *Art in America*, XIII, 1925, pp. 48–55.

Mayer 1928 A. L. Mayer, *Gotik in Spanien*, Leipzig, 1928.

Merchan R. Merchan Cantisan, *El Deán López-Cepero y su Coleccion Pictorica*, Seville, 1979.

Millar O. Millar, 'Abraham van der Doort's Catalogue of the Collections of Charles I' *Walpole Society* XXXVII, 1958–60.

Miller A. Miller, *Tradition in Sculpture*, London, 1949.

Mills J. W. Mills, *The Technique of Sculpture*, London, 1976.

Mollaret and Brossollet H. H. Mollaret and J. Brossollet, 'La Peste, Source Méconnue d'Inspiration Artistique', *Jaarboek Koninklijk Museum voor Schone Kunsten Antwerp*, 13/146, 1965, pp. 3–112.

Montagu J. Montagu, *Alessandro Algardi*, New Haven, 1985.

Montesinos Montesinos C. Montesinos Montesinos, *El Escultor D. Cristóbal Ramos (1725–1799)*, Seville, 1986.

Montserrat 1981 *Selecció de Gravats de la Mare de Déu de Montserrat segles XVI al XX*, Abadia de Montserrat, 1981.

Morán and Checa 1985 M. Morán and F. Checa, *El Coleccionismo en España*, Madrid, 1985.

Moreno Mendoza 1992 A. Moreno Mendoza, J. M. Palomero Páramo, E. Valdivieso González *et al.*, *Obras Maestras del Museo de Bellas Artes de Sevilla Siglos XV–XVIII* (exhibition catalogue), Seville, 1992.

Mulcahy 1994 R. Mulcahy, *The Decoration of the Royal Basilica of El Escorial*, Cambridge, 1994.

Museo Camón Aznar 1979 *Museo Camón Aznar, Obra Social de la Caja de Ahorros de Zaragoza, Aragón y Rioja*, Zaragoza, 1979.

NACF 1943 *National Art-Collections Fund Fortieth Annual Report 1943*, London, 1944.

Nicolau 1983 J. Nicolau, 'Dos relieves del circulo de Gregorio Pardo en la Parroquia de Santa Leocadia y en el Monasterio de Santa Clara en Toledo', *AEA*, no. 224, 1983, pp. 416–18.

Nicolau Castro 1990 J. Nicolau Castro, 'Unos Bronces de Alejandro Algardi en el Monasterio Toledano de Madres Capuchinas', *AEA*, no. 249, 1990, pp. 1–13.

Nicolau Castro 1991 J. Nicolau Castro, *Escultura Toledana del Siglo XVIII*, Toledo, 1991.

Nigra sum *Nigra sum: Iconografía de Santa Maria de Montserrat* (exhibition catalogue), ed. J. de C. Laplana and T. Macià, Museu de Montserrat, 1995.

OED J. A. Simpson and E. S. C. Weiner (eds.), *The Oxford English Dictionary* (20 vols), (2nd edition), Oxford, 1989.

Oman C. Oman, *The Golden Age of Hispanic Silver 1400–1665 (Victoria and Albert Museum)*, London, 1968.

Orozco Díaz 1934 E. Orozco Díaz, 'Los Hermanos García (Escultores del Ecce-Homo', *Boletín de la Universidad de Granada*, VI, 1934, no. 30, pp. 1–18.

Oroczo Díaz 1939–41 E. Orozco Díaz, 'La Escultura en Barro en Granada', *Cuadernos de Arte*, Granada, IV–VI, 1939–41, pp. 93–108.

Orozco Díaz 1956 E. Orozco Díaz, 'Los barros de Risueño y la estética Granadina', *Goya*, no. 14, 1956, pp. 76–82.

Orozco Díaz 1963 E. Orozco Díaz, 'Devoción y Barroquismo en las Dolorosas de Pedro de Mena', *Goya*, LV, 1963, pp. 235–41.

Orozco Díaz 1971 E. Orozco Díaz, 'Unas Obras de Risueño y de Mora Desconocidas', *AEA*, XLIV, 1971, pp. 245–6

Orueta 1914 R. de Orueta y Duarte, *La Vida y la Obra de Pedro de Mena y Medrano*, Madrid, 1914.

Orueta 1919 R. de Orueta, *La Escultura Funeraria en España*, Madrid, 1919.

Orueta 1927 R. de Orueta y Duarte, 'Sobre José de Mora', *AEA*, III, 1927, pp. 71–5.

van Os 1994 H. van Os *et al.*, *The Art of Devotion in the Late Middle Ages in Europe 1300–1500* (exhibition catalogue), Rijksmuseum, Amsterdam, 1994.

Osborne H. Osborne (ed.), *The Oxford Companion to the Decorative Arts*, Oxford, 1975.

Osma G. J. de Osma y Scull, *Catálogo de Azabaches Compostelanos precedido de Apuntes sobre los Amuletos contra el Aojo, las Imágenes del Apóstol-Romero y la Cofradía de los Azabacheros de Santiago*, Madrid, 1916.

Ossorio y Bernard M. Ossorio y Bernard, *Galeria Biográfica de Artistas Españoles del Siglo XIX* (2 vols), Madrid, 1868.

Osuna 1994 *El Mundo de los Osuna ca.1460–ca.1540* (exhibition catalogue), Museu Sant Pius V, Valencia, 1994.

Pacheco F. Pacheco, *Arte de la Pintura* [1638], (2 vols) ed. F. J. Sánchez Cantón, Madrid, 1956.

Palmer 1987 G. G. Palmer, *Sculpture in the Kingdom of Quito*, Albuquerque, 1987.

Palomero Páramo 1981 J. M. Palomero Páramo, *Gerónimo Hernández*, Seville, 1981.

Palomino, El Parnaso 1936 A. Palomino, *El Parnaso Español*, [1714] in Sánchez Cantón, *Fuentes* (q.v.), IV.

Palomino Lives A. Palomino, *Lives of the Eminent Spanish Painters and Sculptors* (translated by N. A. Mallory), Cambridge, 1987.

Pardo Canalis E. Pardo Canalis, *Francisco Salzillo* (2nd ed.), Madrid, 1983.

Pareja López and Megía Navarro 1990 E. Pareja López and L. M. Megía Navarro, *El Arte de la Reconquista Cristiana (Historia del Arte en Andalucía III)*, Seville, 1990.

Pareja López 1991 E. Pareja López *et al.*, *Museo de Bellas Artes de Sevilla*, Seville, 1991.

Parrado del Olmo Ávila 1981 J. M. Parrado del Olmo, *Los Escultores Seguidores de Berruguete en Ávila*, Ávila, 1981.

Parrado del Olmo Palencia 1981 J. M. Parrado del Olmo, *Los Escultores Seguidores de Berruguete en Palencia*, Valladolid, 1981.

Pedro de Mena Centenario *Pedro de Mena: III Centenario de su Muerte* (exhibition catalogue), Málaga Cathedral, April (Junta de Andalucía), 1989.

Pedro de Mena 1989 *Pedro de Mena y Castilla* (exhibition catalogue), Museo Nacional de Escultura, Valladolid, 1989.

Penny 1992 N. Penny, *Catalogue of European Sculpture in the Ashmolean Museum 1540 to the Present Day*, (3 vols) Oxford, 1992.

Penny 1993 N. Penny, *The Materials of Sculpture*, New Haven, 1993.

Pequeña Escultura *La Pequeña Escultura en Valladolid (Siglos XVI a XVIII)*, (exhibition catalogue), Caja de Ahorros Popular de Valladolid, Valladolid, 1983.

Pequeñas Imágenes *Pequeñas Imágenes de la Pasión en Valladolid* (exhibition catalogue), Museo Nacional de Escultura, Valladolid, 1987.

Pérez and Romero L. Pérez del Campo and J. L. Romero Torres, *La Catedral de Málaga*, León, 1986.

Pérez-Embid F. Pérez-Embid, *Pedro Millán y los Orígenes de la Escultura en Sevilla*, Madrid, 1973.

Pérez Sánchez A. E. Pérez Sánchez and N. Spinosa, *L'Opera Completa del Ribera*, Milan, 1978.

Pijoan J. Pijoan, *History of Art* (translated by R.L. Roys), Barcelona, 1927.

Pita Andrade 1991 J. M. Pita Andrade (ed.), *El Libro de la Academia* (Real Academia de Bellas Artes de San Fernando), Madrid, 1991.

Pita Andrade 1994 J. M. Pita Andrade (ed.), *El Libro de la Capilla Real Granada*, Granada, 1994.

Pliny Pliny, *Natural History*, (ed. D. E. Eichholz), London, 1962.

Ponz D. Antonio Ponz, *Viage de España* (18 vols), Madrid, 1787.

Pope-Hennessy J. Pope-Hennessy (assisted by R. W. Lightbown), *Catalogue of Italian Sculpture Victoria and Albert Museum*, (3 vols), London, 1963.

Portela Sandoval F. J. Portela Sandoval, *La Escultura del Siglo XVI en Palencia*, (Colección Pallantia 4), Palencia, 1977.

Praz 1964 M. Praz, *Studies in Seventeenth-century Imagery* (2nd ed.), Rome, 1964.

Puget 1994 *Pierre Puget Peintre, Sculpteur, Architecte 1620–1694* (exhibition catalogue), Musée des Beaux-Arts, Marseilles, 1994.

Pugliatti T. Pugliatti, *Giulio Mazzoni e la Decorazione a Roma nella Cerchia di Daniele da Volterra*, Rome, 1984.

Quadrado and de la Fuente J. M. Quadrado and V. de la Fuente, *Toledo y Ciudad Real (Castilla La Nueva III)*, Barcelona, 1978 (reprint of 1886 ed.).

Radcliffe, Baker and Maek-Gérard A. Radcliffe, M. Baker and M. Maek-Gérard, *The Thyssen-Bornemisza Collection: Renaissance and Later Sculpture*, London, 1992.

Rafols 1942 J. F. Rafols, *Historia del Arte*, Barcelona, 1942.

Ramallo Asensio G. Ramallo Asensio, *Escultura Barocca en Asturias*, Oviedo, 1985.

Rasmussen J. Rasmussen, '<<far stupire el mondo>>. Zur Verbreitung der Kunst des Veit Stoss', *Veit Stoss: Die Vorträge des Nürnberger Symposions* (ed. R. Kahsnitz), Munich, 1985, pp. 107–23.

Réau L. Réau, *Iconographie de l'Art Chrétien*, Paris, 1958.

Redondo Cantera M. J. Redondo Cantera, *El Sepulcro en España en el Siglo XVI: Tipología e Iconografía*, Madrid, 1987.

Review 1919 *Victoria and Albert Museum. Review of the Principal Acquisitions during the Year 1919*, London, 1922.

Review 1932 *Victoria and Albert Museum. Review of the Principal Acquisitions during the Year 1932*, London, 1933.

Reyes y Mecenas *Reyes y Mecenas: Los Reyes Católicos – Maximiliano I y los Inicios de la casa de Austria en España*, (exhibition catalogue), Toledo, Museo de Santa Cruz, 1992.

Riaño J. F. Riaño, *Classified and Descriptive Catalogue of the Art Objects of Spanish Production in the South Kensington Museum*, London, 1872.

Ribadeneira Pedro de Ribadeneira, *Flos Sanctorum o Libro de las Vidas de los Santos*, Barcelona, 1643.

del Rio de la Hoz I. del Rio de la Hoz, 'El mármol de Carrara: una elección social del Condestable de Castilla (1532–1555)', in *Le Vie del Marmo: Aspetti della produzione e della diffusione dei manufatti marmorei tra Quattrocento e Cinquecento*, Centro Culturale L. Russo, Pietra Santa, 3 October, 1992, pp. 31–40.

Riquer M. de Riquer, *L'Arnès del Cavaller: Armes i Armadures Catalanes Medievals*, Barcelona, 1968.

Rivera J. J. Rivera, 'Alejandro Carnicero y el Organo de la Catedral de León', *BSAA*, XLIV, 1978, pp. 485–90.

Robertson I. Robertson, *Los Curiosos Impertinentes: Viajeros Ingleses por España 1760–1855* (tr. F. J. Mayan), Madrid, 1975.

Robinson Ashmolean John Charles Robinson Papers held in the Ashmolean Museum Oxford.

Robinson Reports John Charles Robinson Art Referee Reports (1863–1869). Papers held in the National Art Library at the Victoria and Albert Museum.

Robinson 1897 J. C. Robinson, 'Our Public Art Museums', *The Nineteenth Century*, 1897, no. 250, December, 1897, pp. 940–64.

Rodríguez Ceballos 1971 A. Rodríguez G. de Ceballos, 'El Escultor Indiano Bernardo Pérez de Robles', *BSAA*, XXXVII, 1971, pp. 311–25.

Rodríguez Ceballos 1986 A. Rodríguez Ceballos, 'El Escultor José de Larra Domínguez, Cuñado de los Churriguera', *AEA*, LIX, 1986, no. 233, pp. 1–32.

Rodríguez Martínez L. Rodríguez Martínez, *Historia del Monasterio de San Benito el Real de Valladolid*, Valladolid, 1981.

Rogers M. R. Rogers, 'A Spanish Reredos', *St Louis City Art Museum Bulletin*, XX, 1935, pp. 1–5.

Rorimer J. J. Rorimer, *The Metropolitan Museum of Art: The Cloisters* (3rd edition, revised by M. B. Freeman and others), New York, 1963.

Ruiz J. Ruiz-Navarro Pérez, *Arnao de Bruselas Imaginero Renacentista y su Obra en el Valle Medio del Ebro*, Logroño, 1981.

Ruiz Alcón M. T. Ruiz Alcón, 'Imágenes del Niño Jesús del Monasterio Convento de la Descalzas Reales', *Reales Sitios*, no. 6, 1965, pp. 28–36.

Ruiz Cabriada 1958 A. Ruiz Cabriada, *Bio-Bibliografía del Cuerpo Facultativo de Archiveros, Bibliotecarios y Arqueologos 1858–1958*, Madrid, 1958.

Salzillo 1973 *Salzillo (1707–1783). Exposición Antológica*, Iglesia de San Andrés/Museo Salzillo, Murcia, 1973.

Salzillo 1977 *Salzillo: su Arte y su Obra en la Prensa Diaria* (Academia Alfonso X el Sabio/ Museo Salzillo), Murcia, 1977.

Salzillo 1983 *Francisco Salzillo y el Reino de Murcia en el Siglo XVIII*, (exhibition catalogue), Museo de Bellas Artes, Murcia, 1983.

Sánchez Cantón 1926 F. J. Sánchez Cantón, *San Francisco de Asís en la Escultura Española*, Madrid, 1926.

Sánchez Cantón 1933 F. J. Sánchez Cantón, 'Los Sepulcros de Espeja', *AEA*, IX, 1933, pp. 117–25.

Sánchez Cantón 1949 F. J. Sánchez Cantón, 'Conocimiento y Estudios sobre el Arte de España en Inglaterra', *Arbor*, XII, no. 40, April, 1949, pp. 555–77.

Sánchez Cantón, *Fuentes* F. J. Sánchez Cantón, *Fuentes Literarias para la Historia del Arte Español*, Madrid, (Vols. I–V), 1923–41.

Sánchez-Mesa Martín 1967 D. Sánchez-Mesa Martín, 'Nuevas Obras de Luisa Roldán y José Risueño en Londras y Granada', *AEA*, XL, 1967, pp. 325–31.

Sánchez-Mesa Martín 1971 D. Sánchez-Mesa Martín, *Tecnica de la Escultura Policromada Granadina*, Granada, 1971.

Sánchez-Mesa Martín 1972 D. Sánchez-Mesa Martín, *José Risueño Escultor y Pintor Granadino (1665–1732)*, Granada, 1972.

Sánchez-Mesa Martín 1988 D. Sánchez-Mesa Martín, 'La Infancia de Jesús en el Arte Granadino', *Cuadernos de Arte e Iconografía*, I, no. 1, 1988, pp. 39–53.

Sánchez-Mesa Martín 1990 D. Sánchez-Mesa Martín, 'En el Tercer Centenario de la Muerte del Escultor Granadino Pedro de Mena', *Boletín de la Real Academia de Bellas Artes de Granada*, no. 1, Granada, 1990, pp. 51–67.

Sánchez-Mesa Martín 1991 D. Sánchez-Mesa Martín, *El Arte del Barroco. Escultura-Pintura y Artes Decorativas* (*Historia del Arte en Andalucía* VII), Seville, 1991.

Sánchez Moreno 1983 J. Sánchez Moreno, *Vida y Obra de Francisco Salzillo*, Madrid, 1983 (revised and expanded version of 1945 edition).

Sánchez-Rojas Fenoll 1982 M. del Carmen Sánchez-Rojas Fenoll, *El Escultor Nicolas de Bussy*, Murcia, 1982.

Santamaria 1992 J. M. Santamaria, *Segovia 1492: Entre dos Siglos*, (exhibition catalogue), Caja Segovia, Segovia, 1992.

Santiago Camino 1993 *Santiago, Camino de Europa: Culto y Cultura en la Peregrinación a Compostela*, (exhibition catalogue) Monasterio de San Martín Pinario, Santiago de Compostela, 1993.

Schaefer and Fusco 1987 S. Schaefer and P. Fusco, *European Painting and Sculpture in the Los Angeles County Museum of Art*, Los Angeles, 1987.

Schmitz-Eichhoff 1977 M.-T. Schmitz-Eichhoff, *St Rochus: Ikonographische und Medizin-Historische Studien*, Cologne, 1977.

Schottmüller 1913 F. Schottmüller, *Königliche Museen zu Berlin*, V, *Die Italienischen und Spanischen Bildwerke der Renaissance und des Barocks*, Berlin, 1913.

Schurhammer 1955 G. Schurhammer, *Franz Xaver: Sein Leben und Seine Zeit* (3 vols), Freiburg, 1955.

Sebastián 1989 S. Sebastián, *Contrarreforma y barroco: Lecturas iconográficas e iconológicas*, Madrid, 1989.

Serrano Fatigati E. Serrano Fatigati, 'Escultura en Madrid', *Boletín de la Sociedad de Excursiones*, XVIII, 1910.

Seznec J. Seznec, 'Youth, Innocence and Death', *Journal of the Warburg Institute*, I, no. 4, 1937–8, pp. 298–303.

Smouse F. I. Smouse, 'La Sculpture à Gênes au XVIIe Siècle: Pierre Puget, Filippo Parodi et Leurs Contemporains', *Gazette des Beaux Arts*, 4ème série, XII, 1914, pp. 11–24.

Schulte A. Schulte, *Geschichte des grossen Ravensburger Handelsgesellschaft 1380–1530* (3 vols), Stuttgart and Berlin, 1923.

Sparrow Simpson W. Sparrow Simpson, 'Two inventories of the cathedral church of St Paul, London . . .', *Archaeologia*, L, 1887, pp. 472–3.

Stirling 1847 W. Stirling [later Stirling-Maxwell], *Annals of the Artists of Spain* (3 vols, plus additional fourth volume produced in limited edition of 25 copies), London, 1847.

Stirling-Maxwell 1891 W. Stirling-Maxwell, *Annals of the Artists of Spain* (new edition incorporating the author's own notes, additions and emendations), (4 vols), London, 1891.

Stoichita V. I. Stoichita, *Visionary Experience in the Golden Age of Spanish Art*, London, 1995.

Stratton 1993 S. L. Stratton (ed.), *Spanish Polychrome Sculpture 1500–1800 in United States Collections*, New York, 1993.

Stratton 1994 S. L. Stratton, *The Immaculate Conception in Spanish Art*, Cambridge, 1994.

Street G. E. Street, *Some Account of Gothic Architecture in Spain* (ed. G. G. King), London, [first published 1865], 1914.

Stumm *Antiquitäten und Alte Gemälde aus dem nachlass des verstorbenen Freiherrn F von Stumm* (sale catalogue), G. Deneke, Berlin, 4th October, 1932.

Tesoros *Tesoros de la Catedral de Burgos* (exhibition catalogue), Salas del Banco Bilbao Vizcaya, Madrid, 1995.

Testore C. Testore, *Santos y Beatos de la Compañía de Jesús*, Madrid, 1951.

Thieme Becker U. Thieme and F. Becker, *Allgemeines Lexikon der Bildenden Künstler* (37 vols), Leipzig, 1907–50.

Thring M. Thring, 'A Statuette by Pedro Millán of Seville', *Burlington Magazine*, LXXXIII, 1943, pp. 253–5.

Tormo 1972 E. Tormo, *Las Iglesias de Madrid*, Madrid, (2nd edition), 1972.

Trens M. Trens, *María: Iconografía de la Virgen en el Arte Español*, Madrid, 1948.

Trota José R. Trota José, *Images of Faith: Religious Carvings from the Philippines*, Pasadena, 1990.

Trusted 1987 M. Trusted, 'A Work by Esteban Jordán: An Effigy of a Spanish Knight of the Order of St John', *BSAA*, LIII, 1987, pp. 351–9.

Trusted M. Trusted, 'Three Spanish Terracottas in the Victoria and Albert Museum', *BSAA*, LIX, 1993, pp. 321–30.

Trusted M. Trusted, 'Moving Church Monuments: Processional Images in Spain in the Seventeenth Century', *Journal of the Church Monuments Society*, X, 1995, pp. 55–69.

Uranga Galdiano J. E. Uranga Galdiano, *Retablos Navarros del Renacimiento*, Pamplona, 1947.

Urrea Fernández J. Urrea Fernández, 'A Proposito de los Yacentes de Gregorio Fernández', *BSAA*, XXXVIII, 1972, pp. 543–6.

Urrea Fernández J. Urrea Fernández, *La Catedral de Valladolid y Museo Diocesano*, León, 1978.

Urrea Fernández J. Urrea Fernández, *La Catedral de Burgos*, León, 1982.

Urrea J. Urrea, 'Nuevas Esculturas de Pedro de Mena', *Pedro de Mena y su Época*, Granada/Málaga, 5–7 April, 1989, pp. 361–71.

Valdivieso 1980 E. Valdivieso, R. Otero, J. Urrea, *Historia del Arte Hispanico, IV: El Barroco y el Rococo*, Madrid, 1980.

Valdivieso and Serrera 1979 E. Valdivieso and J. M. Serrera, *El Hospital de la Caridad de Sevilla*, Valladolid, 1979.

de Vega Giménez M. T. de Vega Giménez, *Historia, Icongrafía y Evolución de las Imágenes Exentas del Niño Jesús (Catálogo de la Provincia de Valladolid)*, Valladolid, 1984.

Velado Graña B. Velado Graña, *Gaspar Becerra: Retablo Mayor de la Catedral de Astorga*, Astorga, 1993.

Velasco B. Velasco, 'Esculturas de Alejandro Carnicero en Salamanca', *BSAA* XL–XLI, 1975, pp. 679 82.

Veliz Z. Veliz (ed.), *Artists' Techniques in Golden Age Spain: Six Treatises in Translation*, Cambridge, 1986.

Verrié F. P. Verrié, *Los Monumentos Cardinales de España: Montserrat*, Madrid, 1950.

Vila Jato M. D. Vila Jato, *Escultura Manierista (Arte Galega Sánchez Cantón)*, Santiago de Compostela, 1983.

Villa-Amil 1899 J. Villa-Amil y Castro, 'La Azabachería Compostelana', *Boletín de la Sociedad Española de Excursiones*, VI, 1899, pp. 185–94.

Viñaza El Conde de la Viñaza, *Adiciones al Diccionario Histórico . . . de Ceán Bermúdez* (4 vols), Madrid, 1889–94.

Vlaanderen *Vlaanderen en Casilla y León op de Drempel van Europa* (exhibition catalogue), Antwerp Cathedral, 1995.

de Vries A. de Vries, *Dictionary of Symbols and Imagery*, Amsterdam, 1976.

Wattenberg F. Wattenberg, *Museo Nacional de Escultura de Valladolid*, Madrid, 1963.

Weise G. Weise, *Renaissance und Frühbarock in Altkastilien (Spanische Plastik aus Sieben Jahrhunderten III, 1)*, Tübingen, 1929.

Weise G. Weise, *Die Plastik der Renaissance und des Frühbarock im Nördlichen Spanien* (2 vols), Tübingen, 1957 and 1959.

Westmoreland and Hermanès R. Westmoreland and T.-A. Hermanès, 'Examination and Treatment of a Seventeenth-Century Spanish Polychrome Sculpture by José Caro', *Conservation of the Iberian and Latin American Cultural Heritage*, Madrid, 9–12 September, 1992, pp. 175–8.

Wethey H. Wethey, *Gil de Siloe and his School*, Cambridge, Mass, 1936.

Wethey H. E. Wethey, 'A Madonna and Child by Diego de Siloe', *Art Bulletin*, XXII, 1940, pp. 190–6.

Wethey 1943 H. E. Wethey, 'The Early Works of Bartolomé Ordóñez and Diego de Siloe', *Art Bulletin*, XXV, 1943, p. 336.

Wethey 1955 H. E. Wethey, *Alonso Cano: Painter, Sculptor, Architect*, Princeton, 1955.

Wethey 1959 H. E. Wethey, 'Dos Estatuas de la Familia Cardenas de Ocaña', *AEA*, XXXII, 1959, pp. 29–37.

Widdrington 1843 S. E. Widdrington, *Spain and the Spaniards in 1843* (2 vols), London, 1844.

Willamson 1983 P. Williamson, *Catalogue of Romanesque Sculpture*, London, 1983.

Williamson 1988 P. Williamson and P. Evelyn, *Northern Gothic Sculpture*, London, 1988.

Williamson 1996 P. Williamson (ed.), *European Sculpture at the Victoria and Albert Museum*, London, 1996.

Winckworth 1961 P. Winckworth, 'Málaga Clay Figures', *Connoisseur*, CXLVII, March, 1961, pp. 106–8.

Wind E. Wind, 'The Eloquence of Symbols', *Burlington Magazine*, XCII, 1950, pp. 349–50.

Wittkower R. Wittkower, 'Death and Resurrection in a Picture by Marten de Vos', *Allegory and the Migration of Symbols*, London, 1977, pp. 160–6.

Yarza Luaces J. Yarza Luaces, *Los Reyes Católicos: Paisaje Artístico de una Monarquia*, Madrid, 1993.

Zanetti V. Zanetti, *Monografia della Vetraria Veneziana e Muranese*, Venice, 1874.

INDEX OF ARTISTS

INDEX OF SUBJECTS

INDEX OF INVENTORY NUMBERS

REJECTED ATTRIBUTIONS

Below is a concise list of objects formerly thought to be Spanish, and now considered to have been produced elsewhere.

1. *Virgin and Child*
 Boxwood relief
 Netherlandish/French; *c.* 1830–60?
 89–1864

2. *A Horse*
 Painted wood with velvet saddle
 Attributed to Carlo Amatucci (active in Lisbon 1803–d. 1809)
 Neapolitan/Portuguese; before 1809
 93–1864

3. *Male Saint*
 Boxwood statuette
 Netherlandish; *c.* 1630
 165–1864

4. *Alexander the Great*
 Boxwood statuette
 Bavarian(?); *c.* 1680
 169–1864

5. *Julius Caesar*
 Boxwood statuette
 Bavarian(?); *c.* 1680
 170–1864

6. *Virgin and Child*
 Boxwood statuette
 Netherlandish; *c.* 1600–1650
 173–1864

7. *Virgin and Child*
 Boxwood statuette
 Netherlandish; *c.* 1600–1650
 322–1864

8. *Three figures of mounted negroes*
 Painted wood and silk, velvet trimmings
 Neapolitan; *c.* 1750
 325 to 327–1864

9. *Virgin and Child*
 Boxwood statuette
 Netherlandish; *c.* 1600–1650
 600–1864

10. *Seated Christ on the Mound*
 Boxwood statuette
 Netherlandish; *c.* 1600–1650
 60–1904

11. *St John Nepomuk*
 Boxwood statuette
 Prague(?); *c.* 1700
 A.1064–1910

12. *Ecce Homo*
 Painted and gilt limewood half-length figure
 South German (?); about 1650–1700
 A.10–1940

13. *Christ at the Column*
 Boxwood statuette
 Silesia(?); *c.* 1650
 A.5–1951

14. *Virgin and Child*
 Boxwood statuette
 Netherlandish; *c.* 1600–1650
 A.18–1951

15. *Virgin of the Immaculate Conception*
 Painted and gilt poplar figure
 Central European; *c.* 1770–1790
 A.18–1954